Architecture : Art

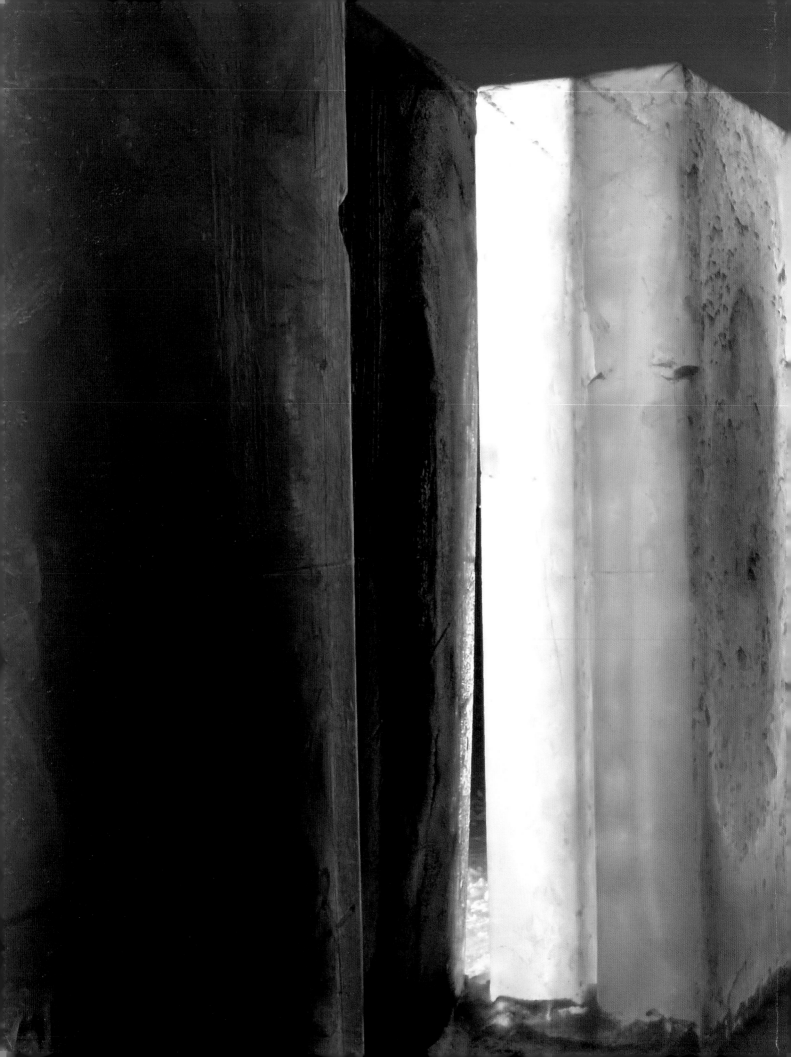

Philip Jodidio

Architecture : Art

Prestel
Munich · Berlin · London · New York

Contents

8 The World That is Already There

38 Acconci Studio
Mur Island Project Graz, Austria 2003

40 Tadao Ando
Chichu Art Museum Naoshima, Japan 2004

44 Bernd and Hilla Becher
Blast Furnaces 1961, 1979, 1986, 1995

46 Mario Botta, Enzo Cucchi
Chapel of Santa Maria degli Angeli Monte Tamaro, Switzerland 1990–96

50 Chris Burden
Tyne Bridge Baltic Centre for Contemporary Art,
Gateshead, United Kingdom 2002

52 Santiago Calatrava
Planetarium, City of Arts and Sciences Valencia, Spain 1991–98

56 Christo and Jeanne-Claude
The Gates, Project for Central Park New York, USA 1979–2005

60 dECOi
Aegis Hyposurface since 1999
Bankside Paramorph London, United Kingdom 2003

62 Thomas Demand
Public Housing 2003

64 Diller + Scofidio
Blur Building Expo.02, Yverdon-les-Bains, Switzerland 2002

66 (EEA) Erick van Egeraat associated architects
Yakimanka Residential Complex Moscow, Russia 2004–06

72 Peter Eisenman
Memorial to the Murdered Jews
of Europe Berlin, Germany 1997–2005

74 Olafur Eliasson
The Weather Project Tate Modern, London, United Kingdom 2003–04

76 Weng Fen
Sitting on the Wall — Shenzen 1 2002

78 FOA Foreign Office Architects
Yokohama International Port Terminal Yokohama, Japan 2000–02

82 Frank O. Gehry
DG Bank Berlin, Germany 1995–2001

84 Andy Goldsworthy
Stone Houses Metropolitan Museum of Art, New York, USA 2004

86 Dan Graham, Johanne Nalbach
Café Bravo Berlin, Germany 1998

88 Cai Guo-Qiang
Tonight So Lovely Shanghai, China 2001–02

90 Andreas Gursky
Shanghai 2000

92 Zaha Hadid with Patrik Schumacher
Guggenheim Museum Taichung, Taiwan since 2003

96 David Hockney
A Bigger Splash 1967
Pearblossom Highway, 11–18th April 1986 (second version) 1986

98 Candida Höfer
Netherlands Embassy, Berlin, by OMA/Rem Koolhaas Berlin, Germany 2003

102 Steven Holl
Loisium Visitors' Center Langenlois, Austria 2001–03

106 Robert Irwin
Prologue: x183 DIA Center for the Arts, New York, USA 1998

108 Arata Isozaki
Nagi MoCA Nagi-cho, Japan 1992–94

112 Toyo Ito
Tower of the Winds Yokohama, Kanagawa, Japan 1986

114 Jakob + MacFarlane
Georges Restaurant Centre Georges Pompidou, Paris, France 2000

118 Michael Jantzen
Virtual Reality Interface VRI 2002

120 Anish Kapoor
Marsyas Tate Modern, London, United Kingdom 2003
Cloud Gate Millennium Park, Chicago, USA 2004

126 Tadashi Kawamata
Sur la voie Évreux, France 2000

128 Yann Kersalé, Jean Nouvel
LED System for Agbar Tower Barcelona, Spain 2005

130 **Anselm Kiefer**
The Unknown Painter 1982

132 **Michael Landy**
Semi-Detached Tate Britain, London, United Kingdom 2004

134 Maya Lin
Vietnam Veterans Memorial Washington, D.C., USA 1982

136 Iñigo Manglano-Ovalle
Cloud Prototype No. 1 2003

138 Richard Meier
Jubilee Church Rome, Italy 1996–2003

142 Eric Owen Moss
The Umbrella Culver City, California, USA 1998–2000

144 Oscar Niemeyer
Serpentine Gallery Pavilion London, United Kingdom 2002

146 Enrique Norten, **Lawrence Weiner**
The Snow Show Kemi, Finland 2004

148 Jean Nouvel
The Monolith Expo.02, Murten, Switzerland 2002

150 Marcos Novak
Allobio Architecture Biennale, Venice, Italy 2004

152 NOX Lars Spuybroek
Son-O-House Son en Breugel, The Netherlands 2000–03

156 **Tony Oursler**
9/11 2001

158 **Philippe Parreno,** François Roche
The Boys from Mars 2003
Hybrid Muscle Chiang Mai, Thailand 2003

162 **Jaume Plensa**
Crown Fountain Millennium Park, Chicago, USA 2004

166 **Jean-Pierre Raynaud**
La Mastaba La Garenne-Colombes, France 1989

170 **Andrea Robbins, Max Becher**
Where do you think you are? Universal Guggenheim 2004
New York NY, Las Vegas NV: Whitney Museum 1996

172 **Ed Ruscha**
The Los Angeles County Museum on Fire 1965–68
Parking Lots (Universal Studios, Universal City) # 18 1967–99
Pools (9) 1968–97

174 SANAA Kazuyo Sejima + Ryue Nishizawa
21st Century Museum of Contemporary Art Kanazawa, Japan 2004

178 **Richard Serra**
Torqued Ellipses 1996, 1997, 1998

180 **Santiago Sierra**
300 Tons Kunsthaus Bregenz, Austria 2004

182 Álvaro Siza
Portuguese Pavilion Expo '98, Lisbon, Portugal 1996–98

186 **Wolfgang Staehle**
Untitled 2001

188 **Frank Stella**
Prinz Friedrich von Homburg, Ein Schauspiel, 3X 2001
The Broken Jug 1999

190 **Thomas Struth**
Pantheon, Rome 1990
Shanghai Panorama, Shanghai 2002

194 **Hiroshi Sugimoto**
Go'o Shrine, "Appropriate Proportion" 2002
Conceptual Forms. Mathematical Forms:
Surfaces 0012, Clebsch diagonal surface, cubic with 27 lines 2004

196 **David Thorpe**
Good People 2002

198 UN Studio
La Defense Almere, The Netherlands 1999–2004

202 **Felice Varini**
Octogone au carré Château des Adhémar, Montélimar, France 2003

204 **Jeff Wall**
Morning Cleaning 1999

206 Makoto Sei Watanabe
Shin Minamata Station and Shin Minamata Mon Minamata, Japan 2005

210 **Rachel Whiteread**
(Untitled) House London, United Kingdom 1993

212 Lebbeus Woods
Shard Houses 1997
La Chute (The Fall) Paris, France 2002–03

218 Suggested Reading
219 Biography
220 Index
223 Illustration Credits

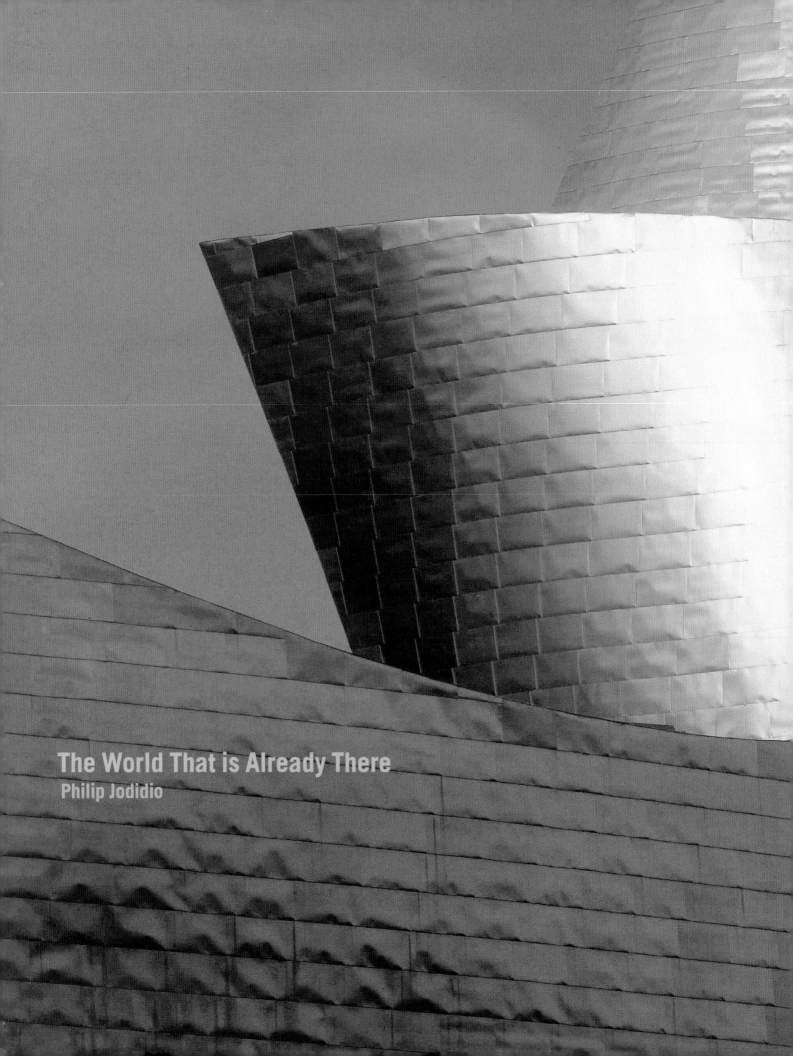

The World That is Already There
Philip Jodidio

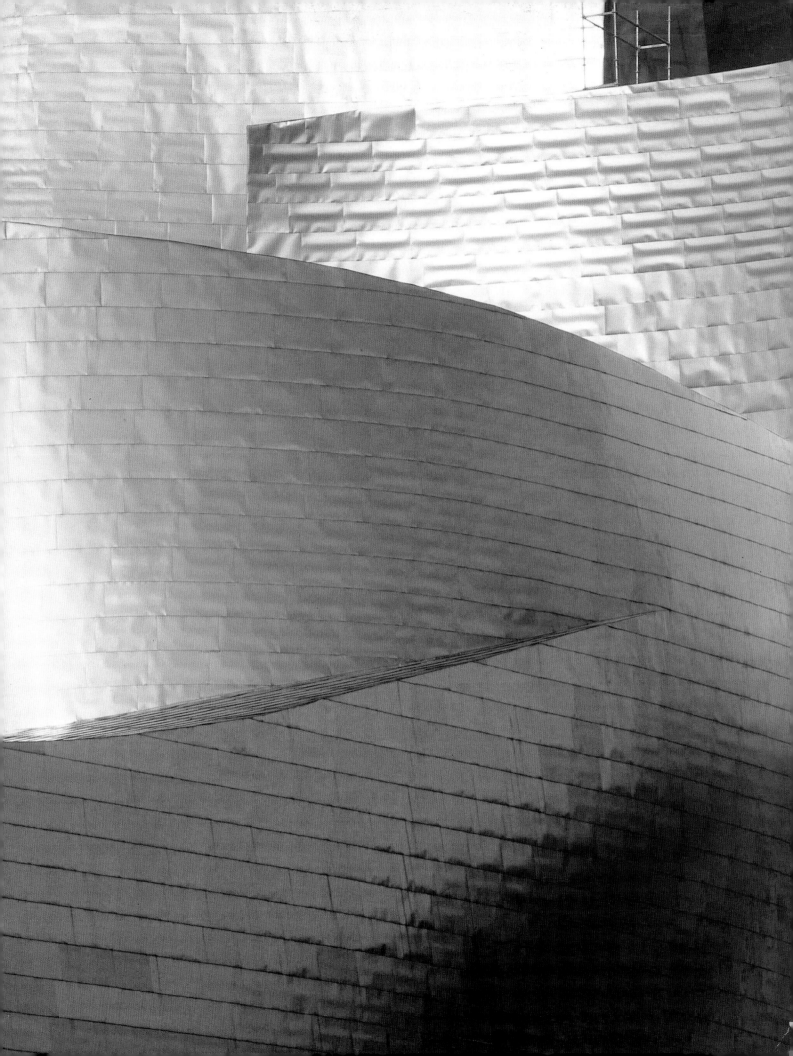

The World That is Already There

Art and architecture have been linked since the dawn of time. Representations of nature and man, invocations of fertility and life after death, are bound together not only by history, but by essence. Beyond its primordial connotation as sanctuary, architecture, as much as art, symbolizes life and destiny. As Rudolf Arnheim has written, "All works of art worth their name are symbolic, and works of architecture are no exception. By symbolism, I mean that these works, in addition to their physical functions, such as that of sheltering, protecting and facilitating the activities of their users, convey through their visible appearance the spiritual and philosophical meaning of their functions.... This symbolic meaning is not simply an attribution applied to the building by some thinker 'from the outside' as a kind of added interpretation, but it is of the very nature and essence of the design itself."[1] Analogies abound in architectural form, from the column-tree to the dome-sky-skull, but might it not be that even the simplest of shapes also carry in them — beyond the literal representation — the explanation of why art and architecture are forever linked? In his essential work *Art and Visual Perception,* first published in 1954, Arnheim defines the significance of the circle as the most fundamental of shapes. "It has been maintained that the child receives the inspiration for his earliest shapes from various round objects observed in the environment. The Freudian psychologist derives them from the mother's breasts, the Jungian from the *mandala;* others point to the sun and the moon. These speculations are based on the conviction that every form quality of pictures must somehow be derived from observations in the physical world. Actually, the fundamental tendency toward simplest shape in motor and visual behavior is quite sufficient to explain the priority of circular shapes. The circle is the simplest shape available in the pictorial medium because it is centrically symmetrical in all directions."[2] The earliest known prehistoric habitation was round, and the circle inhabits art and architecture of all ages.

Superimposed on the simple geometry of the circle, a great variety of symbolic meanings emerged as each civilization, each period, created its own interpretation. In the East, the *mandala,* but also the *stupa or enso,* assume this most basic form, while the halo graces the sacred personages of many times and places. One of the most visually arresting and significant artistic representations of the circle might be Leonardo da Vinci's study of the proportions of the human body (1485–90), his *Vitruvian Man,* or man as the origin of form. This drawing and its name are, of course, derived from Vitruvius's *De architectura libri decem,* in which the author states that architecture was the "first of the arts or sciences to emerge and hence has a *prima facie* claim to primacy among the arts."[3] The idea that this body inscribed by da Vinci in a circle is the origin of *all* things has been frequently explored. As Joseph Rykwert has written, "In the east of the Mediterranean basin ... in various Indo-European texts in Persia and in India, the creation of the universe as primal man, or even the creation of the universe *out* of his body, was also repeatedly sung and meditated. Inevitably, such scriptures are mirrored in rituals, such as those ancient ones concerned with the simplest fire altar, the elemental sacrificial ground. The best known of these, the ninetieth hymn of the *Rig-Veda*, suggests the creation of the cosmos and of society through a sacrificial dismembering of Purusa, the first man."[4] In his work *Le nombre d'or,* Matila Ghyka points to the significance of the circular form as related to the human body by Vitruvius in deriving the basic north-south axis that was essential to the orientation of ancient architecture.[5] From there, the subdivision of the circle by the inscription of a pentagon or, for example, a decagon was the basis of the proportions of much of ancient architecture, from Egyptian temples to the Pantheon in Rome, or again in the Renaissance with Donato Bramante's Tempietto.

If symbolism comes to reside in a form, be it architectural or artistic, is this not so because it is intimately related to perception? Such discourse is applicable not only to the distant past, but is very much an idea of the present, as exemplified in the influence of phenomenology on contemporary artists such as James Turrell. The French philosopher Maurice Merleau-Ponty, who greatly influenced Turrell, wrote: "... I create an exploratory body dedicated to things and to the world, of such sensitivity that it invests me to the most

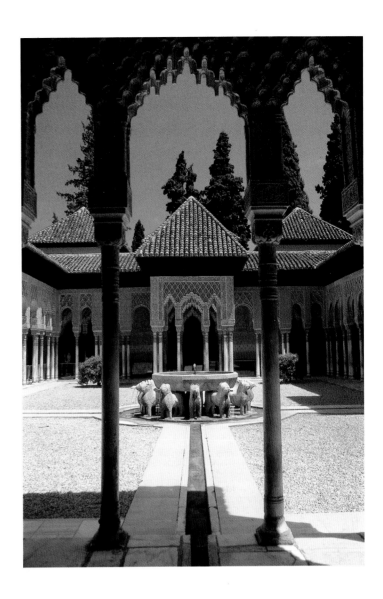

Alhambra, Granada, *ca.* 1350

profound recesses of myself and draws me immediately to the quality of space, from space to the object, and from the object to the horizon of all things, which is to say a world that is already there."[6] In the "world that is already there" art and architecture have always been one.

Palace of the Sky, Palace of the Earth

The number of examples that could be chosen to illustrate the intimate links between art and architecture throughout history is almost limitless. Indeed, there may be as many ways to define this relationship as there are cases in point. The union of art and architecture obviously reaches great heights in places of worship and palaces, where both forms of expression are placed at the service of an ideal, a belief, or an expression of power, and the role of the individual is subsumed in a collective purpose. The powerful connection between the *Elgin Marbles* and the Parthenon, one that endures over time despite physical separation, is a sufficient evocation of the breadth of this history to prove a point. Born of the most fundamental physiological and emotional needs, art and architecture, "from space to the object, and from the object to the horizon of all things," are, like mind and body, inseparable. Beginning in the early Renaissance, with the rise of humanism, a different balance emerges, where art may represent architecture, and architecture, even in the service of church and state, begins to assume the aura of individual creativity. In his work *De re aedificatoria*, Leon Battista Alberti wrote in 1452 that "a building is a *kind of body*, consisting of lines and materials, in which the lines are produced by mind, the material obtained from nature."[7] It would take centuries before the "impression" of an artist alone would be judged sufficient to create a work of art, but it is no exaggeration to say that the flow of inspiration from three dimensions to two and back again is at the very heart of the history of both art and architecture.

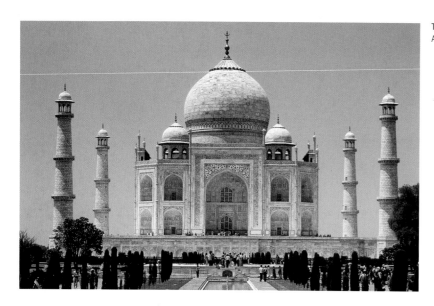

Taj Mahal,
Agra, India, 1643

Such concepts of the fundamental unity and importance of the relationship between art and architecture are not reserved to Western or, indeed, Christian thinking. One of the great monuments of Islamic architecture was the fruit of the gradual retreat of the Moors from Spain, under the growing pressure of the *Reconquista*. The Alhambra was begun in 1238 by Muhammad ibn al-Ahmar, who, when King Ferdinand of Aragon laid siege to Granada, rode to his opponent's tent and humbly offered to become the king's vassal in return for peace. On which side of the dividing line between Christian and Muslim did civilization lie in Al Andalus in 1238? With its exquisite decorations and gardens, the Alhambra was nothing less than a vision of paradise on earth. Indeed, its forms are closely linked to verses from the *Qur'an*: "Unto those who do right shall be given an excellent reward in this world; but the dwelling of the next life shall be better; and happy shall be the dwelling of the pious! Namely, gardens of eternal abode, into which they shall enter; rivers shall flow beneath the same; therein shall they enjoy whatever they wish. Thus will God recompense the pious." (*Qur'an*, Surah 9:9–72)

The Taj Majal was the last and greatest architectural and artistic achievement of the Mughal period in Agra, before its builder, Shah Jehan (1592–1658), shifted his capital to what is now called Delhi. History has concentrated on the idea that the Taj Majal is a monument to love, since it began to be erected in 1630 in honor of Shah Jehan's wife, Arjmand Banu, yet the monument and its gardens carry a clear evocation of paradise as defined in the *Qur'an* and Islamic symbolism. Indeed, verses from the *Qur'an* inlaid in stone adorn both the gates and the Taj Majal itself. According to Islam, there are four rivers in paradise, a concept at the origin of the Persian *Charbagh* style of garden planning. Having passed through the main gate, itself an evocation of the entrance to paradise, the visitor to the Taj Majal discovers two marble canals that cross in the center of the garden, dividing it into four equal squares. The Taj Majal itself is elevated on a 95.5-meter-square plinth. The majestic dome that dominates the structure is placed in the center of this square and forms a perfect circle. It has frequently been written that in the symbolism of Islam, a square represents man, and a circle the divine. Da Vinci's *Vitruvian Man* is, of course, inscribed in a circle and a square, giving a humanist interpretation to shapes used by the Mughals to other ends, and yet years and continents apart, art and architecture fuse around the same essential forms. The fact that different religions and civilizations produce such similarities of symbolism and form is more than coincidence; it is proof of how deeply rooted the ties are between various other forms of artistic expression and architecture.

If the Taj Majal was, indeed, a representation of paradise on earth, it made reference to the *Qur'an* and to Islam. Buried beneath its faultless dome, Shah Jehan and his wife were surely that much closer to heaven. At the same moment, and half a world away, another vision of perfection was taking form near Kyoto, but this was a more worldly apparition, based on the art and literature of Japan. Prince Toshihito, the creator of Katsura, was born in 1579. Younger brother of Emperor Goyozei, Toshihito showed interest from an early age in literature, particularly *The Tale of the Genji*.

Written just after 1000 AD, *The Tale of the Genji*, which chronicles the life of an ideal courtier, is considered by some to be the first novel. Little is known about its author, Murasaki Shikibu, except that she was the daughter of a provincial governor who lived roughly between 973 and 1025. She could hardly have imag-

ined that six centuries later her words would be at the origin of one of Japan's great works of art and architecture, the Imperial Villa of Katsura. In the chapter of her work entitled "The Wind in the Pines," Murasaki wrote: "Far away, in the country village of Katsura, the reflection of the moon upon the water is clear and tranquil." As circumstances would have it, land south of the Katsura River, near Kyoto, came into the possession of Toshihito, who surely was aware of its literary significance. This area had also been the site of a residence modeled on the villa of the Tang-era poet Po Chu-I (772–846). Po Chu-I's poem *The Song of Everlasting Regret* (806) figures prominently in *The Tale of the Genji*. Little more than a melon patch when Toshihito began to transform the area, it was described in the records of Shokoku-ji Temple in 1631 as a "palace" used for moon-viewing parties based on *The Tale of the Genji*.

Toshihito died in 1629, but by 1642 his son Prince Toshitada began to renovate and expand the original structures. Toshitada expressed his desire to transform Katsura into an ideal place for the tea ceremony and he built several additional teahouses on the grounds. He also explicitly mentioned his wish to make the garden similar to the one in *The Tale of the Genji*. Although some sources credit the design of Katsura to the tea ceremony master and architect Kobori Enshu, it was also the product of the active interest of the princes who developed it progressively. As early as the 14th century, the cultivated nobility of Japan had rejected ornate architecture in favor of a search for harmony with nature, and Katsura represents an apogee of this esthetic sensibility called the s*ukiya* style. But Katsura is more than the expression of a single style. Toshihito also used the so-called *shoin* style, which is more formal and orthogonal than *sukiya*. In 1658, Toshitada built the New Shoin at Katsura on the occasion of a visit of former Emperor Gomino-o.

Katsura Rikyu, Shôkintei, Kyoto, *ca.* 1660

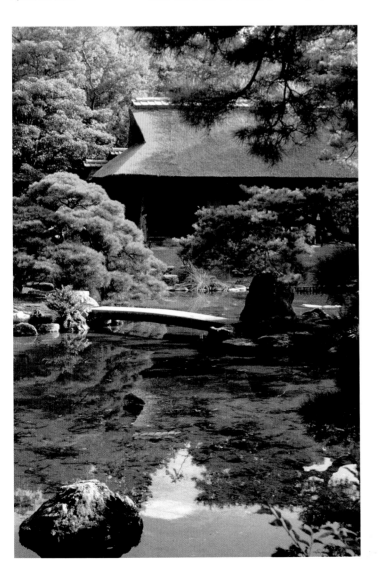

Toshitada died in 1662 and his successors did not live long enough to continue work on the Imperial Villa, although Prince Yakahito (1703–67) did repair the structures without changing the fundamental composition of Katsura. When the family line died out in 1883, Katsura became a domain of the Emperor, but for historical reasons it fell into disrepair. Like many historical buildings in other countries, Katsura was not fully appreciated until much later, in Katsura's case not by the Japanese until the architect Bruno Taut arrived in Japan in 1933 at the invitation of the Japanese Association for International Architecture. Such was its state of neglect that on November 4, 1935, Taut wrote, "I can claim to be the 'discoverer' of Katsura." Taut and then Le Corbusier and Gropius were fascinated by Katsura's "modernity." They saw its undecorated orthogonal and modular spaces as parallels to contemporary Modernism, going so far as to identify Katsura as a "historical" example of modernity. The Modernists saw what they wanted to see in Katsura — the Mondrian-like simplicity of certain designs — while looking less at its rustic side, or at the "complexity and contradiction" that lies in almost every aspect of the buildings and gardens.

Later, Japanese critics and architects, at first strongly influenced by Taut, took up their own analysis of Katsura. Kenzo Tange felt that the villa was the result of a synthesis of two ancient Japanese cultures — the Yayoi and the Jomon, or the traditions of sophistication and a more rural, energetic spirit. As he wrote: "It was in the period when the

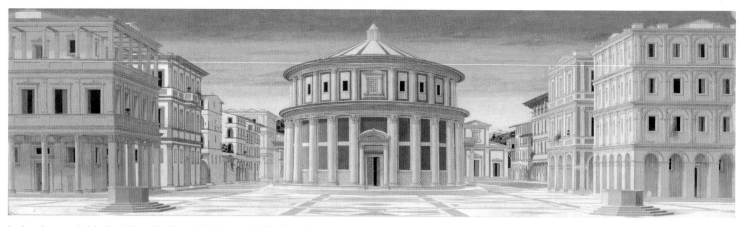

Luciano Laurana (originally attributed to Piero della Francesca), *The Ideal City, ca.* 1420–79. Tempera on wood, 67.5 x 239.5 cm. Palazzo Ducale, Urbino

Katsura Palace was built that the two traditions, Jomon and Yayoi, first actually collided. When they did, the cultural formalism of the upper class encountered the vital energy of the lower classes. From their dynamic union emerged the creativity seen in Katsura." More recently, Arata Isozaki has written about the fundamental ambiguity of the Palace: "I have not been able to see the Katsura in the same light as the Modernists once did. They selected what they wanted from the Katsura, its transparence, its functionally designed space. I have viewed it rather as a great mixture, as deeply ambiguous. I have taken its evolution as resulting from accidents and a certain opacity of design." Clearly, Katsura is a secular masterpiece, an alliance of architecture and the arts of the garden or of décor. Like most great works, it can be read or understood by different visitors in different ways, and it remains a fundamental expression of Japan, or rather of universal culture. It did not evolve from the symbolic and religious vocabulary that informed the Alhambra or the Taj Majal, but from a sense of beauty and harmony that is the quintessence of an ancient culture. Where modernity sought the *gesamtkunstwerk*, the total work of art, the Japanese found it in Katsura almost four centuries ago. Though animist currents run deep in Japanese culture, Katsura was a triumph of humanist vision, an ideal of beauty as expressed and designed for this world and not for the hereafter.

The ways in which Christian churches have combined art and architecture over the centuries have been amply studied. In its turn, Christian architecture has provided powerful inspiration to painting, for different reasons depending on the period concerned. An enigmatic fragment of an architectural painting attributed to the Flemish painter Jan van Eyck — the *Retable de la Chartreuse de Champmol* (1443) representing architecture — might symbolize many of these efforts. In 1363, Jean le Bon, King of France, named his son Philippe le Hardi Duke of Burgundy. The Duke created the Chartreuse de Champmol, a Carthusian monastery, near Dijon in 1384. Philippe le Hardi had formed close ties with Flanders on June 19, 1369, when he married Marguerite, sole heir of Louis de Male, Count of Flanders. Beginning in September 1377, and until 1410, some of the greatest artists and artisans of the time, from Burgundy, Flanders and other areas, worked on the Chartreuse de Champmol, destined to become the place of burial of the Dukes of Burgundy. The work was directed at first by Drouet de Dammartin, an assistant to Raymond du Temple, architect of the Louvre under Charles V, and brother of Guy de Dammartin, the architect of the Duke of Berry. The sculptors Jean de Marville and Claus Sluter from Holland worked on the project, as did the painter Melchior Broederlam, the wood-carver Jean de Liege and Robert de Cambrai, who created the stained-glass windows. The Chartreuse de Champmol did not survive the Revolution, its works of art were sold on April 30, 1791, and its church and other structures razed in 1792, and yet through texts and surviving pieces it remains one of the most remarkable historic examples of collaboration between the greatest artists and architects of a period.

Even after the completion of the Chartreuse, the successors of Philippe le Hardi continued to enrich its works of art. On May 19, 1425 Jan van Eyck entered the service of Duke Philippe le Bon, and certainly painted an *Annunciation* for the Chartreuse. Van Eyck is considered to be the founder of Renaissance painting in Flanders and the Netherlands. He was influenced by the realism of the Limbourg brothers and the use of light in the work of Robert Campin, also called the "Master of Flémalle." The presumed fragment (from the Paris Decorative Arts Museum) of an altarpiece representing rather fantastic religious architecture shows the painter's mastery of architectural form, even if he is indulging here in pure invention. It is speculated that Van Eyck's vision is not of any particular church, but indeed of a paradisiacal ideal that may have been

inspired by a passage from the *Book of Revelation*. "Then I saw a new heaven and a new earth, for the first heaven and the first earth had passed away, and there was no longer any sea. I saw the Holy City, the New Jerusalem, coming down out of heaven from God, prepared as a bride beautifully dressed for her husband. And I heard a loud voice from the throne saying, 'Now the dwelling of God is with men, and he will live with them. They will be his people, and God himself will be with them and be their God. He will wipe every tear from their eyes. There will be no more death or mourning or crying or pain, for the old order of things has passed away.'" *(Revelation 21)*

Like Masaccio in Italy, Van Eyck was a pioneer of a new, more realistic way of painting that laid down some of the premises of the idea of perspective. That painting here indulges in a search for an otherworldly perfection is a natural continuation of its role as an accompaniment to sacred architecture. No longer limited to fresco but executed on panels that could be moved, paintings often took such ideal architecture as their theme in a religious context. Biblical scholars maintain that the New Jerusalem was never thought of as a "real" city but as an evocation of the kingdom to come. Building God's kingdom would surely not be the work of any mortal, but art could represent its perfection in ways that architecture found more difficult. In any case, built and painted works still shared a common denominator even if one could now dare to go forward without being part of the other.

Even as religion inspired creativity, the new force of humanism emerged in Renaissance Italy, inspired in part by the vestiges of ancient Greece and Rome. Here, as elsewhere, the union of art and architecture was a chosen means of articulating the new ideals. Filippo Brunelleschi was born in Florence in 1377 and died there in 1446. Although he is known largely for his achievements in architecture, Brunelleschi also invented scientific perspective in about 1415, using mirrors. He understood that there should be a single vanishing point to which all parallel lines in a plane, other than the plane of the painting, converge. He also correctly computed the relation between the actual length of an object and its length in the painting or drawing depending on its distance behind the plane of the canvas. Using these principles he drew numerous scenes of Florence with correct perspective. These perspective drawings by Brunelleschi have disappeared, but a fresco of the *Trinity* by Masaccio (1427) that uses his principles still exists. Donatello's *Feast of Herod* is the oldest surviving example of the use of scientific perspective with a single vanishing point.

In a work often attributed to Piero della Francesca, *The Ideal City* (1420–79), the principle of mathematical perspective is applied to an architectural setting that shows an obvious fusion between built and painted forms. Somewhat later, da Vinci would say that "perspective is the rein and rudder of painting." In any case, it allowed painting to create a kind of "realism" never obtained in earlier works. The significance of this discovery cannot be underestimated. As William Rubin has written: "Fifteenth-century perspective was, in its most profound sense, a branch of humanism. For the first time — at least in a systematic manner — the world was imaged not according to a hierarchy of collective values attributed to the subject matter, but rather as that subject matter would be perceived from the vantage point of an individual, the now mobile viewer."[8] It is clear that architecture and its representation play an essential role in the humanist ideal that emerged during the Renaissance. Even if the goal was no longer to represent life after death, art and architecture inevitably were joined as the tools necessary to explain and create the world to come. Nor were the simplest and most symbolically charged forms set aside because they were now destined less and less to the glorification of God, and more to that of man. Federico Barocci's drawing *Tempietto of San Pietro in Montorio* (*ca.* 1590), long considered to be a study by Donato Bramante for the Tempietto in the courtyard of San Pietro in Montorio (1502–10), epitomizes the idealization of the circular design.

Few countries and periods have produced greater painting than Holland in the 17th century. Realism and an accent placed on the humanity of

Federico Barocci,
*Tempietto of
San Pietro in Montorio*,
ca. 1590.
Drawing, ink,
charcoal on paper,
458 x 427 mm.
Gabinetto dei Disegni
e delle Stampe degli
Uffizi, Florence

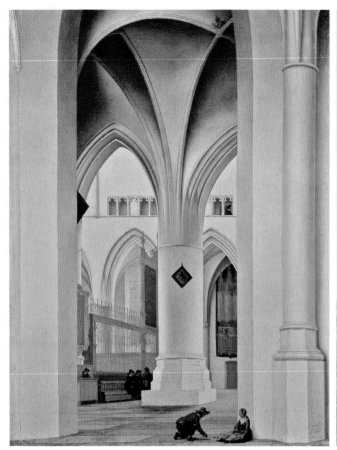

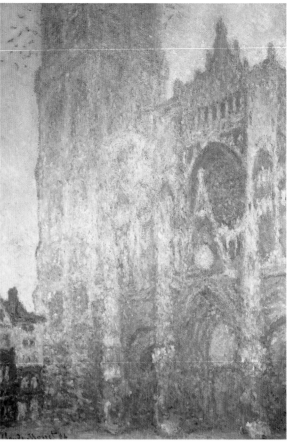

Pieter Janszoon Saenredam, *Interior of the St. Bavo Church in Haarlem*, 1636. Oil on panel, 49 x 36.6 cm. Collection Frits Lugt, Institut Néerlandais, Paris

Claude Monet, *Rouen Cathedral, Portal and Tower Saint-Romain in Morning Light*, 1893. Oil on canvas, 106 x 73 cm. Musée d'Orsay, Paris

subjects, usually derived from local life, replaced the religiously inspired art of another era. There were, of course, notable exceptions to these rules, but even when they were inventing landscapes, in the taste of Jacob van Ruisdael, the Dutch painters were unsurpassed in their realistic depiction of subjects ranging from portraits to still lifes to architecture. Pieter Janszoon Saenredam (1597–1665) was known as "the first portraitist of architecture" because of his faithful representations of specific buildings, usually churches. He was certainly influenced by two architect-painters, Jacob van Campen and Pieter Post, but Saenredam's remarkable attention to detail and light gave him a particular place in the representation of the built environment. For works such as his *Interior of the St. Bavo Church in Haarlem*, 1636, he first made a careful on-site sketch, and then created a large drawing executed with the aid of measurements and plans. His works are so faithful to reality that they allow present-day scholars to judge the precise state of 17th-century buildings. Although Saenredam's paintings are suffused with light, they are dispassionate appraisals of space whose real ideal is exactitude as opposed to religious fervor. They are compositions of light and space translated into two dimensions in a masterful way, proving that the even the gradual shift to a more secular society would not dissolve the already ancient links between art and architecture.

Where Saenredam sought above all to reproduce every detail of his architectural subjects, somewhat in the way that cameras would do from the 19th century onwards, the Impressionists gave a new significance to personal interpretation in painting. Speaking of this and later evolutions in art, Marshall McLuhan wrote in his influential book *Understanding Media*: "Perhaps the greatest revolution produced by photographs was in the traditional arts. The painter could no longer depict a world that had been much photographed. He turned, instead, to reveal the inner process of creativity in expressionism and abstract art.... Thus art moved from outer matching to inner making. Instead of depicting a world that matched the world we already knew, the artists turned to presenting the creative process for public participation. He has given to us now the means of becoming involved in the making-process."[9] A significant step in this progression from "outer matching to inner making" occurred when Claude Monet sought to depict the same subject at different times of the day, in an almost cinematographic manner. In two different campaigns in 1892 and 1893 he painted the facade of Rouen Cathedral more than thirty times. He became so obsessed with this process that he exhausted himself

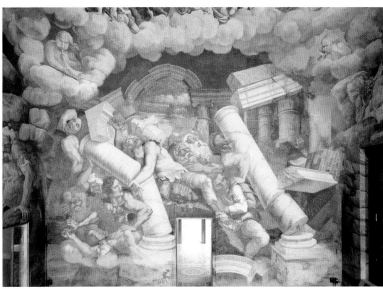

Pieter the Elder Breughel, *The Building of the Tower of Babel*, 1563. Oil on panel, 114 x 155 cm. Kunsthistorisches Museum, Vienna

Giulio Romano (School), *The Fall of the Giants*, 1526–35. Fresco. Palazzo del Tè, Padua

even as he brought painting closer to modernity. "I am broken," he wrote, "I can't do anything more, and what's more, I have had a nightmare where the cathedral falls on me and seems to be either blue or rose or yellow."[10] "Everything changes, even stone," remarked Monet, but with works such as *Rouen Cathedral, Portal and Tower Saint-Romain in Morning Light* (1893), he went beyond the kind of precise observation that characterized Saenredam's paintings to allow his impressions to guide palette and brush. The cathedral is the object of the entire series, but the real subject is how the painter sees. Rather than expressing a religious or earthly ideal, Monet has, in a sense, made himself the center of creativity. Perception, though, is not so much a personal quality as it is a fundamental aspect of existence. The words of Merleau-Ponty come to mind when trying to grasp the revolution in art that modernity, set on its way by figures like Monet, represents: "… from space to the object, and from the object to the horizon of all things, which is to say a world that is already there."

Complexity and Collapse

Though it is tempting to imagine art and architecture as heralds of paradise or earthly perfection, creative minds have also dreamt worlds of complexity, loss, collapse and darkness. Long before Dante's *Inferno* or Milton's *Paradise Lost,* hellfire and brimstone were the inevitable foil to heavenly perfection, while earthly disaster of various kinds filled legend and scripture. Nor are art and architecture separated when darkness is evoked. One of the most famous works of Pieter the Elder Brueghel (*ca.*1525–69), *The Building of the Tower of Babel* (1563), depicts a quintessential moment of the Biblical wrath of God. "And the whole earth was of one language, and of one speech. And it came to pass, as they journeyed from the east, that they found a plain in the land of Shinar; and they dwelt there. And they said one to another, Go to, let us make brick, and burn them thoroughly. And they had brick for stone, and slime had they for mortar. And they said, Go to, let us build us a city and a tower, whose top may reach unto heaven; and let us make us a name, lest we be scattered abroad upon the face of the whole earth. And the Lord came down to see the city and the tower, which the children of men builded. And the Lord said, Behold, the people is one, and they have all one language; and this they begin to do: and now nothing will be restrained from them, which they have imagined to do. Go to, let us go down, and there confound their language, that they may not understand one another's speech. So the Lord scattered them abroad from thence upon the face of all the earth: and they left off to build the city. Therefore is the name of it called Babel; because the Lord did there confound the language of all the earth: and from thence did the Lord scatter them abroad upon the face of all the earth." (*Genesis* 11: 1–9)[11]

Brueghel's well-known painting is but one of many examples of works associating art and architecture in a language of disaster and collapse. Another prodigious work is Giulio Romano's Palazzo del Tè (Mantua, 1526–35). Whether it was the end of Renaissance purity in favor of the complexity of Mannerism that he

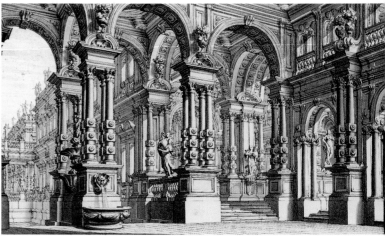

François de Nomé (Monsù Desiderio), *King Asa of Judea Destroying the Idols*, *ca.* 1640. Oil on canvas, 74 x 100.5 cm. Fitzwilliam Museum, Cambridge

Antonio Galli Bibiena (attributed), *Cortile Regio*, n. d. Pen and ink and watercolor, 31.9 x 53.3 cm. Graphische Sammlung Albertina, Vienna, Collection Albert von Sachsen-Tesche

hailed, or simply the legendary collapse of the world of the giants, Romano brought art and architecture together in an extraordinary cacophony of forms in the famous *Cela dei Giganti* (Room of the Giants). In a true flight of the imagination, the artist-architect here associates his own structure in a fantastic orgy of destruction. Another famous, if enigmatic, painter of darkness and fire is François de Nomé (known with his partner, Didier Barra, as Monsù Desiderio). His *King Asa of Judea Destroying the Idols* (*ca.* 1640) may have been inspired by the ruins of empire which he discovered as a child when his family moved from Metz to Rome in about 1602. Rather than being swept up in the rising tide of the Baroque, François de Nomé worked in a Mannerist style whose meaning and real sources are not fully known.

The association of art and architecture reached one of its high points in the work of the Galli Bibiena family in and around Bologna from the end of the 17th century onwards. The best-known member of this dynasty, Fernandino Galli Bibiena (1657–1743), invented an oblique form of perspective for his stage designs.

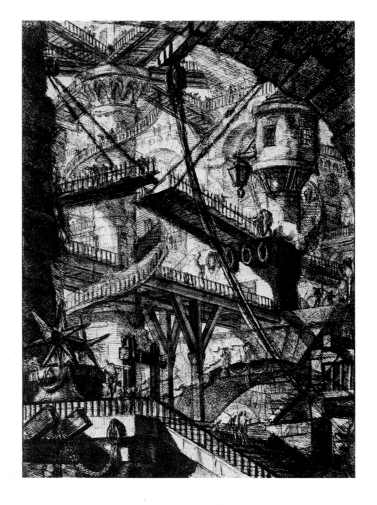

Giambattista Piranesi, *Carceri d'Invenzioni*, Plate 7, 1760. Engraving

Like other members of the family, Antonio Galli Bibiena, Fernandino's third son, was both an artist and an architect, and designed the Virgilian Academy in Mantua and the Teatro Communale in Bologna. His *Stage Set Design for Royal Apartments* (*ca.* 1728) shows an unbridled Baroque imagination. As Rob Wilson recalls, "Such inventions usually were created for wealthy royal courts, as an exaggeration of the pomp, ostentation and display of the audience itself."[12] Dealing in both the illusion of architecture with their stage sets and in the reality of the built form with their theaters, the Galli Bibiena family certainly glorified and sustained the taste for Baroque excess. The continuing shift from religious subjects, as exemplified by Brueghel's depiction of the Tower of Babel, to secular ones, such as the real and fantasy structures of the Galli Bibienas, did nothing to weaken the eternal link between two dimensions and three, between the dreamt and the built.

Though it is only speculated that the ruins of Rome are the source of the fantastical paintings of François de Nomé, it is much clearer that Giambattista Piranesi was fascinated by these vestiges of a lost empire. After early experience as a stage designer, he made accurate engravings of the ruins of Rome: his *Vedute*, a series of 135 etchings of ancient and contemporary Rome, were published from 1745 on. Piranesi was both an architect and a theoretician, as demonstrated by his treatises *Della magnificenza ed architettura dei Romani*

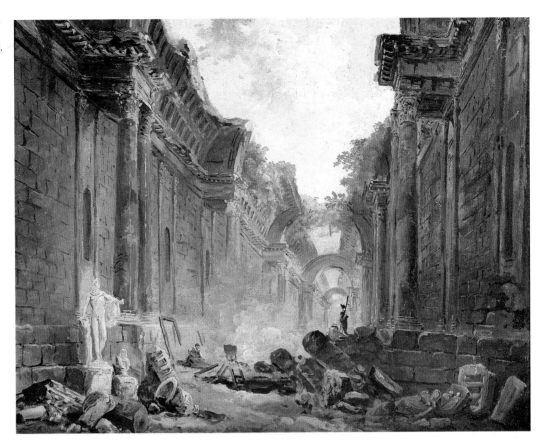

("On the Magnificence of Roman Architecture," 1761), and *Parere sull 'architettura* ("Observations on Architecture," 1765), in which he argued for the use of the Roman example to produce a new style of architecture. His only built work, S. Maria del Priorato (Rome, 1764–66), may not have had great influence, but his imaginary views of prisons, his *Invenzioni capric di Carceri* (*ca.* 1745), certainly did — right up until the Surrealists and contemporary horror or adventure movies. It has been noted that Piranesi changed the title of this series for later editions to *Carceri d'Invenzione* (Prisons of the Imagination), which surely lends them more than a purely architectural sense. Dark visions of a subterranean world, the *Carceri* have again and again been a source of inspiration for modern architecture, as seen, for example, in some work of I.M. Pei (the suspended bridges in the East Building of the National Gallery of Art, Washington, D.C., 1977) and Tadao Ando (the vertiginous underground library of the Ryotaro Shiba Memorial Hall, Higashiosaka, Osaka, 2001). The *Carceri* are an imagined, disturbing world unto themselves, an inner universe whose connection to the Surrealists seems obvious. Artists such as Hieronymus Bosch had ventured deep into the territory of dreams before Piranesi, but the architectural presence of the *Carceri* had an unrivaled array of influences.

Shadows of Doubt

Among those influenced by Piranesi, the French painter Hubert Robert (1733–1808) seems to have retained the *Vedute* more than the *Carceri*. In his *Imaginary View of the Grand Gallery of the Louvre in Ruins* there is more than meets the eye. At the same time as he showed this work, the painter, called "Robert des ruines," was also proposing a new design for the Grande Galerie, which he also painted. Curiously, in both cases, the figures present are in contemporary dress, despite the fact that an image of ruins of the Louvre would presumably have been set in the distant future. Trees have grown above the open roof of the Grande Galerie, and the Apollo Belvedere stands forlornly abandoned amongst the stones. The profound influence of ruins and the artifacts of ancient civilizations on Europe from the Renaissance onwards was chronicled by Francis Haskell and Nicholas Penny in their book *Taste and the Antique*,[13] and Hubert Robert was surely not the only artist to draw inspiration from the past in this way. Romanticism as exemplified in the work of Caspar David Friedrich, for example, made use of ruins to illustrate a nostalgic contemplation of the passage of time and the futility of human ambitions. The idea of depicting a highlight of French art and culture in a state of ruins is an unexpected one that underlines the doubts and nostalgia that animated the artist's period. The famous Désert de Retz

garden, which François Racine de Monville (1734–97) began to create near Versailles in 1744, is ample indication of the popularity of ruins as a device of 18th-century art and architecture.

The doubts expressed in Romantic ruins would, of course, only increase with time, in parallel with more hopeful schools of art and architecture ranging from the Impressionists to the rise of modernity. Even as Futurism took form in Italy, Giorgio de Chirico was depicting views of cities that undermined the rather comfortable world of architecture in painting that was born of the Renaissance (*The Great Tower,* 1913). As William Rubin has written, "Renaissance perspective projects a space that is secure and eminently traversable. De Chirico's tilted ground planes, on the contrary, produce a space that, when not positively obstructed, is shallow and vertiginous.... The multiple vanishing points of these de Chiricos thus subvert the coherence of Renaissance perspective by confronting the viewer with a network of conflicting spatial tensions that undermine, psychologically speaking, any initial impression of quietude or stability."[14] Another painter who looked closely at architecture early in the 20th century was Lyonel Feininger. Born in New York of German parents, he was a Bauhaus instructor from 1919 to 1932, and head of the Print Workshop for many years. Feininger came into contact with Robert Delaunay and was influenced by French Cubism, before getting to know the members of the Expressionist group Die Brücke and beginning work on numerous architectural compositions in the region of Weimar. He focused repeatedly on the church in the town of Gelmeroda, near Weimar. Between 1913 and 1936 he made thirteen paintings of Gelmeroda of which ten were finished. His dark and complex work *Gelmeroda IV* (1915) shows the influences of Cubism, but also gives an almost anthropomorphic cast to the subject. The church is no longer an object of religious fervor, nor even of the realist fascination of a Saenredam. It is rather the artist who gives life to these stones, and makes the viewer worry about the forbidding mass of a village church.

Even as the modern world gave some reason for hope, there were those, perhaps more visionary, who had doubts. One of these was the filmmaker Fritz Lang, whose remarkable movie *Metropolis* (Universum Film A.G., 1927) showed a city of the future whose grandiose architecture worked only thanks to thousands of slaves laboring underground. As Dieter Neumann points out, Lang was trained as an architect, but here he called in three set designers, Erich Kettelhut, Otto Hunte and Karl Vollbrecht.[15] In about 1960, Kettelhut described one essential scene in the movie: "There was, for example, the Tower of Babel, final image of a grandiose vision, which had begun with the building of the tower, with hundreds of slaves pulling an enormous block of ashlar through the desert sand." *Metropolis* shows the world of the future and its spectacular architecture as a place of abuse and revolt. It is, of course, significant that the designers and Lang chose to retain the name of Tower of Babel for the massive modern building seen in the movie. There is no stronger metaphor in the popular imagination for collapse and ruin. If film is truly the new art form of the 20th century, then this prophetic movie unites art and fantastic architecture as they have never been joined before, embodying the dark future. The city, a center of hope in Futurism, and Modernism are here depicted as evil incarnate.

Seen as hopeful or ominous, according to the point of view of artists and architects, the city takes another, more perfidious turn in the hands of the American painter Edward Hopper. Though he also painted isolated buildings and some interior scenes, some of his most powerful work has to do with emptiness, even in the midst of a metropolis. His work *Nighthawks* (1942), a brightly-lit place standing out against the engulfing darkness, uses a sweeping modern-style window to peer in at the barrenness of a bar interior and its customers. "*Nighthawks* seems to be the way I think of a night street," Hopper said later. "I didn't see it as particularly lonely, I simplified the scene a great deal and made the restaurant bigger. Unconsciously, probably, I was painting the loneliness of a large city." The few figures that appear in Hopper's paintings usually do not interact; they stand and sit, waiting. His architecture, a constant preoccupation, often seems more alive than its inhabitants. More than a backdrop for painting human activity, architecture stands out in Hopper's work as a more palpable physical presence than the rigid actors of this modern drama. As Gail Levin has written, "Hopper's identification of his art with his internal feelings is emphasized by a quotation from Goethe that he carried around in his wallet and cited for its relevance to artistic endeavor: 'The beginning and end of all literary activity is the reproduction of the world that surrounds me by means of the world that is in me, all

Giorgio de Chirico,
The Great Tower, 1913.
Oil on canvas,
123.5 x 52.5 cm.
Kunstsammlung
Nordrhein-Westfalen,
Düsseldorf

things being grasped, related, recreated, molded and reconstructed in a personal form and an original manner.'"[16] Hopper's attachment to the forms of the buildings that he carefully observed, and the sharp, uncompromising light that illuminates them, creates a world that Americans of a certain age can identify with easily. Whether they choose to see Hopper's emptiness as ominous or not is very much a personal question. Hopper's stage is not the dark future of the film *Metropolis*, nor the nostalgia for the past that inspired Europeans in the 18th century. He paints a barren history and a hopeless present.

"Western art, once the celebrator of emperors and popes, turned to serve the newly powerful bourgeoisie, becoming an instrument of the glorification of bourgeois ideal," wrote the Dutch artist Constant Nieuwenhuys in his *Manifesto* (1948). "Now that these ideals have become a fiction with the disappearance of their economic base," he continued, "a new era is upon us, in which the whole matrix of cultural conventions loses its significance and new freedom can be won from the most primary source of life." Nieuwenhuys, or Constant, as he was known, was a co-founder of the Cobra group in the late 1940s, but he abandoned painting in 1953 with the intention of concentrating his efforts on what he called "construction." Constant was one of the founders of the Situationist International (1957) and he began during the previous year to work on his idea of a city that would at once be a kind of utopia and a critique of society. He called his project *New Babylon* (Spatiovore, 1959). As Mark Wigley has written, "*New Babylon* envisages a society of total automation in which the need to work is replaced with a nomadic life of creative play, in which traditional architecture has disintegrated along with the social institutions that it propped up. A vast network of enormous multilevel interior spaces propagates to eventually cover the planet. These interconnected 'sectors' float above the ground on tall columns. While vehicular traffic rushes underneath and air traffic lands on the roof, the inhabitants drift by foot through the huge labyrinthine interiors, endlessly reconstructing the atmospheres of the spaces. Every aspect of the environment can be controlled and reconfigured spontaneously. Social life becomes architectural play. Architecture becomes a flickering display of interacting desires."[17] Wigley insists that Constant intended *New Babylon* as a city that could, indeed, be built, an affirmation that provoked great debate in architectural circles for many years. And yet one of the most interesting aspects of his project was that it appeared at the frontier between art and architecture, proposing to enrich and transform both the built environment and

Constant (Constant Nieuwenhuys),
Gele sector,
1958. Slide.
Gemeentemuseum
Den Haag, The Hague

the practice of art. "Constant insisted that the traditional arts would be displaced by a collective form of creativity," says Wigley. "He positioned his project at the threshold of the end of art and architecture." Where Fritz Lang had seen the city of *Metropolis* as an embodiment of evil, Constant proposes nothing less than a synthesis of the arts as the only way to avoid the catastrophic collapse of society. Intentionally polemical and critical, his *New Babylon* poses the question of the role of artists and architects in society in a way that is pertinent fifty years after he began work on this "ideal" city.

Where Fritz Lang and Constant both created imaginary cities of foreboding portent, the German painter Anselm Kiefer has frequently taken a very real incarnation of evil in architecture as his subject. His *Innenraum* (Interior Space, 1981) is a representation of the Mosaic Hall of the Reichskanzlei designed by Albert Speer. In a text published in *Die Kunst im dritten Reich*, Hitler made reference to the "Austrian question" in explaining the orders he gave to Speer for the design of this building. "In December 1937 and January 1938 I decided to resolve the Austrian question, thus establishing a Greater

German Reich. Under no circumstances could either the purely administrative tasks or the representative functions that were necessarily connected with this be satisfied any longer by the old Reichskanzlei. I therefore commissioned Generalbauinspektor Professor Speer with the rebuilding of the Reichskanzlei in Voßstraße on 11 January 1938, setting as the completion date 10 January 1939."[18] Iain Boyd Whyte has written about the Reichskanzlei: "The formal intentions of Speer's design are easily listed: powerful, cubic massing, flat wall planes, deep window reveals, hard-edged moldings, vigorous repetition, and an insistence on axiality and symmetry. Speer himself characterized the 'new way of thinking about architecture' as 'austere and severe, but never monotonous. Simple and clear, and without false ornamentation. Sparing in its decoration, but with each decorative motif placed in such a way that it could never be thought superfluous.' Exactly these qualities of austerity and severity are those alighted on by the distinguished British critic Lionel Brett, who noted in 1946 amid the ruins of the Reichskanzlei that 'Speer's taste was impeccable and it is remarkable that so cold and correct a piece of architecture should exhale such malevolence.' This cold severity is also central to the fascination exercised by Nazi architecture."[19] Kiefer invests the *Innenraum* with a darkness befitting not only of the history that unfolded here, but of the impending ruin, both of the architecture and of its progenitors. While 18th-century artists could look at the ruins of Rome and wonder at such glory, 20th-century ruins are fraught with other meanings. Art and architecture, at the service of such "impeccable taste" as that of Speer and his master, were harbingers of the apocalypse.

Brave New World

While some had dark thoughts about the onset of modernity, others dreamed of a new world, where things would be better and not worse. Again, the sacred union of art and architecture plays a central role in defining and depicting these new utopias. One of the most visionary of early 20th-century architects was the Catalan Antoni Gaudí. In works such as his Parque Guell (Barcelona, 1900–14) he created a fusion between colorful, sculptural forms and the built environment that remains one of the most interesting attempts to unify the arts. Somewhat less well known and, indeed, not attributed to Gaudí with absolute certainty, his plan for the American Hotel (New York, 1908) is known only through drawings by his collaborator Juan Matamala.

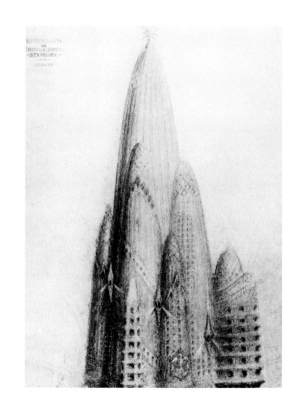

Antoni Gaudí, *American Hotel*, New York, 1908

Approached by mysterious financiers to create a true landmark in or near Manhattan, in 1906, Gaudí apparently worked on preliminary sketches of the building whose total height would have been 329 meters, including an 18-meter-high observatory called the "Sphere of All Space" perched at its summit. Had it been built, the American Hotel would have been almost 30 meters taller than the Eiffel Tower, then the tallest structure in the world. In light of recent towers designed for London (Swiss Re Tower, Lord Norman Foster, architect, 2004) or Barcelona (Agbar Tower, Jean Nouvel, architect, 2005), the cluster of soaring parabolic shafts devised by Gaudí a century ago look positively prescient. As it is, the American Hotel remains little more than a series of drawings, and as such, not works of the master himself. Almost all architects draw their work before actually building it, and those who do not draw hire assistants to do so for them. Architecture is inevitably two-dimensional before it becomes three-dimensional and, at their best, sketches by architects have every right to be considered works of art.

Artists rarely draw and paint architecture with the intention of actually building something. Rather, they seem to be attracted by the very solidity of the third dimension, a certainty that escapes the more subjective realm of paint and canvas. The Dutch painter Piet Mondrian had clear and obvious ties to architecture through such designers as Theo van Doesburg, but in his earlier, more figurative period, he frequently took churches or windmills as his

Piet Mondrian, *Molen: Red Mill at Domburg*, 1911. Oil on canvas, 150 x 86 cm. Gemeentemuseum Den Haag, The Hague

subject. Even late works like *Broadway Boogie Woogie* (1942–43) are his own impression of the urban organization and activity of New York. The artist is one of the "inventors" of abstraction and, in a way, his struggle to depict architecture is one of the keys to the emergence of a non-figurative art in the 20th century. His *Molen: Red Mill at Domburg* (1911) deals with a traditional Dutch architectural form, but it strikes out into new territory, where color begins to take precedence over subject. "The sky is pure," wrote Mondrian, "but so is the mill! Visually, it appears as merely dark and lacking color. But gradations of light and dark paint are inadequate to convey a full impression of the mill and the sky, as I frequently found. The blue calls for another color to oppose it…. I found it satisfactory to paint the mill red against the blue." This image and its implications clearly were very present in Mondrian's mind because, in his text of 1919–20 called *Trialogue*, he imagines Scene 4 near "a windmill seen at very close range; dark, sharply silhouetted against the clear night sky; its arms, at rest, forming a cross." This scene ends with a dialogue between X, who is a "naturalistic painter," and Z, who represents Mondrian:

"X: But to return to the windmill, if you found it satisfactory to exaggerate the color, why didn't you continue to work that way, why did you discard all forms?

Z: Because otherwise, objects as such would have remained in the painting – and then the plastic expression would not be exclusively plastic. When the 'object' dominates, it always limits the emotion of beauty…. That's why the object had to be discarded from the plastic."[20]

The case of Mondrian is significant insofar as the transition of the relationship of art and architecture into abstraction is concerned. As the American art historian Meyer Schapiro wrote in 1960, "While Mondrian's abstract paintings of the 1920s and 1930s have an architectural effect with an impressive stability and strength, the surprise of *Broadway Boogie Woogie* lies in its movement and colorful visual music. The reversion to his earlier styles clearly served a new expressive intent. In conceiving *Broadway Boogie Woogie*, Mondrian could well have been inspired by the sights of New York, the dazzling night spectacle of its high buildings with their countless points of light, and in particular the moving illumined signs at Times Square. He had been prepared for this new conception by his enjoyment of Paris, where on first encountering jazz and modern popular dance in the 1920s he defended them against detractors. In Paris he discovered, besides Cubist painting, the beauty of a big city as a collective work of art and its promise of greater freedom and an understanding milieu. Shortly before coming to New York he had disclosed a new inspiration in paintings with more complex grids, which he called *Place de la Concorde and Trafalgar Square* — the forerunner of the interwoven grid in New York City and *Broadway Boogie Woogie*…. Mondrian was never freer and more colorful, and closer to the city spectacle in its double aspect of the architectural as an endless construction of repeated regular units and of the random in the perpetual movement of people, traffic, and flashing lights."[21] Schapiro's point had to do with demonstrating the humanity that underlies even the apparently cold compositions of Mondrian, but his analysis demonstrates that the artist also sought a synthesis of his understanding of different forms of expression — the architectural (or urban), the musical and the painted in his last work, *Broadway Boogie Woogie*.

Antonio Sant'Elia, *Airport and Railway Station*, 1914. Ink and pencil on paper, 27.9 x 20.9 cm. Musei Civici, Como

Vladimir Tatlin, *Monument to the Third International*, 1919–20. Computer simulation by Professor Takehiko Nagakura (MIT), 1999

Shortly after the time when Piet Mondrian painted *Molen: Red Mill at Domburg*, the Italian architect Antonio Sant'Elia, having attended the Academy of Brera, where he met Funi, Erba, Carrà and other founders of Futurism, moved to Milan and opened his own office. Between 1912 and 1914, influenced by the industrial cities of the United States, but also the work of Wagner and Loos, Sant'Elia began to imagine the *Città Nuova* — a multilevel, interconnected and mechanized city of the future. Published in the magazine *Lacerba*, his masterful image of an *Airport and Railway Station* (1914) shows how architectural drawings can sometimes be more influential than buildings themselves. In his *Manifesto of Futurist Architecture*, published on July 14, 1914, Sant'Elia called for a radical rejection of tradition in architecture. "No architecture has existed since 1700," he proclaimed. "A moronic cocktail of the most various stylistic elements that used to cover up the skeletons of modern houses is called modern architecture. The new beauty of cement and iron is profaned by the superimposition of motley decorative incrustations that neither constructive necessity nor our (modern) taste can justify and whose origins are Egyptian, Indian or Byzantine antiquity, or that idiotic flowering of stupidity and importance that took the name of Neoclassicism." Continuing in a decidedly polemical tone, he declared, "We must invent and rebuild the Futurist city like an immense and tumultuous shipyard: agile, mobile and dynamic in every detail; and the Futurist house must be like a gigantic machine. The decorative must be abolished," said Sant'Elia, before proclaiming:

"1. That Futurist architecture is the architecture of calculation, of audacious temerity and of simplicity; the architecture of reinforced concrete, of steel, glass, cardboard, textile fiber, and of all those substitutes for wood, stone and brick that allow us to obtain maximum elasticity and lightness;

2. That Futurist architecture is not because of this an arid combination of practicality and usefulness, but remains art, that is, a synthesis and expression…"

Sant'Elia's *Manifesto* still seems modern today, and his definition of art, "synthesis and expression," carries a particular significance for the evolving relationship between art and architecture. Like art, architecture, too, would begin to cast aside its pretensions to immortality. As Hanno-Walter Kruft puts it, "One new point (in Sant'Elia's *Manifesto*) is the notion of the temporary and transitory nature of Futurist architecture, coupled with the principle that each generation must build its own city: 'The houses will not last as long as we do. Each generation will have to build its own city.' … Now architecture was not only to become the expression of a life process but was itself to be absorbed into this process."[22]

Futurist faith in the machine as the basis of a new era in art, architecture and urban development found a less mechanistic but equally utopian echo with the rise of Russia's avant-garde. Here, many artists took to imagining the architecture of the future and, indeed, of the revolutionary present. With few opportunities to construct designs as ambitious as their dreams, architects also joined this chorus of representations of the built form. What is surprising today is just how close to late 20th-century architecture many of their efforts appear. The complex relationship between the two-dimensional representations of architecture by

painters and architects during the period leading up to and following 1917 is elucidated by Anatolii Strigalev: "Architecture was unprepared both artistically and technically to absorb the 'extremes' of vanguard art, and it was only after the October Revolution that architects began to use the cityscapes of the Russian Cubo-Futurists — the paintings dating from the 1910s of Aristarkh Lentulov, Aleksandra Ekster, Ljubov Popova, Kasimir Malevich, Ivan Kliun, Ivan Puni and others — as a 'textbook' on a new spatial vision and the 'esthetics of rupture and dislocation,' as a source of certain concrete formal 'motifs.' The results of acquaintance with Cubo-Futurist painting are evident in the architect Vladimir Krinskii's experimental projects from 1919–21 (*Experimental Project, Zhivskul'ptarkh: Temple of Communion Among Nations, Variant,* 1919). These are not architectural drawings but Cubist 'paintings' of buildings. And the plicated, or serrated, dismembered architectural masses favored from 1922 by the architect Konstantin Melnikov were surely indebted both to Lentulov's 1919–20 series of landscapes depicting the ancient architectural ensembles of the Monastery of the Holy Trinity and St. Sergei, New Jerusalem and Tsaritzyno, as well as to Popova's architectural paintings of 1916."[23]

The brief flowering of avant-garde art and architecture in Russia before and after the October Revolution led to few actual buildings, but to a number of ambitious proposals. One of the most emblematic of these was Vladimir Tatlin's *Monument to the Third International* (1919–20). Tatlin is known as the founder of Constructivism (1913), whose purely abstract forms and architectonic emphasis included the work of Naum Gabo and Antoine Pevsner after 1916. In 1919 and 1920, Tatlin produced sketches and a model for a spiraling tower. The model, a 670-cm iron frame on which rested a revolving glass cylinder, a cube and a cone, was exhibited in Petrograd in November 1920, at the same time as Iuri Annenkov's theatrical action, *The Storming of the Winter Palace*, was performed. The work was hailed by Vladimir Mayakovsky as "the first object of October." The *Monument to the Third International* never came close to being built. Tatlin was many things, but certainly not an engineer, and even the precise height of the Tower was never defined. What was clear is that the artist wished to combine art and architecture in a symbol of the dynamic nature of the revolution. In "The Work Ahead of Us," a manifesto Tatlin wrote in 1920 for the *Daily Bulletin of the Eighth Congress of Soviets*, he said: "The investigation of material, volume and construction made it possible for us in 1918, in an artistic form, to begin to combine materials like iron and glass, the materials of modern Classicism, comparable in their severity with the marble of antiquity. In this way an opportunity emerges of uniting purely artistic forms with utilitarian intentions. An example is the project for a monument to the Third International." Having at first encouraged movements such as Constructivism, the Soviet regime began in 1921 to disparage them as being unsuitable for the purposes of mass propaganda. Though Gabo and Pevsner went into exile, Tatlin remained in the Soviet Union until his death in 1956.

Utopian dreams of art and architecture flourished in many places as the century opened. The Expressionist movement in Germany that lasted from 1907 to about 1925 produced a number of interesting efforts to integrate the arts. One of these, which was more theoretical than practical, was the so-called *Gläserne Kette* (Crystal Chain) that united Bruno Taut, Hermann Finsterlin, Walter Gropius and others. In the founding letter of this group, on November 19, 1919, Taut lamented that modern architects had so little to build, before exhorting his comrades to "Let us consciously be imaginary architects." The very notion of an imaginary architecture, accepted as such and expressed in writing and in drawings, was just as revolutionary as anything produced by the Russians. Works like Finsterlin's *Dream in Glass* (1920) prefigure the sculptural work of Frank Gehry, for example, but they also bring architecture more into the realm of two dimensions. There is surely a long tradition of dream architecture, but usually

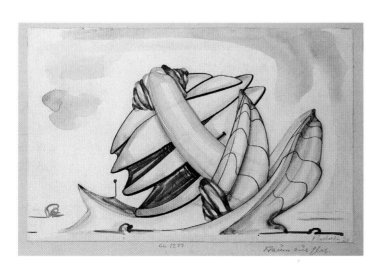

Hermann Finsterlin,
Dream in Glass, 1920.
Watercolor, 18.8 x 29 cm.
Staatsgalerie, Stuttgart

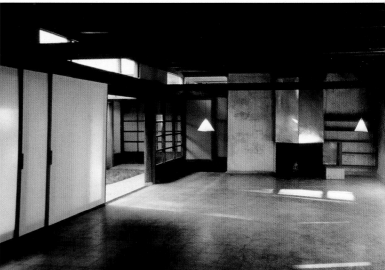

R.M. Schindler, Schindler House, Los Angeles, 1921–22

this type of representation developed on existing models, as seen in Van Eyck's paintings, for example. Taut and Finsterlin, but also figures like Krinskii or Tatlin, imagined an entirely new vocabulary of architecture, in many ways freed of its material constraints to express the hopes of the early 20th century. The idea of the *gesamtkunstwerk* was never far from their preoccupations. In the first *Bauhaus manifesto*, published in 1919, Gropius wrote: "Together let us desire, conceive and create the new structure of the future, which will embrace architecture and sculpture and painting in one unity, and which will one day rise towards heaven from the hands of a million workers like the crystal symbol of a new faith."

Another artist who figures prominently in the development of utopian architectural forms is Kasimir Malevich, who was an admirer of both Mondrian, and the Modernist school of architecture, viewing Suprematism as related to their work. Created in 1913 by Malevich, parallel to the emergence of Constructivism, Suprematism was viewed as revolutionary non-objective art. Its followers included Alexander Rodchenko and El Lissitzky, and its influence was propagated later by the Bauhaus. As Malevich wrote, "The new art of Suprematism, which has produced new forms and form relationships by giving external expression to pictorial feeling, will become a new architecture: it will transfer these forms from the surface of canvas to space. The Suprematist element, whether in painting or in architecture, is free of every tendency which is social or otherwise materialistic." Further explaining the links between art and architecture in his own work, Malevich went on to say, "Suprematism has opened up new possibilities to creative art, since by virtue of the abandonment of so-called 'practical consideration,' a plastic feeling rendered on canvas can be carried over into space. The artist (the painter) is no longer bound to the canvas (the picture plane) and can transfer his compositions from canvas to space." The pictorial origin of Malevich's movement into the third dimension led him to create various models of architectural form ("from canvas into space"), intended for no real purpose, but very much resembling towers and modern buildings (*Gota 2-A*, 1923–27). The goal of this creativity may not have been so much to improve buildings as it was to bring art and architecture together. As Hanno-Walter Kruft confirms, "The artistic driving force behind the new architectural movement that now emerged in Russia against the background of Cubo-futurism was, significantly, the concept of the *gesamtkunstwerk*, and the first significant work to embody this synthetic 'union of the arts' was Kruchenykh's Futurist opera *Victory over the Sun* (1913)."[24]

In an article entitled "Care of the Body," the architect Rudolf Schindler (1887–1953) described the house of the future: "Our rooms will descend close to the ground and the garden will become an integral part of the house. The distinction between the indoors and the out-of-doors will disappear. The walls will be few, thin and removable. All rooms will become parts of an organic unit instead of being small separate boxes with peepholes." The house he built for himself in Los Angeles embodies many of the ideas expressed in this article (Kings Road or Schindler House, 1921–22).[25] Having studied under Otto Wagner at the Vienna Academy of Fine Arts, from which he graduated in 1913, and worked with Frank Lloyd Wright in California beginning in 1917, Schindler did more than anyone to bring architectural modernity to America. Peter Noever, Director of the MAK Vienna since 1986 and founder of the MAK Center for Art and Architecture, writes in *Schindler House*

(1994) that "The interaction of art and architecture, a process basic to the 20th century and exemplified with particular clarity by Schindler's work, points the way to a future in which the boundaries between different disciplines will be eliminated in the same way as national, hierarchical or static dogmatisms."[26] Schindler was fortunate enough to evolve professionally and personally in an environment that was open to innovation. Taking his ideas as much from traditional Japanese design as from European Modernism, he asserted that in new architecture, space would be a more significant factor than mere building materials. Noever writes that "From 1922 onwards, quite in keeping with the lifestyle of the dream factory, the Kings Road house became a cultural phenomenon, the home base where Schindler surrounded himself with artists, intellectuals and architects, cultivated an extravagant, unconventional lifestyle and finally abandoned his desire to return to Europe. The Schindler House was as much an architectural statement as a vision of 'communal living,' of a modern social experiment. Schindler's house broke with all the traditional rules of interior layout, of 'home-liness,' of division into private and public spaces and indoor and outdoor areas." Both in his insistence on the importance of space in modern architecture, and in the use to which he put his house, Schindler fits in with the utopian ideals of the architects and artists who remained in Europe, even when they did not have an opportunity to actually build.

While some conceived of the union of the arts as a social enterprise, others produced more personal visions. One of the most unusual and significant of these is Kurt Schwitters's *Merzbau* (1923), which the artist described as his "life's work." The word *Merz* was derived from *Kommerz* and *Bau* (building), but there was nothing commercial about the accretion of forms and objects that Schwitters accumulated in his Hannover atelier between 1923 and 1937. Around a free-standing sculpture, which Schwitters called the *Säule des erotischen Elends* (Column of Erotic Misery), he created a labyrinth of niches or grottoes dedicated to friends and containing "spoils and relics" related to Hans Arp, Theo van Doesburg, Hannah Höch or Mies

Kurt Schwitters, *Merz Building* (Detail view: "*Grand Group*"), ca. 1932

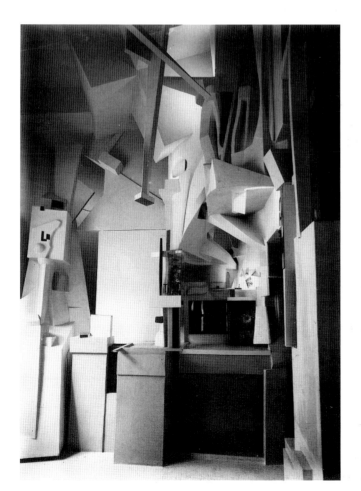

van der Rohe, as well as certain ideas. Covering these "relics" over progressively with layers of building material that extend within and even outside the limits of his studio, Schwitters wrote, "The overall impression is one of a Cubist painting or Gothic architecture (not really!)." In any case, *Merzbau* was one artist's attempt to create space (architecture) that formed a coherent whole with his own work. The inclusion of samples of his own hair, nail cuttings and urine in the design does echo the function of reliquaries in past centuries, but it also recalls the fundamental origins of the link between art and architecture — in their expression of nature and the human body.

In 1927, three artists — Sophie Taeuber-Arp, Jean Arp and Theo van Doesburg — collaborated on the decoration of the Café L'Aubette, in Strasbourg. Including a tea-room, several bars, function rooms, a ballroom, a cellar nightclub and a cinema, Café L'Aubette was finished in 1928 but almost immediately was changed because of the disapproval of the café's clients. Between them, Taueber-Arp, her husband and Van Doesburg came into contact with a veritable Who's Who of European art early in the century. Arp (1886–1966) was with Kandinsky in Munich and Robert Delaunay in Paris in 1912, with Picasso, Modigliani and Apollinaire in 1914, and in Zurich with Tristan Tzara when Dada was created in 1916. Van Doesburg (1883–1931) was a painter and art critic who collaborated with the architects J. J. P. Oud and Jan Wils from 1916 onwards. In 1917, they founded the group De Stijl and the magazine of the same

name, with Vilmos Huszár, Piet Mondrian, Bart van der Leck and Georges Vantongerloo. Van Doesburg visited Berlin and Weimar in 1921 and the following year taught at the Weimar Bauhaus, where he worked with Raoul Hausmann, Le Corbusier, Ludwig Mies van der Rohe and Hans Richter. He was interested in Dada, and worked with Kurt Schwitters as well as Jean Arp, Tristan Tzara and others on the publication *Mécano* in 1922. The emphasis of De Stijl was on abstraction and the collaboration between architects, artists, graphic artists or industrial designers. Influenced by the work of Frank Lloyd Wright, the movement sought continuity between the exterior and interior of buildings. Sophie Taeuber-Arp's abstract stained-glass designs for the Café L'Aubette conformed to the architectural doctrine of Van Doesburg and the Arp couple joined De Stijl shortly after the completion of the Café.

Few would hesitate to call some buildings of previous centuries works of art, in and of themselves. However, definition of "art" has become notoriously complex in modern times, and the word is surely used too easily to refer to second-rate productions. But even a very short list of the great buildings of the 20th century would probably include Ludwig Mies van der Rohe's Barcelona Pavilion (1928–29).

Built as the German national pavilion for the 1929 *Barcelona International Exhibition*, the structure was conceived to accommodate the official opening reception presided over by King Alfonso XIII of Spain. It was built of glass, steel and four different kinds of marble: Roman travertine, green Alpine marble, ancient green marble from Greece and golden onyx from the Atlas Mountains. A study in perfect modernity, the Barcelona Pavilion was dismantled after the exhibition in 1930. In 1980, Oriol Bohigas, then head of the Urban Planning Department of the Barcelona City Council, set out to rebuild it with the aid of architects Ignasi de Solà-Morales, Cristian Cirici and Fernando Ramos. Work began in 1983 and the new building was opened on its original site in 1986. Mies van der Rohe was famously told by the German Ministry of Foreign Affairs that in the Pavilion "Nothing will be exhibited, the pavilion itself will be the exhibit." Indeed, the structure contained only one sculpture by Georg Kolbe (*Alba*) and the furniture the architect designed for the building, including the Barcelona Chair, which became one of the icons of 20th-century design. The emptiness and rectilinear purity of the Barcelona Pavilion remains one of the high points of Modernism, and certainly raises the question of the building as a work of art. If it is said that the difference between a building and a work of art is that the former has a purpose while the latter does not, then the limited usefulness of the Barcelona Pavilion pleads

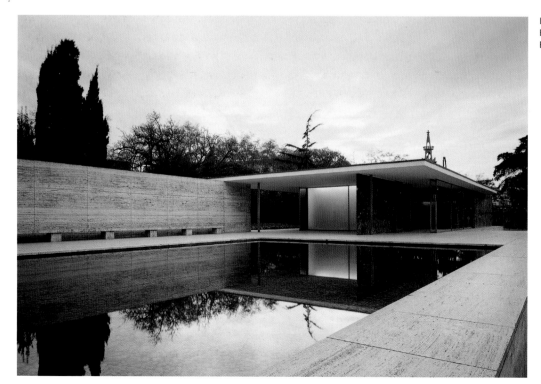

Ludwig Mies van der Rohe,
Barcelona Pavilion,
Barcelona, 1928–29

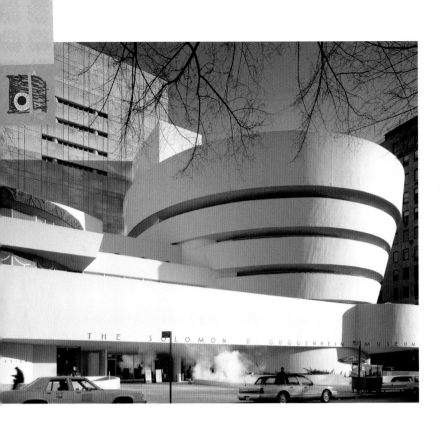

Frank Lloyd Wright,
Solomon R.
Guggenheim Museum,
New York, 1956–59

in favor of calling it art. Though the Barcelona Pavilion was dismantled three years before Bruno Taut saw Katsura, the rectilinear simplicity and emptiness of the architecture of Mies van der Rohe does strongly evoke certain types of traditional Japanese design. As Arata Isozaki points out, other Western architects, such as the German Gustav Pratts, had visited Katsura even before Taut, and had integrated its lessons into "the renewal of world architecture."[27]

"I need a fighter, a lover of space, an agitator, a tester and a wise man … I want a temple of spirit, a monument!" It was with these words that Hilla Rebay, an advisor to Solomon R. Guggenheim, asked Frank Lloyd Wright to design a new museum in June of 1943. Although it was not to be completed until after the architect's death, in 1959, the Solomon R. Guggenheim Museum in New York is another of the icons of 20th-century architecture. It might be said that what Mies van der Rohe did for the straight line, Wright did for the curve. The very idea of a continuous gallery that spirals around an empty central core was unheard of in the museum world. Although Guggenheim's Museum of Non-Objective Painting might have called for new solutions to the problems of museum space, New York was the home of the Museum of Modern Art, with its white box rigor. Wright was not in favor of New York, but not because of its cultural institutions. "I can think of several more desirable places in the world to build this great museum," Wright wrote in 1949, "but we will have to try New York." Compared to an inverted ziggurat, or a nautilus shell, Wright's tilted ramp and powerful architecture lead many to express concern that the art would be overwhelmed by the structure. "On the contrary," Wright replied, "it was to make the building and the painting an uninterrupted, beautiful symphony such as never existed in the world of art before." Though some would continue to disagree with his assessment of the design, it remains a fact that Wright was seeking a symbiotic relationship between art and architecture when he built the Guggenheim.

Though most museums exhibit works that were not necessarily made for their spaces, the relationship between art and architecture has evolved considerably since World War II because of the proliferation of new museums, particularly those intended for modern and contemporary art. There has always been a fine balance to be found between the strength of an architectural solution and the quality and presence of the art it contains, and clearly museums have taken up when churches left off where it comes to integrating the arts in a single location.

Dissolving Boundaries

Since the 1960s, a formidable number of collaborative efforts have been made between artists and architects to recompose a relationship that was in many ways torn asunder by the collapse of the patronage of church and state in most countries. At the same time, art and architecture have been challenged to regenerate themselves even as traditional forms of expression have been set aside. Art was no longer a term confined to oil paintings on canvas, and sculpture came down from its pedestal in a very literal way. The eternal fascination of artists with the third dimension, and the longing of architects to be as respected as artists certainly drove many creators to seek to transcend or transgress the barriers between disciplines that have arisen progressively since the Renaissance. The French artist Yves Klein, for example, was very much interested in the relationship between art and architecture, but in a radically new way that he called *Air Architecture*. As Mark Wigley has written, "For Klein, traditional solid architecture is an 'anti-space' whose effects have to be actively countered to liberate space. The built environment is a constricting prison he describes himself as

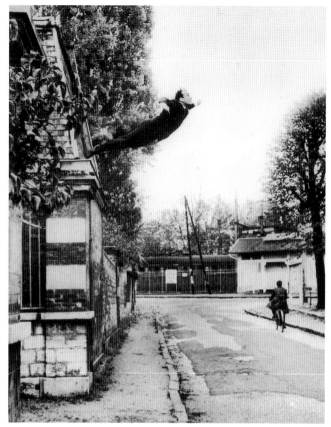

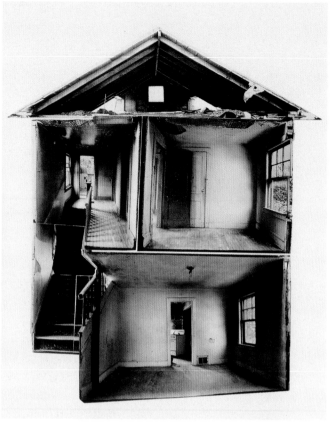

Yves Klein, *Saut dans le vide*, Paris, October 19, 1960

Gordon Matta-Clark, *Splitting*, 1974. Collaged black-and-white photograph on cardboard, 103.5 x 78.1 x 3.8 cm (framed), 82.6 x 70.5 cm (photocollage)

trying to escape for ten years by focusing on the void. Yet the only way to move to the void is to leap into it. The move from anti-space to space is necessarily a leap: "'We will thus become men of the air, we will feel the force of attraction driving us upwards, towards space, towards nowhere and everywhere at the same time. Having thus controlled the force of attraction we will literally levitate in a total and spiritual state of freedom.' The photograph *Saut dans le vide* (Leap into the Void), made in October 1960 and published the follwing month, is therefore an integral part of the *Air Architecture* project."[28] Klein was particularly interested in color and his reputation is largely based on monochrome works, in particular blue ones made with a specific color baptized "bleu Klein." In his 1958 text *The Monochrome Adventure*, Klein brings to mind some of James Turrell's thoughts on light. "Color," he wrote, "is impregnated in space, it inhabits space... color is free! It is instantaneously dissolved into space.... For me, colors are living beings, highly-evolved individuals who integrate themselves to us and to everything. Colors are the true inhabitants of space." The new collaboration that Klein proposed between art and architecture, his *Air Architecture*, was, indeed, a leap into the void. Rather than the built form, what would matter in the future, he said, were the colors that would inhabit space thanks to the artist's intervention. The ultimate synthesis of art and architecture would be nothing other than pure, colored space. This space would be formed by the architect, and colored by the artist, but the fusion of the two would be both disciplines and neither.

One of the more interesting attempts at collaboration between an architect and an artist in recent years occurred in New York, where Isamu Noguchi and Louis Kahn tried to design the Riverside Park Playground (1961–66) together. The fact that they failed has to do with circumstances, but also, surely, with the differing objectives of a sculptor and an architect. As Noguchi described the project, "The idea of playgrounds as a sculptural landscape, natural to children, had never been realized. How sad, I felt, that the possibility of actually building one presented itself when it was past my age of interest. Why could it not have been thirty years before, when the idea first came to me? I found myself getting involuntarily involved in the design of a large project to remake a portion of Riverside Park as a Children's Playground for New York. It was as if I was no longer free to choose — the work chose me. In this dilemma, and needing the association of an architect of strong convictions and ability, a partnership was formed with Mr. Louis I. Kahn." The architect and the sculptor faced various forms of opposition to their project, but a more serious difficulty had to do with their

own collaboration as the park came under pressure to reduce in size. "More distressing to me," admits Noguchi, "was my belated realization that the architect must, above all, be primarily responsible to the architecture. Its scale is often as not in contradistinction to its surroundings. A playground, however, is necessarily related to the use of children. There is a limit to its adaptability to changes in architectural scale. While I marshaled my plans to cope with an ever more formidable fenestration, in the end I could not help feeling that while I may agree with the resolutions as architecture, the playground itself, because of its limited space, had become visually inadequate."[29] Five new designs led only to the ultimate cancellation of the project by New York's Mayor John Lindsay. The only real monument to the connection between the sculptor and the architect is the four-part basalt sculptural group *Constellation* (*For Louis Kahn*) installed by Noguchi in the southern court of Louis Kahn's Kimbell Art Museum in Fort Worth, Texas, in 1983.

It might not seem surprising that the son of the Chilean Surrealist painter Roberto Matta (*ca.* 1912–2002), and godson of Marcel Duchamp, would become an artist of some importance in his own right. As it happens, Gordon Matta-Clark (1943–78) is something of a cult figure for both contemporary art and architecture. Born in New York and trained as an architect, Matta-Clark's best-known works involved cutting through facades, walls and floors of derelict buildings. He effectively turned these structures into sculptures, more a commentary on the voids he created and the ephemeral nature of architecture than a glorification in any sense of the built environment. Together with a group of artists that included Laurie Anderson, Tina Girouard and Richard Landry, Matta-Clark worked on what he called *Anarchitecture* beginning in 1973. As he explained, "Our thinking about *anarchitecture* was more elusive than doing pieces that would demonstrate an alternative attitude to buildings, or, rather, to the attitudes that determine containerization of usable space. We were thinking more about metaphoric voids, gaps, leftover spaces, places that were not developed.... For example, the places where you stop to tie your shoelaces, places that are just interruptions in your own daily movements." For the critic Yves-Alain Bois, "Architecture has one destiny, that it, sooner or later, will go down the chute, because it is waste. His own project was to underscore this state of things, not to transcend it."[30] One of Matta-Clark's best-known interventions was *Conical Intersect* (Paris, 1975), where he cut a conical space at an upward angle through two 1700s-era houses (27 and 29 rue Beaubourg) destined for demolition at the time of the construction of the Centre Pompidou. Another was the enormous hole he cut through a warehouse located on Pier 52 in New York (*Days End*, 1975). In *Splitting* (1974) he actually cut a suburban house in half, leaving an increasingly large gap as visitors walked up through the structure, which was, again, destined for demolition. The only record of most of these works is in the form of photographs. The interventions of Matta-Clark are surely not as optimistic as the (literally) colorful ruminations of Yves Klein on *Air Architecture*, but they are just as surely about a leap into the void. Should there be any doubt whether his work can, indeed, be classified in the realm of art, works by Matta-Clark have been exhibited in major museums since his untimely death — for example, *Bingo* (1974), which consisted of building fragments installed in the Westfälisches Landesmuseum für Kunst und Kulturgeschichte (Münster, 1999). Concentrating on buildings that could have no pretense to artistic accomplishment, Matta-Clark made art more out of the void than of the architecture itself. His was a pertinent comment on the emptiness that surrounds contemporary life, and as such he is one of the more original artists to have contributed to the dissolution of the boundaries between art and architecture.

"The installation of my own work, for instance, as well as that of others, is contemporary with its creation, and the space surrounding the work is crucial to it. Frequently, as much thought has gone into the placement of a piece as into the piece itself." This is how the American artist Donald Judd provided in his last will and testament for the care of his works of art. He was particularly concerned about the complex of buildings and works located in Marfa, Texas, in what is called the Mansana de Chinati. There, beginning in the 1970s, he converted industrial buildings, warehouses, airplane hangars and army barracks into studios for sculpture, printmaking, architecture or the display of art. Judd is best known as a minimalist sculptor and, indeed, one of his major works is a series of fifteen groups of three large concrete sculptures located in Marfa (*15 Untitled Works in Concrete*, 1980–84). Like Turrell and others of his generation, Judd may have been more interested

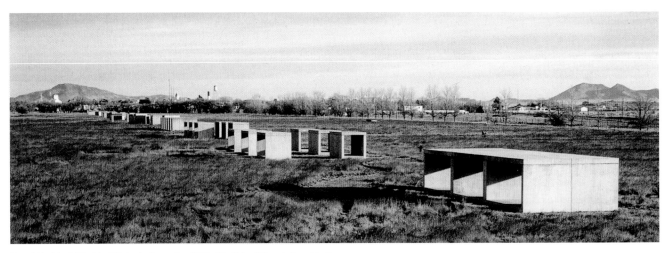

Donald Judd, *15 Untitled Works in Concrete,* 1980–84. Chinati Foundation, Marfa

in the relationship of viewers to his works than he was in specific sculptural forms, and for this reason, archi-tecture played an essential role in his creativity. As Nicholas Serota, Director of the Tate Gallery, writes, "Judd's creation of a compound at the Mansana de Chinati was an act of recuperation: he took a plot of apparently waste ground and a handful of semi-derelict buildings, and with a few deft moves transformed the plot into a 'place' with identity and purpose.... Throughout his practice as a maker of buildings Judd therefore sought to make whole that which had been destroyed, abandoned or left derelict.... Judd's work as an artist, an architect, a designer of furniture and rancher is all of a piece. There is a striking consistency of purpose and method. At its center lies a concern for space and for the phenomenological relationship between objects and the viewer. Judd explicitly denied that his ambition was the creation of a spiritual experience or spiritual place."[31]

When is a house a work of art? The French artist Jean-Pierre Raynaud formulated an original answer to this question in 1969 when he began transforming a small residence located in La Celle Saint-Cloud near Paris by covering its interior with white tiles (*La Maison,* 1992). In 1974, he opened this *Maison* on a limited basis to visitors who were encouraged to visit it the way they would visit a museum or a work of art. Floors, ceil-ings and walls were all covered with standard square white tiles, recalling the use of this material in bath-rooms, kitchens or, as Raynaud insists, morgues. Much of Raynaud's work has to do with the appropriation of ordinary signs — like the standard one-way sign, or the symbol for radioactivity. His white tiles carry with them a symbolic banality that he used in the La Celle Saint-Cloud house to create a spiritual emptiness, a "clean, well-lit place" that brought with it any number of thoughts, depending on the experiences and the awareness of the visitor. Raynaud has always been interested in architecture, as his current studio in La Garenne-Colombes

Jean-Pierre Raynaud,
La Maison, 1992

demonstrates (see pages 166–69). In a commentary related to the studio, he stat-ed, "Death is such a positive word for us that it is frightening. I can't imagine that death could be more terrible than birth. Birth and death are so closely linked that rejecting the latter would be like saying that a leg is noble and an arm is not. Light changes with every passing moment. There are times when we are euphoric and times when melancholy reigns. It is certain that when the sun shines, this space is voluptuous. When an architectural form is created in the depths, it seeks another rapport with the outside world. It seeks to take its distance from the exterior. It redis-covers autonomy and silence. It becomes a parallel world, defensive and protective.

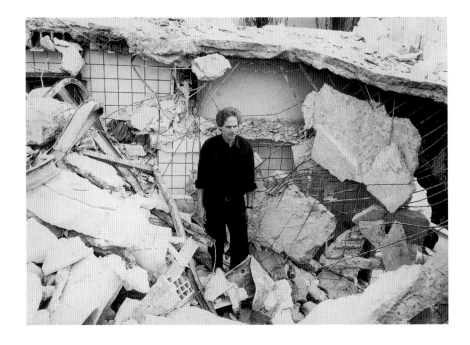

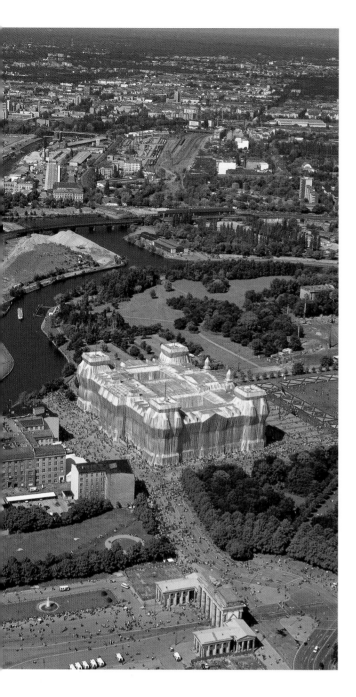

Christo and Jeanne-Claude,
Wrapped Reichstag,
Berlin, 1995

It is necessary, then, to be able to assume the solitude that it implies. Alone in this place, I feel very much at ease, not at all sad." The unexpected way in which Raynaud speaks about his studio could for the most part have been applied to the house in La Celle Saint-Cloud. He had an almost visceral relationship with the house and he decided when it was "complete," which is to say entirely, perfectly tiled over, to demolish it, in order to give it "another destiny," as he says. In 1993, after the demolition of the house, he exhibited its rubble in 1,000 stainless-steel hospital basins in the vast volume of the CAPC in Bordeaux. The creation of a parallel universe has been a preoccupation of artists and architects over the ages — a more perfect world where only the artist or architect's will forms space, time and thought. Often, these new worlds have been imagined as being eternal, or outside the clutches of time. Raynaud's courage and fundamental modernity was in the ironic content of his *Maison*, using the materials of a morgue or a public toilet to create a universe of white perfection, making spirituality out of the most banal substance and symbol possible. That he then decided to demolish this house and to exhibit its ruins in hospital basins, as though it were his own flesh and blood offered to the public, transports the *Maison* into a very contemporary sphere where art and architecture meet and are nothing more than a thought. Raynaud's own home, converted into a monastic grid of whiteness, was willfully crushed, and put on public display. The religious overtones of this work are also apparent. The Christian doctrine of transubstantiation is surely evoked in the conversion of an ordinary suburban house into a work of art and its dissolution and exhibition in basins in a museum. "And as they were eating, Jesus took bread, and blessed it, and broke it, and gave it to his disciples, and said, 'Take, eat; this is my body.' And he took the cup, and gave thanks and gave it to them, saying, 'Drink ye all of it; for this is my blood of the New Testament, which is shed for many for the remission of sins. But I say unto you, I will not drink henceforth of this fruit of the vine, until that day when I drink it new with you in my Father's kingdom.'" (*Matthew* 26:26–28)

"The Reichstag stands up in an open, strangely metaphysical area, The building has experienced its own continuous changes and perturbations: built in 1894, burned in 1933, almost destroyed in 1945, it was restored in the Sixties, but the Reichstag always remained the symbol of Democracy. Throughout the history of art, the use of fabric has been a fascination for artists. From the most ancient times to the present, fabric, forming folds, pleats and draperies, is a significant part of paintings, frescoes, reliefs and sculptures made of wood, stone and bronze. The use of fabric on the Reichstag follows the classical tradition. Fabric, like clothing or skin, is fragile, it translates the unique quality of impermanence. For a period of two weeks, the richness of the silvery fabric, shaped by the blue ropes, created a sumptuous flow of vertical folds highlighting the features and proportions of the imposing structure, revealing the essence of the Reichstag."[32] It was in these terms that the artists Christo and Jeanne-Claude described their work *Wrapped Reichstag* (Berlin, 1971–95). It was their idea to cover the entire Reichstag with 100,000 square meters of silver polypropylene fabric for fourteen days beginning on June 24, 1995. Subsequently renovated by Lord Norman Foster, the Reichstag is, of course, again the seat of the German Parliament.

With this ephemeral action and others of the kind, Christo and Jeanne-Claude have succeeded in temporarily converting buildings or natural settings into works of art, and extremely popular ones at that. The act of "wrapping," as practiced by the artists, of course calls attention to a structure and makes people think about it in a new way. It also creates an esthetic sensation that is new despite public familiarity with such

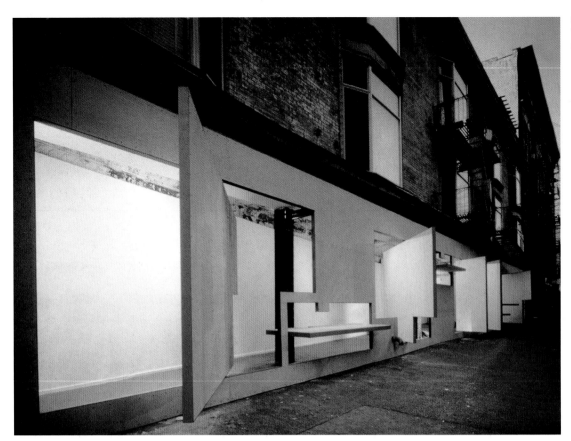

Vito Acconci with Steven Holl,
*The Storefront for Art and
Architecture,* New York, 1993

monuments. A "found object" in an unusual sense, the Reichstag normally would have very little connection with the world of art, and yet for two weeks it became a work of art in and of itself on an urban scale. If their work of art served no purpose as such, it did cover a building that has had a very real purpose and existence. Burned, abandoned and born again, the Reichstag may indeed have "always remained the symbol of Democracy," but more importantly it is the symbol of German democracy. Art and architecture meet here at a sensitive point of conjunction with political life and history. The *Wrapped Reichstag* may have meant nothing in particular, and a great deal in the historical context of the heart of Berlin. During the two weeks that the installation lasted, art and architecture engaged in a symbiotic relationship in which the boundaries between one and the other became indistinguishable.

Located on Kenmare Street, at the eastern extremity of the Soho gallery area in Manhattan, *The Storefront for Art and Architecture* (1993) is a 250-square-meter, wedge-shaped space redesigned by the architect Steven Holl and the artist Vito Acconci. They replaced the old storefront with pivoting concrete-and-wood-fiber panels. Cut into differently-sized geometric shapes, the panels open completely towards the street, with the interior of the space being left much as it was, aside from a small office cubicle. Intended for cutting-edge exhibitions on art and architecture, *The Storefront* may not boast the most practical of designs, but it is an interesting example of direct collaboration between disciplines. "We wanted to pull the sidewalk into the gallery — the sidewalk would sweep in with the pivoting of a wall — and we wanted the gallery to spill out, ooze out, onto the street," says Acconci. Although the collaboration of Acconci and Holl was more fruitful than that attempted years earlier in New York between Isamu Noguchi and Louis Kahn, both participants in this initiative express some reticence about the very idea. "It's very difficult to collaborate with artists," says Holl. "I think I do it because I like to inflict a kind of punishment on myself. I worked with Vito Acconci: we worked for maybe one year to design a tiny little gallery called *The Storefront for Art and Architecture.* I think the intensity of our effort of banging our heads against each other with ideas gets inside the work somehow and the work is neither Vito's nor mine: it's both of ours and I think it's a true collaboration." Indeed, it is impossible to tell where art begins and architecture ends at the corner of Kenmare Street, and this may be the most telling analysis of *The Storefront.* It is successful because it is neither one nor the other, but both at once. Vito Acconci has said, "I love architecture because it deals with the materials and processes of the everyday world; but I hate architecture because it is inherently fascist, architecture determines human behavior." By challenging the most basic element of architectural integrity, its facade, Holl and Acconci raise more questions than they solve. Practically speaking, *The Storefront* is a fair-weather project, ill adapted to extensive use in bad weather, but just as it dissolves the barrier between inside and out, so, too, it deconstructs the definitions of art and architecture.

On a much larger scale than *The Storefront for Art and Architecture*, the Guggenheim Bilbao (1991–97) experiments with the ultimate dissolution between disciplines, making art where architecture had almost never dared to before. The Guggenheim Bilbao is without any doubt one of Frank Gehry's most spectacular architectural works. Here, the complex forms he had been studying and proposing for a number of years for projects like the Disney Concert Hall in Los Angeles come together in a symphony of sculptural volumes. The structure has total floor space of 24,000 square meters with 10,600 square meters of exhibition area on three levels. From the outside, its most spectacular feature is the titanium cladding of its "metallic flower" shapes that were modeled by Gehry using the CATIA program developed by Dassault Aviation in France for fighter-plane design. On the inside, visitors are greeted by a 55-meter-high atrium that cuts through the heart of the building. There are eighteen galleries, but the most spectacular of these by far is the main exhibition space that is free of structural columns and measures no less than 130 meters in length and thirty meters in width. Inevitably, such spaces do invite comparison to the cathedrals of another era. Gehry also reaches the apogee here of his natural tendency to want to create buildings that are themselves works of art.

Born in 1929 in Toronto, Frank Gehry studied at the University of Southern California, Los Angeles (1949–51), and then at Harvard (1956–57). He created his own firm, Frank O. Gehry and Associates, Inc., in Los Angeles in 1962, but he was not to become well known outside of a relatively small circle until almost twenty years later. The significance of his contribution was recognized when he received the 1989 Pritzker Prize. In his acceptance speech, he described some of the factors which explain his style: "My artist friends, like Jasper Johns, Bob Rauschenberg, Ed Kienholz and Claes Oldenburg, were working with very inexpensive materials — broken wood and paper — and they were making beauty. These were not superficial details, they were direct, and raised the question in my mind of what beauty was. I chose to use the craft available, and to work with craftsmen and make a virtue out of their limitations. Painting had an immediacy that I craved for in architecture. I explored the process of new construction materials to try giving feeling and spirit to form. In trying to find the essence of my own expression, I fantasized that I was an artist standing before a white canvas deciding what the first move should be."

It seems unexpected that an architect with the inventive capacity of a Frank Gehry should build his real masterpiece so far from the "anything goes" climes of Southern California, where he came to be known. This has to do with the persuasive powers of Thomas Krens, but also with the maturity of the Guggenheim Bilbao as a piece of architectural art. Frank Gehry makes it clear that much of the program of the museum must be attributed to Krens. Its spaces, from the atrium to the spectacular ground-floor exhibition room, and on to the somewhat more classical galleries above were crafted with the idea that this would be no encyclopedic

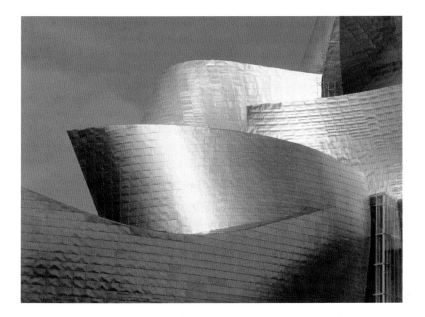

19th-century-style museum. It is a museum for a new era in which people come to be entertained, or to discover the selected works of a limited number of artists. Art, when it is conceived in harmony with the architecture, like Richard Serra's powerful Corten steel *Snake*, sings in this space. This, it seems, is a place where art and architecture finally meet in harmonious amplification. In galleries used for large-scale paintings, like those of Anselm Kiefer, there is another "epiphany," a discovery of what the art of the late 20th century is all about. It makes sense here as it never has in any converted 19th-century palazzo, or even in most of the purpose-built museums conceived in outdated modes.

Frank O. Gehry, Guggenheim
Museum, Bilbao, 1991–97

Riders on the Storm

It is interesting to note that Hermann Finsterlin's 1920 *Dream in Glass* bears an astonishing resemblance to Gehry's Guggenheim Bilbao, erected seventy-five years later. This is not to suggest that the American copied the German, but rather that unseen links connect those who are inspired to search for the place where art and architecture meet. Perhaps the *Crystal Chain* runs through the centuries, unspoken, unwritten, and yet always present. Even more than the isolated efforts of the builder or the painter, works that approach the nexus, the meeting point of body and mind, where neither are both, share what is essential.

When Yves Klein staged his *Saut dans le vide* in 1960, the ancient collaboration between art and architecture reached one of its most significant turning points. Though Klein spoke of the artist bringing color to a building, his real fascination was with the void, the emptiness of the *in-between*. In a very real sense, this is where the modern nexus lies, in the realm of non-being. And so Gordon Matta-Clark, too, could bore a hole through two early 18th-century Parisian buildings to discover the nothingness that had held them together for almost three centuries. Ashes to ashes. What remains is the light, the moon over James Turrell's *Roden Crater*. After centuries of searching, from the ancient dome to the forceful splendor of the unbuilt *Monument to the Third International,* art and architecture finally come together where they originated, between the mind and the body. Even if some recent examples of collaboration between artists and architects have given limited results, this is not to say that such efforts will not continue, that art will not be born of architecture and vice versa. On the contrary, the story of this affair of love and hate and jealousy is obviously destined to continue. "I like the thing-ness of light," says James Turrell, "that presence of light that almost seems more powerful a thing than the object which is the thing." His is an architecture of sensibilities, just as Yves Klein could say, "Colors are the true inhabitants of space."

Since the first circle shaped in stone — color, light and form have been brought together to mark the gateway to and future dreams — the paradise of some and the brave new world of others. Whether the product of human logic or a dream of otherworldly perfection, the gates to utopia are surely the work of artists and architects, at last conscious of where their path must lead. Elaborately carved and embellished with phrases from the *Qur'an*, roughly sliced through a building about to be demolished, this gate is always the same, and

James Turrell, *Roden Crater*, Arizona, since 1977

yet always different. Ultimately, it might be nothing more than a floating impression, changing light on the face of Rouen Cathedral, early December sun in the gardens of Katsura. On the other side of the gate it may be this life or another that awaits. It may also be the vision of the apocalypse of Monsù Desiderio, or the prisons of the mind seen by Piranesi that lie in store. Or perhaps form will dissolve in the void where only color will remain. The gate will be built from the in-between, from the place where emptiness is all, where art and architecture touch, and become one, at "the horizon of all things."

James Turrell collaborated with the Japanese architect Tadao Ando on the island of Naoshima (*Minami Dera*, 1999). Ando created a blank and black 163-square-meter wooden structure in the fishing village of Honmura on the site of a former temple, specifically for a haunting work by James Turrell entitled *Backside of the Moon*. The visitor to *Minami Dera* is led into an interior space so dark that nothing is visible. Indeed, depending on external light conditions, it may

be necessary to sit for fifteen minutes before a faint purple glow appears at an indeterminate distance. Standing, walking towards an ultra-violet rectangle that hovers in space, the visitor is confronted with "a place that is nowhere." In a sensation perhaps matched by some of Mark Rothko's late, brooding paintings, Turrell places the viewer opposite nothing other than eternity. Even gravity has no hold over this indefinable light, a color floating in the darkness, mysterious and yet strangely familiar; this is the place we all go to at the end of our journey. Where art and architecture of this quality come together, there is a purpose that has nothing to do with the material contingencies of the built world. This true collaboration and union serves to open the door to the world that is already there.

1 Rudolf Arnheim, "Notes on religious architecture," in: *Languages of Design – Formalisms for Word, Image and Sound*, vol. 1, no. 3, August 1993. Elsevier Publishers.
2 Rudolf Arnheim, *Art and Visual Perception. A Psychology of the Creative Eye*, University of California Press, Berkeley, California, 1974.
3 Hanno-Walter Kruft, *A History of Architectural Theory*, Zwemmer, Princeton Architectural Press, New York, 1994. German original edition, C. H. Beck'sche Verlagsbuchhandlung, Munich 1985.
4 Joseph Rykwert, *The Dancing Column, On Order in Architecture*, MIT Press, Cambridge, 1996.
5 Matila C. Ghyka, *Le nombre d'or*, Gallimard, Paris, 1982.
6 "C'est dans l'épreuve que je fais d'un corps explorateur voué aux choses et au monde, d'un sensible qui m'investit jusqu'au plus individuel de moi-même et m'attire aussitôt de la qualité à l'espace, de l'espace à la chose et de la chose à l'horizon des choses, c'est-à-dire à un monde déjà là, que se noue ma relation avec l'être." Maurice Merleau-Ponty, *Phénoménologie de la Perception,* Gallimard, Paris, 1976.
7 Hanno-Walter Kruft, *A History of Architectural Theory*, Zwemmer, Princeton Architectural Press, New York, 1994.
8 William Rubin, "De Chirico and Modernism," in: *De Chirico*, Museum of Modern Art, New York, 1982.
9 Marshall McLuhan, *Understanding Media*, McGraw-Hill, New York, 1964.
10 "Je suis rompu, je n'en peux plus, et, ce qui ne m'arrive jamais, j'ai eu une nuit remplie de chauchemars: la cathédrale me tombait dessus, elle semblait ou bleue ou rose ou jaune."
11 King James version (1611).
12 *Fantasy Architecture, 1500–2036*, RIBA, Hayward Gallery Publishing, 2004.
13 Francis Haskell and Nicholas Penny, *Taste and the Antique,* Yale University Press, New Haven, 1993.
14 William Rubin,"De Chirico and Modernism," in: *De Chirico*, Museum of Modern Art, New York, 1982.
15 Dieter Neumann, *Film Architecture*, Prestel, Munich, 1996.
16 Gail Levin, *Edward Hopper, the Art and the Artist*, Whitney Museum of American Art, W.W. Norton & Company, New York, 1980.
17 Mark Wigley, *Constant's New Babylon: The Hyper-architecture of Desire*, Uitgeverij 010 Publishers, Rotterdam, 1998.
18 Quoted in: Iain Boyd Whyte, "Reflections on a Polished Floor," in: *Harvard Design Magazine*, Fall 1998, no. 6.
19 Ibid.
20 Yves-Alain Bois et al., *Piet Mondrian*, Haags Gemeentemuseum, Leonardo Arte, Milan, 1994.
21 Meyer Schapiro, *Mondrian: On the Humanity of Abstract Painting,* republished by George Braziller, New York, 1995.
22 Hanno-Walter Kruft, *A History of Architectural Theory,* Zwemmer, Princeton Architectural Press, New York, 1994.
23 Anatolii Strigalev, "Nonarchitects in Architecture," in: *The Great Utopia, The Russian and Soviet Avant-Garde, 1915–1932*, Guggenheim Museum, New York, 1992.
24 Hanno-Walter Kruft, *A History of Architectural Theory,* Zwemmer, Princeton Architectural Press, New York, 1994.
25 Now the MAK Center for Art and Architecture, 835 King's Road, West Hollywood, CA 90069-5409, Tel. 00 1 213 651 1510.
26 Peter Noever (ed.), *MAK Center for Art and Architecture*, Prestel, Munich, 1995.
27 Arata Isozaki, "Katsura: A Model for Post-Modern Architecture," in: *Katsura Villa – Space and Form*, Iwanami Shoten Publishers, Tokyo, 1983.
28 *Air Architecture, Yves Klein*, Peter Noever (ed.) and François Perrin; Mark Wigley, "The Architecture of the Leap," in: *MAK Center for Art and Architecture,* Los Angeles, Hatje Cantz, Ostfildern-Ruit, Germany, 2004.
29 Kenneth Frampton, et al., *Play Mountain: Isamu Noguchi + Louis Kahn*, Watari-um, Tokyo, 1996.
30 Corinne Diserens (ed.), *Gordon Matta-Clark*, Phaidon, New York, 2003.
31 Nicholas Serota (ed.), "Donald Judd: A Sense of Place," in: *Donald Judd*, Tate Publishing, London, 2004.
32 http://www.christojeanneclaude.net/wr.html

Architecture : Art

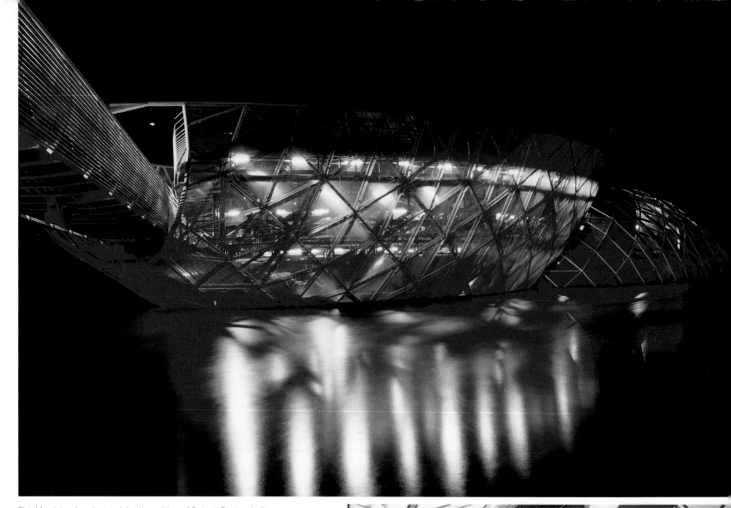

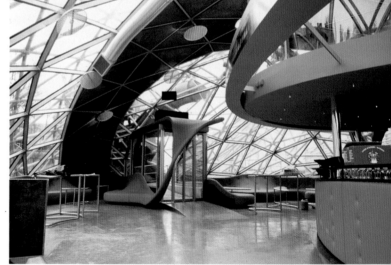

The Mur Island project, originally an idea of Robert Punkenhofer, was intended "to break the prevailing isolation between the river and the city," by creating a modern, bright presence in the midst of the traditional architecture of Graz.

Vito Acconci has made a career of breaking down the barriers between art, architecture and other disciplines. Born in the Bronx in 1940, he lives and works in Brooklyn. Having experimented with performance, photography, video and audio installations, in 1988 he created the Acconci Studio, whose avowed intention is to make space "fluid, changeable, portable." Acconci has been involved in direct collaboration with architects, for example, *The Storefront for Art and Architecture* (1993) in New York, designed with Steven Holl.

One of his most recent and visible projects was the floating island he built in Graz, Austria, as part of the city's selection as European Cultural Capital of 2003. Sitting in the river opposite the old city and the Mariahilferplatz, the 7 x 18 x 47-meter structure was fashioned from "steel, glass, rubber, asphalt, water, and light." Acconci describes the project as "A twist in the river, a node in the river, a circulation-route in the middle of the river. The circulation-route is an island; the island is a dome that morphs into a bowl that morphs into a dome … the dome functions as a café/restaurant…. Where dome and bowl intersect, and where the dome is transformed

into a bowl and vice versa, a playground is formed by the collision and by the melting…. Functions are mixed on this island; the playground functions in the theater as a backdrop for the stage and in the café as part of the ceiling — one function fluidly becomes another." It was built at the suggestion of Robert Punkenhofer, an Austrian whose Art & Idea association specializes in "promoting and facilitating a cultural dialogue by organizing contemporary arts programs of international scope."

The **Mur Island** is illustrative of the strong tendency that exists in contemporary art and architecture to do away with the barri-

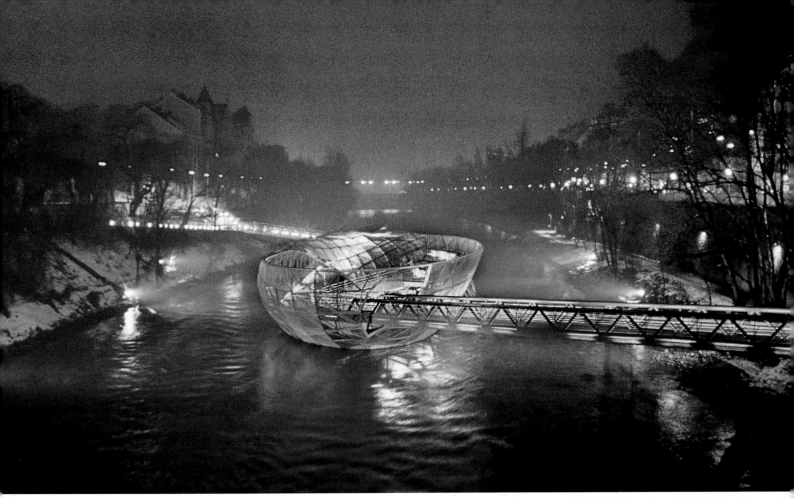

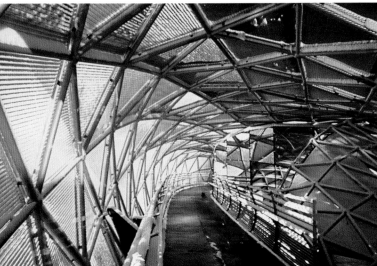

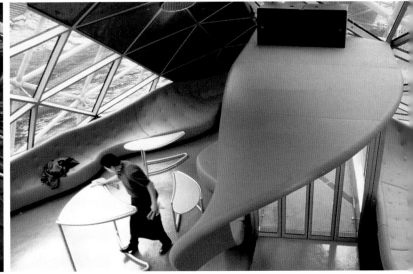

ers that have long separated different forms of expression. Just as he did in the case of *The Storefront for Art and Architecture* on Kenmare Street near SoHo, Acconci concentrates in Graz on opening facades and spaces, and making them usable in various configurations. The pivoting panel facade of the Storefront posed a certain number of problems during the cold New York winters, but the radical nature of Acconci's challenge to form and function deserves careful attention. He emphasizes the polyvalence of the Mur Island design, underlining the increasing awareness that architecture need not always have strictly defined functions — rather, it should be left to users to decide how a building can best meet their needs. The designer clearly plays a key role, first, in examining public needs and hopes and then in transforming such ideas into solid form. Acconci's background — studies in psychology and the design of community meeting spaces — may bring him closer to sociology than art in this instance, and the Mur Island project looks more like architecture than sculpture. What he demonstrates above all is the wide field to be investigated once barriers between disciplines have been swept aside. What, he asks, would happen if it became impossible to tell where art ends and architecture begins?

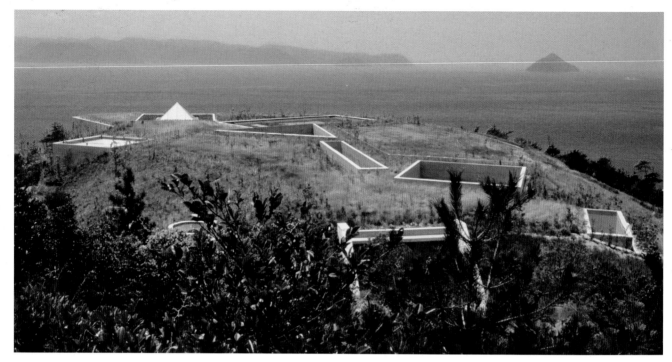

Seen from ground level, the Chichu Art Museum looks like a collection
of abstract concrete sculptures.

One of the most recent and interesting works of the Osaka architect
Tadao Ando is the **Chichu Art Museum**, located on the island of
Naoshima in the Inland Sea of Japan. In this largely underground
structure funded by the family foundation of Soichiro Fukutake, CEO
of the Bennesse Corporation, Ando has designed spaces for works
of art by Claude Monet, James Turrell and Walter De Maria. In fact,
the room housing De Maria's monumental *Time/Timeless/No Time*
(2004) is more the result of a close collaboration between artist,
architect, curator and client than it is purely a work of Ando's. As
Fukutake puts it, "I told Walter De Maria that I feel very strongly
about the Pergamon Museum in Berlin with its great staircase." The
space referred to here is that which houses the *Pergamon Altar* (2nd
century BC). Its frieze depicting the battle between the Gods and
Giants is considered to be a masterpiece of Hellenistic art. The
finished work does indeed include a monumental staircase even if it
remains thoroughly modern. The space was also influenced in its
final form by the museum's curator, Yuji Akimoto. As he says, "In the
past, it was common to first have an architectural space, within
which an art space was created. Instead, we proceeded to develop
both architecture and art at the same time. By doing this, we were
able to provide an opportunity for artwork to be developed fully.
During the design, I asked Ando to consider what kind of architectur-
al space would be necessary for the permanent placement of the
works of art." Finally, an interesting dialogue between Ando and De
Maria emerged which had an impact on the overhead lighting of the
space. "The curator, Yuji Akimoto, the artist and I worked hard on

the De Maria room," says Ando. "It was only through gradual discus-
sions that we decided on the curvature of the roof and the skylight. I
felt for some time that the skylight could have been a bit narrower,
but now everyone agrees."

It is rare indeed to find a fruitful dialogue between an artist and
architect working on the same project. Egos tend to get in the way of
the mutual concessions necessary to make such a discussion
successful. It is even rarer that curator, client, architect and artist
manage to agree on a given solution. A good deal of the credit in this
instance must be given to Tadao Ando for his own innate under-
standing of the need for a pragmatic approach. The point was not so
much to create a masterpiece of architecture as it was to develop a
remarkably coherent space for the exhibition of three apparently
incongruous types of work. One might well think that Monet's monu-
mental waterlily painting (*Le bassin aux nymphéas*, diptych, oil on
canvas, each part: 200 x 300 cm, 1915–26), Turrell's impressive
works, including one of his *Sky Spaces*, and De Maria's more mas-
sive granite and wood piece have nothing in common, and yet here
they come together to create what can only be described as a spiri-
tual experience. As Ando puts it, "Yes, it is a building that inspires a
unique feeling because these are spaces that you have never seen
before. It is the result of work with the artists and the curator. The
spirituality that you can feel in the building has emerged because of
the ideal collaboration with the artists. This was made easier by the
fact that De Maria and Turrell had worked with me on Naoshima
before — they knew and like my architecture. They created works to
fit with my architecture, just as I sought to work toward their goals.
We had very positive discussions whereas artists can be difficult in
other circumstances. The passion of Fukutake was also an essen-
tial element in this equation."

Following pages:
The room in the Chichu Art Museum designed by Tadao Ando in
close collaboration with Walter De Maria for the artist's work
Time/Timeless/No Time (2004, granite, mahogany, gold leaf, concrete).

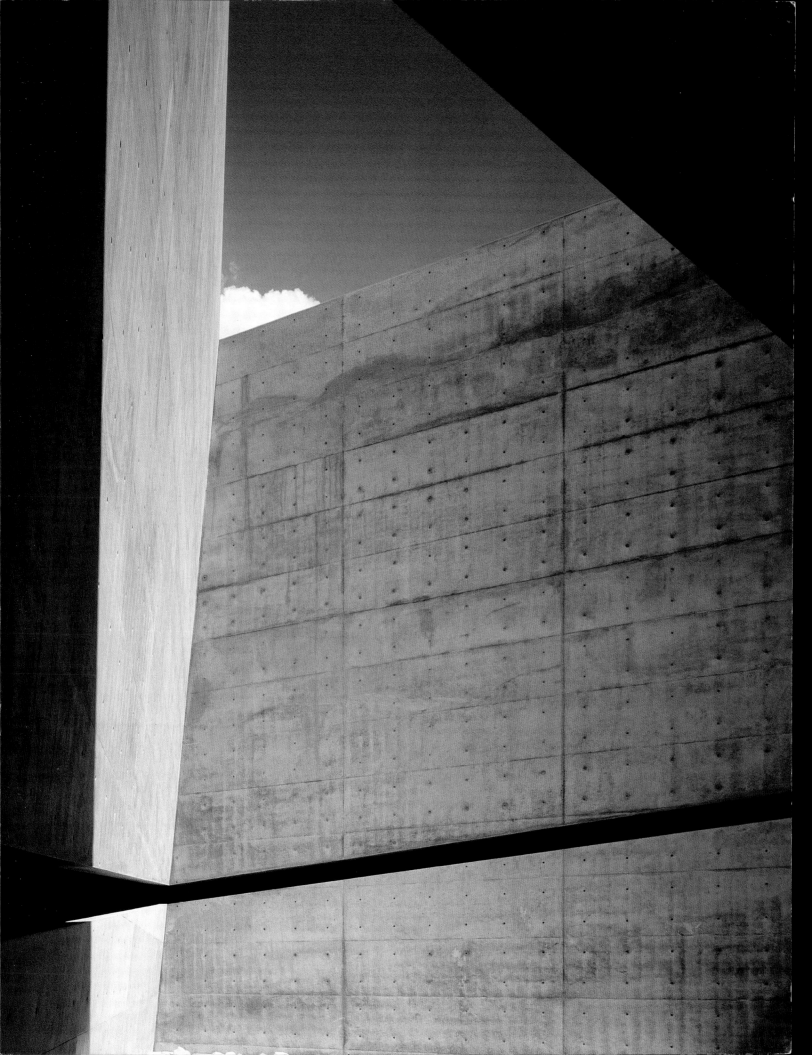

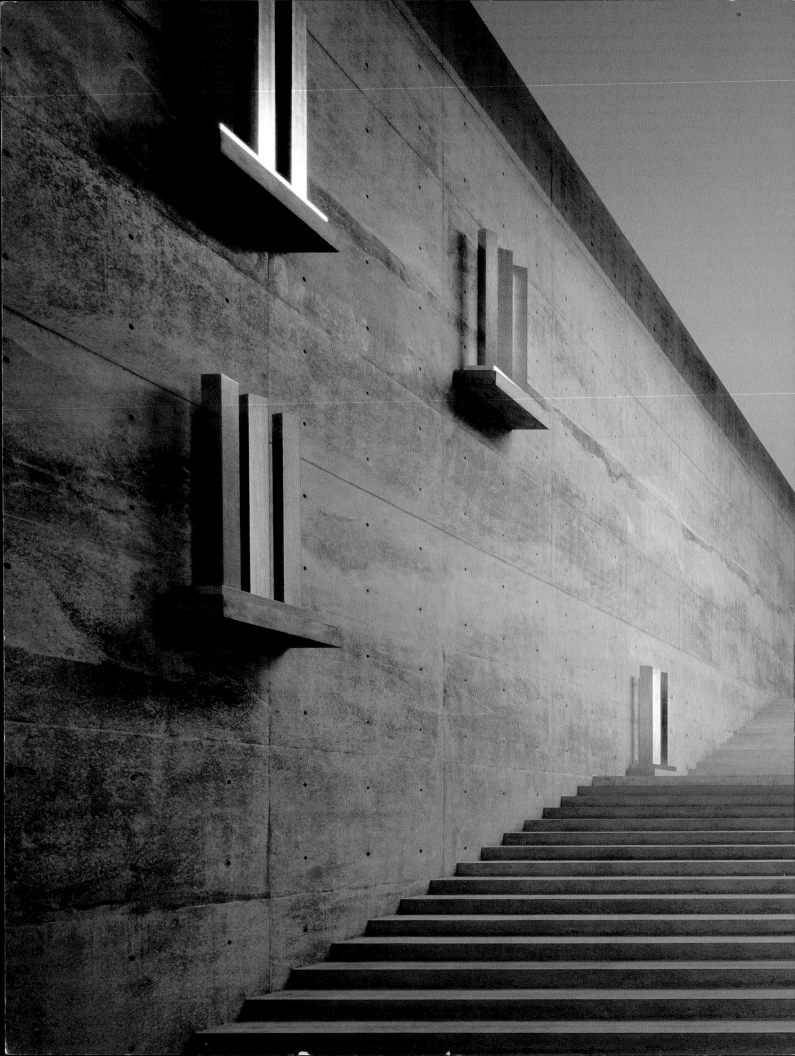

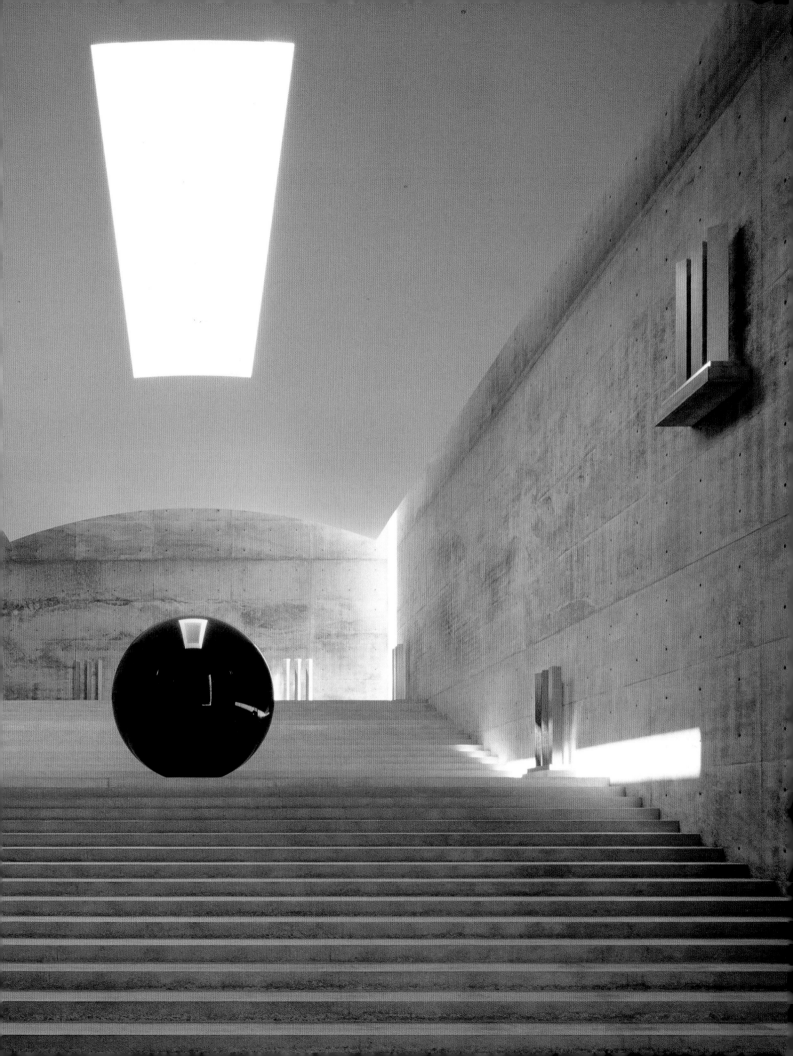

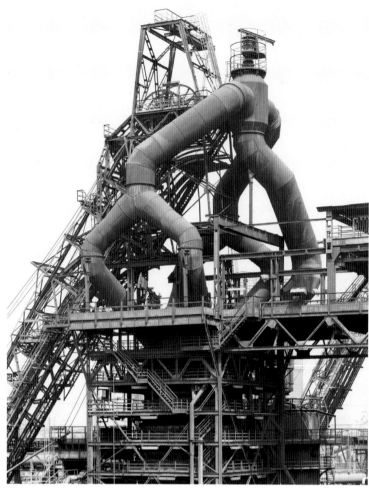

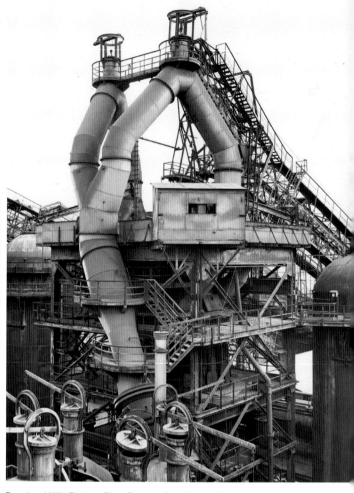

Bernd and Hilla Becher, *Blast Furnace. Duisburg-Bruckhausen,
D 1995*. Photograph

Bernd and Hilla Becher, *Blast Furnace. Terre Rouge, Esch-Alzette,
L 1979*. Photograph

Can photographs of industrial architecture be called art? In the case of Bernd and Hilla Becher, the response is unequivocally positive. They began to photograph gas tanks, silos and water towers in black and white in the early 1960s, and they have never changed their basic method of meticulous, frontal inventory. First called "anonymous sculptures" in a 1969 headline in the Düsseldorf publication *Kunst-Zeitung*, their work was given a Leone d'Oro award for sculpture at the *Venice Biennale* in 1991. Their first book was called *Anonyme Skulpturen: Eine Typologie technischer Bauten (Anonymous Sculpture: A Typology of Technical Buildings,* 1970). They have long taught photography at the Staatliche Kunstakademie Düsseldorf and had a direct influence on such photographers as Thomas Struth, Candida Höfer, and Thomas Ruff.

Part of the artistic reputation of the Bechers comes from their method as opposed to their subject matter: the idea of a serial representation and hangings of pictures of the same size and nature conditions their relationship to the work of artists such as Sol LeWitt, Carl Andre or Donald Judd. Judd and Ed Ruscha also shared with them an interest in apparently banal industrial or urban architecture. Clearly, the younger generation of photographers they taught in Düsseldorf have differentiated their own work from that of the Bechers, preferring large-format color images and less of an emphasis on seriality, though Höfer and the others clearly categorize their production (libraries etc.). What makes the work of the Bechers so interesting lies partly in the translation of three-dimensional architecture into the two dimensions of a reproduction. Aligning technically similar pictures of certain building types, in patterns that recall scientific procedures, they draw attention to the similarities of the architecture, but also to the surprising variety given to structures intended for the same purposes. Within a strict format and subject choice, their aligned works reveal an almost physiological diversity. Aside from its implications for artistic expression, their work has

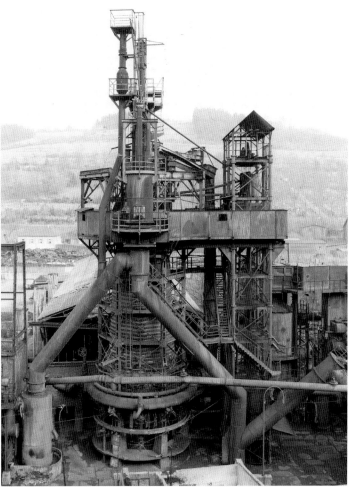

Bernd and Hilla Becher, *Blast Furnace. Aliquippa, Pennsylvania, USA 1986*. Photograph

Bernd and Hilla Becher, *Blast Furnace. Hainer Hütte, Siegen, D 1961*. Photograph

surely played a role in arousing the interest of contemporary architects toward industrial heritage. Numerous architects, ranging from such different figures as Rem Koolhaas to the American Wes Jones, have designed buildings that glorify rather than hide their industrial inspiration.

Minimalist art and architecture seeks to create a valid expression on the basis of reduced, usually geometric vocabulary. The Bechers have long applied an essentially Minimalist method, but their subject matter is by no means a matter of straight lines and squares. Quite the contrary, the industrial architecture they photograph has a Baroque or more appropriately functional complexity. Although there is surely a part of esthetic judgment that goes into the creation of many water towers, for example, their form is also dictated by the laws of physics and the resistance or the capacity of the materials used. Industrial architecture appears to be the antithesis of natural forms and yet it evolves more according to the

laws of nature than it does for any artistic reason. There is a frankness in the Bechers' frontal black-and-white images that expresses an astonishing diversity rather than a mass-produced sameness. In that fact lies the interest of their work for art, but also for architecture. While many architects from Frank Lloyd Wright onwards have claimed to create "organic" structures when they imitate natural forms, it appears evident that industrial architecture evolves in an even more natural or organic manner. Their images frequently have an unexpected anthropomorphic appearance. Within the constraints of industrial function and the laws of engineering, designers who indeed remain anonymous have brought forth entire categories of sculptural buildings whose real originality is curiously revealed in the systematically identical photos of Bernd and Hilla Becher. They have succeeded in creating their own art and in discovering the interest of a whole class of architecture that had been ignored by critics and creators alike until the early 1960s.

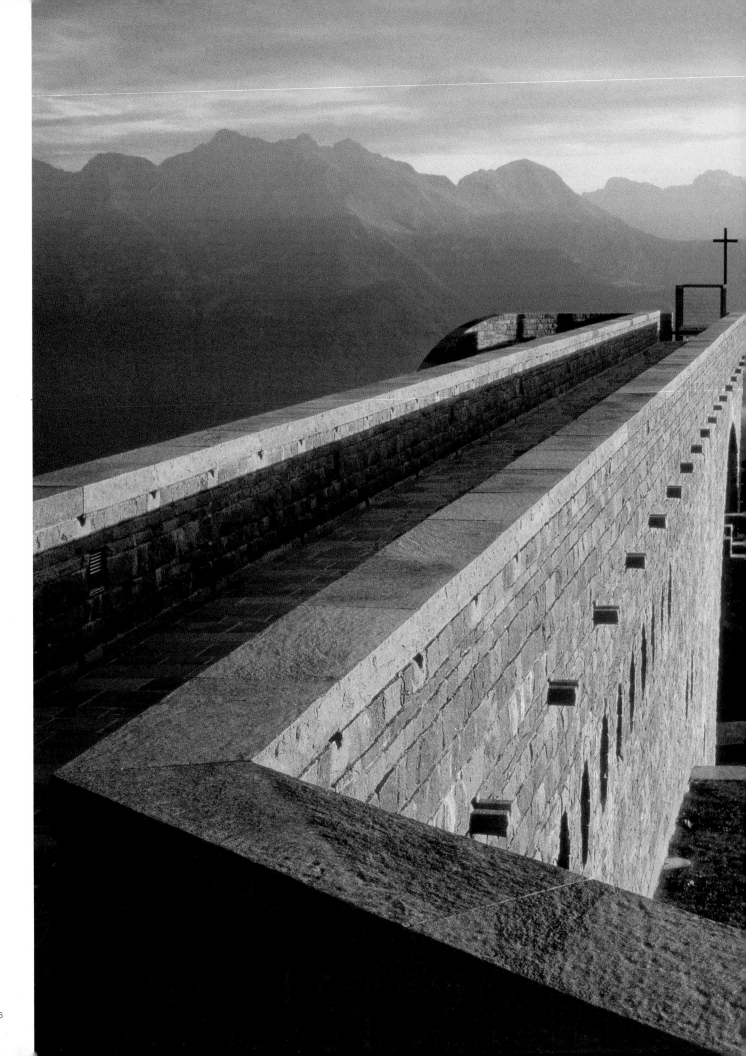

Chapel of Santa Maria degli Angeli Mario Botta, Enzo Cucchi
Monte Tamaro, Switzerland 1990 –96

46

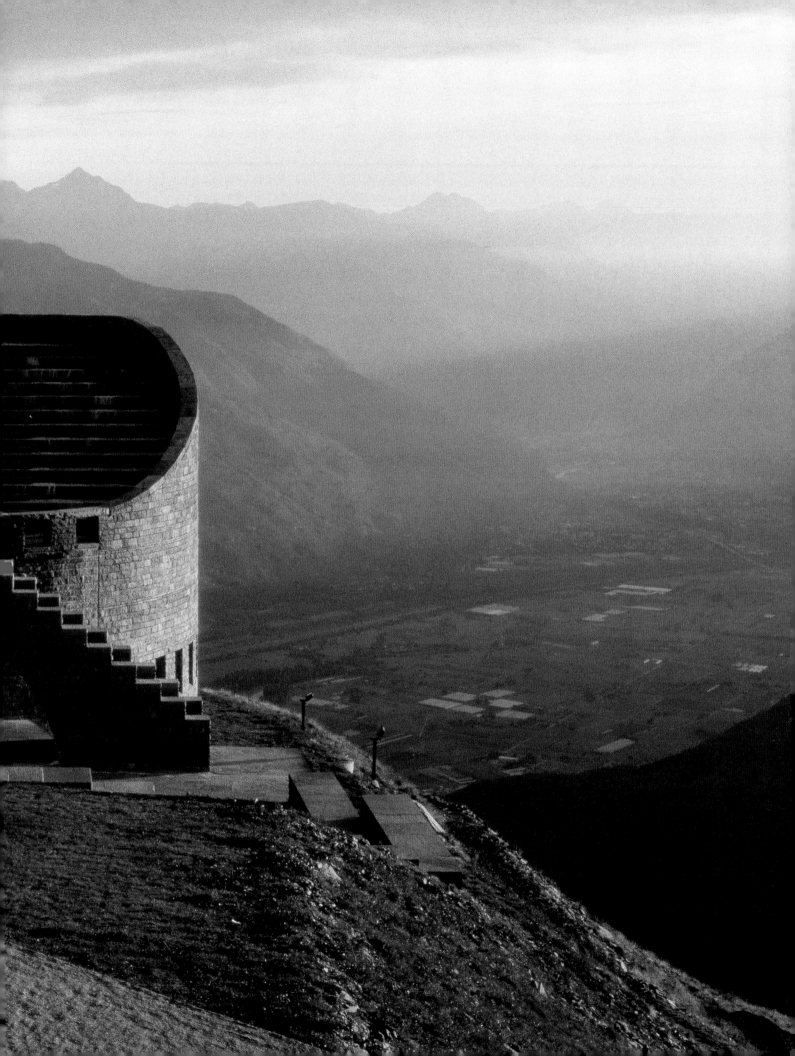

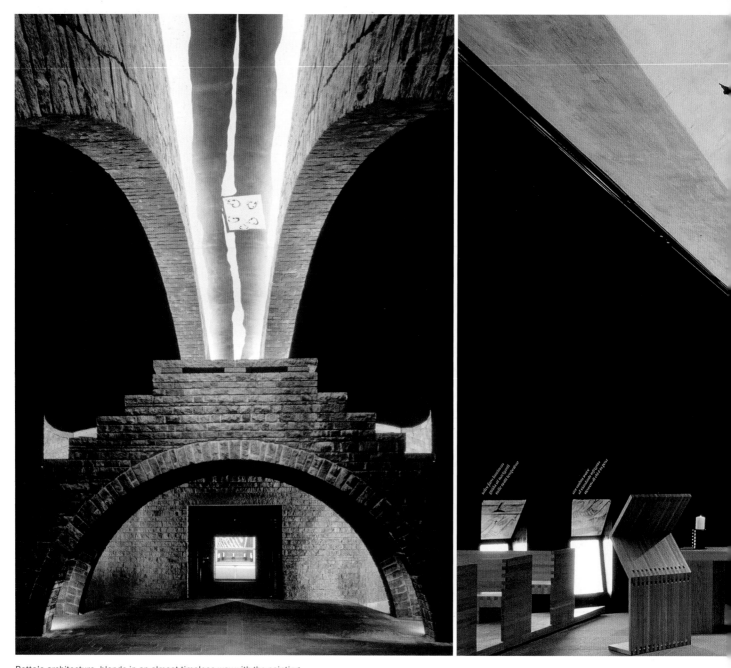

Botta's architecture, blends in an almost timeless way with the painting
of Enzo Cucchi in this exceptionally successful collaboration.

Construction in high mountain sites in Switzerland tends to be limited to ski lifts or the occasional restaurant. It is all the more exceptional that the architect Mario Botta succeeded in building one of his most powerful works at a height of 2,000 meters above the highway between Bellinzona and Lugano. It was at the request of the owner of the Monte Tamaro ski lifts that Botta designed a surprising chapel that juts out over the mountain edge. Clad in rusticated porphyry, the **Chapel of Santa Maria degli Angeli** (1990 – 96) has an almost ancient feeling about it — or at any rate, it is difficult to classify it as a strictly contemporary design. This is fitting both for its function and for the feeling of spirituality that it imparts to the visitor. Mario Botta, in agreement with the client, Egidio Cattaneo, asked the Italian painter Enzo Cucchi to collaborate with him on the interior décor of the building. Born in 1949, Cucchi was a member of the Italian Neo-Expressionist Transavanguardia movement in the 1980s together with

Sandro Chia, Francesco Clemente and Mimmo Paladino. He is known for an essentially anti-intellectual approach in his painting, imagining apocalyptic battles between light and dark or creation and destruction. Cucchi took on the long, narrow form of the chapel to his advantage, painting a sweeping fresco on the ceiling that becomes a pair of hands behind the altar. Whatever the religion of visitors, these great hands that seem ready to gather up the souls of the willing as they stand at the edge of this Alpine abyss have an almost primitive power that speaks with the same voice as Botta's cross of rough stone.

Although he has built numerous large buildings, Mario Botta seems to be at his strongest in his smaller buildings — the private houses for which he first became famous, but also his chapels. His own description of his background may make the power of his Monte Tamaro chapel somewhat easier to comprehend. "My architectural culture is a religious one," he says. "The history of architecture that

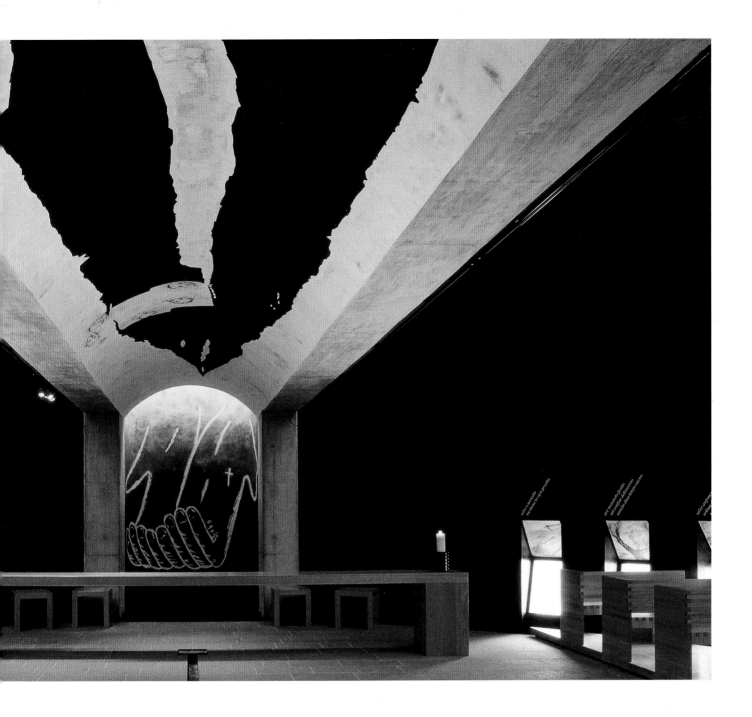

I know is one of churches — from the Romanesque period to Ronchamp. Very few ancient civilian or military buildings have survived. If you think about it, most of the old architecture we study is religious. Ninety percent of what we know about Romanesque, Baroque or even Renaissance architecture comes to us through surviving religious buildings. Naturally, modern culture is more rooted in civilian designs but one must realize that we have many hidden debts to the past." Even where his architecture carries an echo of the past, Botta has remained resolutely modern in his designs — using strict geometry for his plans.

Egidio Cattaneo had been drawn to Botta because of controversy in the late 1980s over another chapel designed by the architect in the mountain village of Mogno (Church of Saint John the Baptist, Mogno, Valle Maggia, Ticino, 1986–92/1996–98). A deadly double avalanche swept away most of the village of Mogno in 1986,

and the mayor of the town called on Mario Botta to replace the 17th-century church destroyed by the avalanche with a new design. Botta's unusual oval plan for the church drew heavy criticism and delayed construction. Cattaneo's original idea had been to allow the architect to build his design for Mogno on his land, but Botta convinced him that the Monte Tamaro site deserved another design. With its echoes of Romanesque architecture, the chapel and its décor form a whole, in much the same way that ancient religious architecture did. Like the vast Alpine perspective that opens from its rooftop balcony, the Monte Tamaro chapel and its décor seem to stand witness to a time before time, to beliefs rooted in the earth and in ancient history. This is not to suggest that there is anything pagan about this chapel, but the roughness of its stone and paint and its defiant solidity make it an unusual case of real and effective collaboration between architecture and art.

The work of Chris Burden has evolved somewhat since his first gallery show. Good thing, too, because he might not otherwise have survived the experience. The performance organized by Burden, born in 1946 in Boston (*Shoot*, F-Space, Santa Ana, California, November 19, 1971), consisted of having a friend shoot him in the left arm with a .22-caliber gun. He studied architecture and art at Harvard and the University of California before embarking on a career using his own body as the subject and substance of his work. Beginning in 1976, he began to work instead with monumental sculptures, often made up of the parts from typical construction toys intended for adolescent boys. Since 1997 in particular he has been working with Meccano and Erector Set parts to build large bridge models. "Toys," says Chris Burden, "are how children are inculcated into the adult world. They're not just a way to entertain children, they're also a tool that is used to make them into functional adults." Aside from his own education, the artist also had family connections to the world of engineering before beginning to produce large models of bridges. Burden's grandfather was Dean of the College of Engineering at Tufts University (1936–57) and his father was an advisor to Harvard's Dean of Engineering and Applied Physics.

For the opening of the Baltic Centre for Contemporary Art (Gateshead, England, July 13, 2002) Burden produced the sixth of his monumental toy bridges, **Tyne Bridge**. This work is an exact replica at 1:20 scale of a 1928 bridge across the Tyne River that can be seen from the Level 4 window of the Baltic Centre. This bridge is itself a close replica of Sydney Harbor Bridge. "I like the metal constructions of Meccano because they become a system in themselves. Even though they are toys, they have a certain built-in logic structure that is very clear and satisfying to me," he says.

In a shift from reproducing "real" bridges, he made a spectacular imaginary *Curved Bridge* for the Gagosian Gallery in 2003 with stainless-steel Erector Set parts. With no roadbed, *Curved Bridge* certainly came closer to traditional ideas about sculpture than the earlier bridge models, even if an implied relationship to a work of "real" engineering remained. His recent, unsuccessful proposal for the "Fourth Plinth" in London's Trafalgar Square was a *Toy Skyscraper As Tall As a Real Building*. "I have always wanted to build a model skyscraper using Erector parts. The proposed model buildings, built from a toy and almost 7 meters in height, take on the dimensions of an actual full-size two-storey building. This full circle of an actual building inspiring a toy, which is then used to build a model building the size of an actual building, is a beautiful metamorphosis," says Burden.

This comment by Burden describes the ambiguity with which he intentionally invests his work, exploring the relationships, both sociological and physical, between toys and "real" structures. He went on to say: "Viewers will undoubtedly be reminded of New York's destroyed World Trade Center. I see this association as positive, as it will spark a conversation about all structural, economic, safety and aesthetic issues involved in building structures that push towards the heavens." Also present in his work is an implied reference to the male gender of most young people who build models (and thus their real counterparts?). Burden is also clearly attracted to the structural complexity and apparent simplicity of bridges, as evidenced by the perfect parabolic curve of *Tyne Bridge*. His fascination for architecture, however, is a wary one, as might be expected from an artist who started his career experimenting with the pain of being shot.

Chris Burden, *Tyne Bridge*, 2002.
Installation, 945 x 152 x 282 cm.
Baltic Centre for Contemporary Art, Gateshead

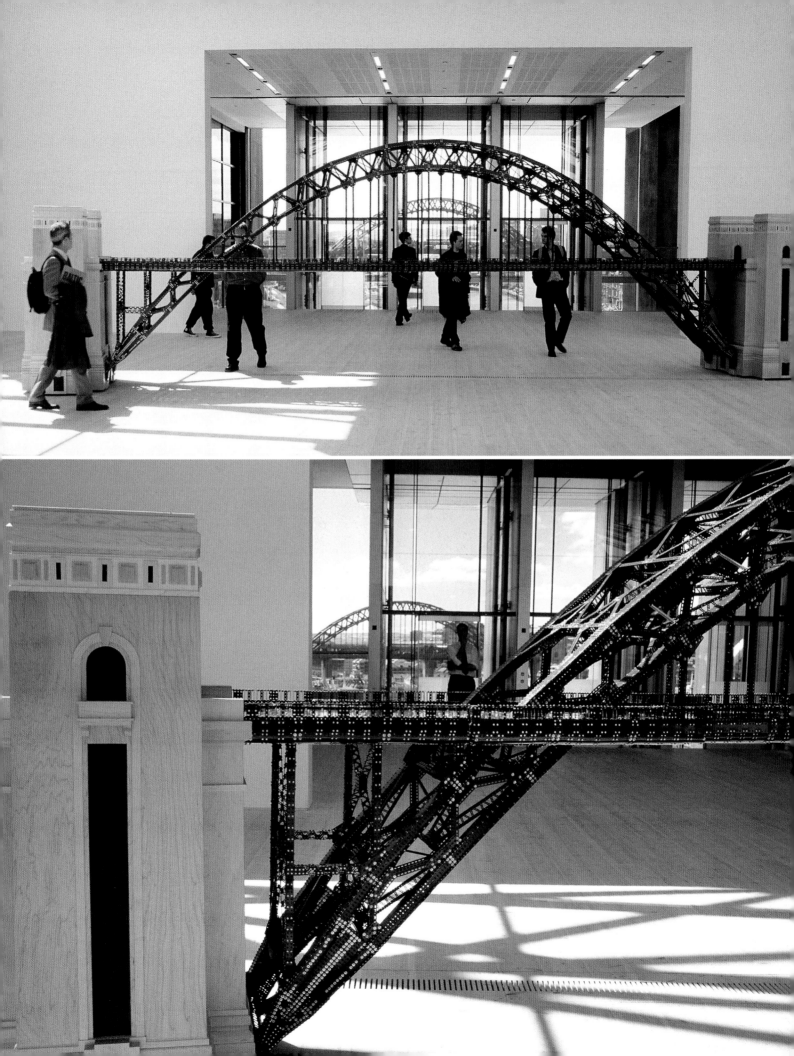

With such highly visible projects as the venue of the 2004 Summer Olympics in Athens, Greece, Santiago Calatrava, winner of the 2005 Gold Medal of the American Institute of Architects, has become one of the best-known architects in the world. Born in Valencia in 1951, he studied art and architecture at Valencia's Escuela Técnica Superior de Arquitectura (1968–73) and engineering at the ETH in Zurich (PhD, 1979). He opened his own architectural and civil engineering office in Zurich the same year. Calatrava worked for almost ten years on a large project — **City of Arts and Sciences** — in his native Valencia. The 2,600-square-meter **Planetarium**, with its elliptical plan and a hemispheric dome with a movable, ribbed covering, was built between 1991 and 1998. As Calatrava's sketches for this structure clearly show, he was directly inspired for the design by the shape of the eye. Indeed, the eye (of the architect) is a frequent theme in his work. A prolific draughtsman and at times a sculptor, Santiago Calatrava makes a close connection between art and architecture. "With all due modesty," says Calatrava, "one might say that what we do is a natural continuation of the work of Gaudí and of Julio Gonzalez, a work of artisans moving toward abstract art." In this instance, he chooses to refer to an architect who was interested in art and to a sculptor who led the way to modernity. "Sometimes, I create structural compositions, which you can call sculptures, if you like," says Calatrava. "They are based on very personal ideas. Just as Fellini or Kurosawa made drawings before their movies, I make sculptures." Although Calatrava has occasionally exhibited his sculpture and drawings and published books on them, it is usually clear that these forms of artistic expression are indeed

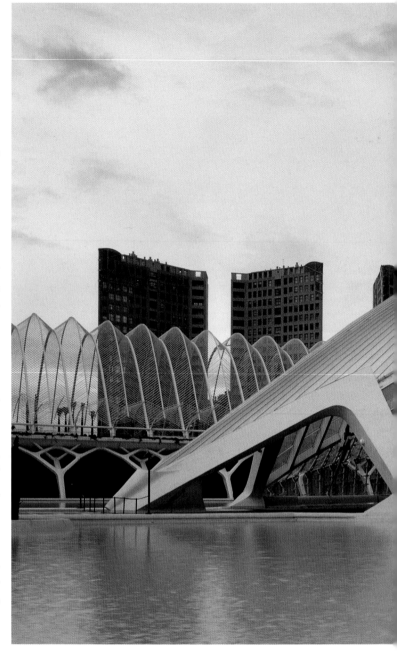

Design sketch
by Santiago Calatrava.
The resemblance of the Planetarium
to a human eye is rendered obvious
by Calatrava's own drawings.

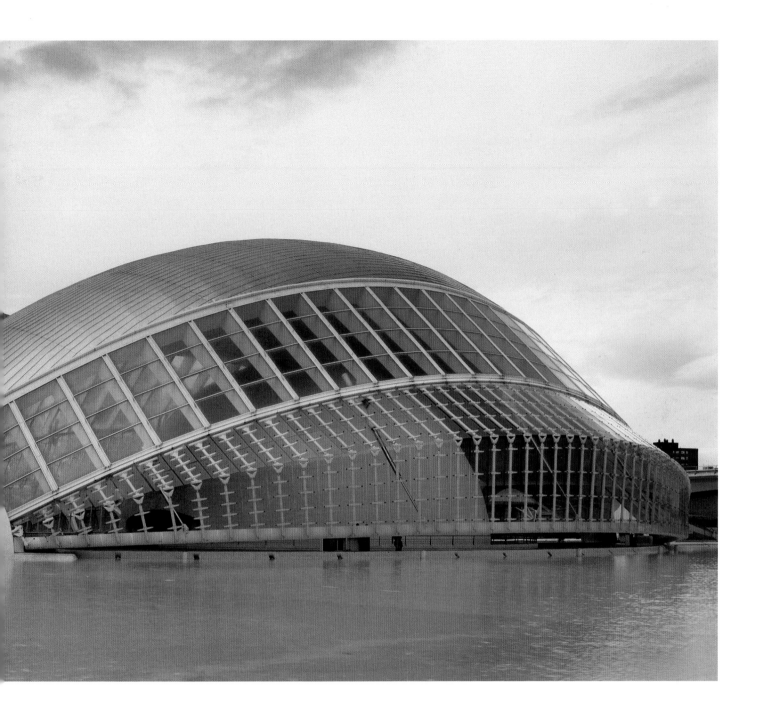

"structural compositions" that bear a direct relationship to his buildings, as opposed to being pure expressions of art. "A series of bridges I designed with inclined arcs might be like Cézanne's series of *Bathers*," he says. "The art of the 20th century," he continues, "has been heavily influenced by the Marxist-Leninist concept of art for everyone. That is finished now. We are again finding the liberty to create, and this implies a new place for the architect as artist, and for architecture as art."

Santiago Calatrava's exceptional energy and talent and his biomorphic sources of inspiration set him apart from other architects. The fact that he is, at the same time, an engineer fascinated by the ways in which structures can be made to soar also means that his is a difficult act to follow. Nonetheless, when he speaks of the "architect as artist" and "architecture as art," he is expressing a very contemporary shift of perception. As art itself has become progressively more and more difficult to identify by any formal criteria, as art has abandoned the museum wall as its sole location, so, too, architecture has begun to claim its rightful place among the real arts of our time. Like many of his illustrious predecessors, Calatrava finds that drawings and sculptures are an appropriate way to develop his thoughts about architecture. This blending of different forms of expression is perfectly natural and coherent in his mind, and he finds ample basis for his attitude in the work of Gaudí or Kurosawa. Does the only real barrier between art and architecture lie in the talent of the architect? As for Calatrava, his open spirit allows him to introduce art into the built environment.

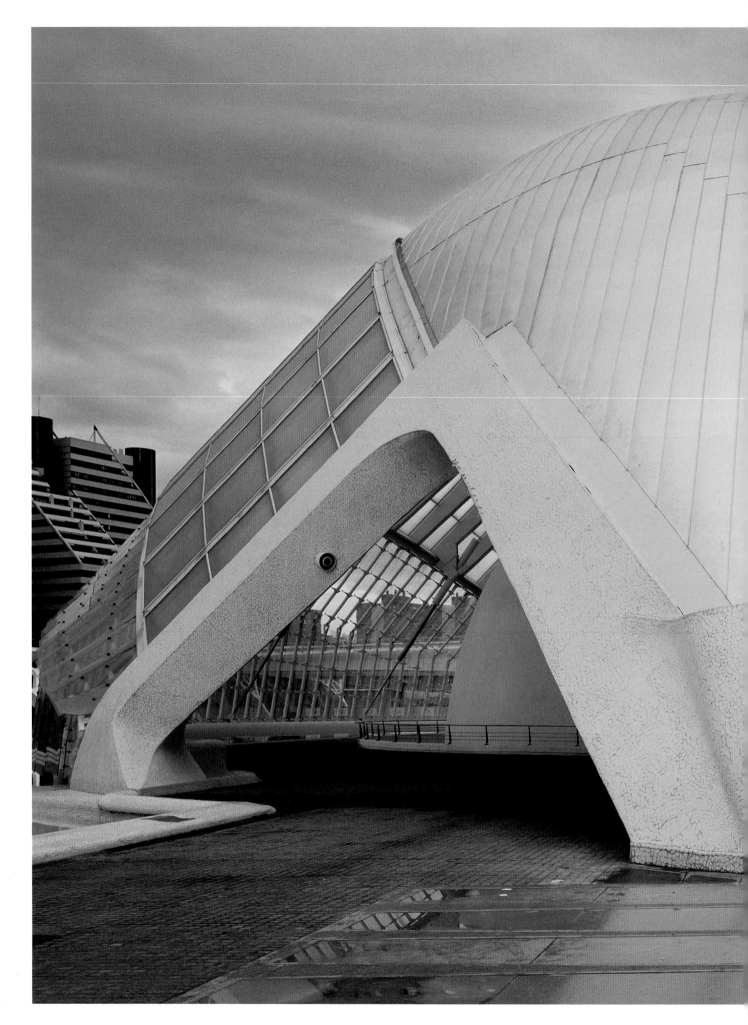

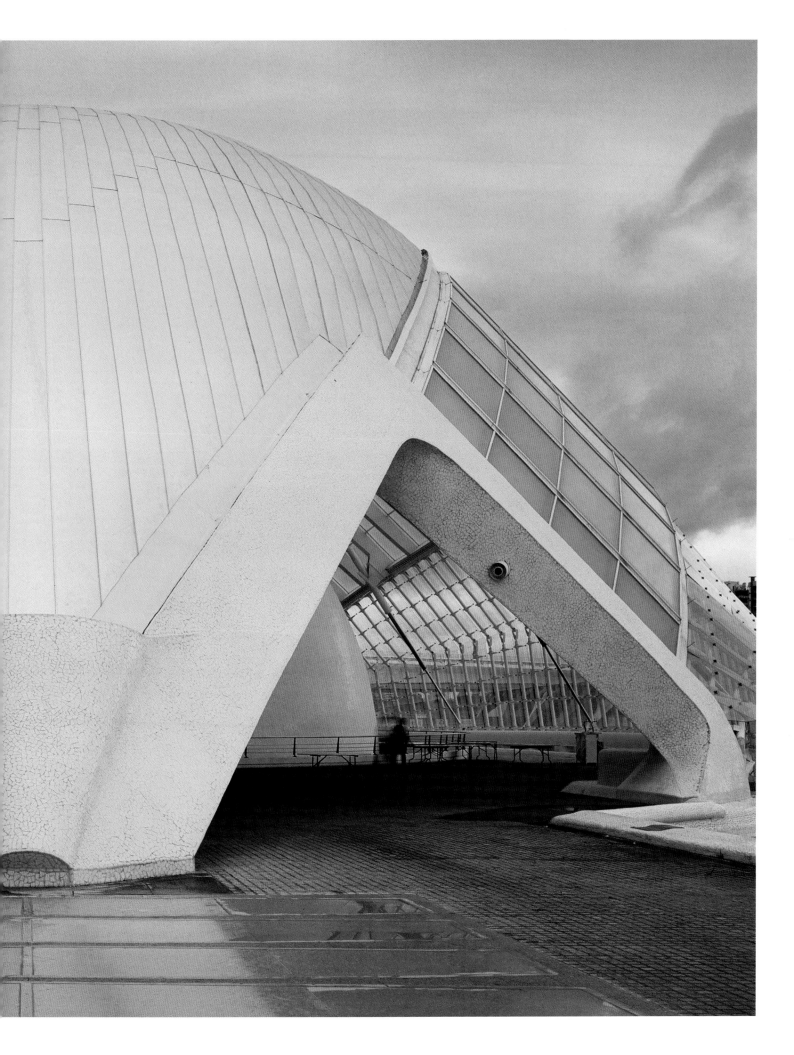

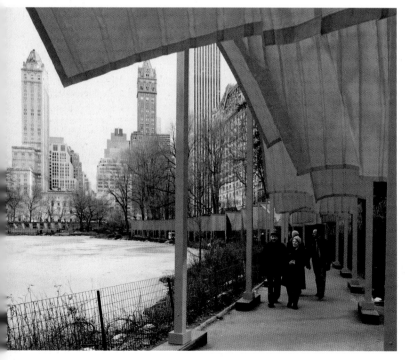

Christo and Jeanne-Claude are patient. When they imagine a project, they keep trying to realize it, even if it takes more than twenty years. The *Wrapped Reichstag*® (Berlin, 1971–95) is a case in point. They are also meticulous in their descriptions and preparations. To wrap the Reichstag, they used "100,000 square meters (1,076,000 square feet) of thick woven polypropylene fabric with an aluminum surface and 15,600 meters (51,181 feet) of blue polypropylene rope, diameter 3.2 cm. (1.25 inches)." Statistics are less important than the fact that they have created some of the most astonishing and moving artworks of the past forty years, and this without sponsorship or public funding.

Christo and Jeanne-Claude were born on the same day (June 13, 1935), he in Gabrovo, Bulgaria, and she in Casablanca, Morocco, of a French military family. As an early celebration of their seventieth birthday, they succeeded in creating another long-term project in New York, **The Gates, Project for Central Park** (1979–2005). Although works like the *Wrapped Reichstag* or the *Wrapped Pont Neuf* (Paris, 1975–85) entailed the ephemeral transformation of architecture, the *Gates* project also deals with an iconic element of the built environment. As described by the artists prior to the event, "The 7,500 Gates, 16 feet (4.87 meters) high with a width varying from 5' 6" to 18 feet (1.67 m to 5.48 meters), will follow the edges of the walkways and will be perpendicular to the selected 23 miles of footpaths in Central Park. Free-hanging, saffron-colored fabric panels suspended from the horizontal top of the gates will come down to approximately 7 feet (2.13 meters) above the ground. The

gates will be spaced at 12-foot (3.65-meter) intervals, except where low branches extend above the walkways."

Installed for 16 days in February 2005, *The Gates, Project for Central Park*, like early works by the two artists, involved a brief transformation of space and a notion of passage and movement in the form of the gates themselves and the floating, saffron-colored fabric panels. Gates, of course, have various functions in architecture. They can be signs of greeting, of a change in types of spaces or of fortification. The *torii* of Shinto architecture or the *torana* in Hinduism and Buddhism mark the passage from the profane to the sacred, while in Japan the *noren* is a short curtain hung in the doorway of a shop or house. The Fushimi Inari Taisha Shrine in Kyoto, founded in the 8th century, has a four-kilometer-long tunnel made up of approximately 10,000 red *torii* gates. Though they are far more solid and permanent than the Gates imagined by Christo and Jeanne-Claude, as well as being placed closer together, the *torii* of Fushimi Inari Taisha do provide an interesting historical analogy to their work. In Buddhist tradition, saffron robes signify full monastic ordination, but the color also has mystical associations in other civilizations. In *The Iliad*, Eos, goddess of the dawn, lays her protective saffron robes upon the earth each morning. In Judaism and Christianity, the door grants access to revelation, while in Taoist thought the opening and closing of the door of heaven is linked to the act of breathing.

Christo and Jeanne-Claude provide technical descriptions of their work very easily, but they comment much less on the significance and interpretation of their works. The *Wrapped Reichstag* clearly had implications in architectural terms, but the building is so charged with history, past and present, that many viewers surely reflected on their art in highly personal ways. The ephemeral nature of their work often temporarily transforms well-known places and allows people to think about the spaces or the architecture. This very intimate form of interaction between art and architecture, or perhaps art and space, is one that Christo and Jeanne-Claude have mastered in a way that would make it rather difficult for others to imitate. They finance their work through the sale of drawings of their projects, giving another, more purely artistic dimension to their creations. In this way, they experiment in altering architectural or natural spaces and also create works of art in two dimensions.

Christo and Jeanne-Claude,
The Gates, Project for Central Park, New York City, 2004. Collage, pencil, fabric, charcoal, wax, crayon, pastel, enamel paint, handdrawn map and fabric sample, in two parts: 30.5 x 77.5 cm and 66.7 x 77.5 cm

Christo and Jeanne-Claude,
The Gates, Project for Central Park, New York City, 1979–2005

The Gates (project for Central Park, New York City) Central Park South, 5th Avenue, Central Park West, West 110th street

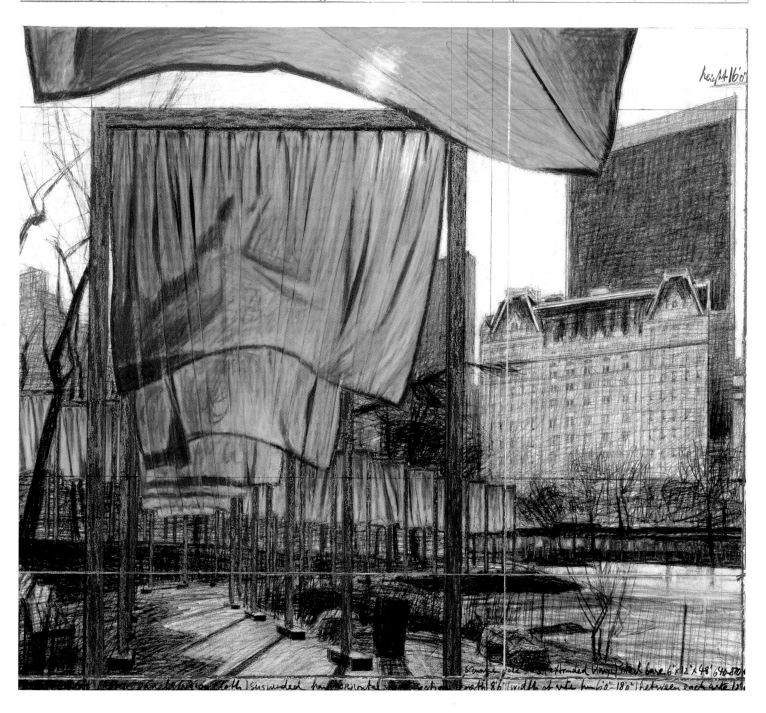

height 16'0"

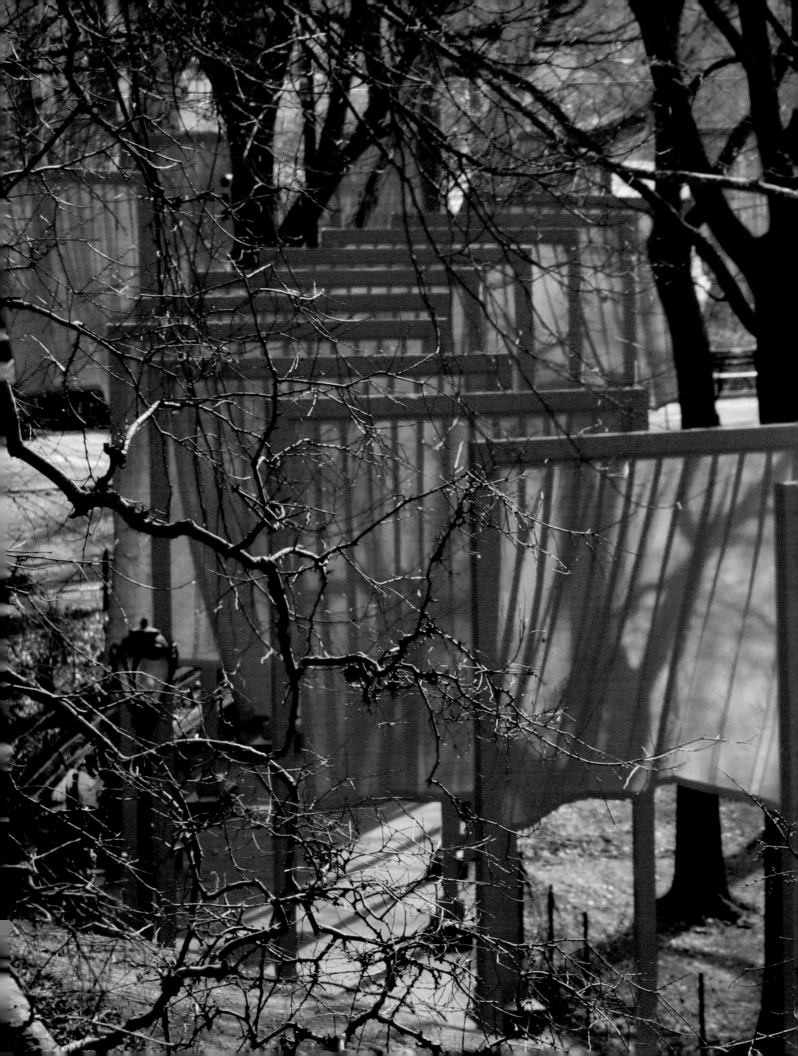

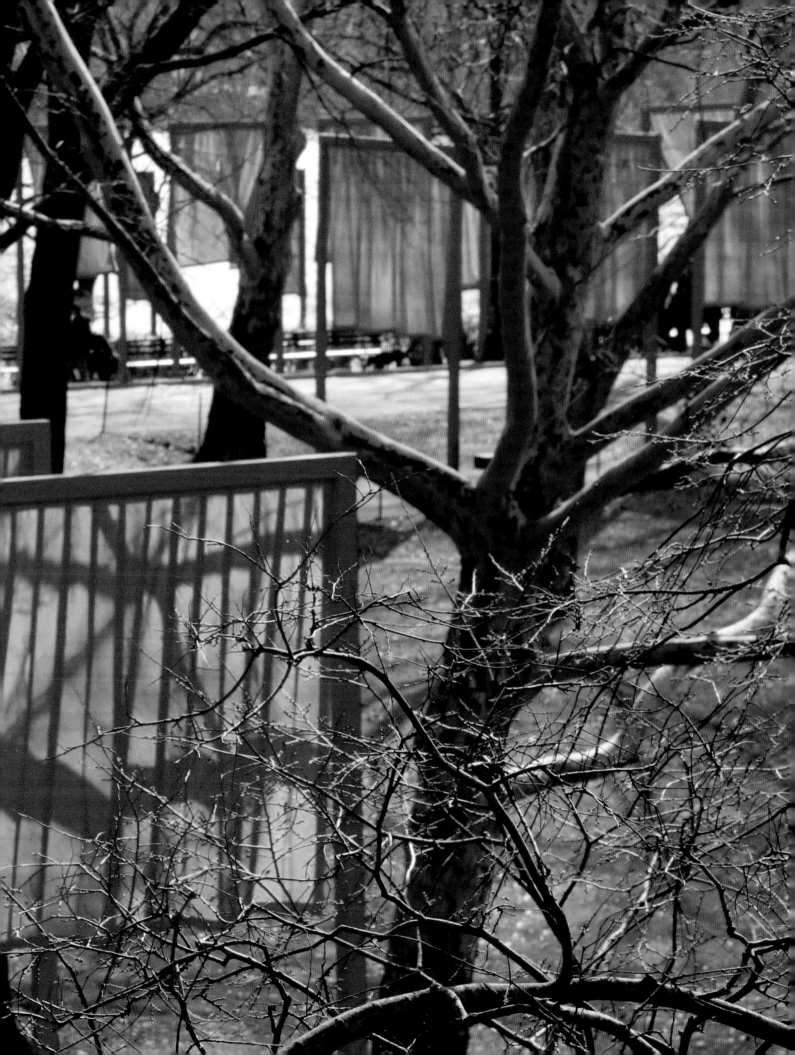

Mark Goulthorpe worked in the office of Richard Meier for three years (1988–91) after receiving his degree at the University of Liverpool, but he did not end up doing white buildings. He created his own firm, dECOi, in 1991 with a particular interest in technologically-oriented projects. As the architect says: "dECOi's portfolio ranges from pure design and artwork through interior design to architecture and urbanism." A good part of his work has indeed been situated at the interstice between art and architecture, sometimes leaning more in one direction and sometimes in the other. In the former category, his **Aegis Hyposurface**, first developed in 1999 and now undergoing improvements at MIT, where Goulthorpe teaches, is, in his words, "an art/architecture device that effectively links information systems with physical form to produce dynamically variable, tactile 'informatic' surfaces." Delving in this fashion into the current interest of architects in buildings or surfaces that change according to how they are used, dECOi has gone further than many practices in making actual working models. The architect says the "potential for information to literally translate into form offers an entirely new medium, digitally dynamic yet materially tactile. Any digital input (microphone, keyboard, movement sensor) can trigger any physical output (a wave or pattern or word.) In this, *Aegis* has potential beyond that of a screen to being a fully "architectural" (that is, social, physical) interface, where activity (sound, movement, etc.) translates into form!" A wall that can change shape and color according to factors programmed in advance, such as sound or visitor presence, can more easily be classified as art than architecture. Its movement serves no specific purpose as such, and yet it has an esthetic interest despite its technological origin.

A second project by Mark Goulthorpe, which he calls **Bankside Paramorph** (London, 2003), is a rooftop addition to an existing tower located next to Tate Modern. The Paramorph is described by the architect as "a complex, spiraling, tessellated enclosure comprised of layered facetted surfaces of metal, glass and fabric. The goal," he states, "is to produce the possibility of an architectural form that can be globally varied to allow for thermal and structural efficiency. The project hints at entirely new spatial and structural arrangements arrived at by sophisticated computer modeling processes." Esthetically astonishing, especially in the vicinity of Tate Modern, Goulthorpe's design is part of a new generation of architecture that is both designed on a computer and manufactured using the same programs and data. The point of this type of process is that it allows for an endless variety of individually shaped parts, and thus a unique architectural form. If Modernism dictated an assembly-line-type process where architects were obliged to use and reuse the same structural and decorative elements, the kind of work Goulthorpe is doing, dubbed "Non-Standard Architecture" in an exhibition organized at the Centre Pompidou, takes on one of the essen-

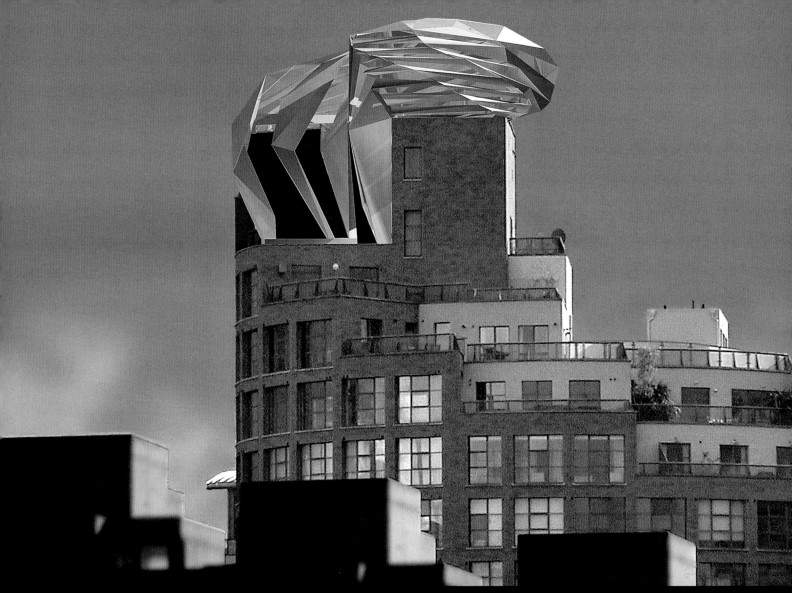

Both the *Aegis Hyposurface* and the Bankside Paramorph by dECOi call
on the latest computer techniques to give movement and unusual new forms
to architecture, resulting in a vocabulary that is close to sculpture.

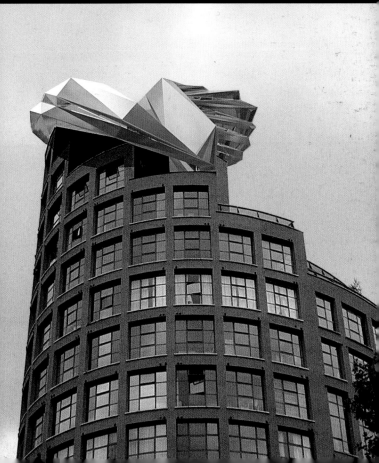

tial characteristics of art — its fundamental inimitability. This is not
to say that modern architecture, especially that designed by talent-
ed practitioners, is unoriginal, but rather that the new processes
used by Goulthorpe and others open the possibility of generating
truly unique forms, as opposed to assemblages of repetitive mod-
ules. Fréderic Migayrou of the Centre Pompidou says that these
methods are nothing short of revolutionary. In any case, they offer
the potential for a new and meaningful dialogue between art and
architecture.

"Architecture," says the photographer Thomas Demand, "has always been in the centre of my attention, because it deals with utopias and ideas of a somehow better future." Having studied first to be a sculptor, Thomas Demand attended the Akademie der Bildenden Künste (Munich, 1987–89), the Kunstakademie Düsseldorf (1989–92), Goldsmiths College (London, 1993–94) and the Rijksakademie van Beeldende Kunsten (Amsterdam, 1995). Basing his large photographs on images he culls from the press or other sources, Thomas Demand builds large-scale cardboard models that bear an astonishing resemblance to the original picture. This obviously leads him to deal with the issues of perspective, color and scale as they will appear in a picture. He then photographs what might in other circumstances be called a sculpture. In the process of creating models, he generally eliminates superficial details and creates a kind of eerie perfection, even when his subject matter is found in dull office space, or public housing.

He has shown on occasion in environments designed for him by the talented London architects Caruso/St John, as he did in the very different environments of the Fondation Cartier by Jean Nouvel (Paris, 2001) and the Palazzo Pitti (Florence, 2003). For entirely different reasons these prestigious buildings are not necessarily very well adapted to the exhibition of large, spare photographs like those of Demand. Caruso/St John went about creating the minimal conditions for appreciation of the images. Demand was honored with one of the first major shows at New York's newly refurbished Museum of Modern Art early in 2005 (March 4–May 30, 2005).

Although interiors are Demand's subject of predilection, he has also occasionally focused on specific objects such as a pile of gold bullion, or an unusual image of public housing. In the case of his work *Public Housing* (2003), he took as his inspiration a drawing he found on the back of a Singapore $10 bill. When building the models, which he has not kept since photographing them in 1993, Demand creates numerous layers of reality that viewers are left to contemplate and to draw conclusions from. Like pictures of movie sets, his images are reproductions of already artificial models, but in his very personal kind of layering and simplification he makes general cases out of specific ones, questioning the veracity of photography (or art) as he comments obliquely on consumer society and the emptiness of modernity.

It is interesting that Thomas Demand relates architecture to a "better future," an idea that architects long ago abandoned. The promise of European Modernism was, of course, that by building anew, mankind itself would be improved, in a kind of Socialist utopia. As in the images themselves, Demand layers his meanings in this instance. It is more the empty dream of utopia than any real nostalgia that he creates in his art. In his process of creation, architecture, too, is nothing but a cardboard model to be quickly thrown away.

Thomas Demand, *Public Housing,* 2003. C-Print/Diasec, 100 x 157 cm

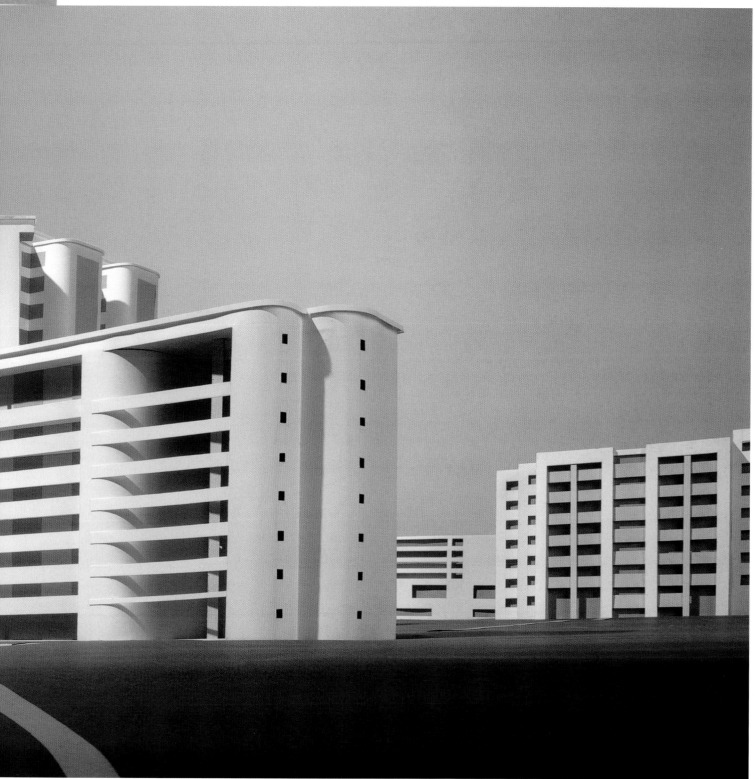

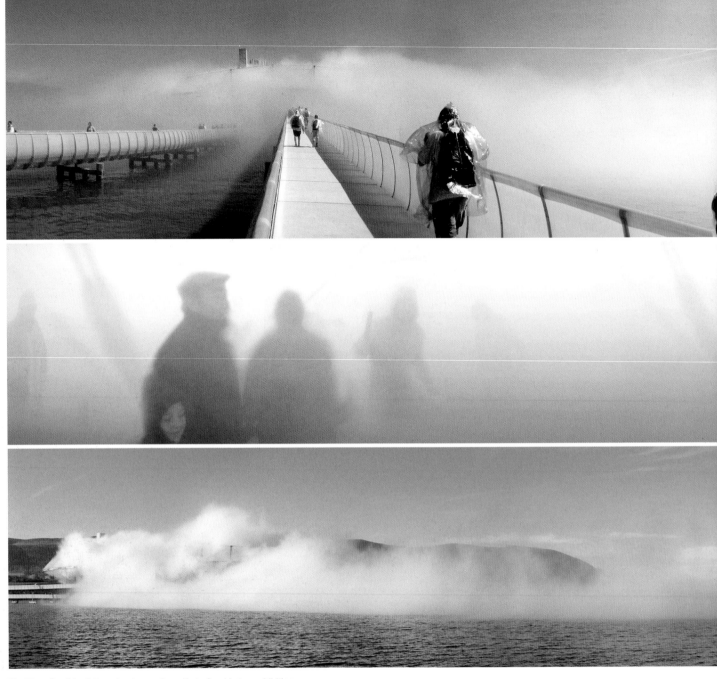

The idea of walking into a cloud, or perhaps that of making an exhibition
pavilion disappear challenges the fundamental nature of architecture.

What is the main difference between a work of art and architecture?
Might it not be in the decidedly solid nature of architecture, in its
programmed usefulness and durability? A certain number of archi-
tects have spent more time imagining structures than actually build-
ing them, and others have dreamed of architecture that would cast
off its "too too solid" substance. Modern technology has actually
allowed this dream to come much closer to fruition. A recent design
by the New York architects Elizabeth Diller and Ricardo Scofidio
comes close to obviating the need for walls, floors, or ceilings in the
traditional sense of these terms. Their **Blur Building** was part of
Expo.02, the Swiss national exhibition held in the lake region to the
west of the country. Taking into account the desire of the organizers
to create ephemeral buildings to be erected on the lakes them-

selves, Diller + Scofidio imagined nothing other than a cloud hover-
ing over Lake Neuchâtel, near the city of Yverdon-les-Bains, 100 me-
ters wide, 65 meters deep and 25 meters high. The "cloud" effect
was obtained through the use of filtered lake water "shot as a fine
mist through a dense array of 31,500 high-pressure water nozzles
integrated into a large cantilevered tensegrity structure." "Unlike en-
tering a space, entering Blur," said Scofidio, "is like stepping into a
habitable medium, one that is formless, featureless, depthless,
scaleless, massless, surfaceless, and dimensionless."

Japanese artists and architects had worked on several "fog
buildings" prior to this initiative. The artist Fujiko Nakaya, who had
designed a geodesic dome surrounded by water-vapor fog for the
1970 *Osaka World's Fair*, acted as a technical and esthetic consul-

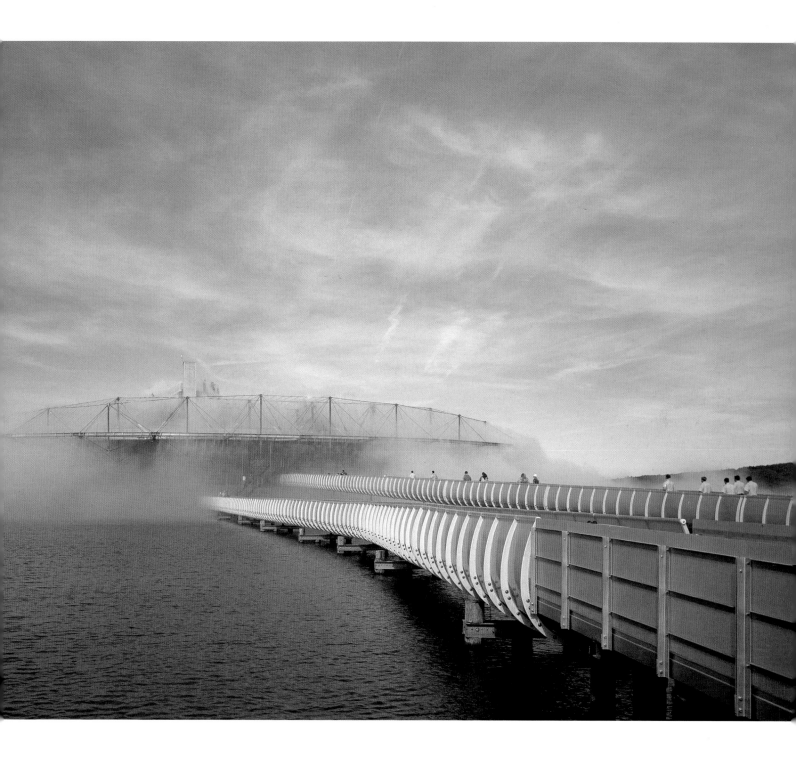

tant for the Blur Building. Although it did feature a water bar on its upper level, the Blur Building was otherwise nothing more than a viewing platform. The notion of architectural function is, of course, applicable to an ephemeral pavilion, but many of the constraints of a real building were obviated by the very nature of this design. The water vapor that enveloped the building also penetrated its lattice-work interior, making a visit an experience intended to challenge the senses. Other visitors appeared more as shadows in the fog than as real people and notions of height, speed and time were also dilated, or rather diluted, by the fog and the attendant hissing noise of the nozzles.

Diller + Scofidio have frequently worked at the limits between various disciplines, but here they seem to have achieved a high point in questioning architecture, art and their intimate relations. The English weekly news magazine *The Economist* published an article on the Blur Building under the title "Heaven's Gate" (August 24, 2002) in which it wrote: "To enter this sublime building perched in the landscape of the Swiss Alps feels like walking into a poem — it is part of nature but removed from reality." The artistic intention and achievement of the Blur Building is well captured in this description. True, it is made up of summary structural elements, but in Yverdon-les-Bains, Diller + Scofidio, as much as any other recent creators, appear to have blurred the very boundary between art and architecture.

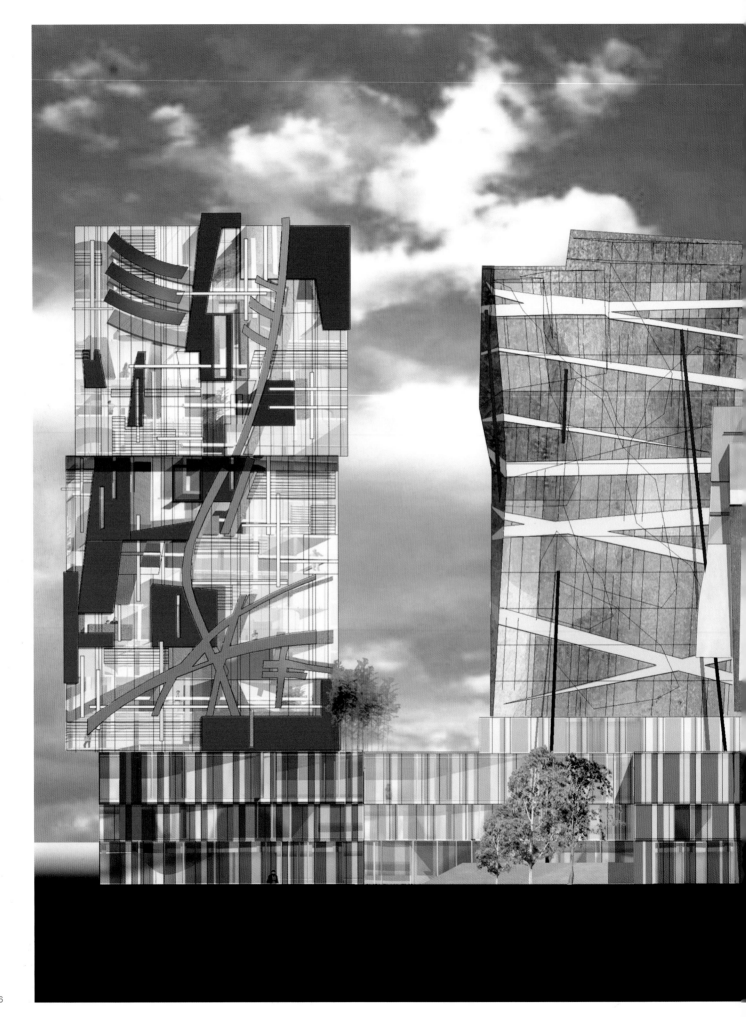

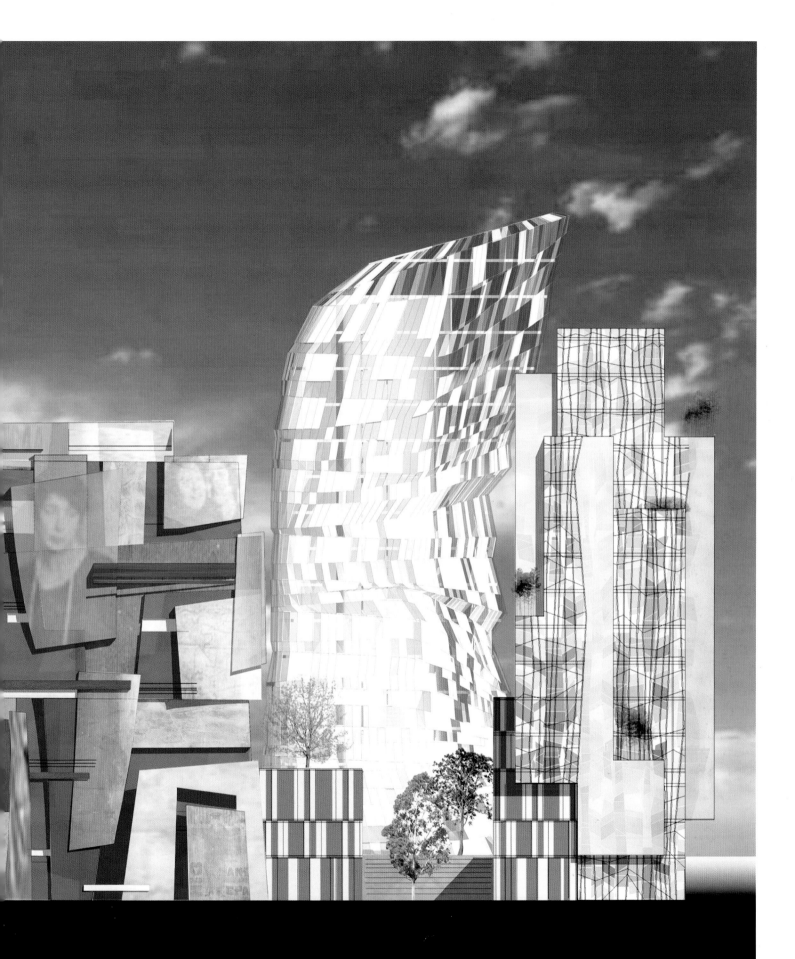

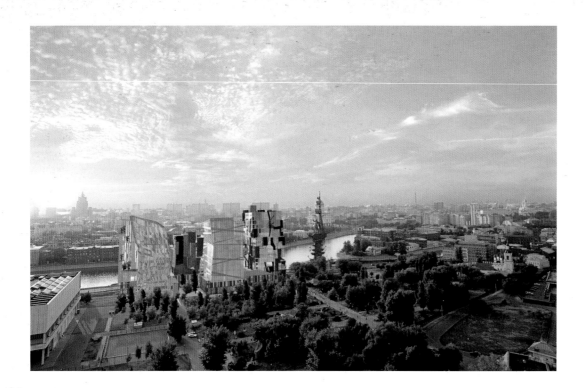

Erick van Egeraat, born in 1956 in Amsterdam, is one of the more flamboyant architects in The Netherlands. Co-founder of the firm Mecanoo (1983), he recently conceived a series of five **residential towers** for a site in Moscow located in the **Yakimanka** area, across from the New Tretyakov Museum, an institution that has one of the best collections of Russian Avant-garde painting. Seizing on this fact, van Egeraat decided that each of the towers would refer to a specific painting: Wassily Kandinsky's *Yellow-Red-Blue* (1925); Alexander Rodchenko's *Linear Construction* (1929); Ljubov Popova's *Painterly Architectonic with Three Stripes* (1916); Kasimir Malevich's *White on White* (1918); and Alexandra Exter's *Sketch for Costume of Salome* (1921). Van Egeraat obviously opens himself to a great deal of criticism in putting forward the idea that a specific relationship can exist between a given painting and a building, although he emphasizes his wish to interpret rather than imitate the works, and that the correspondence will be more than a matter of facade decoration. "Most of our buildings are designed from the inside," he says, "they are not simple facades — we work an enormous amount to create the interiors. We spend more time on what happens inside than what happens outside. There are four hundred different apartments in the Moscow Avant-garde project, and I need those differences. The interiors will be as much about Kandinsky as the exteriors."

Although he keeps his feet firmly enough on the ground to have work in several countries, Erick van Egeraat is an unabashed sensualist and in this he stands quite far apart from many other architects of his generation, or older figures like the much drier Rem Koolhaas. "Architecture is more than a matter of absolutes," he says enthusiastically, "more than a case of being one thing rather that another. Architecture is both/and and not either/or. Architecture is inclusive, not exclusive. It is about a range of possibilities rather that simpleminded certainties." This inclusive approach to architecture leads him toward what he calls a "modern Baroque" approach. When asked what his specific interest is in the Russian Avant-garde, the architect responds: "Throughout the 20th century, Modernism based on primitive architectural forms took the lead. Now it is time to switch from plain to complex, multilevel and multifarious volumes, which make the Russian Avant-garde so dynamic and saturated. Instead of seeking simplicity, Avant-garde artists experimented with new forms. The five painters I chose were famous for an exceptionally rich color palette and a multitude of artistic techniques. They were capable of creating vivid images, a source of our inspiration. We are largely following the maxims they stood for." Van Egeraat is thoroughly unapologetic about an approach that seems to have seduced many Muscovites. He has frequently been asked why he selected the particular paintings that inspired his forms. "I just liked them," he says. "There was only one precondition: that the authors should not have been known as architects, so I excluded Yakov Chernikhov to avoid discussions on how to interpret his works. The paintings by Popova and Ekster are beautiful, but the works of Malevich deserve special treatment. I think my emotions are very close to the basic idea behind his painting. Even if I am wrong, this is only my interpretation." Van Egeraat's Russian Avant-garde project may not be evidence of a new trend in architecture, but it does demonstrate another way that art can enrich the built environment. As this Rotterdam-based designer says: "If anything can be gained in this time and age, contemporary architecture should at least try to offer both temptation and solace."

More than an esthetic whim, Erick van Egeraat's project seeks to fundamentally integrate the colors, form and movement of Russian avant-garde paintings into built forms.

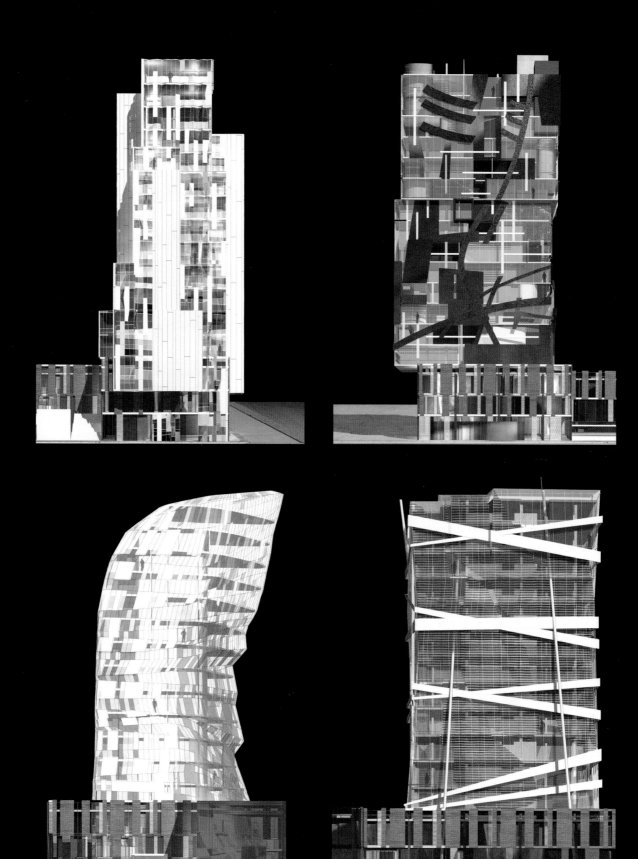

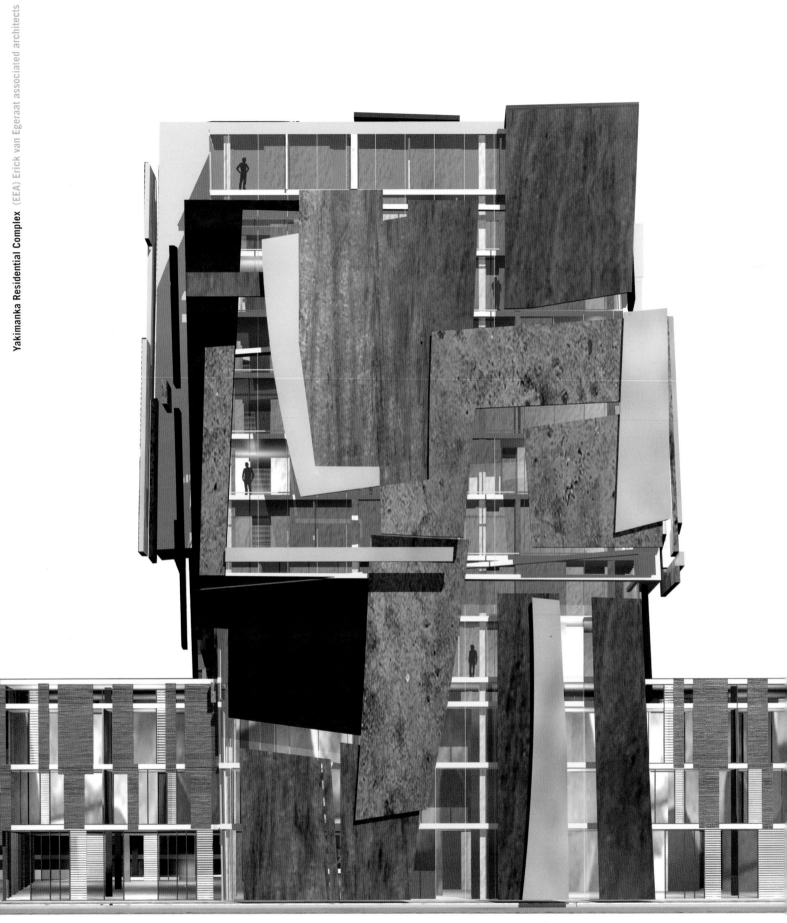

Yakimanka Residential Complex (EEA) Erick van Egeraat associated architects

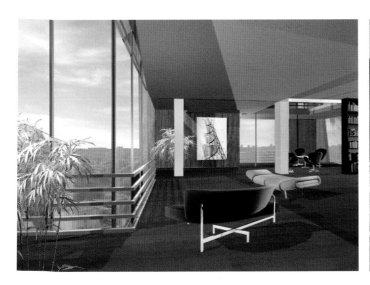

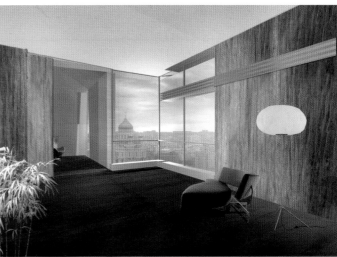

Ljubov Sergejevna Popova, *Painterly Architectonic
with Three Stripes*, 1916. Oil on canvas, 107 x 89 cm.
Tsaritsino Museum for Applied Arts, Moscow

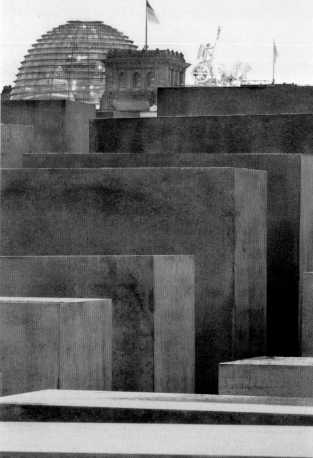

Like a cemetery, a city or a massive sculpture, Eisenman's *Memorial* is difficult to classify. It is art created in the service of an idea, or architecture with no utilitarian function.

In mid-December 2004, the last of 2,751 gray concrete monoliths was lowered into place, completing Peter Eisenman's controversial design for the ***Memorial to the Murdered Jews of Europe*** in Berlin. Located close to the Brandenburg Gate and the Pariser Platz, the memorial covers two hectares with blocks varying in height from a few centimeters to about four meters. Walkways between the mono-

liths are barely wide enough for one person to pass. Originally submitted in 1997 as a collaborative effort with the sculptor Richard Serra, the project was ratified in June 1999 in a 314-to-209 vote in the German Parliament. By that time, Serra had withdrawn for "personal and professional reasons" and Eisenman had become embroiled in other controversies. The architect Daniel Libeskind suggested that the idea might well have been his, and Berlin politicians forced Eisenman to scale down the design, criticized as being too imposing for a site in the heart of a reunited Berlin.

Peter Eisenman, originally best known as an architectural theoretician, has often sought to rethink the fundamentals of his own profession, but in Berlin he attempts to create a work of art using architectural scale and materials. He calls the *Memorial* "the Field" and frequently cites an unexpected source of inspiration. Speaking of a cornfield he visited in Iowa some time ago, he says, "I walked 100 yards in and couldn't see my way out. That moment was very scary. There are moments in time when you feel lost in space. I was trying to create the possibility of that experience, that frisson, something that you don't forget."

A "frisson" is indeed what the visitor feels when looking over this concrete field. Two obvious metaphors come to mind: that of a graveyard with its rows of uneven gray tombstones; and that of a city, with its blocks and towers mysteriously blank and empty. Had it been located on a less sensitive site, its impact might well have been softened, but here, so close to the heart of the new Germany, it is a silent reminder of events better not forgotten. This was not a cornfield, but it is as close to the location of Hitler's chancellery and the bunker where he died as it is to the blazing lights of the new Potsdamer Platz.

In the geometric abstraction that underlies its undulating irregularity, this work might be compared to Maya Lin's *Vietnam Memorial* in Washington, D.C. (see pages 134–35), a black granite gash in the earth, inscribed with the names of the fallen. Here, the names of the fallen could not be engraved, but their presence hangs over the site, as if their very souls inhabited the ominously heavy blocks of concrete. The weight and horror of history are suggested without being rendered explicit. To those who have said that the *Memorial* is too big, the response might well be that its size is commensurate with the events it recalls.

While his architecture may often have seemed extravagant to observers, Eisenman, who describes himself as a "non-practicing Jew," here achieves a stark modernity that is a witness to the power of art. Richard Serra's withdrawal from the project might have been an occasion to note how difficult real collaboration between artists and architects can be. Eisenman's completed work is a testimony to the power that a sculptural use of concrete can express. Apparently more art than architecture, the Berlin *Memorial* is at heart a fusion of the two disciplines.

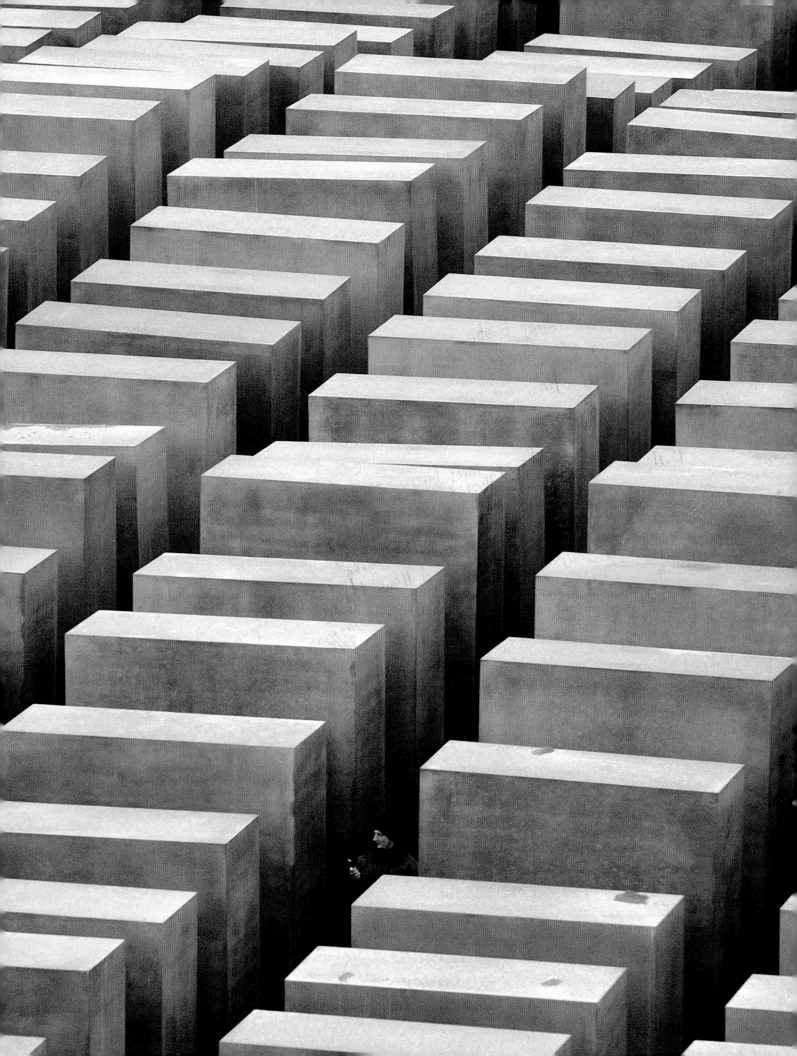

Olafur Eliasson, *The Weather Project,* 2004. Installation. Tate Modern, London

The Turbine Hall of Tate Modern in London is a difficult space for art. It is 155 meters long, 23 meters wide and 35 meters high. Bankside Power Station, as it was formerly known, was designed by Sir Giles Gilbert Scott in 1947. Herzog & de Meuron were appointed architects of Tate Modern in 1995. Loath to add anything that might be construed as decoration to its industrial character, architect Jacques Herzog declared: "I support the idea of the architect as artist, but I think that to apply the image of art to architecture is the worst thing you can do. Contemporary architecture tends to behave like an advertising copywriter; it exploits the field of art in order to renew its own image without reflecting on its conceptual foundations — and everybody gets tired of applied images." The Tate curators were thus left with a huge empty space to fill, and they sought to do so by commissioning large works by Louise Bourgeois, Juan Muñoz, and Anish Kapoor.

Olafur Eliasson's ***The Weather Project*** (October 16, 2003– March 21, 2004) was the fourth in the annual Unilever Series commissions for the Turbine Hall, and by many measures, the most successful. Born in Denmark of Icelandic parents in 1967, Eliasson studied at the Royal Academy of Arts in Copenhagen (1989–95) before embarking on a career marked by installations featuring elements appropriated from nature. For his *Mediated Motion* show at the Kunsthaus Bregenz in 2001, he created a series of spaces filled with materials such as water, fog, earth, wood, or fungus. The artist also modified the rigorously square nature of Peter Zumthor's building by inserting a slanting floor, making visitors more conscious of their movement through the galleries.

For *The Weather Project* at Tate Modern, Eliasson combined his sense of architectural space and his interest in nature to turn the entire Turbine Hall into an astonishing image of the setting sun. At the upper end of the Hall, opposite the entrance, he created a huge semicircular contour with hundreds of mono-frequency lamps. Covering the ceiling of the Hall with mirrors, he gave the impression of a full sun. Into what he called "a vast duotone landscape" created by lamps emitting only in a narrow frequency that makes colors other than yellow and black invisible, he injected a fine mist. Accumulating like clouds during the day, the mist, together with his artificial image of the setting sun, gave visitors the impression that the light of nature had come into this industrial space. People gathered and remained in the normally uninviting space, sometimes lying on their backs to try to identify their own reflections in the mirrors 35 meters above. The Turbine Hall dwarfs all but the largest art works, and its dull light and finish extinguishes colors, but Olafur Eliasson managed to use these conditions to the benefit of his art. Where nature is well and truly excluded by architecture, he used purely artificial means to generate art and a sense of life. This symbiotic interplay between art and architecture was so successful that it made the Turbine Hall appear to be strangely welcoming for a time. With such works, the artist encourages visitors to reflect on their perception of the physical world, to "see yourself sensing," as he says. At Tate Modern, Eliasson also proved that contemporary art retains a formidable power to transform space, and that it can appeal to a broad public, even if *The Weather Project* was much more ephemeral than the Turbine Hall itself.

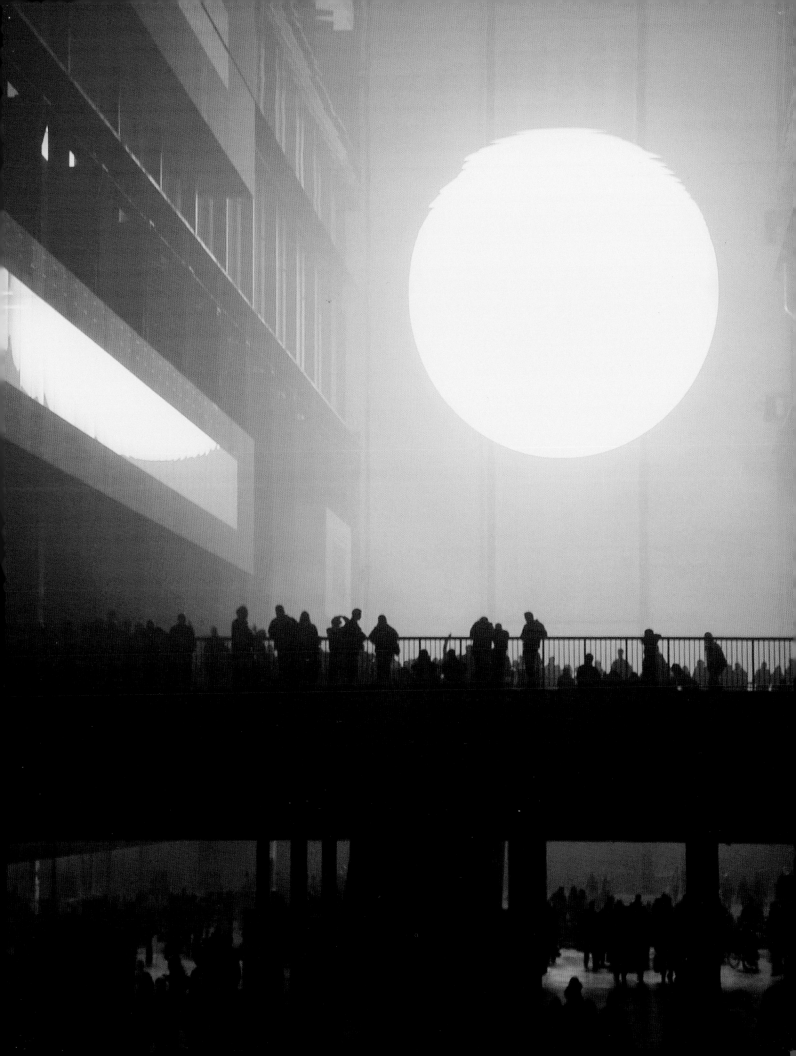

Born in 1961 on Hainan Island, Weng Fen lives and works in Haikou, on Hainan Island, in China. He graduated in 1985 from the Canton Academy of Fine Arts and teaches at the Art School of Haikou. He is one of a number of Chinese photographers who have chosen to document the rapid urbanization of their country. His series *Sitting on the Wall* (2002) shows a young schoolgirl straddling a wall with her back to the viewer, looking out onto the new China, so to speak. The urban skylines of three cities in Southern China — his own home of Haikou, Guangzhou and the Special Economic Zone of Shenzhen — are the locations for these images. Weng Fen participated in the 2003 exhibition *Alors la Chine?* at the Centre Pompidou in Paris with his work **Sitting on the Wall – Shenzhen (1)**. In all of these works, the wall separates an undefined foreground from the image of the metropolis beyond. Like many Chinese, the young girl appears to be hesitating about which side of the wall she prefers, although, as critics have pointed out, we are told little about what is on "our" side of the wall.

The ironic, perhaps cynical, tone of the work of Weng Fen was amply demonstrated in earlier works in which he dressed up like a government official and gave awards to swimmers or village people, all of whom were completely naked. Like the *Sitting on the Wall* series, these works combine the existing situation of many Chinese people, anchored in either a rural or old city environment that has been precipitously transformed by the onslaught of economic prosperity. The extraordinary profusion of towers visible in the background of these images reflects the reality of contemporary coastal China, but the architecture can be interpreted in various ways — as a shimmering mirage, or a bitter denial of tradition. The girl is straddling the wall because there is, after all, something attractive about this "Emerald City," this Eastern Oz, but the viewer can only guess which side she will come down on. Visually, the wall is a barrier that surely has little to do with the skyscrapers in the distance; it is a hurdle, or perhaps a last line of defense. In Weng Fen's pictures, architecture assumes the role of moral commentary. It appears to incarnate an ill-defined evil but is little more than a theater décor in the photographer's lens, all glitter and no visible substance, while the old wall in the foreground seems much more solid and "real."

Laconic and immobile, *Sitting on the Wall* is clearly more than documentary photography; it is worrisome commentary, even if the threats and dreams represented by architecture are not actually defined. China, at least the China that used to be, is on one side of the wall and a brave new world lies on the other. Whereas the built environment visible in these images is massive and devoid of human presence, the girl brings a narrative to the space, a story of youth and choice, the siren call of the tower versus a life well grounded in values that have survived for centuries. Like a contemporary Oz, the city seems almost unbelievable from a distance; but what lurks inside those towers? Modern architecture as the shining incarnation of evil?

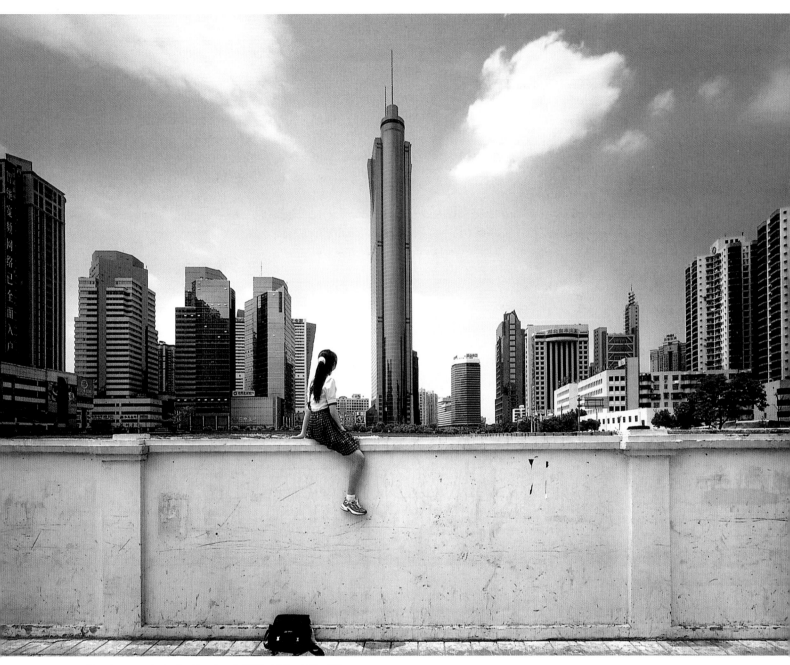

Weng Fen, *Sitting on the Wall – Shenzhen 1*, 2002. C-Print, 126 x 171 cm

Can a building be a work of art even where architects do not invoke its name? Surely. FOA (Foreign Office Architects), founded in 1992 in London by Farshid Moussavi and Alejandro Zaera Polo, have taught extensively, at Princeton, Columbia, or the Berlage Institute of Architecture in Amsterdam. They have built less extensively, but their **Yokohama International Port Terminal** (Yokohama, Japan, 2000–02) is one of the most frequently published works of contemporary architecture. Winners of a 1995 competition to design an 81,000-square-meter facility with a budget of 220 million euros, the two men used sophisticated computer techniques that had to be adapted to actual use in the case of such a complex and large project. As they describe the concept, "Rather than developing the building as an object or figure on the pier, the project is produced as an extension of the urban ground, constructed as a systematic transformation of the lines of the circulation diagram into a folded and bifurcated surface … the folded ground distributes the loads through the surfaces themselves, moving them diagonally to the ground. This structure is also especially adequate in coping with the lateral forces generated by seismic movements that affect Japan. The result is the hybridization of given types of space and program through a distinct tectonic system, in this case, a folded surface." The use of folded shapes and, indeed, of geological formations as a source of architectural inspiration is not entirely new. Peter Eisenman and others put such thoughts to use before the Yokohama Pier was built, but rarely with such success, nor indeed as much correspondence to a real "natural" environment.

Artists such as Richard Long and Robert Smithson have created land art or earthworks since the 1970s. Smithson's best-known work, and probably the most famous piece of all land art, is *Spiral Jetty* (1970), for which he arranged rocks, earth and algae, forming a spiral-shaped jetty protruding into the Great Salt Lake in Utah.

James Turrell's *Roden Crater* (see page 34) is surely also a form of land art since it modifies a natural landscape to artistic ends. This background should be seen in the context of some Japanese attitudes toward architecture and nature in densely built cities like Yokohama. When Itsuko Hasegawa built the Shonandai Cultural Center (Fujisawa, Kanagawa, 1987–90), one of the first significant contemporary buildings in Japan by a female architect, she explained that she had set out to create an artificial form of nature, or an alternative reality. Her almost nostalgic quest for a new nature where aluminum trees might grow is a commentary on the crowding of Japan's eastern coastal areas. Where nature is present in Japanese cities, a jungle of electrical wires, garish signs and ugly buildings usually circumscribes it. Other important Japanese architects and artists, from Toyo Ito to Hiroshi Teshigahara, have also worked on the concept of a new nature to replace that which is lost under so many layers of concrete and steel.

FOA's Yokohama Pier is certainly functional, but it is also a computer-generated landscape, an alternative reality, inspired by natural forms. This is neither *Spiral Jetty* nor *Roden Crater*, but it is an architecture that springs from a thought process that is close to that of contemporary art. Its twisting forms might also bring to mind the very earthquakes it is designed to resist. The Yokohama Terminal is a practical, contemporary evocation of the shapes and forces of nature, "an extension of the urban ground." It is in its essence that it approaches the ideas of art.

The Yokohama International Port Terminal takes on a form which appears to be inspired by nature, while retaining the full functionality required of such a facility.

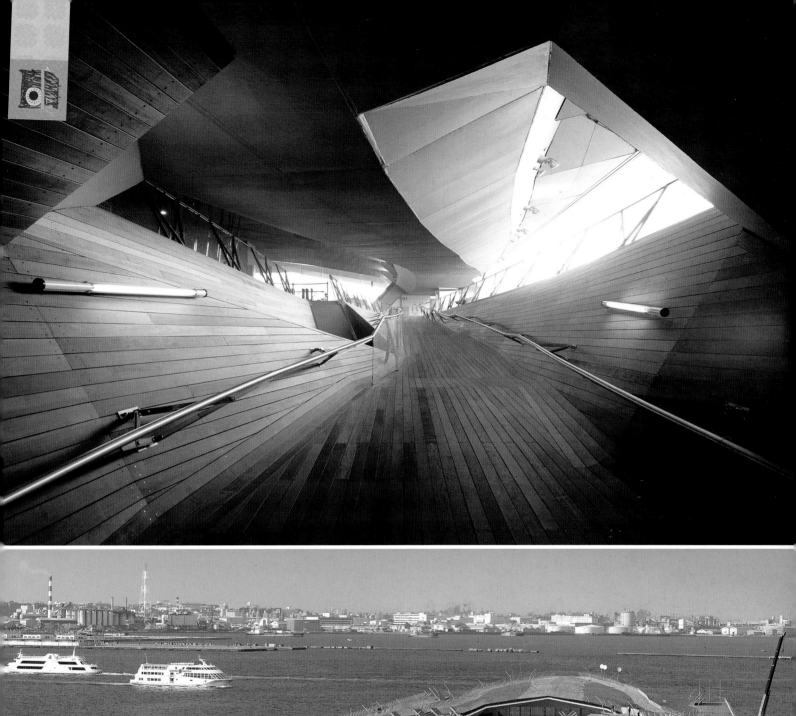
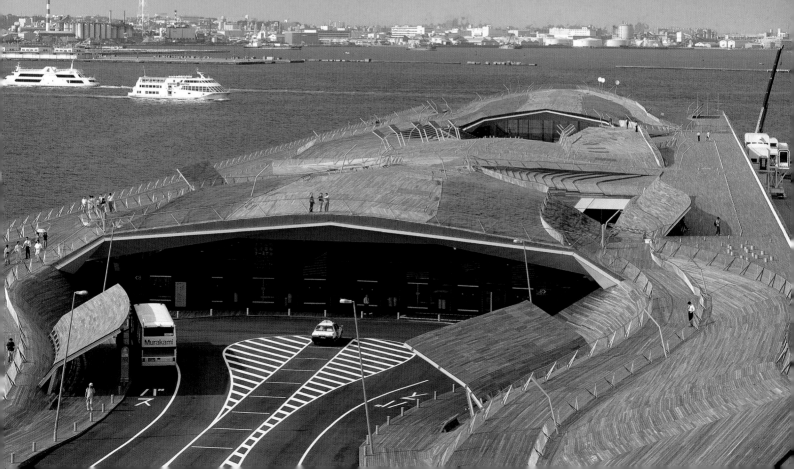

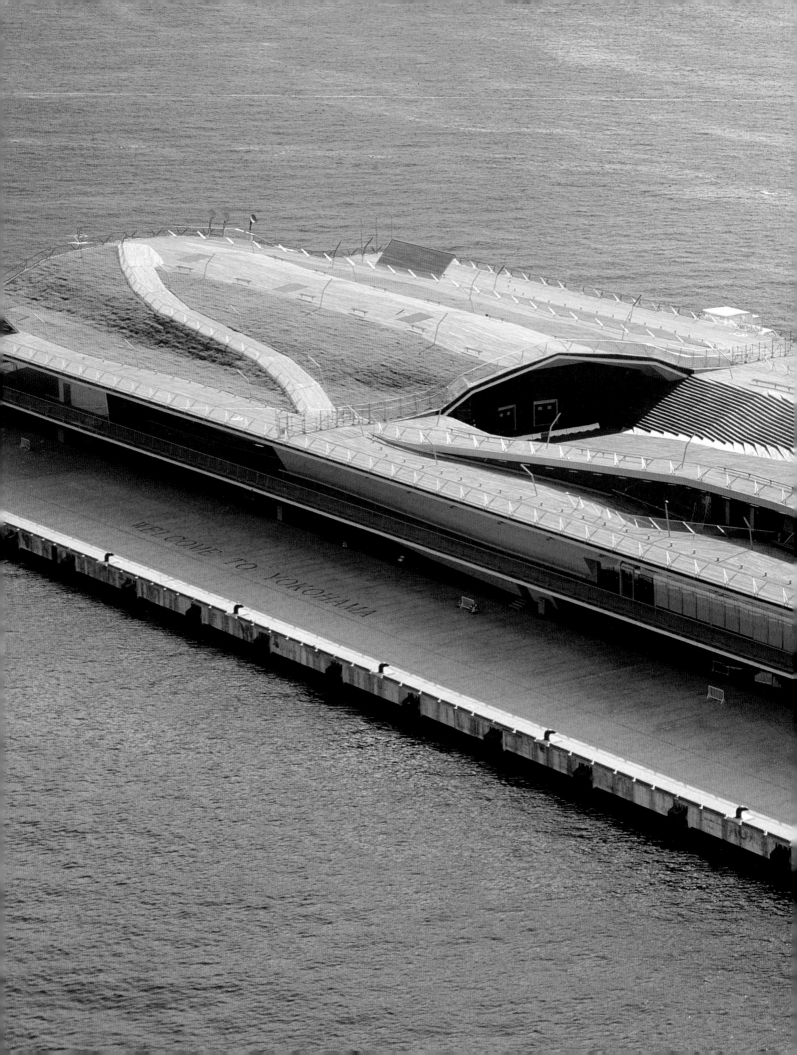

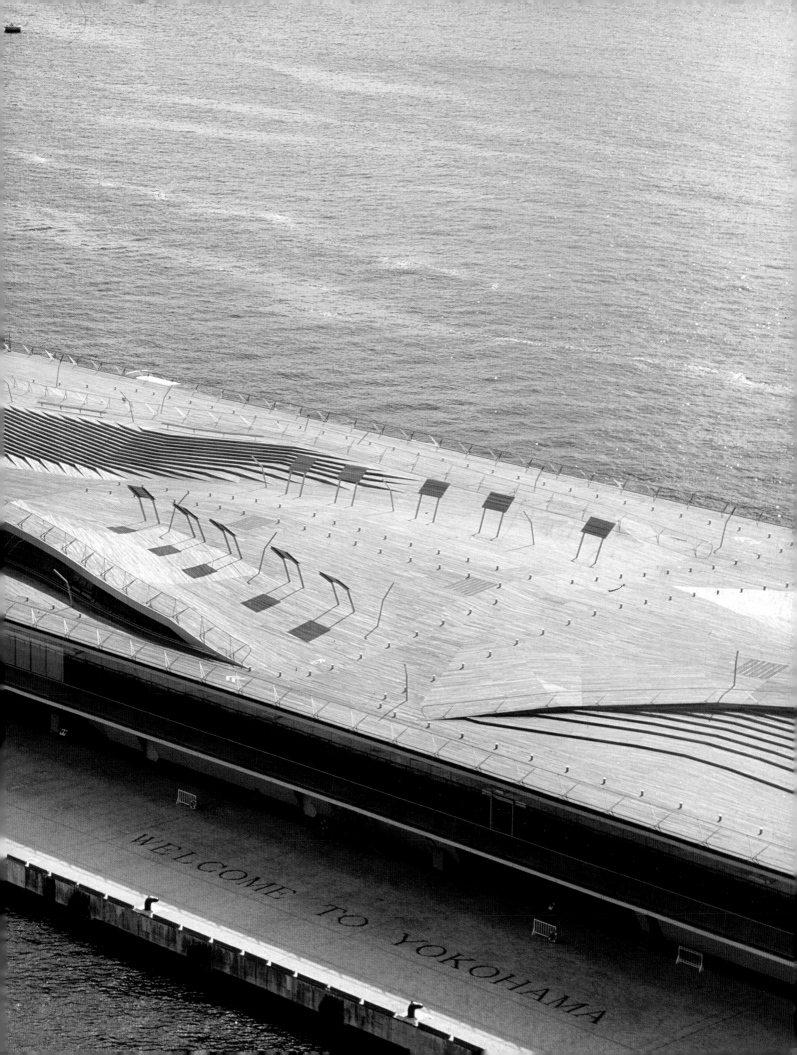

function other than its esthetic presence. Measuring 6 meters high, 7.5 meters wide and a full 12 meters long, his wood-and-lead sculpture surely resembled a horse's head, even if the architect described it as abstract.

As is often the case in Gehry's work, such ideas have a tendency to return in different forms. He insists himself on the intimate connection between his architecture and sculpture. Gehry has stated, "I approach each building as a sculptural object, a spatial container, a space with light and air, a response to context and appropriateness of feeling and spirit. To this container, this sculpture, the user brings his baggage, his program, and interacts with it to accommodate his needs. If he can't do that, I've failed." The horse's head sculpture first seen in Beverly Hills returned in Gehry's **DG Bank** (1995–2001), located at number 3 Pariser Platz, close to the Brandenburg Gate in Berlin. Actually quite bland as seen from the square, the DG Bank's interior is an astonishing study in contrasts. A very large free-form conference center, clad in 4mm-thick stainless-steel panels, is visible as soon as visitors step through the main doors. In the same way that he used fish forms in earlier buildings, Gehry has come full circle, creating a sculptural object that he transforms into architecture. Its surprising Mannerist emergence might be compared to Michelangelo's Laurentian Library in Florence, another place where art and architecture came together.

Visually exciting, the conference room at the DG Bank raises the question of exactly what Gehry's interest in sculptural forms has brought to architecture. He may not have been the only architect to experiment in this area. The Dutch architect Erick van Egeraat created an anthropomorphic conference center dubbed "The Whale" in an otherwise fairly bland 1882 Italianate building that he renovated as the headquarters of ING and NNH on Andrássy út in Budapest in 1994. There is surely something to be said for expressive freedom, but does this injection of art into the built form really improve the architecture? Gehry has commented in his own way on an overly strict building code that guaranteed that an unprecedented opportunity to create great new architecture in Berlin would be lost. Having been obliged to make a punch-window facade on Pariser Platz, he invites visitors to discover a flight of artistic creativity within. Had the interior of the DG Bank been as bland as its facade, the building would have been forgotten quickly, no matter how famous its architect. As it stands, it will long be an object of curiosity and interest.

Frank O. Gehry is certainly one of the most sculptural of contemporary architects. In fact, he bases much of his approach on his early and continuing interest in art. As he stated when he accepted the Pritzker Prize in 1989, "My artist friends, like Jasper Johns, Bob Rauschenberg, Ed Kienholz and Claes Oldenburg, were working with very inexpensive materials — broken wood and paper — and they were making beauty. These were not superficial details, they were direct, and raised the question in my mind of what beauty was. I chose to use the craft available, and to work with craftsmen and make a virtue out of their limitations. Painting had an immediacy that I craved for in architecture. I explored the process of new construction materials to try giving feeling and spirit to form. In trying to find the essence of my own expression, I fantasized that I was an artist standing before a white canvas deciding what the first move should be." Frank Gehry has been both criticized and praised for liberating architecture from some of its formal Modernist constraints. His Guggenheim Bilbao is, of course, the most often-cited example of his artistic penchant, and yet on occasion he has come even closer to the realm of art in his own work. In April of 1999 he exhibited a remarkable sculpture at the Gagosian Gallery in Beverly Hills that approached architectural scale without any suggestion of

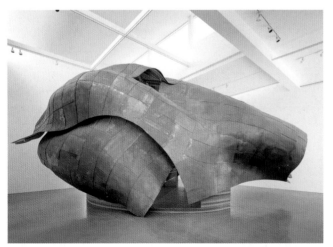

Frank O. Gehry, *A Study,* 1999. Maple wood and lead,
6.10 x 12.20 x 7.60 m. Gagosian Gallery, Beverly Hills

Gehry's interest in sculpture has manifested itself on many occasions. The relationship between the interior of the DG Bank in Berlin and the sculpture he exhibited in Los Angeles in 1999 appears evident.

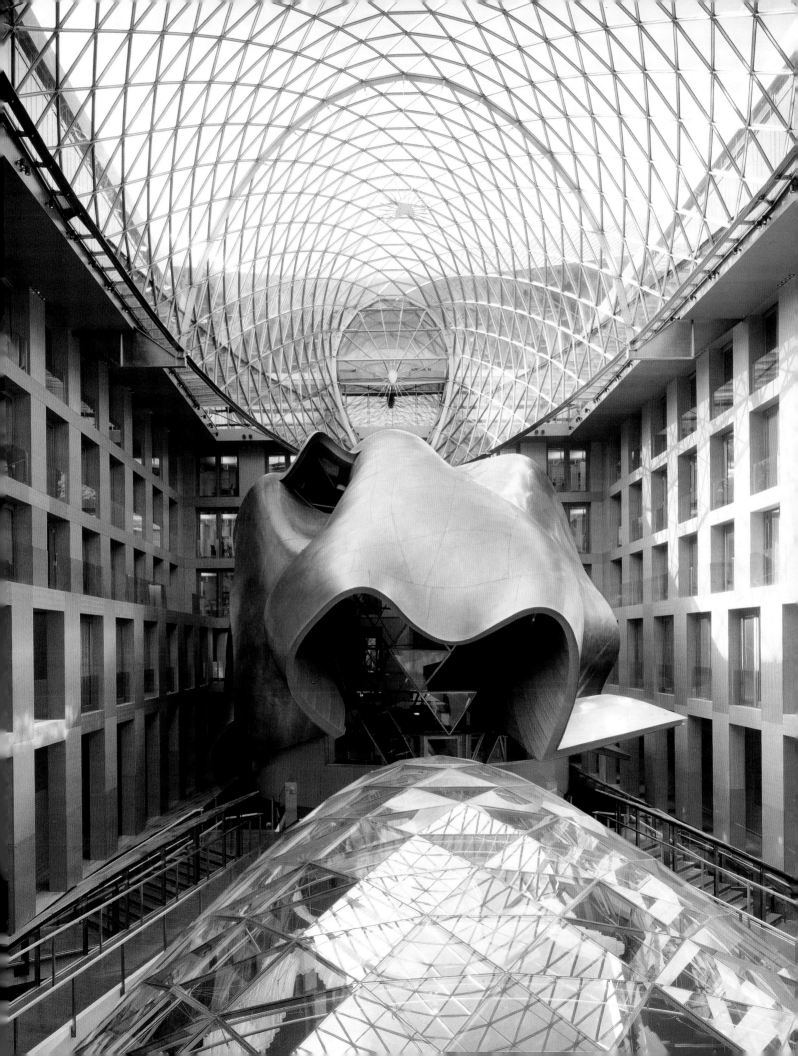

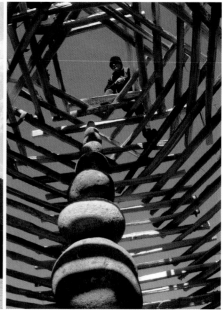

Andy Goldsworthy, *Stone Houses,* 2004. Installation at the Iris and B. Gerald Cantor Roof Garden,
Metropolitan Museum of Art, New York

The work of Andy Goldsworthy is intimately related to nature, but he does on occasion touch on the realm of architectural form. His *Three Cairns* project at the Neuberger Museum of Art in Purchase, New York, the Des Moines Art Center and the San Diego Museum of Contemporary Art in 2001 sought to create an imaginary link between distant locations through art. Cairns are "symbolic stone constructs that identify a place, which may have societal or ritualistic importance, like Stonehenge." Using Iowa limestone, Goldsworthy built these three curious, ovoid, or beehive-shaped objects by hand without the use of mortar. Like other works in stone by this artist, who lives in Scotland, the *Cairns* immediately evoked a sort of ancient monumentality.

A more recent work, his **Stone Houses** installation at the Iris and B. Gerald Cantor Roof Garden of the Metropolitan Museum of Art in New York (2004), had an even clearer relationship to architectural form both in its own design and in its interaction with the New York skyline. He first made stacked, tapered, stone spires, and then surrounded them with 5.5-meter-high octagonal domes made of split rails of northern white cedar from New England. The granite stones, the largest of which weighed one-and-a-half tons, were taken from the beaches of Luce Bay in southern Scotland. Goldsworthy said that this work should be viewed as "an exploration of the relationship between stone and wood... [with] stone the more fragile partner — protected by the [guardian wood rails] — just as trees often hold together and protect the landscape in which they grow." Intended specifically for this location, *Stone Houses* offers a marked contrast both to its immediate terrace environment and to the towers of midtown Manhattan in the background. As Anne Strauss, the Met's curator responsible for this exhibition, says: "Inherent in these seemingly simple forms are the implicit power, beauty, mystery, and elemental aspects of nature, marked by the passage of time and by human contact." Although the trees of Central Park spread beneath the terrace, wood is rarely seen in construction in New York, and handmade objects are just as rare in the architectural environment. With no obviously spiritual or symbolic intentions, the artist nonetheless brings to mind ancient temples or places of worship. The tapered, stone spires of his work also echo Manhattan's skyscrapers, albeit in a far more ancient or primitive form.

Working in the spirit of Italy's Arte Povera movement, Mario Merz created a number of *Igloo* forms in the late 1960s that may have distant intellectual ties to Goldsworthy's domes on the roof of the Met, but the more obviously architectural and nature-related elements of the British artist's work clearly set it apart. Using stone, albeit in the form of natural rocks, Goldsworthy here evokes a solidity that is belied by the apparently unstable stacking of both the spires and the surrounding wooden domes. It is as though an enigmatic structure from a past so distant that the living cannot recall its significance had reemerged in this unlikely location. Might it be from the Indian past of Manhattan? A ritual older than time seems to have called these forms into existence: domes and spires, which are the true building blocks of all architecture.

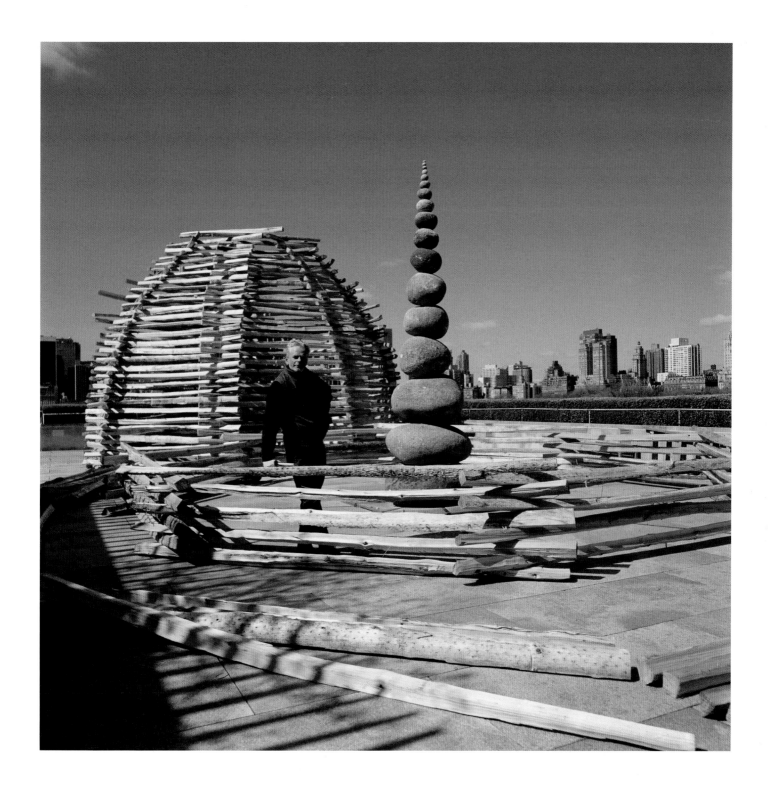

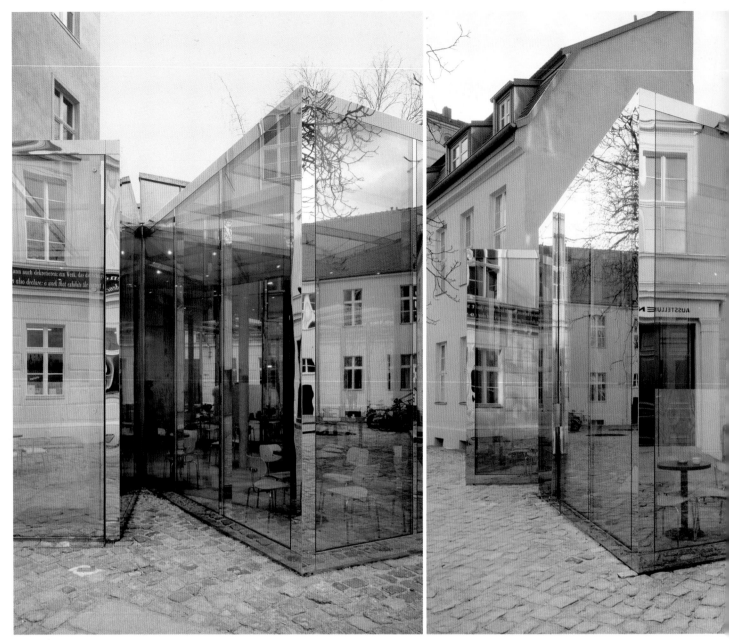

Dan Graham (artist) and Johanne Nalbach (architect), *Café Bravo*, Berlin, 1998

Both architects and artists sometimes play on the ambiguity of space. Opacity and transparency are frequently used to make the viewer have doubts about what is reflected and what is "real." This is frequently the case, for example, in the architecture of Oscar Niemeyer. One artist who has consistently used the vocabulary of architecture is the American Dan Graham (born in Urbana, Illinois, in 1942). His installations are typically free-standing, geometric constructs consisting of a steel frame and different types of glass that are reflective or transparent to different degrees. The result is that viewers are somewhat disoriented by the intentional deformation of space created by the artist. Usually, Graham's works fall clearly into the domain of art, since their only discernible purpose is to awaken visitors to just how unreliable their own senses can be. Solid, archi-

tectural forms are supposed to reassure users, while Graham's work makes them wonder at every step exactly where they, and others around them, are.

In the case of **Café Bravo** (Kunstwerke, Berlin, 1998), he steps over the line to create what must be considered an architectural form as well as an artwork. Whether in photographs or in reality, the multiple layers of *Café Bravo* inexplicably decompose the more solid building against which it stands, or even its guests. As Dan Graham writes: "People inside and outside can see their bodies and gazes superimposed on each other on the facade's surface." The artist's comments on his work are usually quite straightforward. Of *Café Bravo*, he says dryly: "This café … consists of two 2-way mirror cubes aligned at an angle of approximately 30 degrees to each other

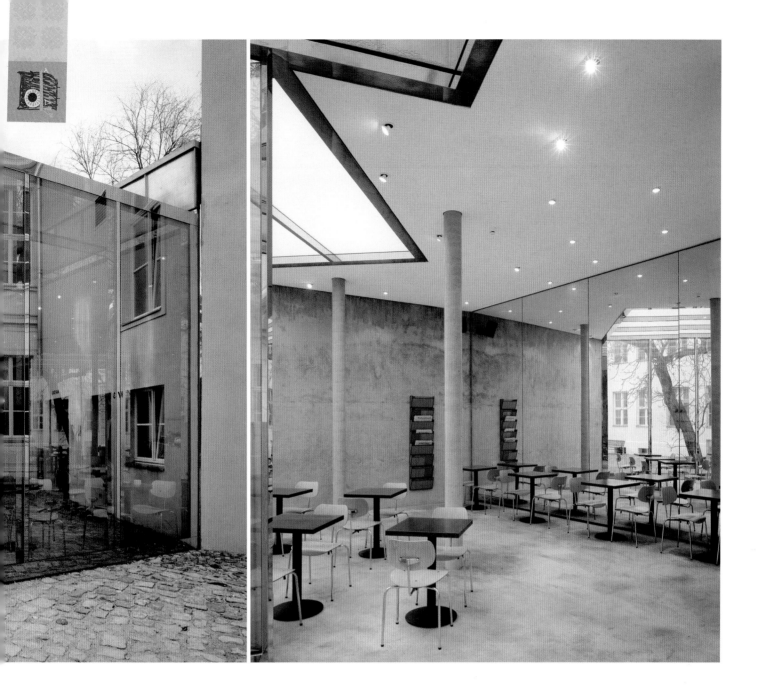

and with common interior space." The canons of Modernist architecture, or indeed Minimalist art, provide for rigorous alignments and a geometric vocabulary. Graham takes this apparently reductive simplicity and shows how it can engender a bewildering ambiguity, or, at the very least, a different way of looking at what seems obvious.

Beatriz Colomina has pointed out that even beyond form, Dan Graham is closely linked to the work of Ludwig Mies van der Rohe and in particular his Barcelona Pavilion (1929). She writes: "When commissioned to build the German pavilion in Barcelona, Mies asked the Ministry of Foreign Affairs what was to be exhibited. 'Nothing will be exhibited,' he was told, 'the pavilion itself will be the exhibit.' In the absence of a traditional program, the pavilion became an exhibit about exhibition. All it exhibited was a new way of looking." (*Dan Graham*, Phaidon, 2001) Quite obviously, where Graham is concerned, the "pavilion itself is the exhibit," and in each case, the object of his work is nothing less than a new way of looking.

The artist's fascination with architecture has been apparent throughout his career, as in his *Homes for America* (1966–67), in which he used a Kodak camera to take pictures of New Jersey development houses, or his *Alteration to a Suburban House* (1978–92), in which he explores the boundaries between private and public space. Whether viewed as a subversion of architecture or a questioning of its certainties, Dan Graham's work surely tests the limits that theoretically divide trustworthy built forms from the more ephemeral constructs of perception.

Cai Guo-Qiang, *APEC Cityscape, Fireworks Show,* Shanghai, October 20, 2001, about 20 minutes. 100,000 explosive devices

Born in 1957 in Quanzhou City, in the province de Fujian, China, Cai Guo-Qiang is one of the most original and powerful artists of his generation. Not least because he frequently uses fireworks in his art, Cai Guo-Qiang sees himself as something of an alchemist: "You take different elements and put them together, then something else comes of it," he says. One of the single features of his art is that no two works really resemble each other, even when the same techniques are used. He professes an admiration for the teachings of the philosopher Lao Tse. "Lao Tse taught that when you have a method, you have nothing else," says the artist. "When you don't have a method you can do whatever you want," he concludes with a smile. Another element in his selective eclecticism is surely the flood of images that came to his attention as pictures of the art of the West suddenly became accessible in China in the early 1980s. Closer in time than Lao Tse, Cai Guo-Qiang cites Joseph Beuys and

Bruce Nauman as his favorite artists: the former because of his interest in the fate of German art, and the latter because of his sense of irony or humor. Despite his continuing interest in the art of China, Guo-Qiang has long been an expatriate, settling first in Tokyo (1986) before moving to New York in 1995. An unexpected form of expression has arisen from his continuing interest in the Socialist Realist art of Communist China. It was this ironic interrogation that led him to create one of his most controversial pieces, the *Rent Collection Courtyard*, a reproduction of figurative sculptures long famous for their representation of the exploitation of the working classes in pre-Revolutionary China.

Cai Guo-Qiang has staged a number of significant art events using fireworks, such as the *Light Cycle: Explosion Project for Central Park* (New York, 2003), *Ye Gong Hao Long: Explosion Project for Tate Modern,* (London, 2003), and *Transient Rainbow,* for the

opening of MoMA Queens (New York, June 29, 2002); but these pale in comparison to the scale of his fireworks display on the Bund in Shanghai on the occasion of the October 2001 Asia Pacific Economic Conference, attended by numerous heads of state. Believed to be the largest fireworks display ever staged, the event was recorded in his film **Tonight So Lovely** (2001–02), and it quite literally gives the impression of a city ablaze. The symbolism of this explosive artwork may not have been lost on the leaders of various countries that unleash deadly force even as they convene at a peaceful economic conference, but the work was also about the ephemeral transformation of one of the world's most dynamic cities — this, too, just weeks after the very real destruction of a large tract of lower Manhattan by terrorists. Be that as it may, the Chinese authorities saw fit to see only the positive aspects of a spectacular demonstration of their own ancient art. After the October 2001 con-

ference, Cai Guo-Qiang gained considerably in credibility in China itself, whereas his status as an expatriate had previously made him an object of suspicion.

The German composer Karl-Heinz Stockhausen was bitterly criticized after he referred to the September 11 attacks on New York as "the ultimate work of art." Cai Guo Qiang, using the traditions of his own country, succeeded in October 2001 in briefly making one of China's great cities the site of a fleeting demonstration of explosive art. Architecture, the art of construction, was here transformed into the stage for an ultimately harmless orgy of sound and fury. Cai Guo-Qiang uses fireworks to provide a curious contrast with the transient nature of any construction, be it a building or a metropolis such as Shanghai. The town of Shanghai was established during the Southern Song Dynasty in 1292, while fireworks were first used by Taoist monks more than a thousand years ago.

Born in Leipzig in 1955, Andreas Gursky, the son of commercial photographers, studied at the Düsseldorf Kunstakademie under Bernd and Hilla Becher (1981–87). Aside from the Bechers, the presence of such figures as Joseph Beuys, Sigmar Polke or Gerhard Richter at the Kunstakademie at the time made it a center for Germany's artistic avant-garde. It would seem that the dimensions, colors and techniques of Gursky could not be further removed from the austere taxonomic approach of his teachers. His pictures are big, sometimes two by three meters. They are colorful, and above all, they usually involve unspecified forms of computer intervention to alter the original picture. Where some might see banality, he deals with photographic surface and pattern in a painterly manner that indeed sets him apart from the Bechers.

Like them, however, Gursky does draw inspiration from apparently uninteresting or repetitive architecture. His *Swimming Pool, Tenerife* (1987) might well, except for its size and color, have been part of Ed Ruscha's studies on the same subject. In a work such as his *Times Square* (1997), the artist confronts the viewer with what would appear to be bands of color, but is revealed as a study of the atrium of the Marriott Marquis Hotel built in Times Square in 1985. Recomposed, perhaps originally consisting of more than one image, the picture uses banal modern architecture practically as a decorative pattern, but nonetheless succeeds in making a commentary on modern society.

His image **Shanghai** (2000) is also a computer-enhanced view of a hotel lobby. Intended to be architecturally spectacular, the space is in fact deadly repetitive, and that appears to be precisely what interests Gursky. It has been said, too, that the German photographer is intensely interested in society as a subject, frequently choosing stock exchanges and other examples of capitalist excess as his subjects. Whether in Shanghai or New York, his gigantic hotel lobbies are also evidence of unimaginative overkill, resulting in numbing banality. The actual location of these scenes is unimportant except to the extent that it is noted that they have no connection to any culture in particular. Where the notion of banality ends, the idea of pictorial modernity begins. Patterns and repetitions are exploited in modern art to many different ends, but the Minimalists, to whom the Bechers are often compared, come readily to mind. Fundamentally then, despite their differences of color, scale and approach, Gursky does draw his fundamental inspiration from his Düsseldorf professors.

Architecture, particularly in its modern manifestations, offers an ideal subject for Andreas Gursky, whether it be from a sociological or purely esthetic point of view. There are multiple layers of meaning in these images. Just as a viewer may carefully search the surface of a photo to discover how computer enhancement has been used, so, too, thoughts about the intent and content of Gursky's art can range from a commentary on architecture, to an appreciation of contemporary painting, or a social critique. Although his images are chosen and manipulated in a purely subjective manner, the "reality" of photography, the assumption that something quite concrete is at the origin of the picture, lends an air of impartiality that is difficult to obtain in painting, for example.

Andreas Gursky, *Shanghai*, 2000.
C-Print, 280 x 200 cm

Zaha Hadid's exploration of sculptural forms takes into account
functionality in increasingly sophisticated ways.

Although she was born in Baghdad, Iraq, in 1950, Zaha Hadid stud-
ied architecture at the Architectural Association in London (AA), be-
ginning in 1972. She then worked with Rem Koolhaas in the Office
for Metropolitan Architecture (OMA) and taught at the AA. In 2004,
Hadid became the first woman to win the coveted Pritzker Prize. She
was included in the *Deconstructivist Architecture* exhibition at New
York's Museum of Modern Art in 1988, along with Koolhaas,
Eisenman, Gehry, Libeskind, Tschumi and Coop Himmelb(l)au.
At the time, exhibition curator Mark Wigley, commenting on
Hadid's prize-winning entry for the Hong Kong Peak International
Competition (1982), remarked that the project was "stretched be-
tween the emptiness of the void and the density of the underground
solids, domains normally excluded from modern architecture, but
found within it by pushing modernism to its limits, forcing it apart. In
this way, the pleasure palace, the hedonist resort, is located in the
twisted center of modernity." Although perhaps contestable in its

intellectual formulation, *Deconstructivist Architecture* did signal a
search for new sources of inspiration in contemporary architecture.
The architect Peter Cook writes: "If Malevitch's *Tektonik* is constant-
ly being erected as the baseline of Zaha's own work, it is through
her own assertion and her reference back to it from the 1992
Guggenheim show *The Great Utopia* and the 1996 *Habitable
Bridge.*" The interest of Russian Constructivist artists for archi-
tectural forms is clearly established. So is their importance for
contemporary architecture, making the link between art and archi-
tecture all the more significant today. For many years Hadid was bet-
ter known for her stretched-out drawings and her esthetic challenge
to conventional forms than for any built work. Today, that situation
has changed, but Hadid remains an architect who imposed herself
more through her drawings than with actual architecture. This is not
to say that her drawings were an independent artistic expression —
they were, indeed, related to her ideas about the future of architec-

ture, but they were more visionary than practical, at least on the surface.

Despite becoming very active in actually building her designs, Zaha Hadid has continued to express her ideas of flowing, interacting spaces through drawings and models that carry an unmistakable stylistic signature. She describes her recent project for the **Guggenheim Museum** (Taichung, Taiwan, 2003) as "an ever-changing event space, with 'stage machinery' made up of large-scale kinetic elements that allow radical transformation of gallery spaces. This insistence on fluidity places her at the heart of current thinking about architecture, art and, indeed, museums. Just as she did in her LF ONE/Landesgartenschau (Weil-am-Rhein, Germany, 1996–99), here, too, Hadid insists on the relationship of the building to its site. "The building emerges from a soft landscape formation," she says, "bleeding into the open public space of the urban axis." Inclined sometimes to an accumulation of planar elements with dramatic

cantilevers (Vitra Fire Station, Weil am Rhein, Germany, 1990–94), and at other moments to block-like accumulations (Contemporary Arts Center, Cincinnati, Ohio, 1997–2003), Hadid has explored the Taichung project with a geologically inspired fluidity at the cutting edge of current architectural thinking. Another architect, Greg Lynn, has commented that Zaha Hadid "combines painting, projective geometry, perspective, model building, now computer renderings and smooth curvaceous geometric surfaces into the masses, interiors and structure of her buildings. Her ability to work across mediums with apparent ease and grace is what has given her work its singularity and consistency of vision — as well as its enduring contemporaneity." The Jury of the 2004 Pritzker Prize concurred when they wrote, "The full dimensions of Ms. Hadid's prodigious artistic outpouring of work is apparent not only in architecture, but in exhibition designs, stage sets, furniture, paintings, and drawings."

The flowing interiors of Hadid's design emphasize
that the exterior appearance is not superficial, but
corresponds rather to the design concept.

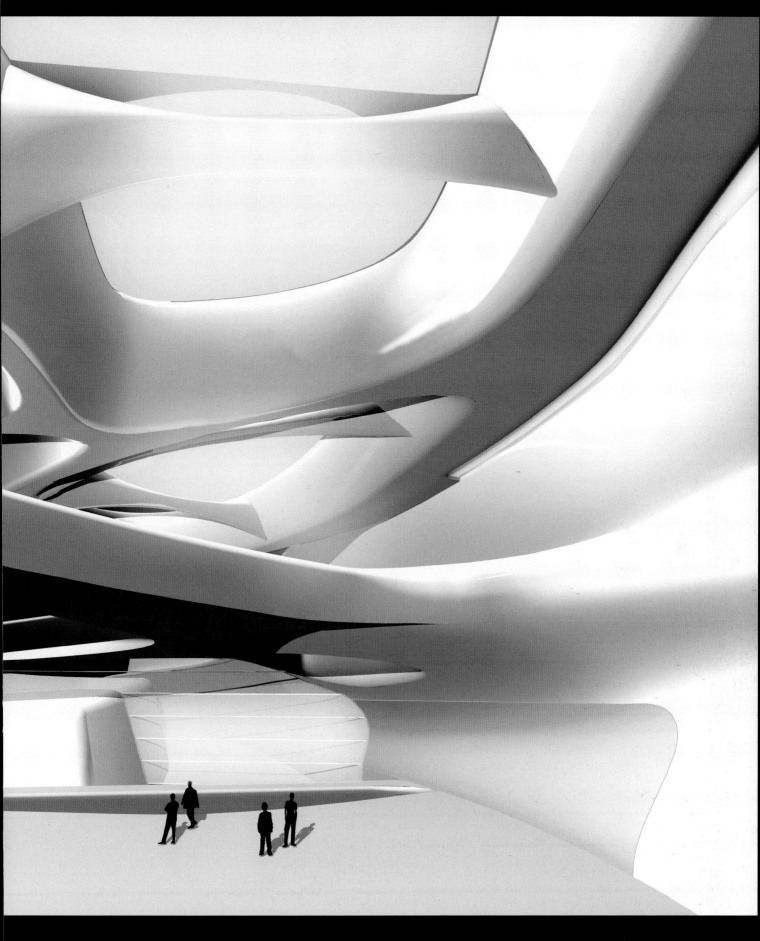

David Hockney has long been interested in the rapport between painting and the third dimension. One of his famous early works, **A Bigger Splash** (1967), is a painting that intentionally contrasts flatness and the depth implied by a modern building, a swimming pool and the splash of the title. He has created numerous stage settings and costumes, such as those for *The Rake's Progress* (Igor Stravinsky, W.H. Auden, Glyndebourne Festival, 1978), or *Parade* (Erik Satie, Jean Cocteau, Metropolitan Opera, New York, 1981). His experiments with assembled photographs *(Sitting in the Zen Garden at the Ryoanji Temple, Kyoto, Feb. 1983)* also attempt to deal with the problems of multiple perspectives, depths of field and the issues raised by the translation of three dimensions into two. He has compared the multiple viewpoints of van Eyck's *Ghent Altarpiece* (1432) to his own **Pearblossom Highway** (1986), a photographic collage consisting of approximately 750 individual chromogenic prints. "I spent two years solid working on photography. When I made that *Pearblossom Highway* work," says David Hockney, "I realized that I had made a totally new kind of landscape photograph that didn't look like any previous landscape photograph. My friends who are in photography said it was really like a drawing. Well, of course, it was

drawn, by pointing a camera. Only drawing can change things. New spaces will have to be drawn, a camera won't make them." In his book *Secret Knowledge* (Thames & Hudson), he shows how Brunelleschi, "the first architect to employ mathematical perspective to redefine Gothic and Romanesque space, used a mirror for the perspective picture of the Baptistry of San Giovanni; a painting that, around 1412, astounded Florence." In 1998 and 1999, Hockney exhibited a number of large-scale paintings whose subject was the Grand Canyon. *A Closer Grand Canyon* was composed on the basis of drawings that took in a 200° angle without reference to photography. Having used photography himself, Hockney became all the more aware of what he perceives as its destructive power vis-à-vis art. He says: "Art is in need of something fresh, but I often think that what is stopping it is photography. It makes you always look at the world in the same way."

David Hockney, *Pearblossom Highway, 11–18th April 1986 (second version)*, 1986. Photographic collage, 181.6 x 271.8 cm overall. J. Paul Getty Museum, Los Angeles, CA

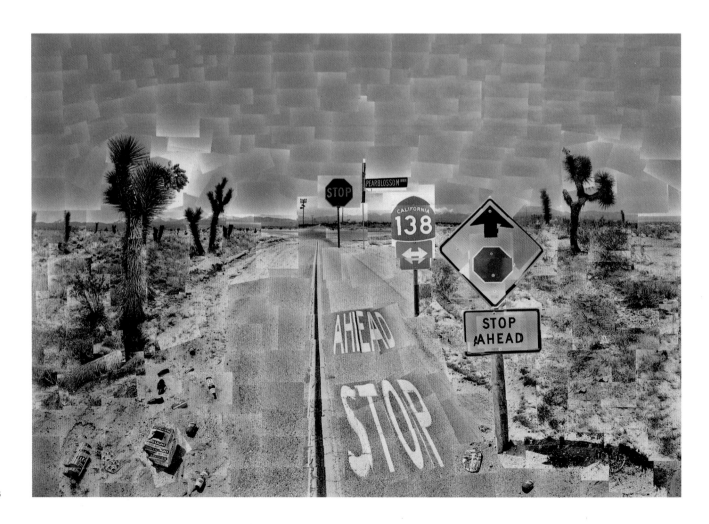

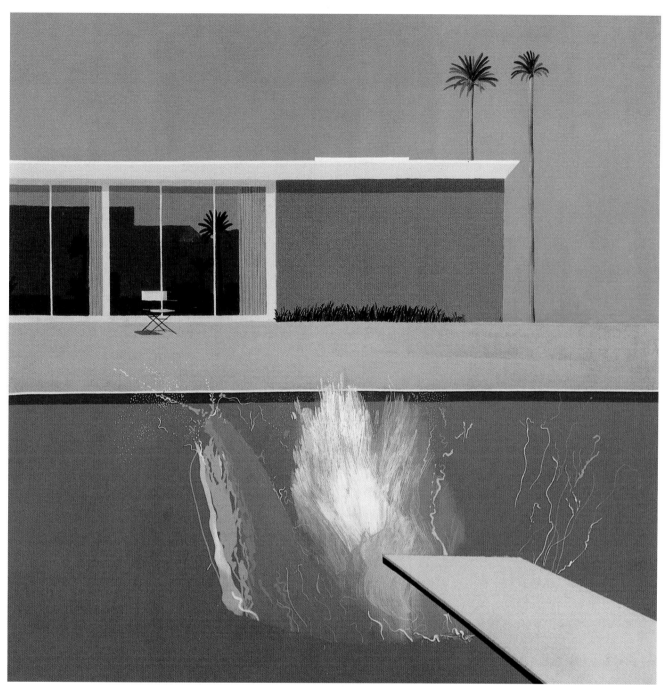

David Hockney, *A Bigger Splash,* 1967. Acrylic on canvas, 243,8 x 243,8 cm. Tate Gallery, London

Impressed by the vastness of the Pacific as he sees it from a small house he has on the beach in Malibu, Hockney says: "I tend to sit at my table, look out, and say all of the nonsense is behind me. You think of how small you are, of how ridiculous a lot of things are. People should contemplate a bit more, look at things. The world is beautiful no matter what they say. Everyone just watches television, which does not give a very good picture of the world. It is boring and small."

David Hockney's struggle with perspective and image is intimately related to the perpetual conflict between art and architecture. Although art, in the form of a sculpture, an installation or even a stage design, can surely conquer the third dimension, there is most often an element of representation or a search for meaning that is not fully expressed in the "real" world, but which art can reveal. Architecture, a subject or model for art, even a source of inspiration, is anchored in the real, and may only on very rare occasions attain the kind of sublimation of space and life that is accessible to art. Hockney's fascination with the relationship between two dimensions and three raises fundamental questions about architecture and art — how they are different, and how one struggles to rise to the challenge of the other. Tellingly, Hockney's own house, located off Mulholland Drive, is painted in the bright colors of his own palette, as if there, too, he were in quest of the eternal link between life and art.

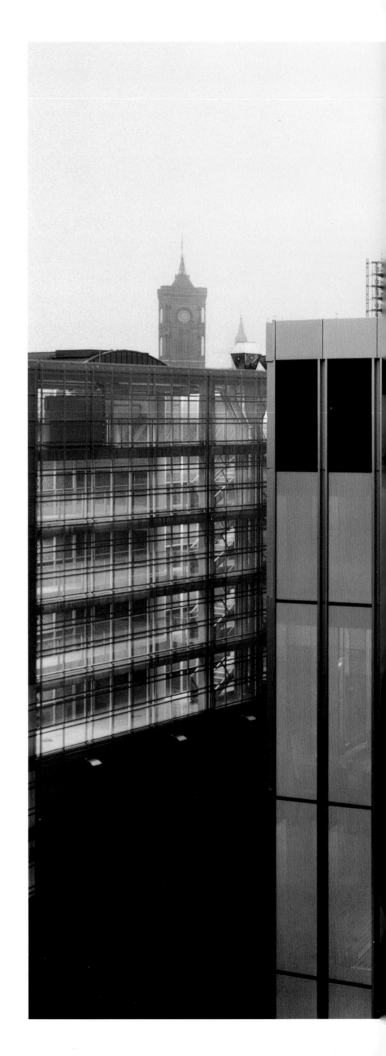

Candida Höfer, *Netherlands Embassy, Berlin, by OMA/Rem Koolhaas*, 2003.

Since the 1970s Candida Höfer has sought to express architectural environments in her images. Fascinated in particular by libraries and museums, she has turned the act of seemingly impartial observation into an art. Almost always devoid of actual human presence, her photographs depict stillness in which activities – that of construction, classification and study — are implicitly her subject. Höfer's large-scale color images of silent public spaces are a commentary on the ways in which architecture creates an order that is profoundly human — they are in a sense a meeting point between art and architecture. Her apparent passivity in using a mechanical means of reproduction to show an incontestably "real" space is nonetheless an artistic interpretation of light, space and order. There is no empathy or emotion here, but as in much contemporary art, and indeed in architecture as well, it is Höfer's emptiness that best expresses life.

Born in 1944 in Eberswalde, Germany, she studied at the Kunstakademie in Düsseldorf (1973–76) and worked with Bernd and Hilla Becher (1976–82). The Bechers' systematic and rigorous depiction of industrial architecture is surely a key to Höfer's vision, but where her mentors sought to bear witness in black and white to forms related to mining or manufacture, Höfer created a more baroque and fundamentally historical universe around such well-known spaces as the reading room of Labrouste's Bibliothèque nationale in Paris, the Round Reading Room of the British Library, or the Biblioteca Angelica in Rome. Höfer has also ventured actively into the domain of contemporary architecture with images of such iconic recent structures as Arata Isozaki's Los Angeles Museum of Contemporary Art or Peter Zumthor's Kunsthaus Bregenz. In each instance, she eschews the tendency of architectural photographers to make their images "attractive" and allows whatever objects are present in her wide field of vision — from spotlights to fire extinguishers — to occupy their real space.

It is thus no surprise that Candida Höfer should photograph another contemporary building, the **Netherlands Embassy, Berlin, by OMA/Rem Koolhaas.** This curious building — described by the breathless critic François Chaslin as "a virtuoso spatial *fantäsie* articulated within a limited, strictly cubic space, where it continually twists and turns upon itself" — is an almost ideal field for Höfer's visual exploration. The ambiguity of space that so fascinates the Dutch architect is the very stuff of the German photographer's art. Shown in the last phases of construction, the Netherlands Embassy becomes a haze of dissolving forms and empty rooms. Neither fully finished nor quite occupied, Koolhaas's work reveals a banality not unlike that seen in Höfer's 1999 picture of a gallery at the Museum of Modern Art in New York: blank walls, ceiling ventilators and the disturbing presence of a large canvas by Jackson Pollock. Architecture as image, or rather a portrait of the meeting of two artists who together define the space of life and dreams? Beauty remains in the eye of the beholder.

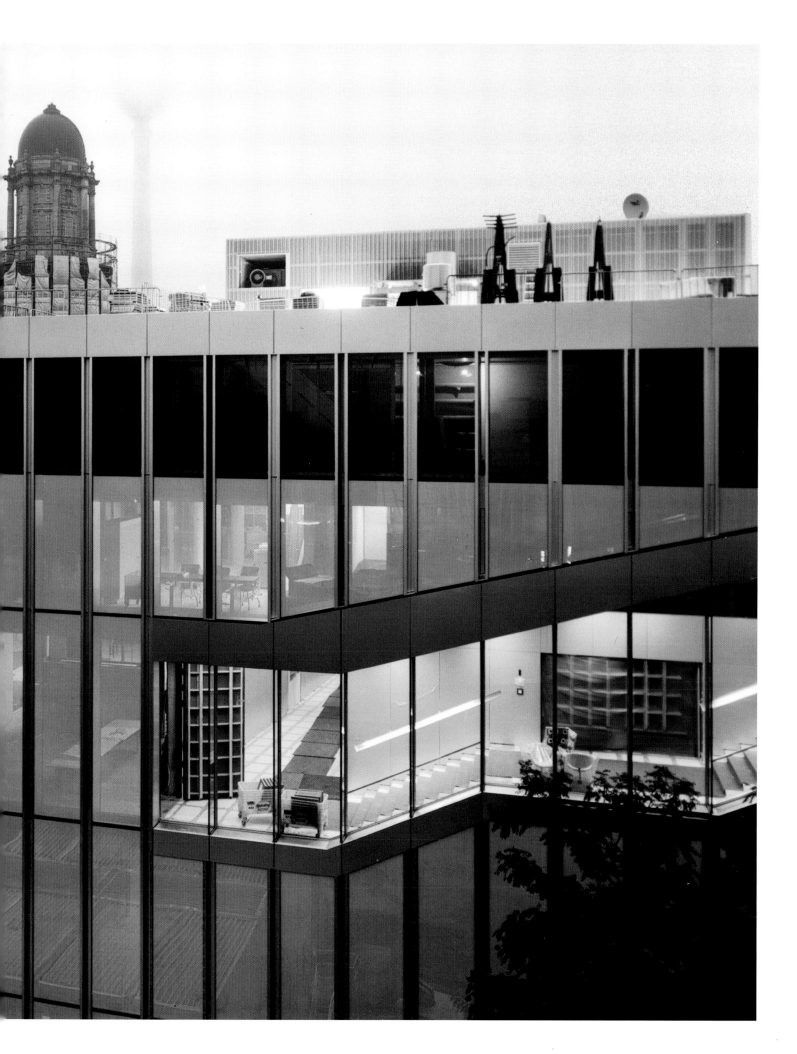

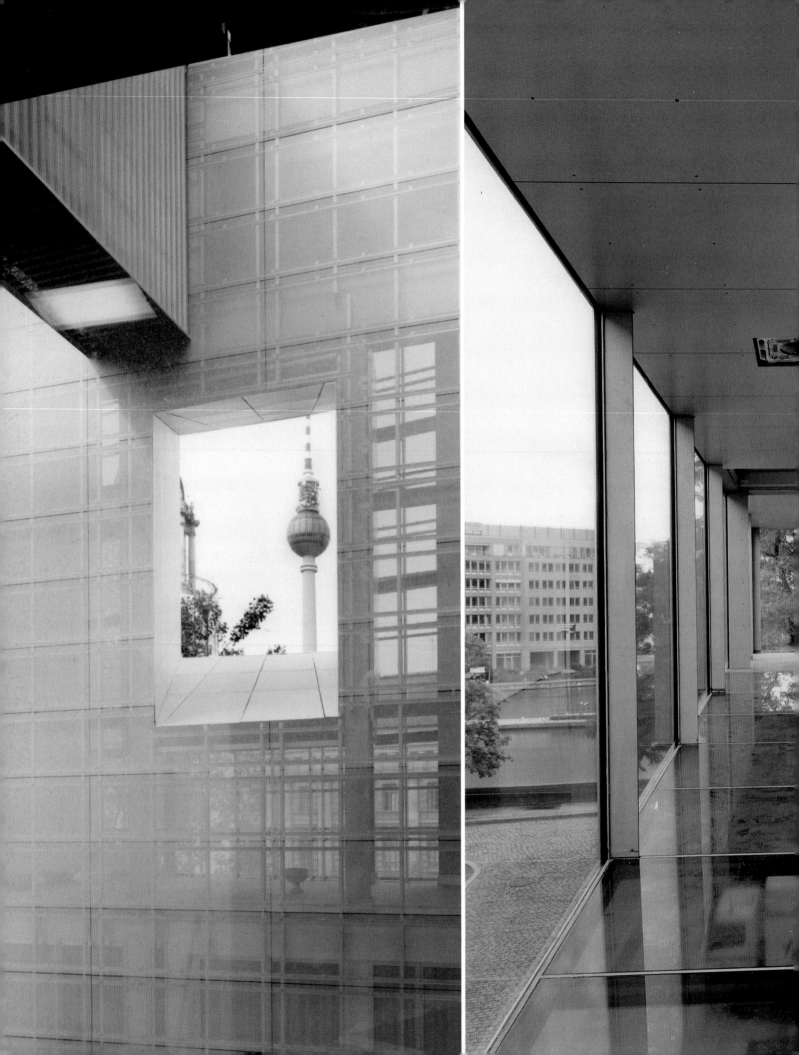

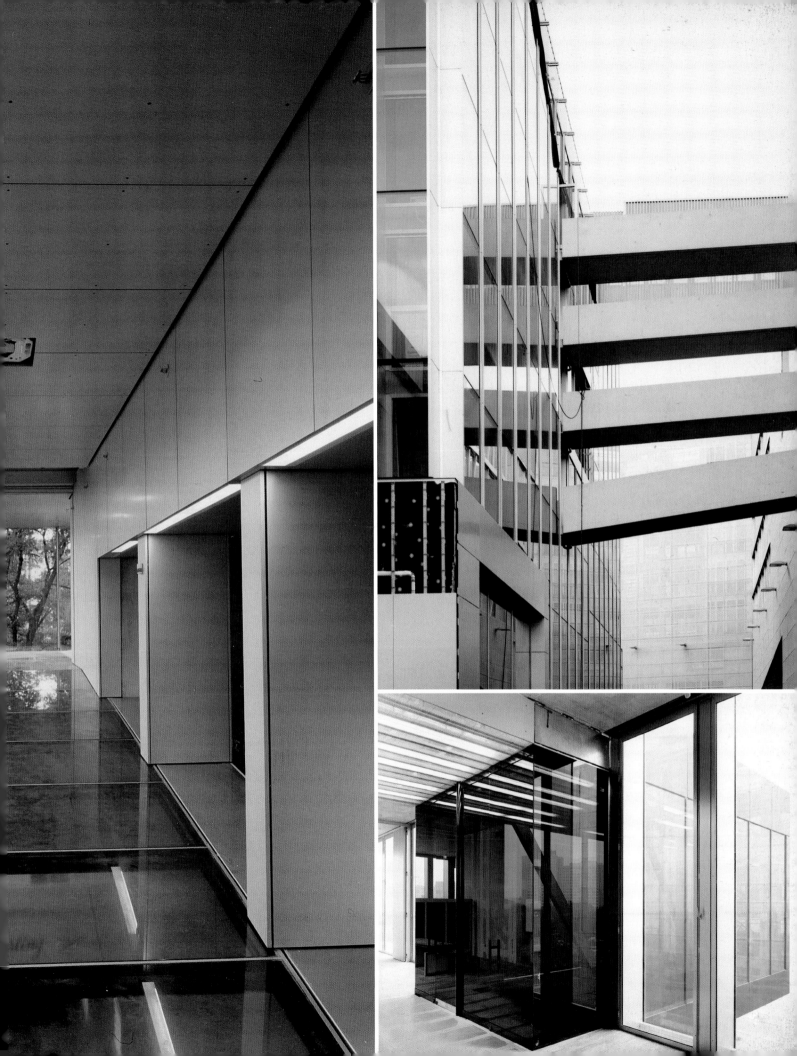

 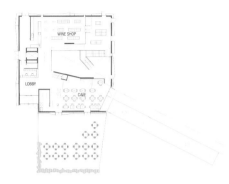

Steven Holl is known as an architect who is interested in art, because of his collaboration with artists and, no doubt, because of his watercolors, which often give a better idea of his work than photographs can. He collaborated with Vito Acconci on *The Storefront for Art and Architecture* in New York, and is working with Walter De Maria at the Nelson-Atkins Museum of Art in Kansas City. Holl disagrees, however, with the idea that "art helps architecture." As he says: "In the last five years, there has been a tendency in the avant-garde to make, let's say, a hybrid of art and architecture. I really don't think that it is healthy. To the extent that architecture is connected to the city, to the landscape, to urban issues, it is a stronger art than if it becomes an artifice as an object, as a kind of object that sits in the city." Although Steven Holl does not think it is healthy to create a "hybrid of art and architecture," he does refer here to architecture itself as an art.

Born in Bremerton, Washington, in 1947, Holl studied in Washington and did post-graduate work at the Architectural Association in London (1976). In 1989, the Museum of Modern Art in New York presented his work and purchased several of his drawings for their permanent collection. His best-known building remains the Kiasma Museum of Contemporary Art (Helsinki, 1992–98). One of his most recent buildings is the **Loisium Visitors' Center** in Langenlois, Austria, a 1,100-square-meter building that is part of a larger complex for which he is also designing a hotel. Essentially a cubic volume with 25-centimeter-thick load-bearing, poured concrete walls, the structure leans approximately 5 degrees to the south, as does the vineyard, where the 82-room hotel will be located. One third of the building is sunk into the ground to form a basement, which is connected to an existing wine vault system by a 90-meter-long concrete tunnel that rises at some points to a height of five meters. This historic subterranean network, which includes stone passages that are 900 years old, underlies the urban plan of the town. The exterior of the Visitors' Center is clad in "marine" aluminum.

The Loisium Visitors' Center is not an artistic collaboration in the sense of the work that Holl did with Acconci in New York, but it is, in and of itself, an artistically inspired effort. Sculptural and, as always, carefully thought out in terms of lighting and colors, the Center has an interior largely designed by the architect. Although Holl's architectural forms are strong, he is rightfully seen as a subtle architect, one for whom a delicate watercolor still has meaning. Holl has given a great deal of thought to the visual and tactile qualities of architecture, and is proud to point out that his architecture is very difficult to photograph. "Architecture," he writes, "intertwines the perception of time, space, light and materials, existing on a 'pre-theoretical ground.' The phenomena which occur within the space of a room, like sunlight entering through a window, or the color and reflection of materials on a surface, all have integral relations in the realm of perception.... The experience of material transformations is immersed in the human dimension and the necessity for beauty.... The joy of living and the enhanced quality of everyday life is argued in a quality architecture. It is whispered in material and detail and chanted in space."

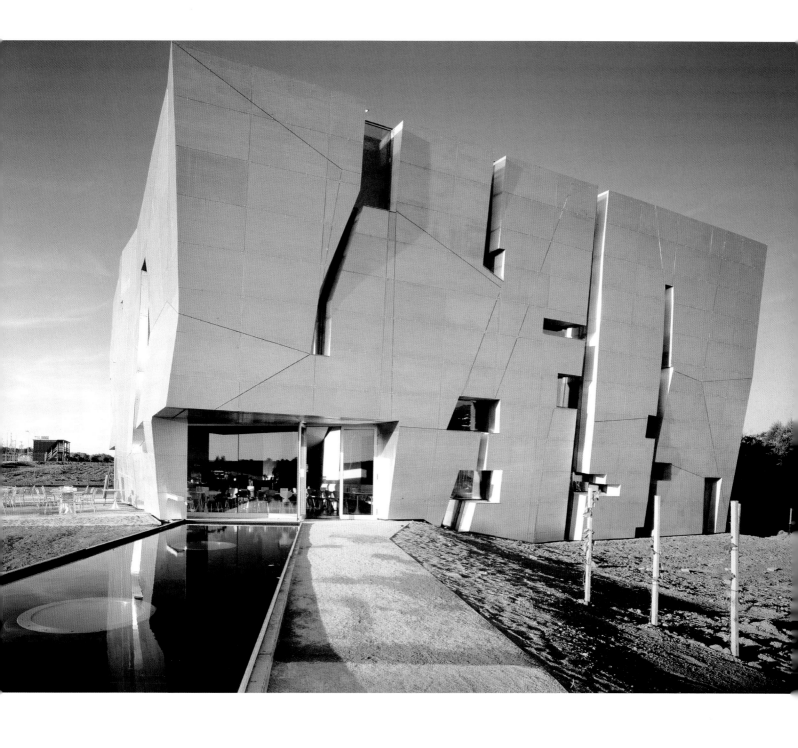

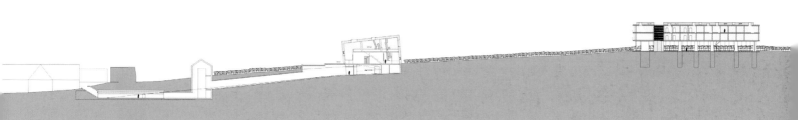

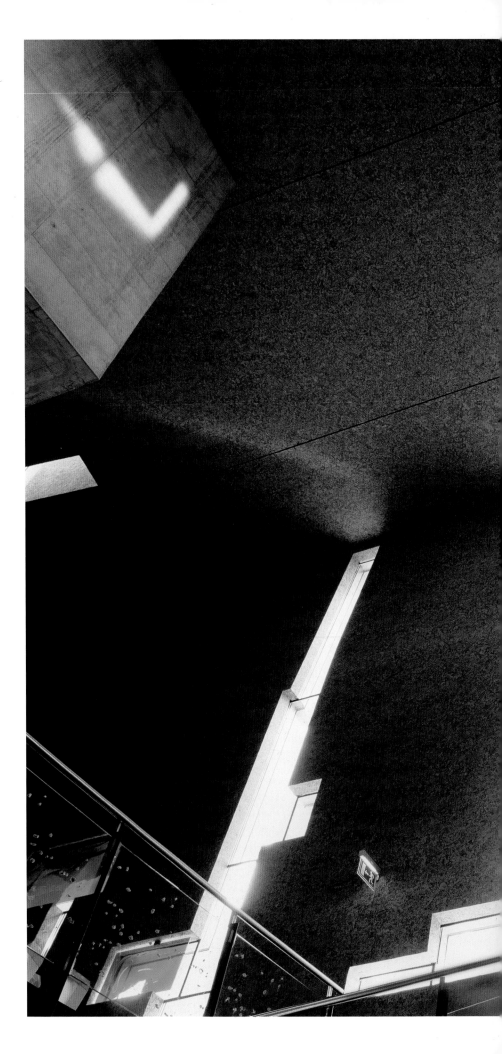

Design sketch by Steven Holl

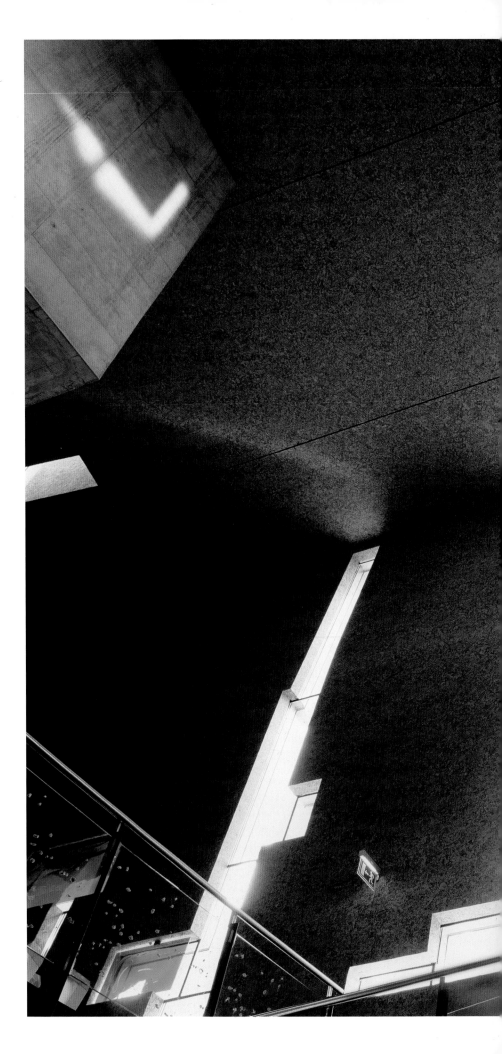

Holl's irregular placement of windows
animates the space and plays on light
in a way that is typical of the architect.

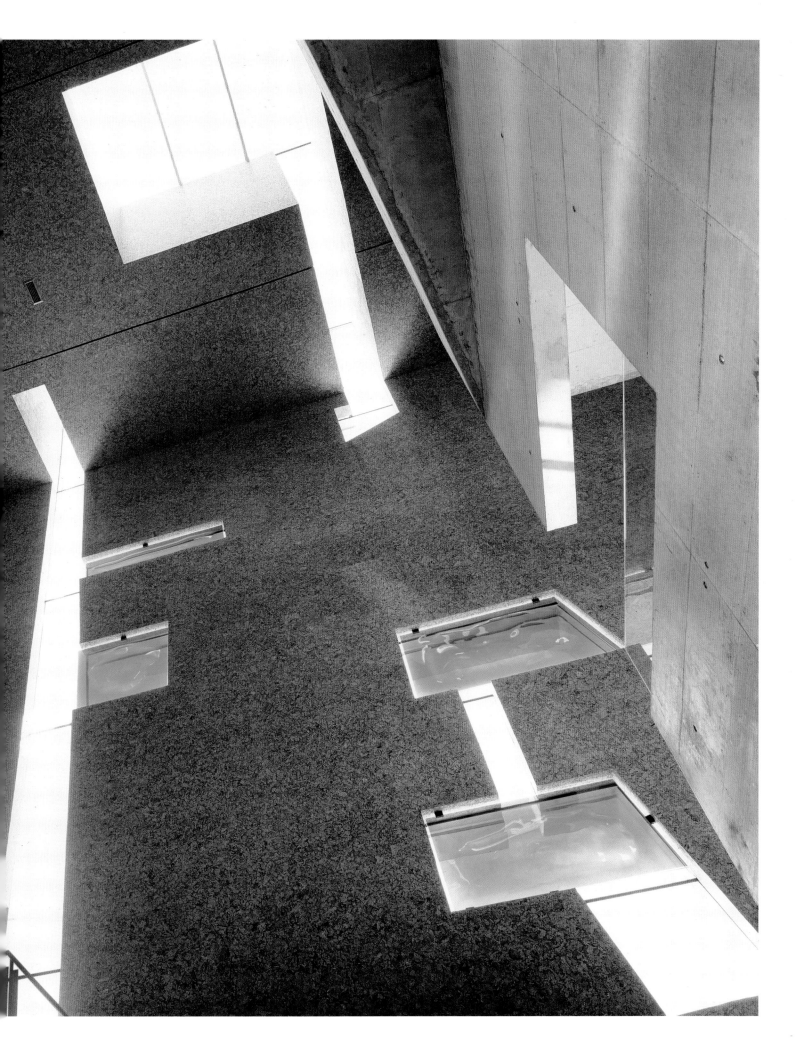

Robert Irwin, *Part I: Prologue: x183*, April 12, 1998–June 14, 1998. Installation view. Installation at Dia Center for the Arts, 548 West 22nd Street, New York City

Robert Irwin is an artist best known for his use of light. His own descriptions of his work tend to be quite complex, but about light he says: "If light is the medium and space is the medium, then, in a sense, the universe is a medium. I know the impracticality of it right now but when I say that the medium is the universe, that maybe the world is an art form, then the gardening of our universe or our consciousness would be the level of our art participation...." In 1998–2000, he used the basically industrial space of the Dia Center for the Arts in Manhattan as the location for two installations called ***Prologue: x183*** and *Excursus: Homage to the Square*,[3] in which the space was divided into chambers by fine mesh scrims. Natural and fluorescent lighting contributed to the creation of curious spaces in which the visitor was left wondering where the "real"

architecture of the building began and where the "work of art" ended. "The relationship between art and the viewer is all firsthand now experience," says Irwin, "and there is no way it can be carried to you through any kind of secondary system [such as art criticism]." In this floating world, other visitors were visible mostly as passing shadows, raising very real questions about space, light and time.

Robert Irwin, perhaps more clearly then other artists, expresses his interest in architecture as being an intellectual and artistic one as opposed to any desire to break down barriers between disciplines. "I am doing things that cross over the boundary of architecture and I am not an architect," he says. "I have no architectural ambitions or architectural pretensions. I don't see myself as an architect. I see the real issue as being what modern art is right

now." When Irwin calls his work *Homage to the Square*, he is refer-
ring clearly to the paintings of Joseph Albers, one of the pioneers of
contemporary art in the United States, and yet he has translated
this homage into the third dimension, as though to prove the imme-
diacy of art. Irwin is influenced by phenomenology and in particular
by the texts of the French philosopher Maurice Merleau-Ponty, who
wrote: "... I create an exploratory body dedicated to things and to
the world, of such sensitivity that it invests me to the most profound
recesses of myself and draws me immediately to the quality of
space, from space to the object, and from the object to the horizon
of all things, which is to say a world that is already there." Though
these words may not be clearer than many of Irwin's own pro-
nouncements, they do lead closer to an understanding of an art that
is far from being empty. When asked if his work is empty, Irwin re-
sponds, "Empty of what?" As the artist has said to his biographer
about his own ambitions: "Basically, it's just to make you a little
more aware than you were the day before of how beautiful the world
is. It's not saying that I know what the world should look like. It's not
that I'm rebuilding the world. Basically what artists do is to teach
you how to exercise your own potential — they always have, that's
the one thread that goes all the way through."

In the case of the installations at the Dia Center, Irwin makes
visitors more aware of space and light in a warehouse that most
would not have considered of interest as such. In a very real way, he
exhibits emptiness, and as such crosses the boundary into archi-
tectural space in a physical, but not a conceptual way.

Arata Isozaki has long been interested in contemporary art, not least because his wife, Aiko Miyawaki, is a noted sculptor. One of his most direct efforts to collaborate with artists came in the small farming town of Nagi-cho in the Okayama Prefecture of Japan: his **Nagi MoCA** (1992–94). Taking advantage of subventions offered by the central government to such localities to create cultural facilities, Isozaki proposed to the municipality what he calls "an anomalous object". "I explained to the people of the town that it was like the way in which a specific sculpture, namely the venerated object, used to be installed in the main hall of a Buddhist temple," says Isozaki. "In short, the artist was to conceive an object that corresponded in contemporary terms to a venerated object, while the architect was to build a roof over it."

The architect proposed a building divided into three distinct parts to house works by Shusaku Arakawa, Kazuro Okazaki and Aiko Miya-waki. As Isozaki explains, "Each artist has been allotted a structure in which to house his or her work. The structures have been given the names 'sun' (Shusaku Arakawa), 'moon' (Kazuro Okazaki) and 'earth' (Aiko Miyawaki). These names have nothing to do with the

Above: Shusaku Arakawa's interpretation of Ryoan-ji Garden.

Right: the arcing steel wire by Aiko Miyawaki animates a pool that is part of her husband's architecture.

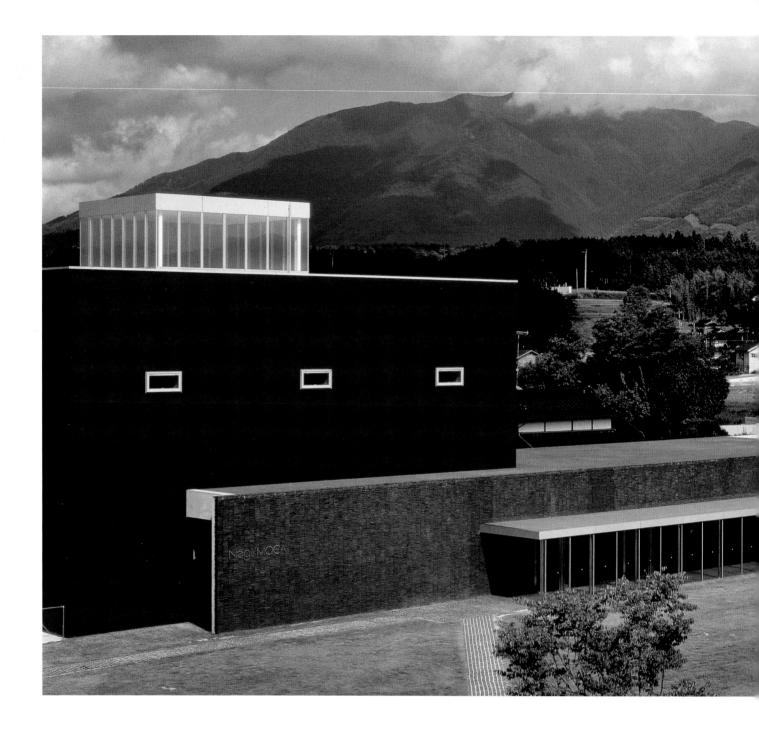

Design sketch by Arata Isozaki

works on display; they have been suggested instead by the shapes of the structures. The 'sun' is a round cylinder lifted at one end an eighth of the way toward the vertical, and its axis is oriented north-south. The 'moon' is semicircular in outline, and its straight wall is pointed in the direction of the moon at 10 PM at the autumnal equinox. The 'earth' is a room half buried underground, and its central axis is pointed in the direction of the peak of Mount Nagi."

Nagi MoCA remains an extremely modern structure, but Isozaki has clearly sought to root it in local geography and beliefs. In each case, Isozaki worked closely with the artists to adapt his work to their needs. "In the case of Shusaku Arakawa," he says, "I first proposed a vertical cylinder. He responded with an idea to install the garden of Ryoan-ji upside down. To accommodate this idea we agreed that the cylinder would be set at an angle rather than stand

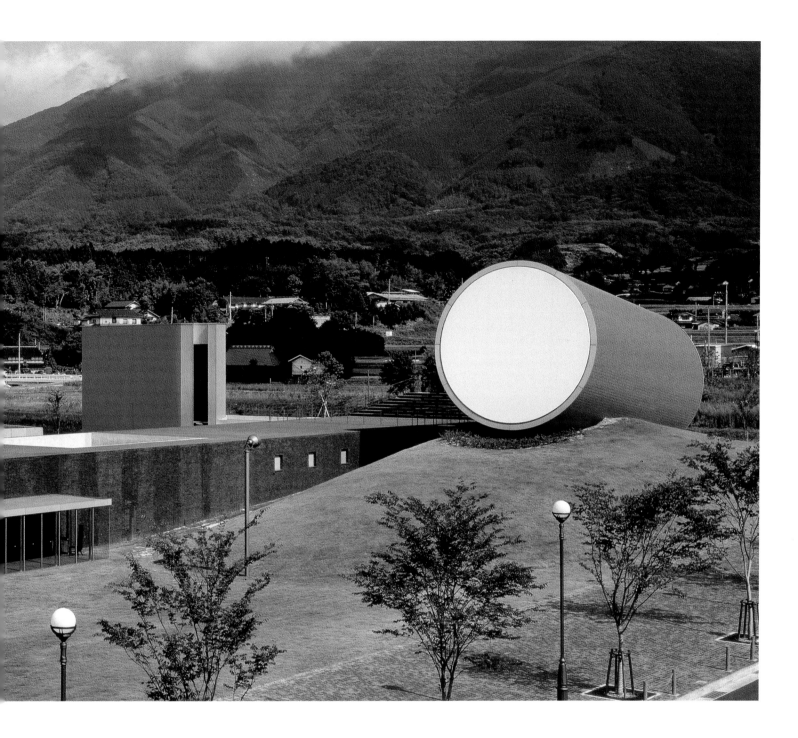

straight up. Kazuro Okazaki at first thought the crescent shape was too difficult," but his work was greeted by outside observers as the most successful. The space is designed to create a repetitive echo. It contains three sculptural forms called *hisashi* that Isozaki likens to clouds or shadows. It also contains two long narrow benches carved from Okayama granite. As the artist says, "Visitors may hear music played by heavenly nymphs, like that of ancient Nara. They may whisper the words 'gates of heaven' as did Michelangelo when he saw Ghiberti's doors for the baptistery in Florence. They may recall the famous *Screen with View of Pine Trees*." Aiko Miyawaki's work, part of her *Utsurohi* series, is formed by arcing lengths of hard but flexible stainless-steel wire above a square pool. "Passing between existing and not existing," she says, "is this not what is meant by *kokoro* (heart and mind)?"

With a floor area of 1,887 square meters, Nagi MoCA might seem to be a disproportionately sophisticated facility for a village of 7,000 people, but Isozaki's status in Japan permitted him to propose a remarkably innovative design, which might not have been possible in a larger city. A more recent but comparable effort to create an appropriate environment for the work of the three artists is Tadao Ando's Chichu Art Museum, located on the island of Naoshima, also in the Okayama region (see pages 40–43). Ando, like Isozaki before him, rooted his museum in the earth and traditions of Japan while remaining resolutely contemporary. The success of Nagi MoCA is a function of the underlying interest of many of the country's artists and architects for their ancient ties to the sun, moon and earth.

"A work of architecture, by its very nature, should be a momentary phenomenon," says the architect Toyo Ito. "I find it unbearable to see how a building remains on earth for hundreds of years, displaying its unchanging appearance. The form of a piece of architecture should be non-completing, non-central, and synchronized with nature and urban spaces." One of his most famous works is the **Tower of the Winds** (Yokohama, Kanagawa, 1986), a ventilation facility and water tank for a shopping center that is located beneath the square in front of the Yokohama JR Railway Station. Ito won a competition to renovate a reinforced-concrete water tower built at the end of the 1960s. He first clad the existing tower in acrylic reflective plates and then enclosed it in a perforated aluminum ellipsoid twenty-one meters high, six meters wide and nine meters long. On the inside surfaces of the Tower, he installed 1,280 small lamps, twelve neon rings and, finally, thirty flood lights situated on the ground and directed upwards. Opaque and apparently blank during the day, the Tower comes to life at night. Its lights and reflective surfaces vary according to the sounds and activity of the city, its computer controls reacting both to man-made and natural influences: ambient sounds, the wind, time of day and season.

Although the computer-controlled lights of the Tower of the Winds no longer function, the structure left its mark on the period perhaps more than any other built in Japan in the 1980s. Long before today's generation of architects, such as Lars Spuybroek (see page 152), experimented with the relationship between sounds, environment and architecture, Toyo Ito created an urban work of art that reacted quite beautifully to its location. At night, the skin of the Tower would become almost invisible, and only its lights would dance in the sky near the station. As Ito has said, "The tower loses its physical presence after sunset and becomes a phenomenon of light. I refer to this metamorphosis from an opaque substance into a transparent object of light as 'fictional.'" Indeed, the Tower of the Winds inspired a work of music by Savvas Ysatis and Taylor Deupree, part of a series called *Architettura* (Caipirinha Productions). Another album in the same series was composed by David Toop on the theme of Itsuko Hasegawa's Museum of Fruit. At a time when the musicality and lighting of works of architecture have come to be considered something of an art form, Ito broke new ground with a transversal approach, linking the thoughts of art and architecture, and accepting that architecture could be, above all, ephemeral and esthetic. He pioneered an approach that is related to his thoughts on "fictional" nature and the urban environment and which is a product of the Japanese situation, but his work has also had an international impact.

The Tower of the Winds clearly has a ventilating function and its volume does conceal a water tower. However, much of its substance is esthetic or, perhaps more properly, a work of art that is intended to respond to the urban environment with changing light patterns. This is true hybrid. Although it achieves architectural scale, it is not intended to be entered, only to be viewed. In this, it is more a contemporary sculpture than it is a purely functional building. It does not "display its unchanging appearance," but rather lives and breathes with its city. There is no real point in attempting to decide whether this is architecture or art — for it is both at the same time.

The ethereal presence of Ito's Tower of the Winds is an early manifestation of the growing symbiosis between art and architecture today.

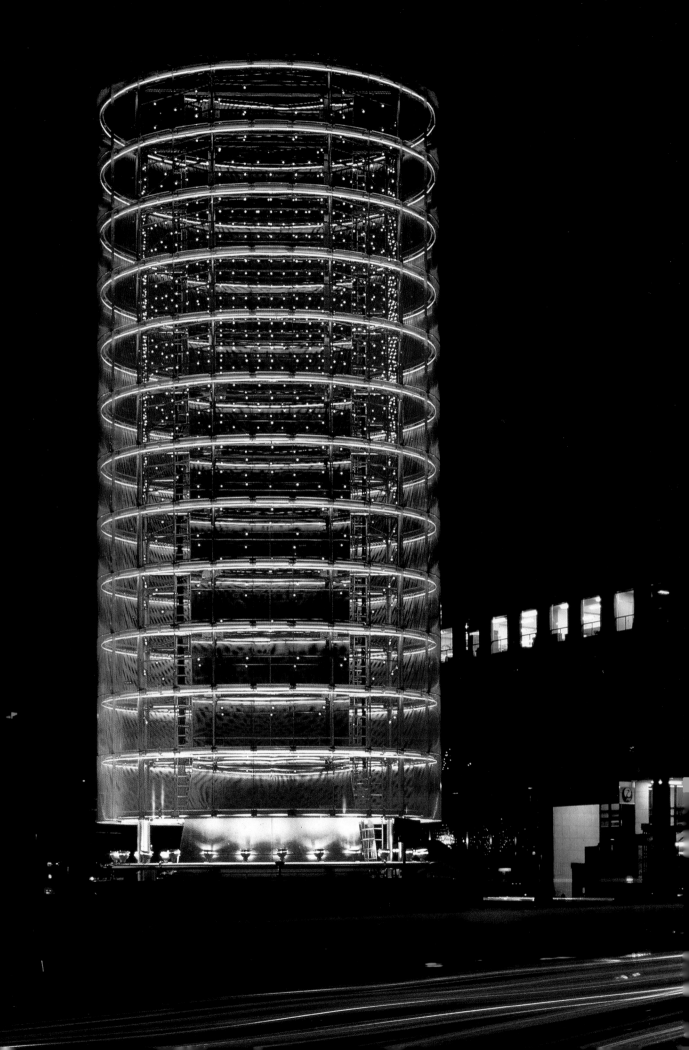

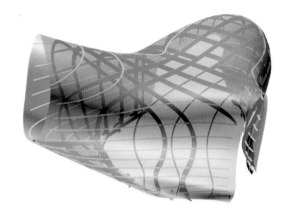

If the forms of architecture are freed by modern technology, then does architecture itself begin to resemble sculpture? Computers have made possible concepts and manufacturing that would have been considered impossible not long ago, and many younger architects have taken advantage of this new element to make shapes that have nothing to do with the orthogonal rigor of Modernism.

Dominique Jakob received a degree in art history at the Université de Paris 1 (1990) before obtaining her degree in architecture at the École d'Architecture Paris-Villemin (1991). She grew up in the Ivory Coast, Gabon and the Niger before beginning her studies. Her partner, Brendan MacFarlane, born in New Zealand, studied architecture at SCI-Arc in Los Angeles (1984) and at the Harvard Graduate School of Design (1990). Both architects worked briefly in the offices of Morphosis in Los Angeles. Designed in conjunction with an overall renovation of the Georges Pompidou Center carried out by Renzo Piano and Jean-François Baudin (1996–2000), the **Georges Restaurant** is located on the sixth floor of the Center. Jakob + MacFarlane won a design competition with their proposal to create four *caves-nuages* (cloud caves) that house the kitchen, toilets, bar and a VIP guest room. Though the aluminum forms of the grottoes appear to be very free, they are, in fact, based on a computer morphing of the original Piano & Rogers grid for the Center. Built in a shipyard located in France near La Rochelle, the *caves-nuages* give the impression of simply rising out of the floor, which is covered in the same aluminum. Indeed, the floor becomes the cladding of the volumes as they rise above floor level. The sculptural aspect of

By deforming the rectilinear grid of Piano & Rogers's iconic Centre Pompidou, Jakob + MacFarlane created unusual free-curving forms for the Georges Restaurant.

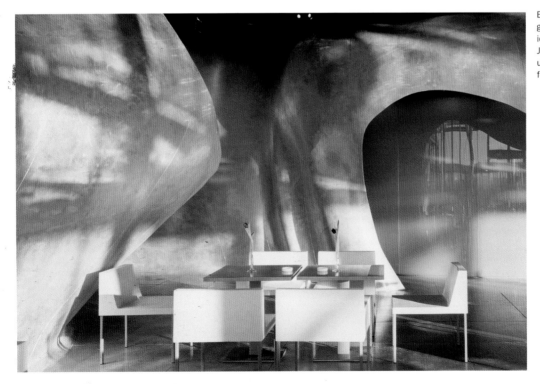

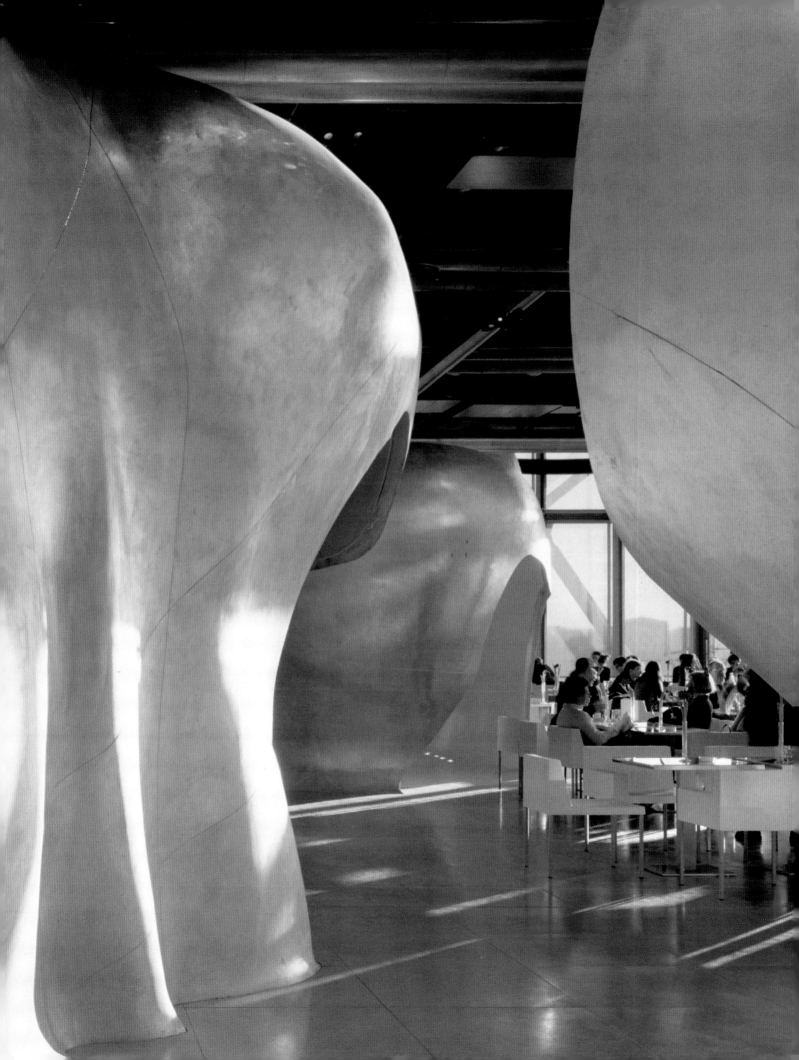

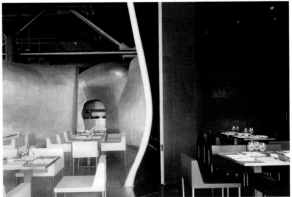

the work of Jakob + MacFarlane is undoubtedly emphasized or rather noticed more here because of the proximity of so much modern art, but they have, in fact, created a functional and very popular restaurant.

The architects, also on the basis of the overall grid system of the building, designed steel-and-polyurethane chairs and steel tables for Georges. The fact that they were able to maintain this degree of design control over the project, in cooperation with the Costes family, who operate the restaurant, creates a feeling of overall unity. Dominique Jakob and Brendan MacFarlane make no excessive claims to artistic creativity in describing their work at the Centre Pompidou. It is rather for visitors, already imbued with the combination of art and architecture represented by the building itself, to draw their own conclusions. Lined with bright red, yellow, green and orange rubber coating applied to the aluminum walls, the grottoes certainly appear to be more contemporary than the Piano & Rogers building (1977), but then the architects are born of the first generation to really use computers for architectural design. Given the highly visible location of the restaurant and its spectacular view over Paris, their work here represents one of the earliest "mainstream" uses of unorthodox shapes derived from digital morphing. Their success is evident in the fact that the freely curving forms they created — although they might appear more biological than mathematical — are, in truth, based on the rigid orthogonal grid of the 1977 building.

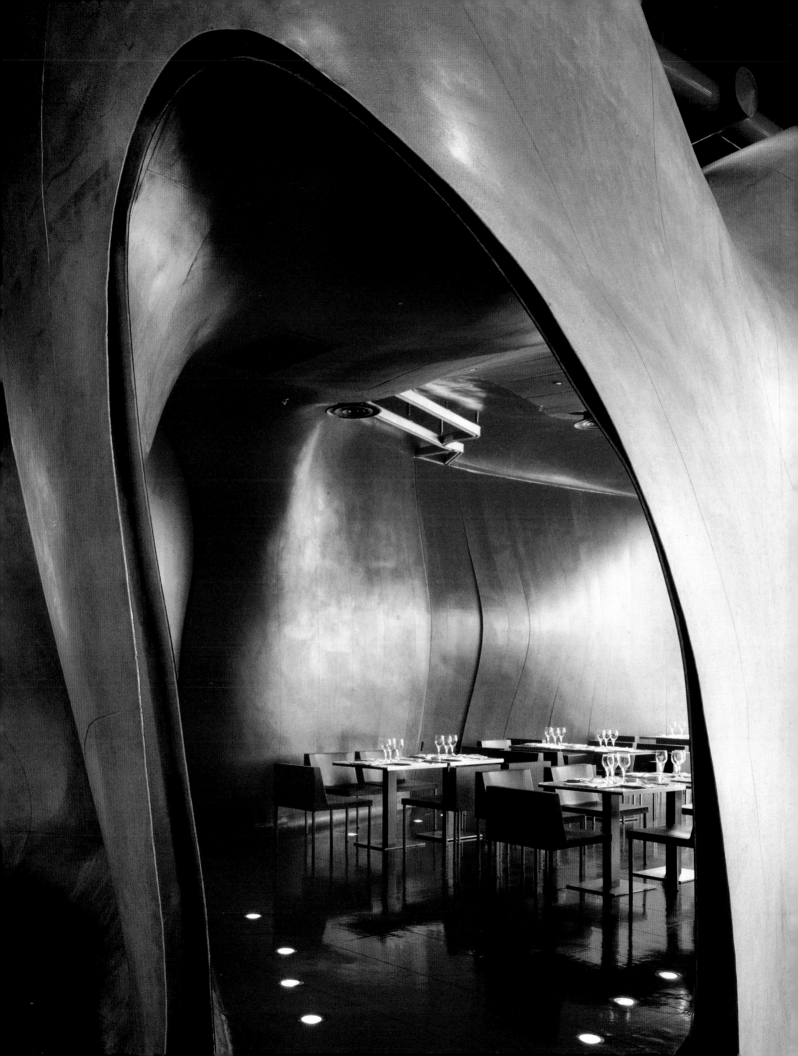

Ultimately, the goal of some architects is to dissolve the physical form of the building, making it change with use and needs.

Michael Jantzen sometimes asks why he gets so much press and has so little to actually build. His *Relocatable M-vironments*, made of a "wide variety of manipulatable components that can be connected in many different ways to a matrix of modular support frames," were intended as a highly flexible building system and garnered wide praise in the architectural press, without actually being put much into use, aside from the one-bedroom cottage Jantzen built himself in Gorman, California (2000). Jantzen certainly has a propensity for visionary projects, and his **Virtual Reality Interface VRI** (2002) is no exception. Inspired by recent advances in the creation of electronic visual data and presentation, the *VRI* is conceived as a sphere in which images could be artificially generated. As Jantzen says, "Windows could appear to be located anywhere on the sphere, and they could simulate the real outside world or alter what you see

to simulate a view from some other part of the world. The window view could have nothing to do with the real world and could be entirely computer generated." He goes on to say, "We primarily experience architecture visually. As a result, the *VRI* system could offer an endless variety of graphic architectural alterations of the spheres, making them look like anything we want."

Although the *VRI* remains an idea, its potential is one that could conceivably bring closer together the domains of architecture and art. Limited by physical reality, architecture, destined to serve a strictly defined purpose, can only on occasion break through the barriers that separate it from the more ethereal concerns of art. By using the latest technology, Jantzen imagines an infinitely variable architectural environment. He does not completely ignore practical requirements, however, and says that within the house "care would

be given to alter only parts of the interior that would not need to be physically negotiated. In this way the people inside could effectively function throughout the space."

If one concedes for a moment that a fundamental difference between art and architecture is a contrast between lightness and weight, then Jantzen's *VRI* could liberate architecture from its all too heavy reality. A real window or wall in even the most esthetically liberated building remains as it was conceived and it is this immutable nature that is at once the strength and the weakness of architecture. In his wonderful essay "The Comic Mask" (*Soliloquies in England and later Soliloquies*, 1922), the philosopher George Santayana wrote: "This world is contingency and absurdity incarnate, the oddest of possibilities masquerading momentarily as fact. Custom blinds persons who are not naturally speculative to the egre-

gious character of the actual, because custom assimilates their expectations to the march of existing things and deadens their power to imagine anything different. But wherever the routine of a barbaric life is broken by the least acquaintance with larger ways, the arbitrariness of the actual begins to be discovered." With his *Virtual Reality Interface*, Michael Jantzen has imagined an architecture that could break with custom in a fundamental way. Making architecture less "solid," or more intentionally ephemeral is a preoccupation of many contemporary architects, as works such as Diller + Scofidio's Blur Building (see pages 64–65) demonstrate. As the solidity of a structure dissolves through whatever method, it comes closer to the lightness of art.

Anish Kapoor is best known as a sculptor, and yet his fascination for architectural space is well known. His work **Marsyas**, exhibited in the Turbine Hall of Tate Modern in London in 2003, was a 155-meter-long, 35-meter-high span of PVC membrane stretched on three metal rings. Kapoor was the third participant in the Unilever series of commissions for the Turbine Hall, after Louise Bourgeois and Juan Muñoz, but unlike his predecessors he truly succeeded in questioning the geometric volume of the Tate with the great red curves of *Marsyas*. Inspired by legend or by a work of Titian (*The Flaying of Marsyas*, 1575–76, oil on canvas, State Museum, Kromeriz, Czech Republic), Kapoor described his choice of dark red PVC as being "rather like flayed skin." Stretched and twisted like the opening to another, inner world, *Marsyas* can be viewed as a fundamental challenge to the order expressed in the great rectangular void of the former Bankside Power Plant. Feeling safe in the great rectangular belly of the Tate, the visitor suddenly discovers the entrance to another, strangely familiar world, one in which the rules of architectural space can no longer impose themselves.

A more recent and presumably permanent work is the highly polished, stainless-steel sculpture entitled **Cloud Gate**, installed on the promenade of Chicago's new Millennium Park. Ten meters high, twenty meters long and weighing 110 tons, the work is surely imposing, but rather than its mass, it is the fluid reflection of the city's skyline, and passersby, that attracts attention. A local newspaper wrote after its July 2004 inauguration that some compared the work to "a rift in the very fabric of space and time." Like *Marsyas*, *Cloud Gate* challenges the perceived solidity of the surrounding architecture by deforming it in unpredictable ways. Even the speed of passing clouds and, therefore, time itself seems to be altered by its billowing

Anish Kapoor, *Marsyas*, 2003.
Installation. Tate Modern, London

skin. Though fashioned with enough non-Euclidean curves and shiny steel to excite the most stylish architect, *Cloud Gate* is not a building but very much a sculpture. In its esthetic perception, it may be compared to Diller + Scofidio's Blur Building (2000–01, see pages 64–65), which appeared to be no more than a cloud floating above an Alpine lake. Whereas the Americans made a building with water vapor, Kapoor dissolves the imposing skyline of the great city around his sculpture. In both cases, architecture approaches a liquid state.

Anish Kapoor might well reject the idea of any conscious commentary on the built environment, leaving it to the viewer to react. It remains a fact that the challenge to solid forms embodied in *Cloud Gate* is very close to areas of great interest to contemporary architects. His sculpture, derisively nicknamed "the bean" by some Chicago residents, can be readily compared in its form to the so-called "blob" architecture born of computer-driven design. Architects and artists today both seem haunted by the preoccupation voiced long ago in *Hamlet:* "O, that this too too solid flesh would melt, Thaw, and resolve itself into a dew!" In the heart of Chicago, *Cloud Gate* reflects the desire for solidity so ardently embodied by corporate towers, and distorts it beyond recognition. This is a rift in time and space, an arch through which the visitor may pass in order to understand that the firmness and solidity of architecture are illusory.

Anish Kapoor, *Cloud Gate,* 2004.
Sculpture. Millennium Park, Chicago

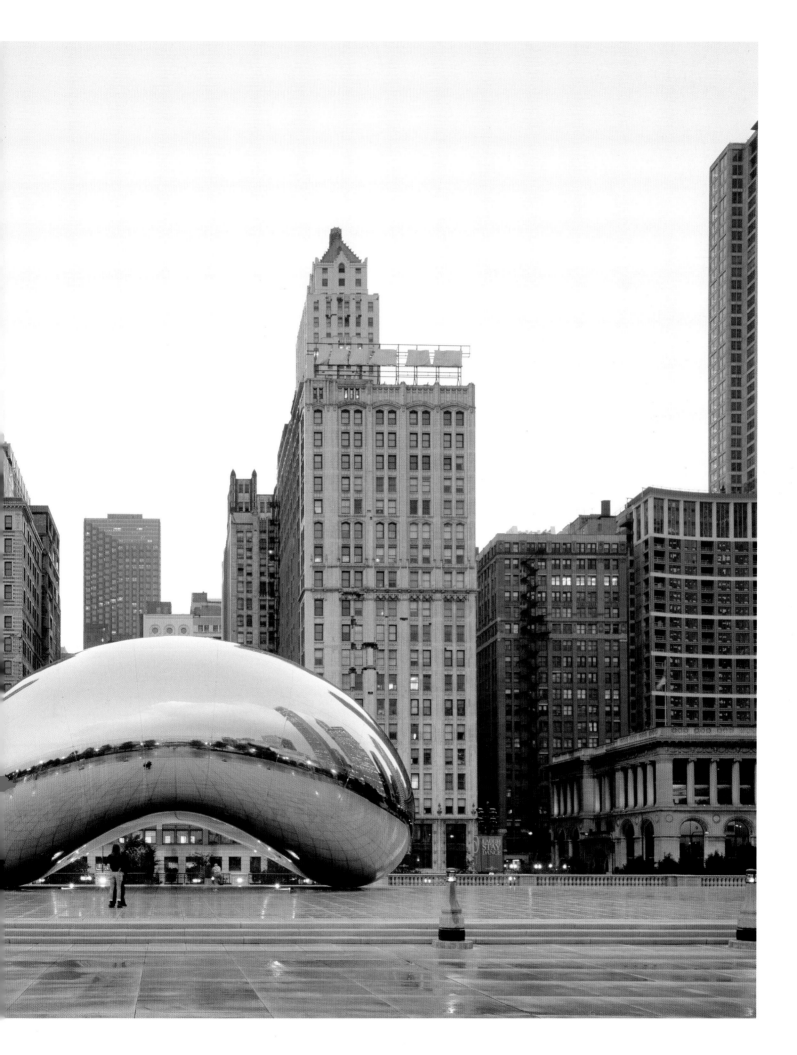

The town of Évreux, in France, is not high on the list of tourist destinations. Located in Normandy, it was founded in Roman times and known as Mediolanum. The town became the seat of a county in the 10th century and changed hands throughout the Middle Ages. Devastated many times during the course of its history, the town was extensively rebuilt after World War II. Although several monuments remain — such as the Notre Dame Cathedral (14th–17th centuries) and the St. Taurin Church — Évreux is, first and foremost, a place that people pass through on their way to somewhere else. Seeking to address this problem, the town invited Japanese artist Tadashi Kawamata to participate in its first art biennale in 2000. Kawamata responded by designing a 400-meter-long elevated walkway made of wood planks and steel scaffolding around the central Charles de Gaulle square that he called **Sur la voie** (*On the Way*). The idea was to allow the townspeople and visitors to discover the square and, in a way, the history of this place from a different angle, sometimes as high as the second floor of the structures.

As it happens, Tadashi Kawamata was just the person to conceive a work of art based on the idea of passage. When he was a young man in Tokyo he was struck, above all, by the impermanence of the Japanese capital, its construction sites, dumping grounds, or the cardboard shelters of the homeless. Since the early 1980s, he has used wood and improvised passageways as a form of artistic expression in several countries. Often, these large-scale installations involve wood and are linked to his ideas about the fundamentally transient nature of cities and their architecture. This was certainly the case of his 1987 work *La Maison des Squatters* (*The Squatters' House, Japon Art Vivant '87*, Grenoble), or his series of *Favela* constructions in 1991. In 1992, he completed his *Roosevelt Island Project*, a rambling wooden assemblage in and around the abandoned Small Pox Hospital, just across the river from the skyscrapers of mid-town Manhattan. His *Passage des Chaises* was a remarkable construction made of wooden chairs inside an old Paris chapel (*Passage of the Chairs*, Saint-Louis de la Salpêtrière Chapel, 1997). South Korean architect and founder of New York's *Storefront for Art and Architecture* Kyong Park has commented on the significance of Kawamata's invention of an art form that challenges the scale of architecture. "In reversing the territorial command between art and architecture," says Park, "Kawamata turns everything there into a contextualism, and begins to dominate and deconstruct the existing. In fact, most of his projects depend on the presence of architecture, for it becomes the subject of response, criticism and improvement. The result is a spatial symbiosis between old and new, art and architecture and where their old autonomy leads to

their new syneresis." Kawamata's importance as an artist close to the world of architecture was underlined when we was selected to succeed Arata Isozaki as director of the 2005 *Yokohama Triennial*.

In Évreux, as he has elsewhere, Kawamata made a substantial effort to involve the townspeople in the process of conceiving and building *Sur la voie*. In this, his work process is similar to that of Christo and Jeanne-Claude, who have also used art to make people see their own architectural (or natural) environment in a new way.

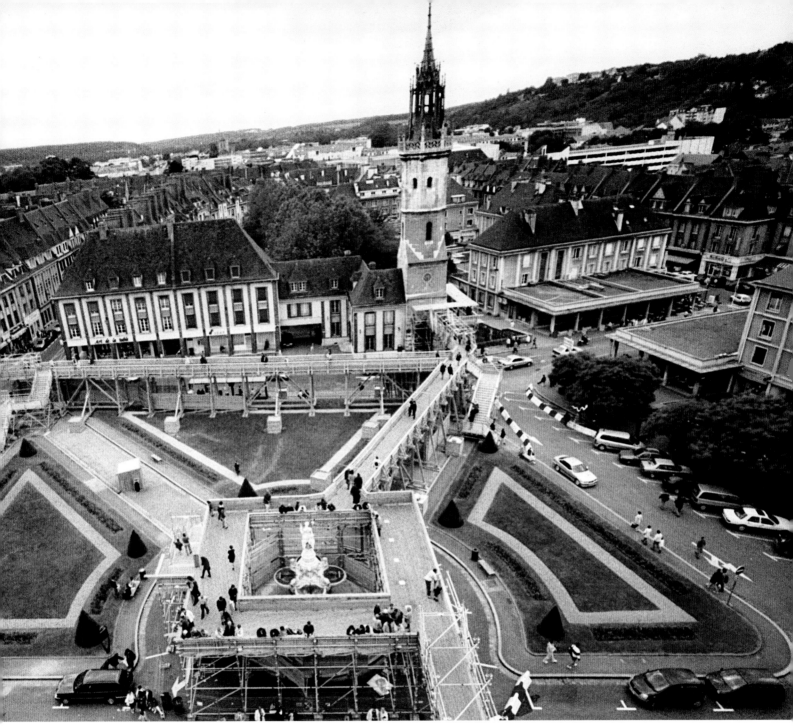

Tadashi Kawamata,
Sur la voie/On the Way, 2000.
Installation. Évreux

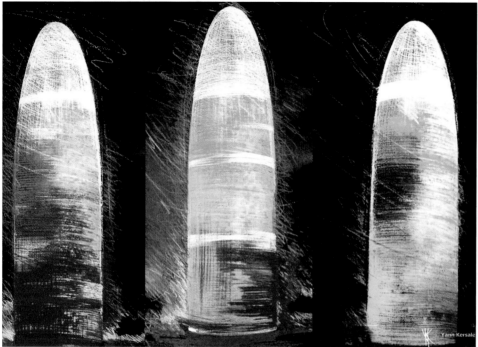

Yann Kersalé, *Torre Agbar/Agbar Tower,* 2005. Light concept. Barcelona

Yann Kersalé uses light to create works of art. Unlike James Turrell, he works almost exclusively outdoors; indeed, one of his preferred means of expression is to create works "on top of" buildings. Using their form, he employs light as "malleable substance," giving architecture a new and different presence in the night. He has worked with Helmut Jahn in Berlin (Sony Center, Potsdamer Platz, 2001) and more recently in Bonn (Deutsche Post Tower, 2003), or with Jean Nouvel in Lyons (Opera, 1988), and soon in Paris (Museum of Arts and Civilizations, 2006).

Born in 1955, Kersalé attended the École des Beaux-Arts in Quimper and has given a new meaning to exterior lighting that certainly deserves to be called art. He is opposed to the type of brutal, direct lighting that usually is reserved for historic monuments and other important buildings, preferring to create an "atmosphere" with his lighting effects. Kersalé's most current project with Jean Nouvel concerns the new **Agbar Tower**, which is located in the heart of Barcelona, on the Diagonal Avenue. The lozenge (or phallic) shape of the tower is intended to evoke a kind of frozen fountain, since the client for the structure is the local water company. Very much interested in the external appearance of his buildings, Nouvel has written that "The surface of the building evokes water: smooth, continuous but also vibrant and transparent since its matter can be read as a colored and uncertain depth, luminous and with nuances." One hundred and forty-two meters high, the building is visible from a good part of the city, but in agreement with Kersalé, Nouvel did not want a lighting that would be too overt or blatant.

Working as he often does in close collaboration with Nouvel, the lighting artist proposed the installation of several hundred bars,

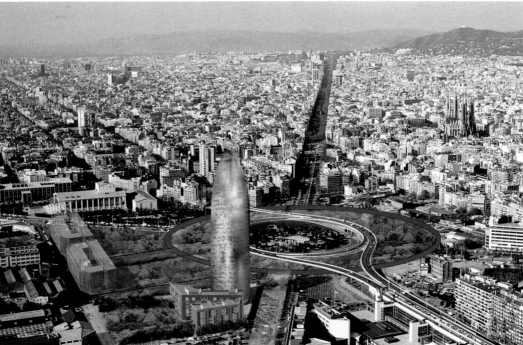

© Yann Kersalé

each containing ten light-emitting diodes in the four primary colors. By varying the intensity of each diode through the use of a simple computer program, Kersalé was able to ensure that an almost infinite variety of subtle coloring would appear on the surface of the Agbar Tower at night. Placed between the inner and outer skins of the structure, this **LED System** was meant more to give a feeling of "evaporating clouds" of light than it was in any sense to underline the specific architecture of Jean Nouvel. With a life expectancy of more than 100,000 hours and extremely low electricity consumption, the LEDs guarantee that this work of art will glow in the sky of Barcelona for many years to come.

Kersalé readily admits his admiration for James Turrell, but points out that his path is quite different from that of the American, going beyond the issue of inside or outside effects. "Turrell is at his best," says Kersalé, "when his works create a physiological effect on the viewer." Enclosed in spaces defined by Turrell, viewers often do get a sensation of falling or floating in the substance of light itself. If Turrell's approach might be likened to sculpting with light, then Kersalé's would be the equivalent of painting. His canvas is the Agbar Tower, or Nouvel's unbuilt Tour Sans Fin (1982). Actively interested in collaboration with architects, engineers or other artists, like Patrick Blanc (inventor of "vegetal walls," such as those seen in the Fondation Cartier in Paris or the 21st Century Museum of Contemporary Art in Kanazawa), Kersalé, like many important artists of today, cannot be easily categorized. In a sense dependent on architecture in a symbiotic relationship that defines his basic forms, Kersalé inevitably retains the ephemeral, shifting nature of outdoor lighting conditions as part of his concepts. Few others have succeeded in making buildings into very contemporary canvases of light.

The union of architecture and art is not always happy, and one painter who has dared to confront this truth is the German Anselm Kiefer. Kiefer's works are often monumental views of dark architectural settings. He is rarely explicit about his sources and intentions, but one series of paintings executed between 1980 and 1983 deals specifically with the architecture and mythology of Nazism. Kiefer has said that he finds Nazi architecture "interesting" and that he painted it "in order to transform it like the Christians transformed the ancient temples of the Pantheon … to give them a new destiny, a new significance." He could hardly have taken on a more emotionally and historically difficult subject.

One of his works, **The Unknown Painter** (*Dem unbekannten Maler*), represents a view of a corner of one of Munich's "Honor Temples" (Ehrentempel, 1935). Designed by the first of Hitler's architects, Paul Ludwig Troost (1878–1934), these were the burial places of the sixteen "martyrs" killed in the putsch of November 9, 1923. The site was watched over day and night by an "Eternal Guard" (Ewige Wache). The US Army razed the Honor Temples in 1947. Troost belonged to a group of architects who had reacted, like Peter Behrens and Walter Gropius, against the ornamental excesses of the Jugendstil, and he evolved after World War I toward a style that has been described as a "Spartan traditionalism with elements of modernity." He designed the Nazi Party's Brown House in Munich, before taking on the Haus der Deutschen Kunst, also in Munich. Clearly, however, the "Ehrentempel" incarnated far more than Hitler's taste in architecture; they were also powerful symbols of a nascent ideology. As Hitler said in 1935, "These temples are not tombs but an eternal guard. They are there for Germany and they watch over our people."

Daniel Arasse has demonstrated convincingly that Anselm Kiefer's *Unknown Painter* is none other than the "Führer" himself, who was often called an "artist" or a "painter" by such figures as Goebbels or Minister of Culture Hans Schemm. Nor are these references to Hitler's mediocre talents as a draughtsman. Arasse cites Goebbels, who wrote in his *Combat for Berlin* (1931): "The masses are nothing other than a raw material for us. It is only by the hand of the artist that from the masses there rises a people, and from the people a nation." Thus, in his dark painting, Anselm Kiefer takes on the most sinister deformations of the glory of art and architecture — the powerful use of art for the purposes of propaganda and the justification of a regime that ultimately caused the death of untold millions.

Although he has chosen to live in France rather than Germany, Kiefer has thus bared wounds that have never healed. In recent years, exhibitions have drawn a great deal of attention to the consistent and clever use of art and architecture to political ends, in particular by totalitarian regimes. Where cathedrals once stood to the glory of god, artists and architects in the 20th century often pooled their efforts to create monuments to new and dark religions. By daring to paint the "Ehrentempel," Kiefer attempts to exorcize the evil art of *The Unknown Painter*, and to restore a sense of power and truth to an architecture of darkness.

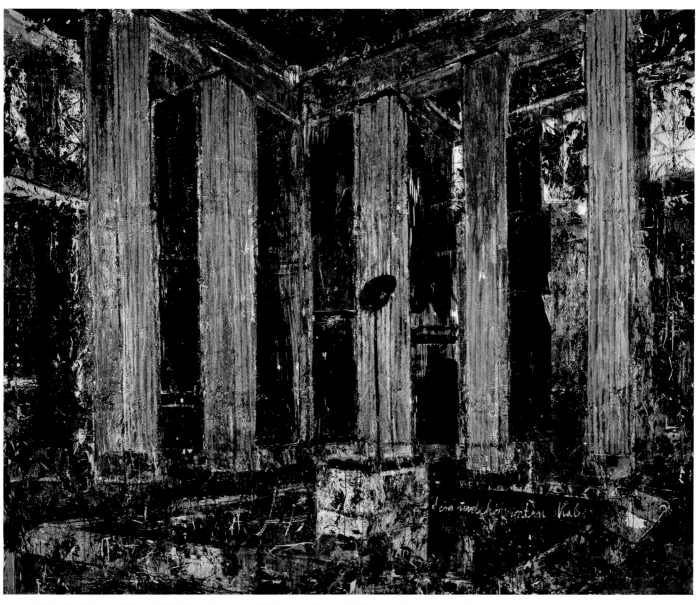

Anselm Kiefer, *The Unknown Painter,* 1982. Oil, acrylic, straw, 280 x 341 cm. Museum Boijmans van Beuningen, Rotterdam

Incongruity and ambiguity are two essential features of contemporary art. Architecture, on the other hand, usually seems to eschew uncertainty. Their very physicality makes it difficult for walls and ceilings to dissolve, in the image of the Blur Building by Diller + Scofidio (see pages 64–65). Art, at the opposite end of this spectrum, rarely seeks the kind of brick-and-mortar solidity of the built environment, but there are notable exceptions. One of the most interesting of these was an installation at Tate Britain (Millbank) in London. The artist Michael Landy, born in 1963 in London, is perhaps best known for his work *Breakdown 2001*, in which he systematically destroyed all of his 7,227 personal belongings on the ground floor of a temporarily abandoned Selfridges store (Oxford Street, London, February 10–24, 2001).

His installation at Tate Britain, ***Semi-Detached*** (May 18–December 12, 2004), was of a radically different nature. In the midst of the rather grand Duveen Galleries, he built, with the help of Mike Smith, an exact replica of his parents' modest, brick home. Every detail of the original house, including the flaking paint and loose wires, was reproduced, although the home was sharply divided in two to allow for video projections of scenes from the artist's life. Even the massive, bronze sculptures of Anthony Caro and others who have exhibited before in this space could not rival Landy's *Semi-Detached* in terms in solidity and presence. There are numerous incongruities in this installation — not the least being the contrast between the willful elevation of art to a cult status by institutions such as Tate Britain and the gritty "reality" of an ordinary home in the midst of so much marble. There is a domestic familiarity about this work that runs counter to the rarified atmosphere of the art museum. Filling the Duveen Galleries in a decidedly unesthetic way,

the work also challenges the canons of classic space. If architecture often aspires to become art, it does not do so through realizations as banal as the artist's parents' house. Like Rachel Whiteread's 1993 concrete cast of an East London *House* (see pages 210–11), Landy's work poses the question of the transposition of the ordinary into the realm of art's hallowed ground. Marcel Duchamp's urinal *Fountain* (1917), of course, raised the issue of artistic transmutation early in the last century, but the intellectual originality of Landy is not really the issue. In an era of high technology and slick surfaces, *Semi-Detached* is also a representation of the kind of environment that most museumgoers actually come from, as interviews carried out during the Tate Britain show testify. Whatever interpretation is given to Landy's work, there could hardly be more tangible proof of the fascination of contemporary artists with architecture. Having physically destroyed his belongings in an earlier show, the artist here reconstitutes a part of his life in real brick and mortar. Despite its meticulous attention to detail the work is, in reality, no more than a decorated surface, since the interior of the building was not part of *Semi-Detached*. In short, the physicality and signature of architecture are present, but neither functions beyond the emotional or visual reactions associated with the exterior view. Painters have long dealt with the ambiguities of surface versus depth, but what Landy has created here is, in effect, a three-dimensional surface, a kind of architectural stage set made with the real materials of a building.

Michael Landy, *Semi-Detached*, 2004.
Installation. Tate Britain, London

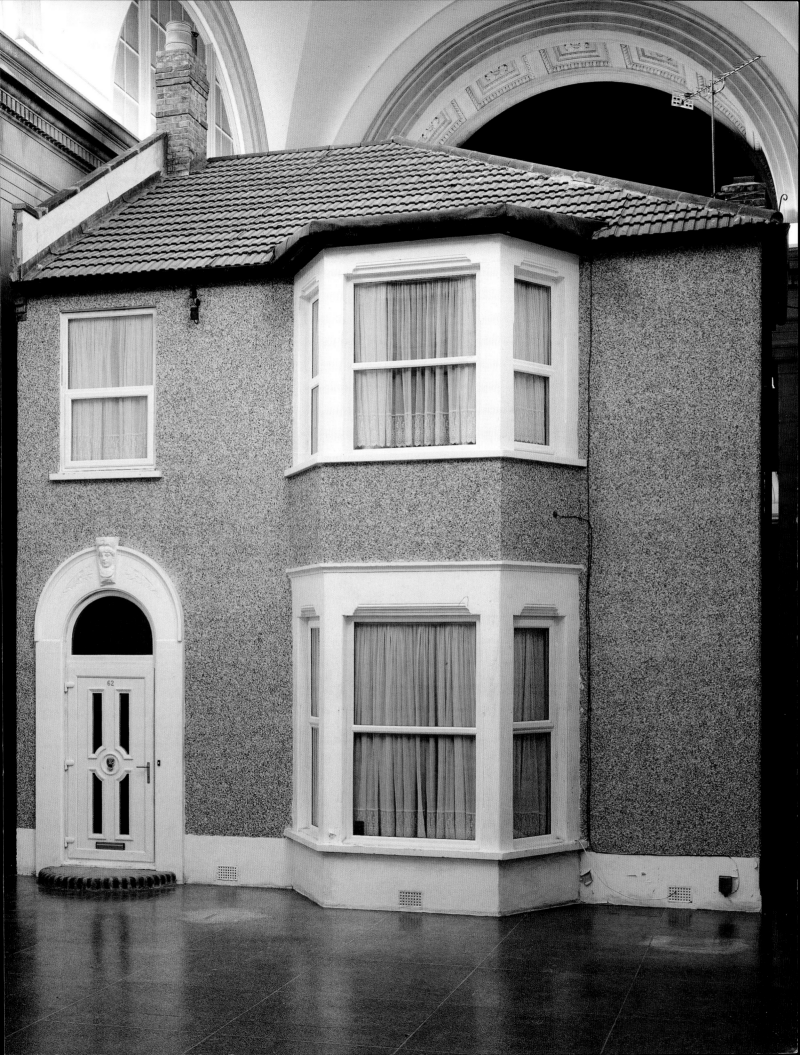

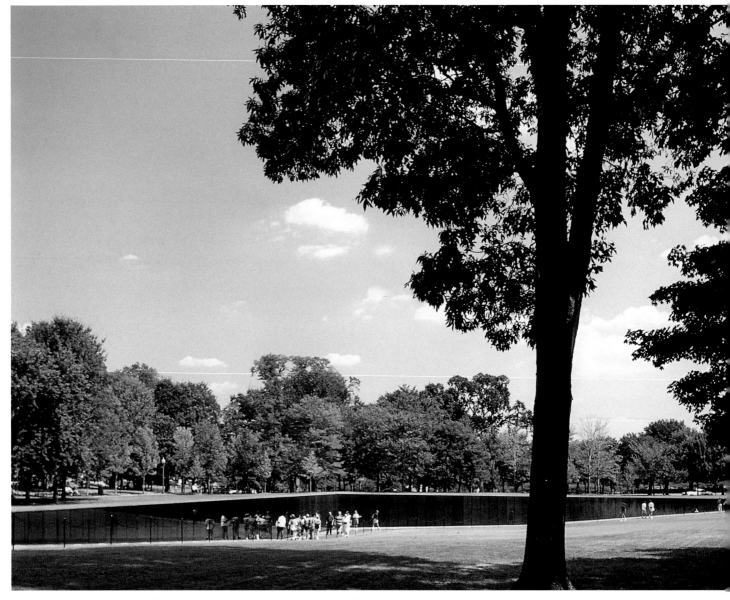

A black granite slash in the earth with the names of America's Vietnam dead engraved in the order of their death negates the expected form of a memorial and simultaneously expresses the less than heroic dimension of the country's plunge into war, without offending the families of the fallen.

"I see architecture not as a form that contains space, but as an experience, a passage," says Maya Lin. At the age of 21, as an architectural student at Yale, she submitted the winning design for the *Vietnam Veterans Memorial* in Washington, D.C. (1982). This V-shaped wedge of black granite slices into the earth of the Mall, not far from the Washington Monument. Inscribed on it, in the order of their death, are the names of the 57,000 Americans who lost their lives in Vietnam. She has since designed other monuments as well as architecture in the more traditional sense, but addressing the differences between forms of expression, she has said, "I consider the monuments to be true hybrids, existing between art and architecture; they have a specific need or function, yet their function is purely symbolic."

Maya Lin attended the Yale School of Architecture after graduating from the college and there she met Frank Gehry. "Frank was very supportive when I was in graduate school," she says. "When I told him that instead of drawing up a design I wanted to collaborate with a sculptor and build something, he said, 'Great, go ahead.' So, without planning, we built this huge tree house 40 or 50 feet off the forest floor in Vermont. Frank was wonderful. He made me realize that it was OK to be in between art and architecture. I remember him saying, 'Don't worry about the distinctions. Do what you need to do.'"

The *Vietnam Memorial*, still visited by more than 2.5 million people each year, is considered to be one of the most successful modern war monuments, precisely because of its sculptural simplicity and the inscription of the names of the dead on its surface. When asked if she makes a conscious effort to challenge the barriers

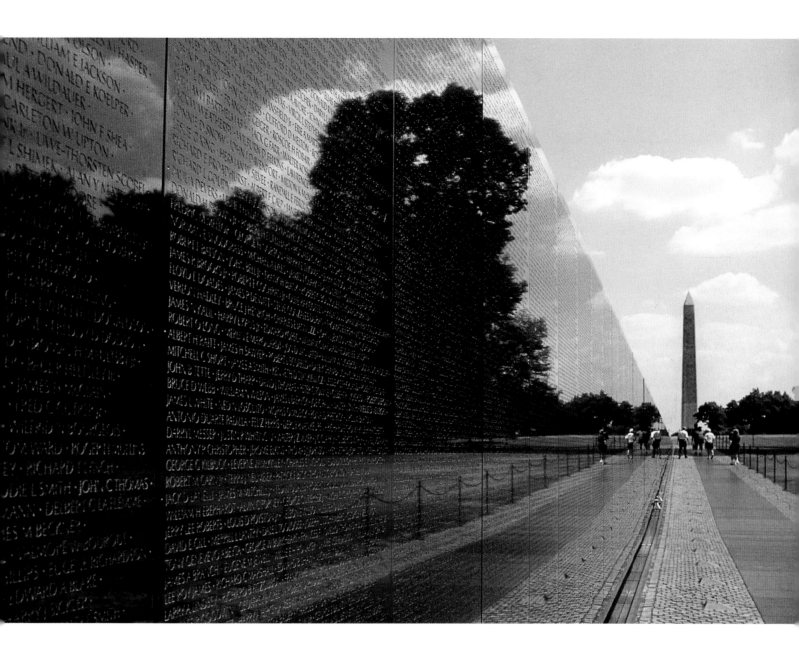

between art and architecture, she answers with some self-contradiction: "I have not tried to make an overt statement. There is inspiration and artistry involved in making a monument or designing a house, and yet you are still apparently involved in making something that is functional. For me, the *Vietnam Memorial* was a sort of exercise, because I never expected it to be built. It was an ideological commentary about trying to go against our standard approach in the United States to monuments. I tried to avoid making any overt political statement. What I was concerned with was not modern art — it was not necessarily an esthetic statement. To be apolitical became political — to not declare a victory. The identification of the individual as the individual — that is a 20th-century idea. I had no notion of making a hybrid of earthworks of the 1970s and architecture. I do not tend to approach that kind of esthetic theorizing or

commentary within the work. I leave it to others to make such comments."

Maya Lin's disavowal of "esthetic theorizing" is an interesting commentary on the real sources of works that cross barriers between disciplines. The *Vietnam Memorial* was more the creation of a young person who felt no need to categorize her work than it was in any sense a conscious attempt to break down barriers between art and architecture. Defining the word "art" has always been notoriously difficult, and even more so in recent times. The elevated status accorded to artists and their output is one reason for hesitation on this account, especially where more pragmatically functional architecture is concerned. An artist is often granted a freedom of expression not afforded to architects. And what, asks Maya Lin, would happen if the work itself were more important than its category?

Designed by Zaha Hadid and completed in 2003, the new home of the Contemporary Arts Center (CAC) is located at the corner of Walnut Street and East Sixth Street in downtown Cincinnati. Prior to moving to this location, the CAC was one of the first institutions in the United States dedicated to exhibiting contemporary art. In 1990, the CAC was at the center of a heavily publicized First Amendment legal case when it successfully defended "the right of Cincinnati's citizens to view an exhibition of the photographs of Robert Mapplethorpe." As the first woman to design a museum in the United States, Zaha Hadid made the transition from an architect best known for her drawings to a builder on a large scale with this project. Sculptural and complex, the building has been widely praised, even in the relatively uninspiring cultural environment of Ohio.

One of the artists who participated in the inaugural exhibition of the CAC was the Spaniard Iñigo Manglano-Ovalle. Born in Madrid in 1961, he obtained degrees in Latin American and Spanish literature at Williams College and in sculpture from the School of the Art Institute of Chicago. He is now a member of the faculty at the University of Illinois in Chicago. Manglano-Ovalle's work has taken many different forms, often implicating architecture or an architectural setting. In his video work *Le Baiser/The Kiss* (1999), for example, a window washer cleans the windows at Mies van der Rohe's Farnsworth House while inside, a DJ mixes music — both characters unaware of each other's presence. For *En Busquedad/Search* (2001), he converted a Tijuana (Mexico) bullring into a deep-space radio telescope, using the venue of a popular local sport to search for "aliens" near the US-Mexican border — a gesture whose social implications were not lost on viewers. More recently, he had a solo exhibition in Mies van der Rohe's Barcelona Pavilion (2002).

The work shown in Cincinnati by Iñigo Manglano-Ovalle, *Cloud Prototype No. 1* (2003), is a "scale model of a 30-kilometer-long cumulonimbus thundercloud based on an actual storm database provided by the Department of Atmospheric Sciences, the National Center for Supercomputing Applications (NCSA), and the Beckman Institute at the University of Illinois at Urbana-Champaign." In the heart of Zaha Hadid's carefully-thought-out orchestrations of architectural forms, it "hangs ominously overhead, invoking both a swirling thunderhead and a mushroom cloud from an atomic bomb," as the CAC press release had it. "Here, Manglano-Ovalle updates the visual vocabulary of the Romantic sublime," says the CAC, "fusing a dramatic staple from late 18th- and early 19th-century landscape painting with a haunting, iconic image of the aftermath of a catastrophic detonation."

Especially in the context of Hadid's solid sculptural environment, *Cloud Prototype No. 1* could indeed be construed as a disturbing presence, a perfect storm in the middle of a perfect building. Exhibited in a hanging position, the work is conferred with an impression of lightness that might be appropriate for a cloud, and yet its titanium covering gives it a shimmering opacity that contrasts with its "real" model. This is not so much an act of collaboration between art and architecture as it is a confrontation — a natural yet potentially menacing form in the midst of Hadid's best effort yet to show the world that she can build, too. Made for art, even the "dangerous" kind as witnessed by the Mapplethorpe case, the CAC embraces this thundercloud in its inner sanctum, thus sheltering the storm.

Iñigo Manglano-Ovalle, *Cloud Prototype No. 1*, 2003. Fiberglass and titanium alloy foil, 3.35 x 4.47 x 2.44 m. Cincinnati Contemporary Arts Center

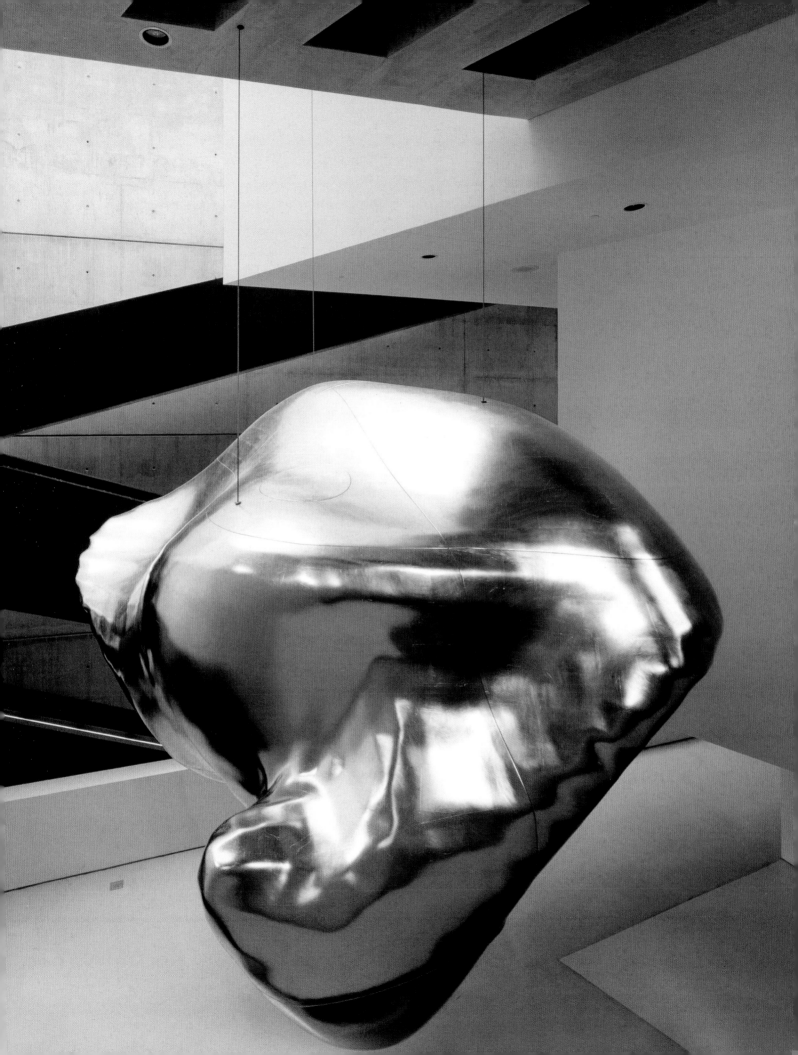

Throughout his career, Richard Meier has made frequent reference to art, whether in his architecture or as a painter and sculptor in his own right. As early as 1963, he worked in the studio of painter Frank Stella and participated with the artist in a competition to design a fountain in Philadelphia. Describing the motivations behind his own white, geometric structures, he says: "As an artist or as an architect, one has a choice: representational art or abstract art. Abstraction allows architecture to express its own organizational and spatial consequences, it permits the creation of space without confusing its volume with any superimposed system of meaning or value." His use of the sail metaphor in Rome may seem to contradict this affirmation, but the reference is rendered sufficiently abstract, or mathematical in its derivation, to be compatible with his usual geometric precision. Unapologetic, he declares: "I consider most of my buildings as works of art."

One of his most recent structures, the **Jubilee Church** (Dio Padre Misericordioso, Tor Tre Teste, Rome, Italy, 1996–2003), is

Using his favored combination of white surfaces and ample light, Richard Meier crosses a frontier in Rome, lifting architecture into the sphere of the spiritual.

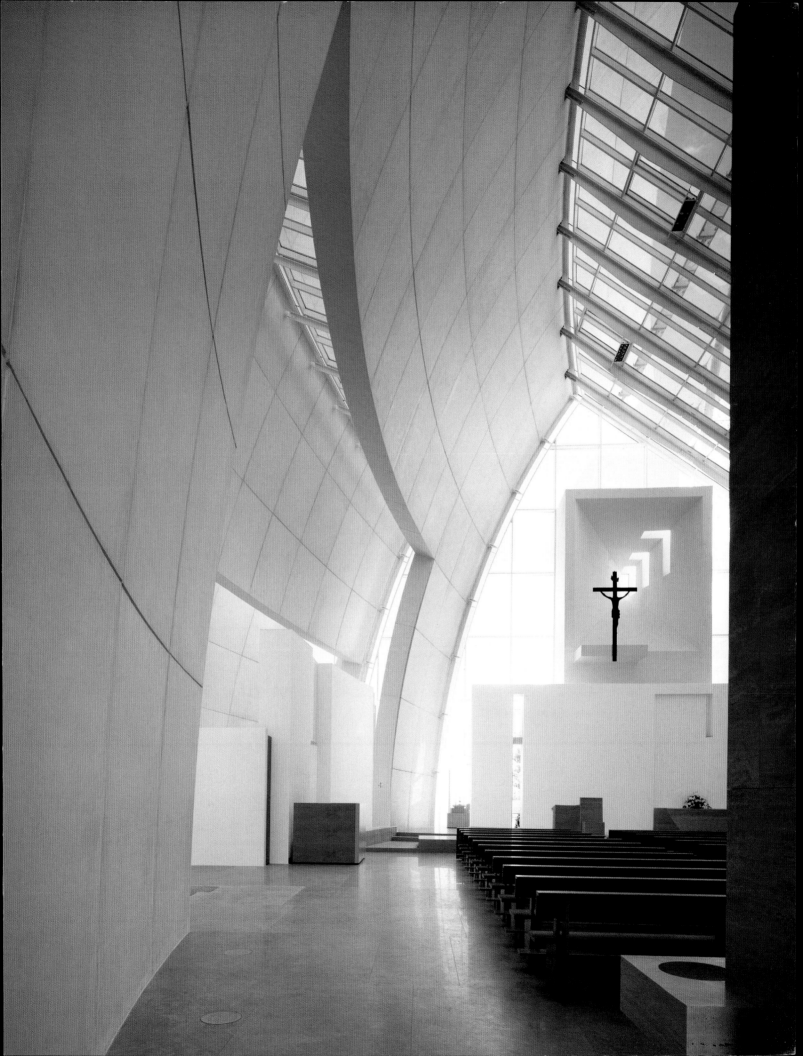

located on a triangular site and features three dramatic shells or arcs that evoke billowing white sails. Winner of a competition that also drew entries from Tadao Ando, Günter Behnisch, Santiago Calatrava, Peter Eisenman and Frank Gehry in the spring of 1996, Meier as usual placed an emphasis on white forms, and natural light. "Light is the protagonist of our understanding and reading of space. Light is the means by which we are able to experience what we call sacred. Light is at the origin of this building." According to the architect, the sources of his inspiration are "the churches in which the presence of the sacred can be felt: Alvar Aalto's churches in Finland, Frank Lloyd Wright's Wayfarer's Chapel in the United States, along with the Chapel at Ronchamp and La Tourette by Le Corbusier." Inaugurated on October 26, 2003 to mark the 25th anniversary of the Pontificate of John Paul II, Dio Padre Misericordioso was Meier's first church, although he had previouisly designed a chapel.

Richard Meier's intellectual and architectural rigor raise the legitimate question of whether a building can be a work of art in and of itself. Sensitive to the values of modern art, he often cites the words of his friend Frank Stella, who has said, "Light is life." Meier's work, like that of James Turrell, has a great deal to do with the use of light as a mediating force, a constant and substantive presence. While Turrell has indulged in the use of colored light, Meier fashions his own environments almost exclusively with white cladding. The comparison to Turrell or other artists need not be insisted on too much — Meier's buildings do stand and serve a purpose. Though he practices the art of collage or sculpture in metal, he is, of course, known primarily as an architect. In the 19th century, John Ruskin (1819–1900) wrote: "No person who is not a great sculptor or painter can be an architect. If he is not a sculptor or painter, he can only be a *builder*." Clearly, the art and architecture of Ruskin's time was quite different from the production of Modernism, and yet his point may still apply to an artistically inclined architect such as Richard Meier. Meier's point is not about creating confusion between art and architecture so much as it is to affirm that architecture, when it reaches a certain level of perfection, can be termed art in its own right.

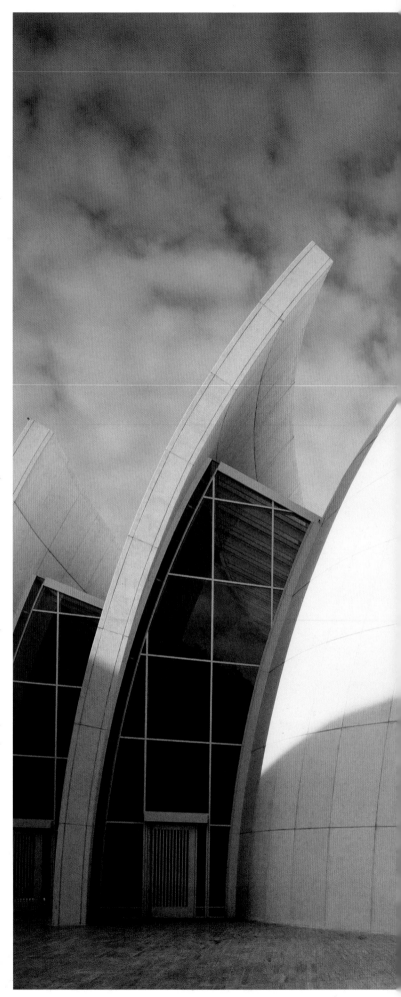

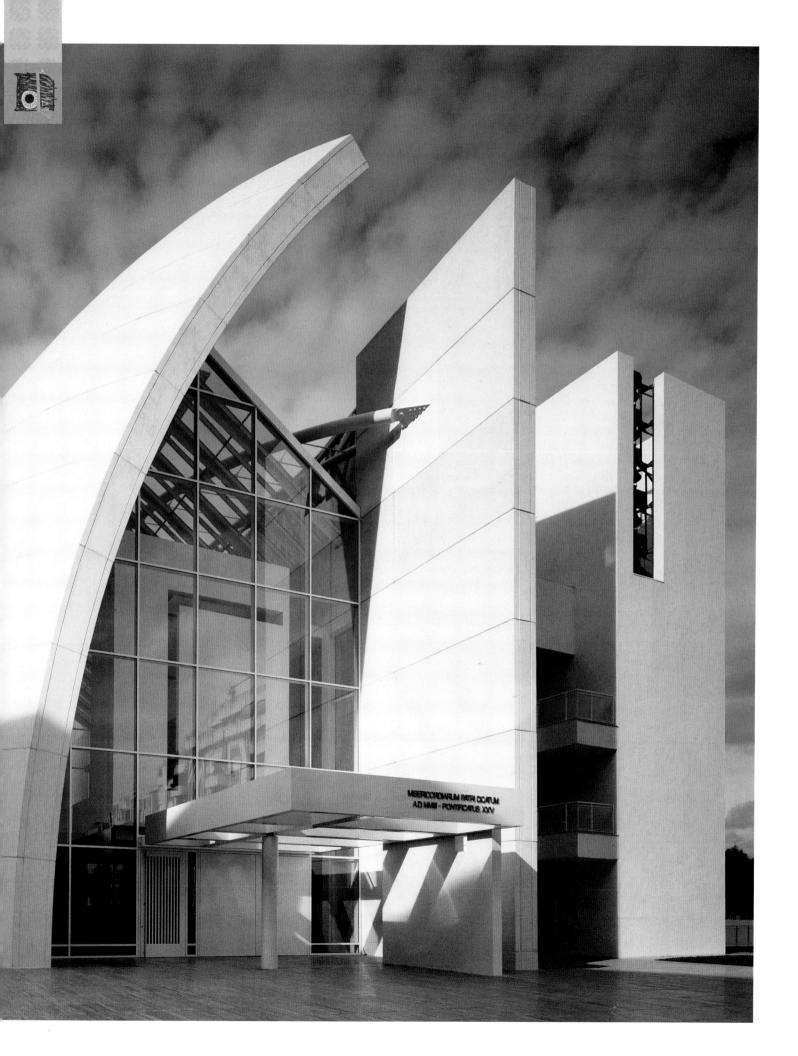

MISERICORDIARUM PATRI DICATUM
A.D. MMIII · PONTIFICATUS XXV

Computer images and the finished building show the fundamentally sculptural nature of The Umbrella.

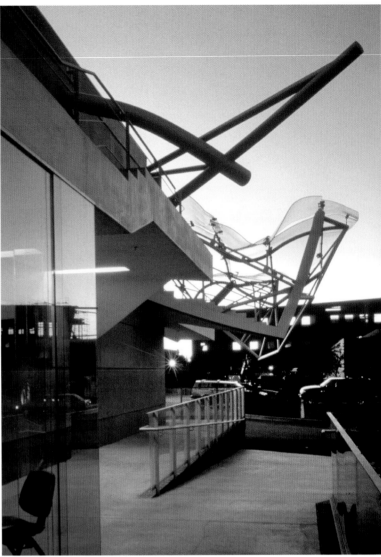

Eric Owen Moss is an unusual architect. The majority of his work has been with one client in one area of Los Angeles — Culver City. The promoter with whom he has worked, Frederick Smith, owns the so-called Hayden Tract, where Moss has renovated a number of warehouse buildings, frequently calling on his own sculptural sense of materials. Some time ago, Philip Johnson dubbed Moss "a jeweler of junk," because of his use of old chains, broken trusses or other structural materials extracted from buildings he is working on. **The Umbrella** (1998–2000), located at 3542 Hayden, is described by the architect as "a cascading series of laminated glass panels mounted over an open-air platform and stairway." A 1,470-square-meter project undertaken for a cost of $1,185,000, The Umbrella is made up of two contiguous warehouses built in the 1940s and renovated to include twenty private offices, two conference areas and large, open workspaces. As for the name of the project, Moss says, "It is a conceptual bowl, an arena, the slope of which is determined by the curving top chord of two inverted wood trusses salvaged from the demolition of an adjacent project and inserted here. Its structure is a careful amalgamation of two existing roof trusses, two recycled

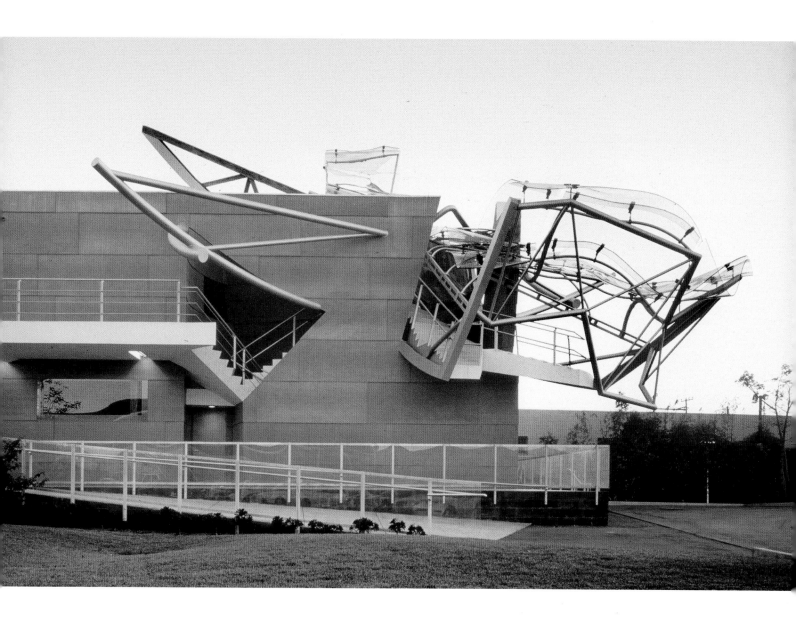

trusses from a demolished building on the site, and a new steel truss-like beam. A steel pipe structure attached to the trusses, which covers the bleacher/stairs, supports the rippled glass canopy."

Eric Owen Moss has spoken frequently about the relationships between contemporary art and architecture, but like his buildings, his point of view is not what one might expect. "A man who is slightly mad is hacking away at a piece of wood and it becomes a cow," says Moss. "Is it art? The question is whether that has anything to do with the intention of the practitioner. The practitioner is obviously not aware of the consequences of his hacking. It is not necessarily a question that you can answer mathematically. There seems to be a lot of contemporary art that is about putting down what is uninten- tional, or trying to get to what is underneath intention by firing paint into a wall. Jackson Pollock did that for a while." His wariness about being called an artist is expressed clearly. "There is a lot of fog and a lot of crap in contemporary art and architecture — a lot of Baudrillard and Derrida. As far as I am concerned, I am beginning to recognize a kind of target that is a sensibility, and I think that I am

starting to understand how to get to that sensibility." Despite his dismissal of two significant figures in the evolution of contemporary American art and architecture, Moss does approach his work from a literary or psychological point of view. "There are paradigms for un- derstanding the world," he says. "There are models like the Freudian or Marxist ones. None of the models ever forecast their own demise. All of these points of view come to an end. Somehow, the advocate of a point of view does not build that into his advocacy. I am talking about intellectual conceptions of the world such as those of Newton, that of Darwin, but also about religion. One has to find a premise that allows you to look backward and forward and to make sense of things. The world has gone on a long run with certain ideas, and now everyone knows that those forms of order are ending." There is a disordered authenticity in the work of Eric Owen Moss when he eviscerates a building and uses its parts to make a clearly sculptural extrusion to what is otherwise a functional office building. He is, however, too clever to call himself a sculptor.

Oscar Niemeyer has long had a passion for art, whether in selecting artists to participate in his own projects from the early work in Pampulha to the present, or in realizing sculptures and drawings. He has spoken of "the creative act, the highly sought-after integration of art and architecture." It is the only way," he says, "to create in a logical fashion, with a view to the indispensable unity and beauty of the work." Though born in 1906, Niemeyer designed a very successful pavilion for the Serpentine Gallery in London in 2003. Serpentine director Julia Peyton-Jones has convinced a series of famous architects, including Toyo Ito and MVRDV, to create ephemeral structures for the Gallery's Kensington Gardens site, and she went to Rio to enlist the participation of the architect of Brasilia. "I am delighted to be designing the **Serpentine Gallery Pavilion**, my first structure in the United Kingdom," wrote Niemeyer after her visit. "My idea was to keep this project different, free and audacious. That is what I prefer. I like to draw, I like to see from the blank sheet of paper a palace, a cathedral, the figure of a woman appearing. But life for me is much more important than architecture." The intimate relation between Niemeyer's sketches and his buildings may be even more apparent with his advancing age, but from the first it was drawing that attracted him to architecture. Responding to critics who have accused him of making sensual drawings that cannot readily be identified as functional buildings, he has recently said: "When I make a drawing of a building, I always think of function. In Paris, for the Com-munist Party Headquarters, they wanted a second building and they asked me to design it just as I had the first one. They called me because my work is logical."

Describing the Serpentine Gallery Pavilion, a 300-sq.-meter concrete veil, he says: "I wanted to give a flavor of everything that characterizes my work. The first thing was to create something floating above the ground. In a small building occupying a small space, using concrete, and few supports and girders, we can give an idea of what my architecture is all about." In works he has designed recently, Niemeyer has made use of his own drawings as decorative elements on exterior or interior walls. But his drawings are more than a décor. As he says himself, they represent the very substance of his creativity. Niemeyer's originality came when he broke from the Purist rigidity of Le Corbusier, one of his first mentors, together with Lucio Costa, the urban designer of Brasilia. His would be an architecture, indeed an art, of curves, perhaps the curves of his native Rio, as Le Corbusier famously suggested, or perhaps more simply the curves of life. "I am not attracted to straight angles or to the straight line, hard and inflexible, created by man," says Niemeyer. "I am attracted to free-flowing sensual curves: the curves that I find in the mountains of my country, in the sinuousness of its rivers, in the waves of the ocean, and on the body of the beloved woman. Curves make up the entire Universe, the curved Universe of Einstein."

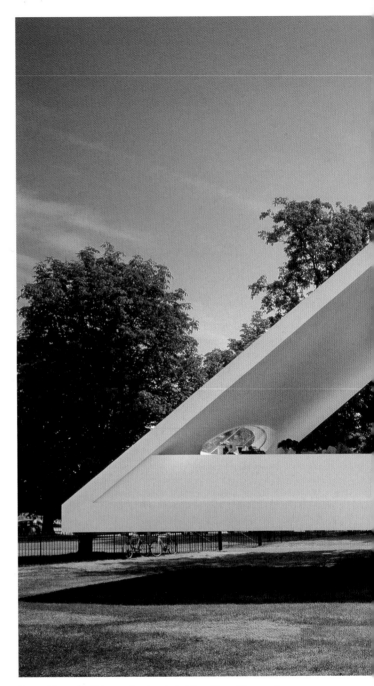

Resembling one of his own free-hand sketches, Oscar Niemeyer's Serpentine Gallery Pavilion floats above the earth, evoking the curves of his native Rio, and showing the possibilities still offered by concrete in contemporary architecture.

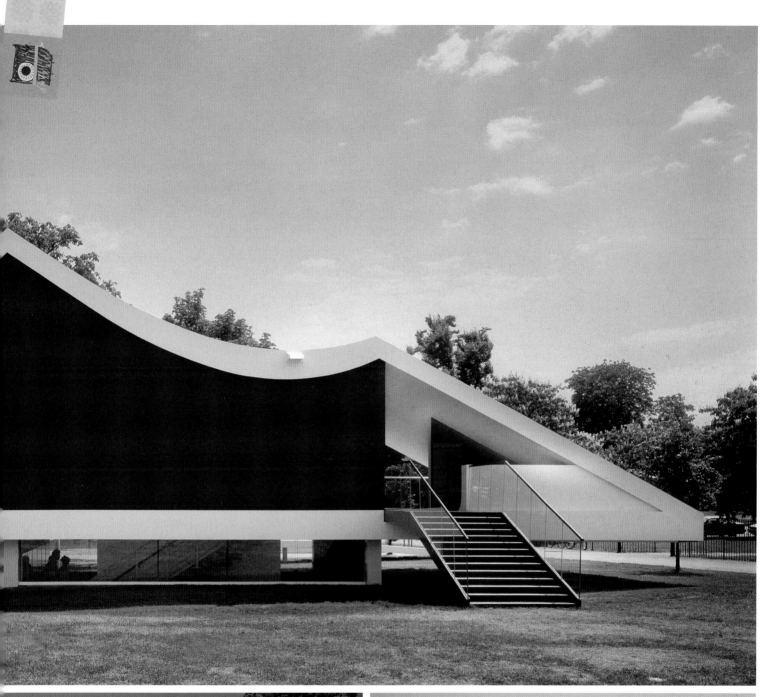

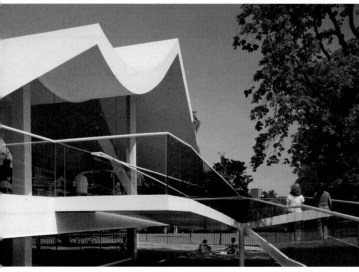

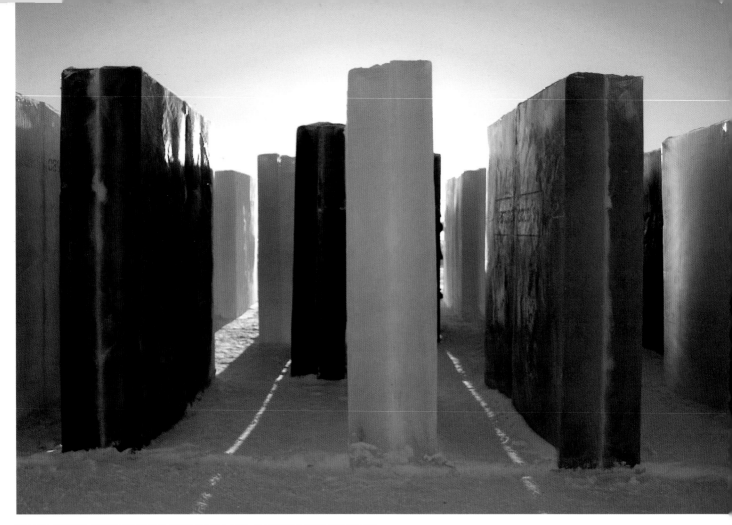

The installation by Norten and Weiner brings to mind a city, or perhaps a more colorful and
ephemeral version of Eisenman's Berlin *Memorial to the Murdered Jews of Europe.*

The Snow Show is an unusual attempt to bring together artists and
architects specifically for the purpose of creating collaborative
works. The last event was organized from February 12 to March 31,
2004 near the towns of Kemi, an industrial port at the northernmost
tip of the Gulf of Ostrobothnia, where Finland meets Sweden, and
Rovaniemi, the capital of Finnish Lapland, which prides itself on
having a town plan and many buildings that were designed by Alvar
Aalto. In all, sixty artists and architects were invited to make free-
standing structures out of ice on footprints of approximately 80
square meters and with a maximum height of 8 meters. Participants
included Cai Guo-Qiang with Zaha Hadid, Anish Kapoor with Future
Systems, Tatsuo Miyajima with Tadao Ando, Yoko Ono with Arata
Isozaki, Kiki Smith with Lebbeus Woods, and Do-Ho Suh with
Morphosis. One of the more successful initiatives was by American
sculptor Lawrence Weiner and Enrique Norten, principal architect of
TEN Arquitectos, who described their intervention as follows: "The
design emphasizes the opportunity of multiple experiences and
readings defined by a series of ice walls. The piece represents a
non-processional space that provides an overview to explore an
architectural experience through different mediums and direct
sensations — temperature, color and light, sound (wind), etc.... The
project is meant to describe content and absence beyond time and
space. It also represents a sequence of gestures that gives ma-
teriality to the illusion and representation of an endless framework
that Weiner has called an 'obscured horizon'."

Each colored slab of ice was marked with the words "obscured
horizon" and the effect of this installation may bring to mind a view
of a cityscape, with its accumulation of towers, or a more cheerful
version of Peter Eisenman's *Memorial to the Murdered Jews of
Europe* in Berlin (see pages 72–73). Both sculptors and architects
usually deal in materials less ephemeral than ice, but in this
instance the usual issues of scale and function did not exist in the
traditional sense. Although some architects, such as Tadao Ando,
did, indeed, create ice pavilions that visitors could walk through,

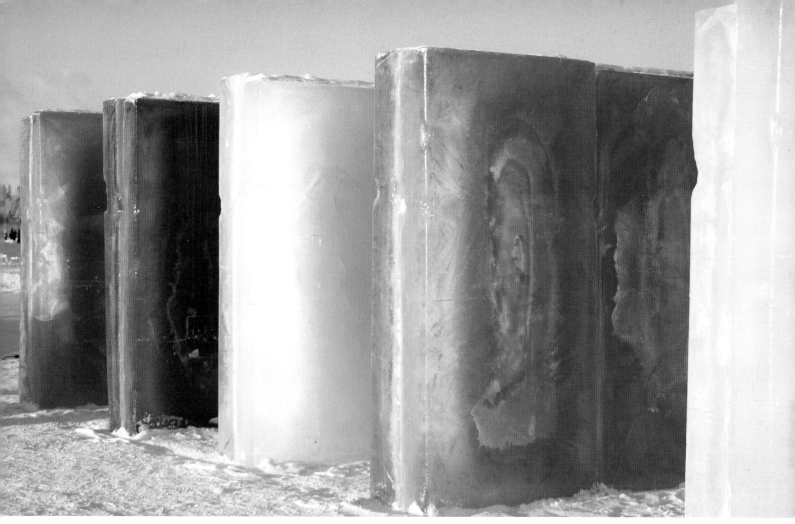

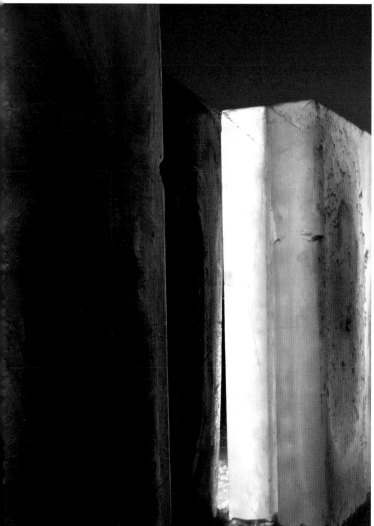

Lawrence Weiner and Enrique Norten preferred to pose the question of scale differently, by evoking large buildings with blocks of ice or by allowing visitors to imagine nothing more than a sculpture if they so wished. Weiner had experimented with ephemeral earthworks in about 1960, when he created his "crater pieces" in California — blowing holes in the earth with TNT, then marking each crater with a number so as to create a careful record of what had occurred. As in the case of the words "obscured horizon," Weiner here has also worked with statements painted on the walls of galleries and public spaces in place of actual sculptures. Based in Mexico City, Norten has said that "The architecture of our generation sits on the inter-section where global and unique, universal and specific collide." This statement might well describe his work in ice with Weiner. Whatever the pretensions to "immortality" of architects or artists, *The Snow Show* was a keen reminder that all works are eventually reduced to dust or, in this case, to a puddle of colorful water in the spring.

World's Fairs and similar exhibitions are by nature useless and, therefore, surely a fine place to look for architecture that is art. Unfortunately, the facts tell a different story, and even when architecture's "big" names participate in major temporary fairs, they are not necessarily always at their best. One exception is Switzerland's *Expo.02*, which was amply criticized for fiscal irresponsibility. Runaway spending is, however, probably another key to architectural quality. Four sites near Neuchâtel, in Switzerland, were selected for *Expo.02*, all of them on lakes and all intended to be ephemeral. Jean Nouvel was asked to work in the city of Murten, and his main intervention took the form of a monolithic block of rusting steel sitting in the water. The architect also worked on several lakeside sites, using rusting steel for a restaurant, as well as logs for an exhibition space occupied by the Fondation Cartier with contemporary art. Using camouflage netting, naval chains and more rusting steel, Nouvel showed a particular sensitivity for this kind of exercise and succeeded in making *Expo.02* a part of a historic city — a feat not matched at the other sites, where the fair grounds stood apart from their locations on or in the lakes.

Nouvel's rusting steel **Monolith** in the lake surely brought to mind Richard Serra's Cor-Ten steel sculptures, albeit on a truly architectural scale. An ephemeral installation that is as interesting as most of the projects carried out by contemporary artists, the Murten *Monolith* would be difficult to classify as architecture in the functional sense. It served no true function, nor did it really illustrate the accomplishments of Switzerland. Be that as it may, the *Monolith*, for all its physical presence, was intended from the outset to be ephemeral, like any self-respecting art installation. Gone are the pretensions to durability that long served to distinguish "real" art from garden-variety commercial products. "A mirage … a temple? … a technical platform … an observatory? A massive hermetic volume, mysterious and worrisome…. Fog and vapor." It was in these words that Jean Nouvel chose to describe the Murten *Monolith*. Aside from the fog and vapor, perhaps more appropriate to describe the work of Diller + Scofidio in Yverdon-les-Bains (see pages 64–65). Nouvel also insisted that "This exhibition is a refusal to dissociate the container from what it contains. The containers are works in the same right as the contents." Though he does not say "works of art," most readers will get his drift. Despite Cartier's use of Nouvel's log pile as a contemporary art gallery, the architect seems, in fact, to have affirmed the priority of the container in this instance. Working on a scale that even a Richard Serra would have found challenging, Jean Nouvel created an enormous sculpture off the shore of Murten. The fact that he used architectural scale meant, of course, that he mastered the object far more surely than if he had tried to create on a more intimate or "artistic" scale.

Scale is seen here as being one of the defining limits between art and architecture. If it is as big as a building, then it must be one? This is the logic that Jean Nouvel convincingly rejected in Murten. If it is as big as a building, why can it not be art?

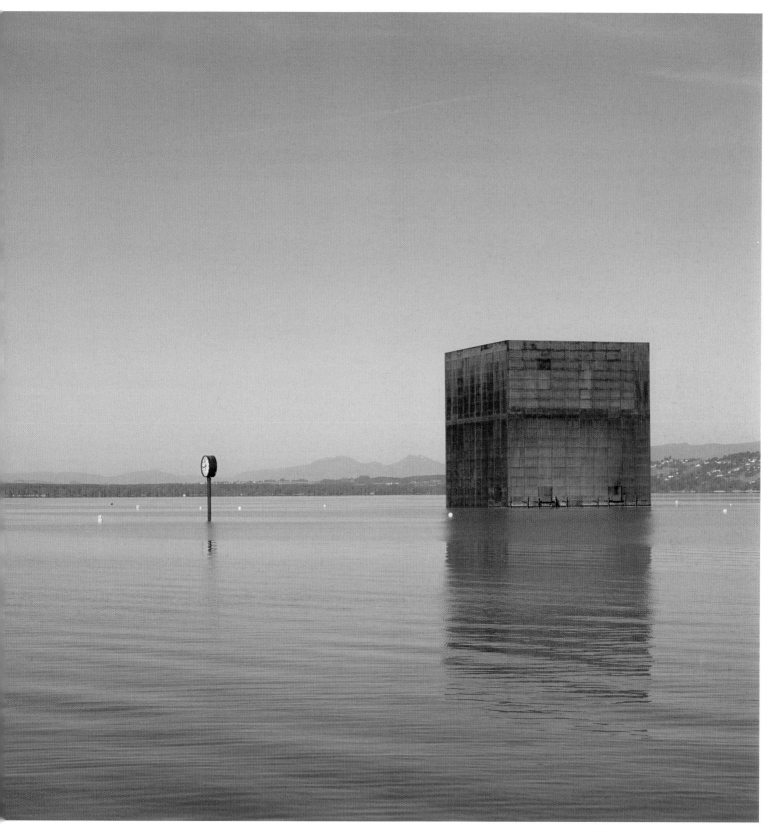

With his *Monolith*, Jean Nouvel certainly "violates" the Miesian rule relating to form and function. Without function, does architecture become art?

Bringing to mind the surreal forms of some of Dalí's paintings, Novak's shapes are at the extreme limit of what might be structurally possible, while they also open new horizons for architecture.

Born in 1957 in Caracas, Venezuela, Marcos Novak is one of the most unexpected figures in contemporary architecture. Indeed, it is difficult to classify him as an architect at all to the extent that he has intentionally remained at the periphery of the built environment in order to imagine possibilities being opened by computers. He states clearly that his interest lies "beyond architecture." Novak is convinced that technologically driven changes are transforming society, and that a real convergence of apparently diverse disciplines is not only possible but inevitable. Currently a professor at the University of California (Santa Barbara), Novak participated in the *9th Architecture Biennale* in Venice (2004) with one of his works, ***Allobio***, whose curiously shaped forms are inspired by "radiolaria and diatoms, echinoderms and other creatures whose endo- or exo-skeletal structures or skins are determined by processes such as secretion or accretion." *Allobio* imagines nothing less than a living form of architecture that would evolve according to circumstances and its required use.

Novak's creations are indicative of the profound changes that can be expected in the future from what he has called "data-driven forms." His originality is that he goes far beyond the liberty given to shape by computer-aided design and production to speculate on what might happen if entire fields of learning merged and participated in a rethinking of the human environment. The form of Novak's work is more the result of the application of his ideas of convergence between apparently disparate areas of research, such as nanotechnology, biotechnology and computer sciences, than it is a willful orientation away from existing esthetic or practical norms. Approaching architecture as though it might become a physical science, one related to growth, birth, death and disease more than

to the old assembly line, Novak emerges as one of the most radical figures in what could prove to become a fundamental amalgamation of science and art.

Marcos Novak cannot be considered an artist in the usual sense, but his pioneering work could have an impact on how artists view their own role. It has been said that the difference between art and architecture is that architecture serves a purpose. Without a defined purpose, contemporary art has often seemed to be adrift. The forms and ideas that Novak generates with his computers have not reached the stage where they serve a purpose in the physical world of architecture, and their esthetics, a result of calculations and scientific assumptions, are not imposed subjectively but derived mathematically. Their shape thus has a legitimacy that escapes the flights of fancy sometimes associated with art. Creating virtual objects that are related to radiolaria or diatoms, Novak may be closer to artists who are inspired by nature, such as Andy Goldsworthy, than he is to most architects. Artists have, of course, long looked to nature for inspiration, but what if their forms could be enriched by the analytical convergence being explored by Novak? Attempts to use chaos theory in art have shown an interest in this type of thought, but Novak goes further.

Neither true science, nor architecture, nor art, Novak's work, emerging from the computer, is all of these combined. Even if one sets aside Novak's own projects, his message — that art, architecture and science are converging — is a powerful one. He speaks without apparent hubris of "the exploration of architectural form in a manner that has been inaccessible since Gaudí, and a cross-fertilization of art and science that has not been seen since the Baroque."

151

The idea that sound can be art is not new. In 1913, the Italian futurist Luigi Russolo wrote a work called *The Art of Noises*. John Cage is also recognized as a pioneer in the use of sound that cannot be clearly recognized as music, but which has been broadly accepted by the art world. And London's Hayward Gallery recently held an exhibition on sound, curated by the musician and author David Toop. In this context, it is, therefore, somewhat less surprising that the architect Lars Spuybroek (NOX) should conceive the **Son-O-House** (2000–03). "The Son-O-house is one of our typical 'art' projects," he says. "The Son-O-House is what we call 'a house where sounds live,' being not a 'real' house, but a structure that refers to living and the bodily movements that accompany habit and habitation. In the Son-O-house, a sound work is continuously generating new sound patterns activated by sensors picking up actual movements of visitors."

Lars Spuybroek has been researching the relationships between architecture and media since the early 1990s. He has been involved with video (*Soft City*) and interactive electronic artwork (*Soft Site, edit Spline, deep Surface*), as well as architecture (H2Oexpo, V2_lab, wetGRID, D-tower, Son-O-House, Maison Folie). The Son-O-House brings together a number of his preoccupations, calling on a complex form, originally derived from a series of paper bands converted into an analog computing model that "is then digitized and remodeled on the basis of combing and curling rules which results in the very complex model of interlacing vaults, which sometimes lean on each other or sometimes cut into each other." One of Spuybroek's interests has been in forms of architecture that are capable of evolving according to their use. This is clearly the case of the Son-O-House. As he says: "In the house-that-is-not-a-house we position eight sensors at strategic spots to indirectly influence

the music. This system of sounds, composed and programmed by sound artist Edwin van der Heide, is based on moiré effects of interference of closely related frequencies. As a visitor … one does not influence the sound directly, which is so often the case with interactive art. One influences the landscape itself that generates the sounds. The score is an evolutionary memoryscape that develops with the traced behavior of the actual bodies in the space." Although the architect tends toward vocabulary that renders his work more difficult to understand, the idea here is clear. If one accepts that sound can be art, then the Son-O-House is an embodiment of the interaction of contemporary art and architecture, informed by continually changing visitor patterns. Spuybroek's collaboration with van der Heide in this instance shows that the cutting edge of different fields can form a coherent work. When the architect speaks of a "house-that-is-not-a-house," he is referring to the conventional wisdom that a building must serve a purpose. The purpose here is esthetic and artistic, but the Son-O-House is not an ephemeral piece of performance art; it has all the solidity of the "real" world, and in this it challenges the idea of easily discernable barriers or limits between disciplines. It looks like a sculpture, is firmly rooted in architecture and functions like a work of sound art.

The almost organic appearance of Lars Spuybroek's Son-O-House demonstrates the type of structural complexity that can now be achieved using computer-assisted design.

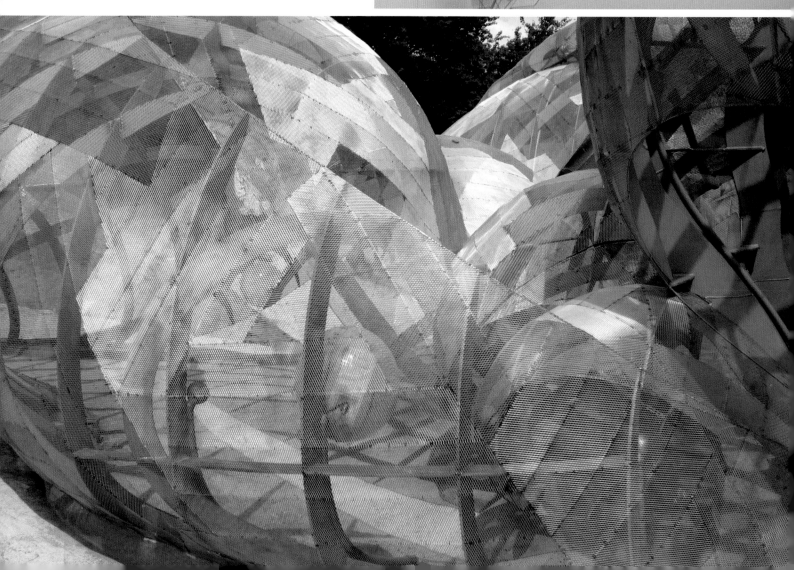

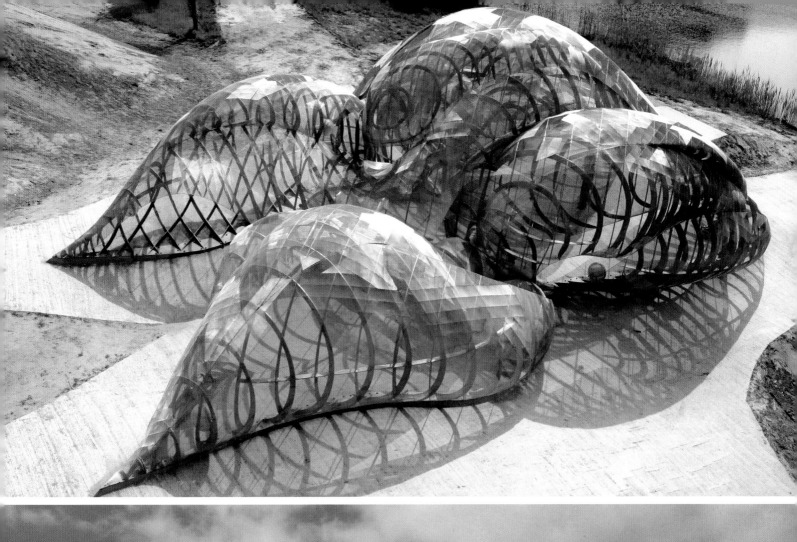
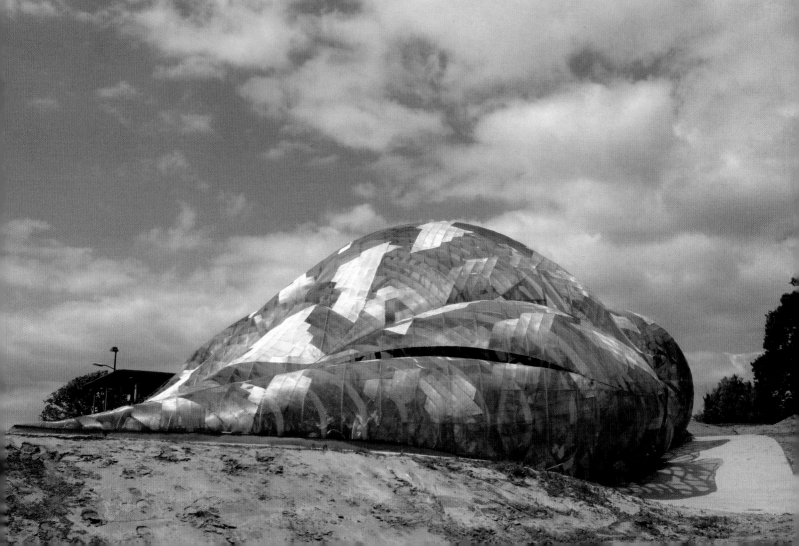

In his prescient 2002 exhibition *Ce qui arrive* (Unknown Quantity) held at the Cartier Foundation in Paris, the philosopher and architect Paul Virilio set about creating an astonishing temporary museum of accidents. "Daily life is becoming a kaleidoscope of incidents and accidents, catastrophes and cataclysms, in which we are endlessly running up against the unexpected, which occurs out of the blue, so to speak. In a shattered mirror, we must then learn to discern what is impending more and more often — but above all more and more quickly, those events coming upon us inopportunely if not simultaneously," wrote Virilio. He also quotes Hannah Arendt, who said, "Progress and catastrophe are opposite sides of the same coin." Events from the Chernobyl disaster to Cai Guo-Qiang's *Tonight So Lovely* fireworks display (see pages 88–89) became the subject for the exhibition of pieces that had to tread a fine line between sensationalism and art. One of these was Tony Oursler's *9/11* (Mini-DV Digital Video, duration: 57:51 min, 2001), the artist's very personal response to events that occurred close to his own apartment in Lower Manhattan.

It might be assumed that the intimate relation of art and architecture would most often be based in the hopefulness inspired by collaboration or mutual observation. In the case of Oursler's *9/11*, it is the catastrophic failure of architecture and technology that becomes the subject for a video. Then, too, the artist's continual interest in nightmares or willfully primitive evocations finds a remarkable field of enquiry on his own doorstep, even as the events of September 11, 2001 unfold. Architecture, once the source of pride and a testimony to man's capacity to overcome the elements or even gravity, becomes the choking, crashing harbinger of his demise. The fascination with ruins shown by painters from Monsù Desiderio to Hubert Robert formed part of a reflection on human vanity and the dark specter of inevitable collapse, but the modern tendency to hide such inconvenient realities as people leaping from a burning tower found a new and terrible contradiction when the World Trade Center was brought down.

Paul Virilio notes that accidents of various kinds have long since become the object of excessive media attention. Long before Tony Oursler, artists made use of this modern attraction to horror. Andy Warhol, of course, painted car crashes and tabloid headlines reflecting morbid public fascination with catastrophes as early as the 1960s. Events such as 9/11 or, on a smaller scale, the 2004 collapse of the brand new Terminal 2E at the Charles-de-Gaulle airport in Paris seem to confirm underlying fears that buildings are not as solid as they are made out to be. Destruction and death are surely a legitimate field for investigation in the multiple forms of interaction between art and architecture. Paul Virilio is convinced that the more complex and interactive technology becomes, the more significant the chances are that one day there will occur what he calls the "integral accident"… and that everything will come to a grinding halt. Whereas Ed Ruscha imagines the *Los Angeles County Museum of Art on Fire* (see pages 172–73), Tony Oursler documents *9/11* through his own eyes. Both comment on the collapse of the gleaming symbols of culture and modernity; both seek to "discern what is impending."

Tony Oursler, *9/11*, 2001. Video

Sitting in his small office in the Belleville district of Paris, François Roche does not necessarily look the part of the revolutionary, but his ideas about architecture and art are quite original. A recent project brought him to collaborate with the conceptual artist Rirkrit Tiravanija and with the French video artist Philippe Parreno. Roche calls Parreno's video *The Boys from Mars* (2003) "the movie that produced a shelter." Since 1998, Tiravanija, who won the 2004 Hugo Boss Prize, has been working on *The Land*, a large-scale collaborative and "transdisciplinary" project near Chiang Mai, Thailand. There, he has called on artists and architects to realize their own projects, and to finance them. Roche and Parreno discovered that getting anyone to pay for a building in a remote Thai rice field was extremely difficult, but that by making a movie, they could finance the construction of the shed, called **Hybrid Muscle**, which serves as the essential backdrop of the video. In describing this project, Roche cites Walter Benjamin, who defined architecture as the "prototype of a work of art, the reception of which is consummated by a collectivity in a state of distraction." He goes on to comment that "This would explain why in its own media (architecture books and magazines) architecture always seems so boring and enervated: because the spaces are always photographed empty, without action, plot or anything else that could possible distract one from the architecture."

Using a water buffalo and a dynamo to generate electricity, Roche conceived his 130-square-meter shelter made of teak and plastic sheeting as part of the intentionally mysterious story that he and Parreno thought up for *The Boys from Mars* video. The use of a typical local farming animal to generate electricity — which in turn makes computers work and the plastic sheets flap just enough to create a breeze — explains the name Hybrid Muscle. As Roche points out, he and Parreno were able to raise $65,000 for the project from the Luxembourg Museum of Modern Art because of the video, but most of the money actually went into building the structure, so that it was a "film that produced a shelter."

Rirkrit Tiravanija's art consists not in producing "artifacts" but in bringing people together — in a social interaction that is furthered in this instance by the project of Parreno and Roche. The element of mystery in Parreno's dark video corresponds to Roche's comment about fiction — the artist and the architect make viewers wonder if this structure in a distant rice field is anything more than a figment of the imagination — a fictitious work of architecture. Damaged by a storm early in 2005, the structure erected by Roche near Chiang Mai may now be modified, in order to give it another life and perhaps make it part of yet another story. "What interests me in the collaboration with an artist is to write a scenario with four hands or more," says Roche. "This is what permits fiction to exist in architecture. It isn't about 'vampirizing' ideas from the world of art, like Jean Nouvel might, or throwing in a bit of sculpture, like Claes Oldenburg did with his binoculars in Frank Gehry's Chiat/Day building (Venice, California, 1989)."

Roche is looking for something more than the now customary interaction between art and architecture. As he says, the idea is already worn out: "The postmodern virus was already in the fruit when Rietveld faceted Mondrian's world in 3D and when his successor, Doesburg, a decorative counterfeiter, covered his buildings with it, thus de facto heralding the YSL dress of the same name."

Philippe Parreno and François Roche,
The Boys from Mars/Hybrid Muscle, 2003.
Video/Transdisciplinary project. Chiang Mai

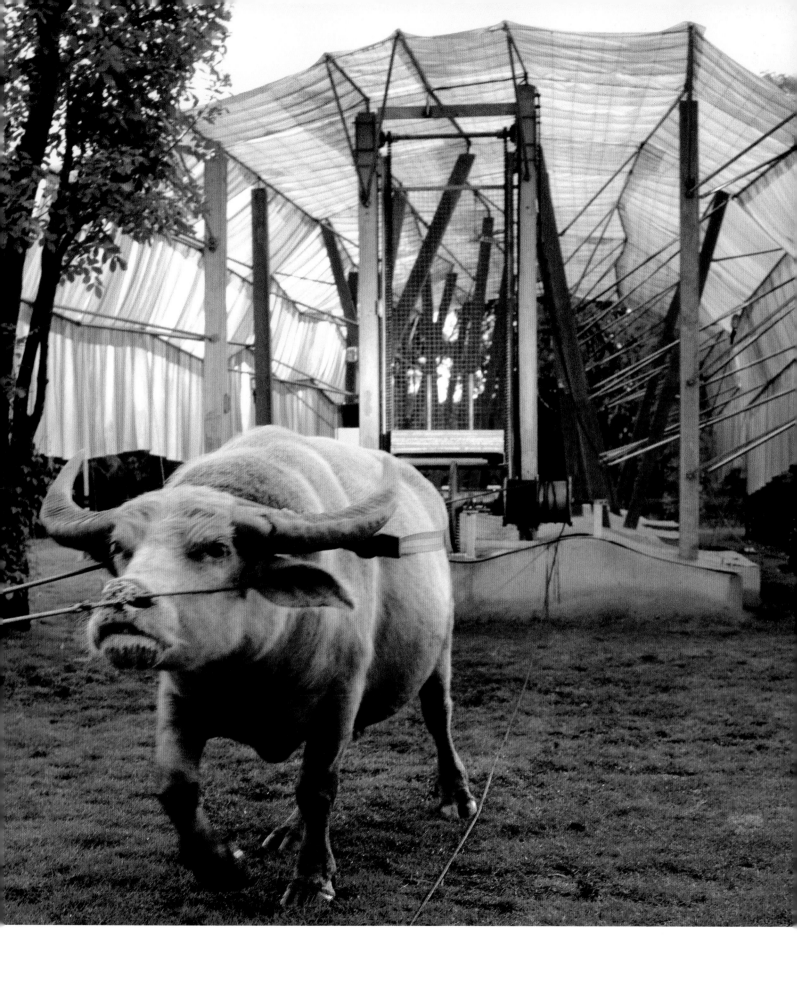

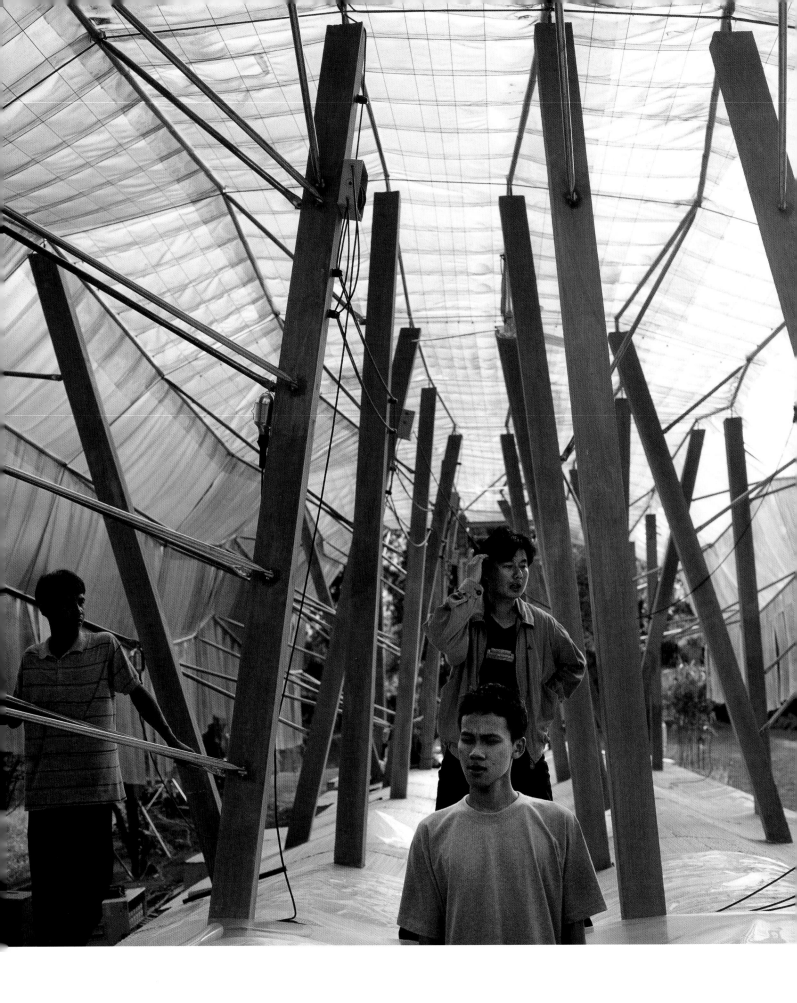

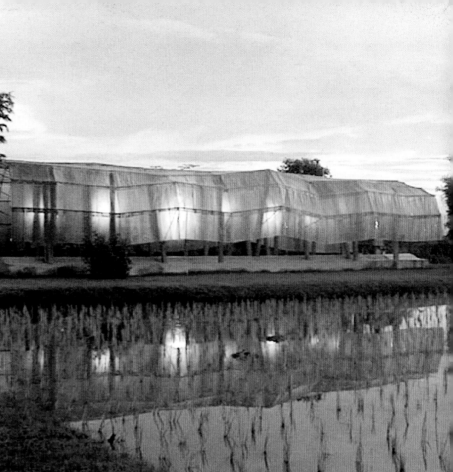

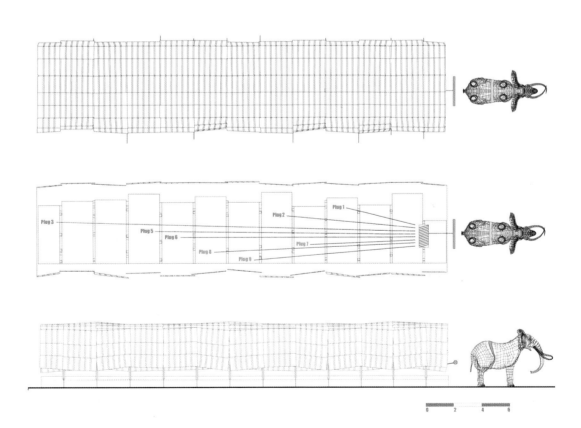

Born in Barcelona in 1955, Jaume Plensa is known as a conceptual artist, and yet he has contributed what can only be described as an architectural artwork to Chicago's new Millennium Park. Two 15-meter-high glass block towers are set at either end of a 70-meter-long reflecting pool made of black granite. The water is only about a third of a centimeter deep, so people are encouraged to walk on it. "I was dreaming of walking on water," says the artist. "That's probably because I don't know how to swim. I was always dreaming … of where to find the right sea for me…. It's not a pool, just a very thin skin of water. I think cities need spaces where people can do every-thing they like, and on the water, it seems that everything is possi-ble. In a way, it's like going back to the origin of life. The Greeks said water was the true symbol of transformation."

The originality of Plensa's *Crown Fountain* project is also that both towers have enormous LED video screens on which the faces of 300 Chicagoans (eventually 1,000) picked at random are pro-jected in high resolution. At the end of these video sequences, the faces on the screens unexpectedly begin to spout water into the pond from their mouths. "I worked very hard," says Plensa, "on the idea that all of us have two sides … the daylight side, and the freak side. We are also freaks. And these huge faces, or gargoyles, be-come the grotesque part of ourselves. That is also the most beauti-ful part of art, when we are out of control. When they spout water from their mouths, they are giving us life, and that is very beautiful for me." Water also cascades down the sides of the towers, built at a cost of US$ 17 million with the assistance of Chicago architects Krueck & Sexton.

Plensa won this commission over two architects, Robert Venturi and Maya Lin, creator of the *Vietnam Memorial* in Washington, D.C. The architectural aspect of the fountain is high-lighted by its location, opposite a row of historic skyscrapers usually called the "Michigan Avenue Cliff." Steven Crown, whose family con-tributed US$ 10 million to the project and oversaw its construction, says: "Jaume took a risk, he's working with ideas from the older school of fountains and updating them, which we liked. The result is very different, very contemporary, and yet it also has a lot of tradi-tional themes running through it." Despite its high-tech elements, Plensa's project appears, indeed, to update the very ancient idea of the gargoyle. He also plays on the juxtaposition of his own tower-like forms with the celebrated skyscraper architecture of Chicago. Enlarging the faces of ordinary people puts the scale of architecture into question and exerts a humanizing influence, even if the size of the images does turn the subjects into "freaks" of a kind. The con-cept of walking on water appeals to anyone, just as the spouting video screens involve a humorous inconsistency. The Buckingham Fountain, a 1927 concoction that stood in Chicago's Grant Park, pre-cursor of the Millennium Park, featured horses spouting water, so Plensa's video gargoyles may not be all that much out of place here.

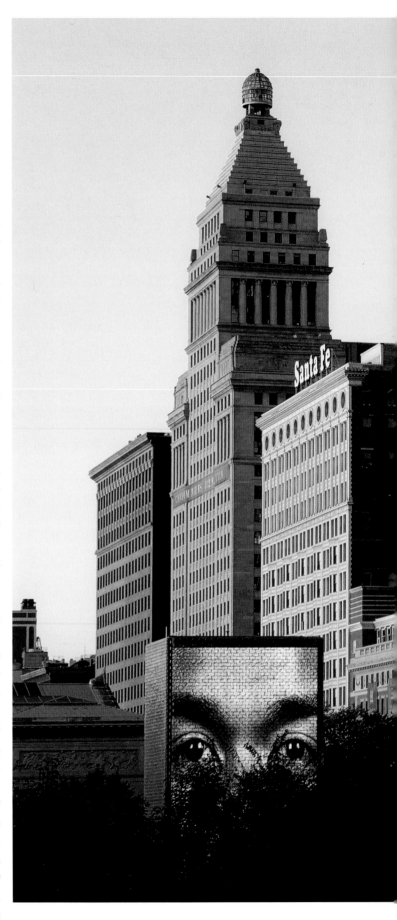

Towers and water are an integral part of the Chicago cityscape, and Plensa has used these elements in a clever juxtaposition that surely borrows architectural forms and seeks a kind of permanence that often eludes contemporary art.

Jaume Plensa, *Crown Fountain*, 2004. Water, LED screens, glass blocks, steel, black granite, pool: 70.71 m long, 32 cm deep, towers: 15.24 m high. Millennium Park, Chicago

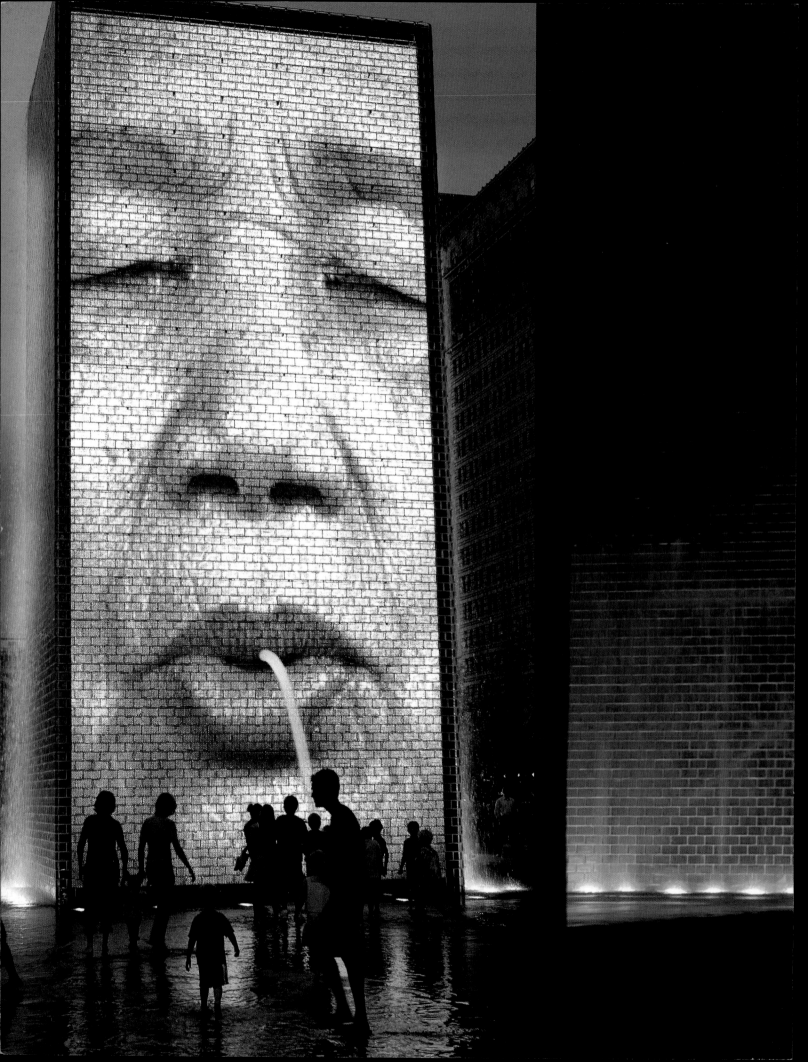

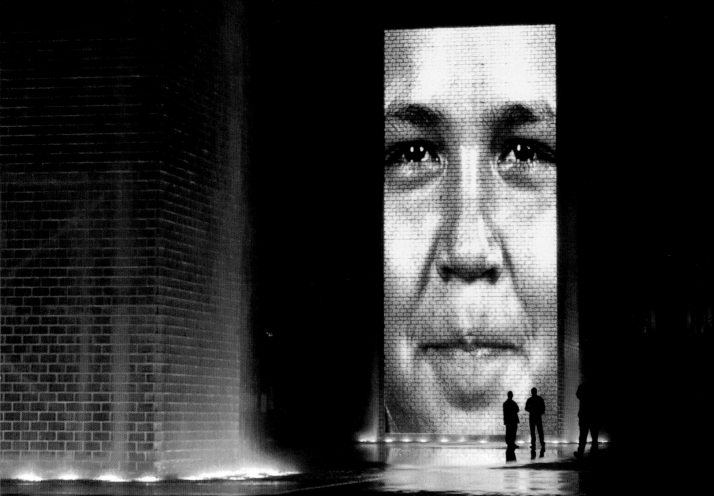

Jean-Pierre Raynaud is mad about architecture. Writing about the first house he built as a work of art beginning in 1969 in Celle Saint-Cloud: "I became mad in the most stimulating sense of the word." One of the best-known contemporary French artists, Raynaud studied to be a gardener, which may explain why one of his signature works is nothing but a flowerpot filled with concrete and painted red. Raynaud has used common elements and symbols of everyday life in his work, ranging from a one-way sign to the 15-by-15-centimeter white tiles that lined his first house. Raynaud's house was very much a work of art in his mind, and he gradually tiled it over to the exclusion of all else — even the furniture was built in and tiled. "When I became conscious in 1988 that the house was finished," he says, "it was a terrible shock for me, like the end of a life. It took me four years, but I realized that the house, which had become a perfect piece of architecture, was frozen and immobile, which is the normal fate of art objects. I decided to give it a worthy fate, to transport it elsewhere, to make it live an absolute experience. In order to do that, the house would have to submit itself to its ultimate transformation: demolition." The end of this adventure at the limits between art and architecture came in 1993 when Raynaud exhibited the remains of his demolished house in 1,000 metal hospital basins neatly aligned in the vast space of the Bordeaux CAPC museum.

Beginning in 1989, with the assistance of architect Jean Dedieu, Raynaud built a new house, in another grimy Paris suburb, La Garenne-Colombes. Set mostly underground, this structure, used today as the artist's studio, is called **La Mastaba**. Although located underground, the entire house, inside and out, is white. Raynaud tiled only the exterior, in part because he considers it a work of art in the same sense as the house in Celle Saint-Cloud. It is, however, intended as a confrontation with death: as the artist has pointed out, his 15-by-15-centimeter white tiles are those most frequently used in morgues. The visible form of Raynaud's new house might recall that of ancient tombs; indeed, it has a specific funerary connotation. "I was born in 1939," he says. "My father died in 1943. He was buried alive by a bomb 500 meters from the location of *La Mastaba*. As soon as I bought the land, I made an underground space. I dug a hole, surely not in a conscious effort to come closer to my father, but it obviously has to do with my own life story." Raynaud lived for a time in *La Mastaba* but he has recently transformed it into an exhibition space and work area, adding an external Plexiglas canopy. It is clear that this structure is a part of his *oeuvre* even if Raynaud himself rejects the idea that it is in itself a work of art. "For me, it is the place that means I have come full circle. I demolished the house in Celle Saint-Cloud, thus voluntarily erasing my own past. There is an implacable logic in this sequence of events. I have come here, to *La Mastaba*, to fulfill my destiny, and what's more, I find that its architecture is sublime."

Jean-Pierre Raynaud, *La Mastaba,* 1989.
La Garenne-Colombes

Andrea Robbins was born in 1963 in Boston. She met her husband and partner in photography, Max Becher (born in 1964 in Düsseldorf), at the Cooper Union School of Art in New York in 1984. As they explain: "The primary focus of our work is what we call the transportation of place — situations in which one limited or isolated place strongly resembles another distant one. Everywhere, not only in the new world, such situations are accumulating and accepted as genuine locales. Traditional notions of place, in which culture and geographic location neatly coincide, are being challenged by legacies of slavery, colonialism, holocaust, immigration, tourism and mass communication. Whether the subject is Germans dressing as Native Americans, New York in Las Vegas, New York in Cuba, or Cuba in exile, our interest tends to be a place out of place with its various causes and consequences." One of their images, ***Where do you think you are? Universal Guggenheim***, shows a curious reproduction of Frank Lloyd Wright's Guggenheim in an unnamed location that is clearly not its Fifth Avenue setting. Andrea Robbins writes: "The building is located at Universal Studios in Orlando, Florida; it is film set and tourist amusement park; much like Disney World. In this setting in Orlando the 'Guggenheim' is right next to a copy of the New York Public Library. We have also photographed a copy of the **Whitney Museum** of Art in Las Vegas, Nevada, where the 'Whitney' is right next to a copy of the facade of the United Nations. Another photograph that is in the same vein is of London Bridge, which was purchased by a town in Arizona and rebuilt, and then a lake was created around the bridge. We have been doing this kind of image for nearly twenty years. In some projects we focus on architecture, and in other instances, culture and language." The viewer is thus informed that this is no vulgar Photoshop manipulation, intended to poke fun at Guggenheim Director Thomas Krens's global ambitions — it is a "real" fake Guggenheim.

Andrea Robbins and Max Becher, *New York NY, Las Vegas NV: Whitney Museum,* 1996. Chromogenic print, 88.27 x 76.2 cm

Although Robbins and Becher have looked elsewhere than America in their quest for the "transportation of place," they may be at their most convincing when they document the great American fake. They are not, of course, the first to notice this propensity for the artificial in America. In his important essay *Travels in Hyper Reality* (1986), Umberto Eco wrote that "the American imagination demands the real thing, and to attain it, must fabricate the absolute fake … from historical information to be absorbed, it has to assume the aspect of a reincarnation … the 'completely real' becomes the 'completely fake'…. Absolute unreality is offered as real presence." The critic Ada Louise Huxtable commented on the same tendency in her book *The Unreal America: Architecture and Illusion* (1997): "The replacement of reality with selective fantasy is a phenomenon of that most successful and staggeringly profitable American phenom-enon, the reinvention of the environment as themed entertainment." Robbins and Becher also photographed the Las Vegas reproductions of European or American cities, but in focusing on the Guggenheim and the Whitney, they aim at the transposition into a fantasy or movie environment of two of the more "iconic" buildings in America, and relatively recent ones at that. Their point is, of course, to underline not their authenticity but their curious alienation. Like Hiroshi Sugimoto's photos of wax figures at Madame Tussauds, which are themselves reproduced from paintings, there are layers of "reality" present in these images that offer nothing authentic in the final analysis except perhaps the photograph itself. If "imitation is the most sincere form of flattery," then Frank Lloyd Wright and Marcel Breuer can rest easy in their graves. Their architecture will long be the stuff of ersatz admiration.

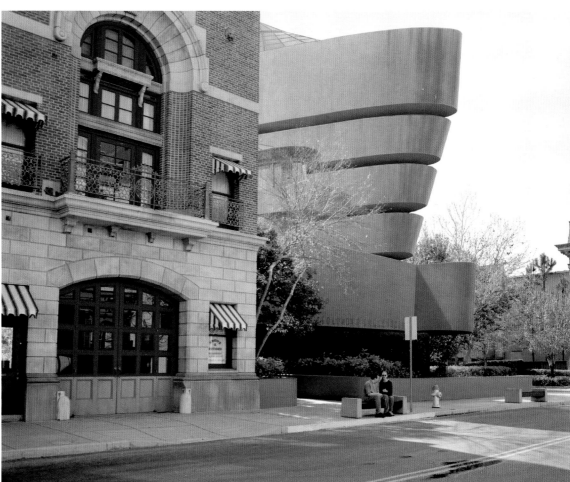

Andrea Robbins and Max Becher, *Where do you think you are? Universal Guggenheim*, 2004.
Archival ink print, 88.27 x 76.2 cm

Born in Omaha, Nebraska, in 1937, the artist Ed Ruscha is indelibly associated with the Los Angeles region where he has lived and worked. Although architecture has not been his unique subject, he has frequently turned banal structures, such as a Standard Oil gas station (1965–66), into iconic symbols of American culture in his paintings. His painting of **The Los Angeles County Museum on Fire** (1965–68) isolates the structure from its urban environment and depicts it in flames at a time when local opinion was strongly divided as to the esthetics of the complex. It may be interesting to note that the German photographers Bernd and Hilla Becher were amongst the early admirers of Ruscha, focusing in particular on his capacity to elevate ordinary images into the sphere of myth through a subjective use of irony. Though by no means as systematic as the Bechers, who have catalogued industrial architecture, Ruscha undertook an exploration of Los Angeles area **Parking Lots** and **Pools** that elevates images of largely dead spaces into the realm of art.

It was in 1972 that Robert Venturi entitled the first part of his seminal book *A Significance for A&P Parking Lots, or Learning from Las Vegas*, demonstrating that, on occasion, art and architecture really do converge. His immediate source of inspiration was none other than the series of photographic books produced by Ed Ruscha, beginning in 1962, on the ordinary aspects of Los Angeles: *Twenty-Six Gasoline Stations* (1963); *Every Building on the Sunset Strip* (1966); or *Nine Swimming Pools and a Broken Glass* (1968). The Canadian Center for Architecture in Montreal recently underscored the significance of this connection in a show called *Learning from …. Ruscha and Venturi Scott Brown, 1962–1977. Everyday Architecture and Urbanism of Los Angeles and Las Vegas.*

Ruscha, of course, went further than most "Pop" artists in his interest in architecture and, indeed, in the architecture of the ordinary. His *Los Angeles County Museum on Fire* mocks a symbol of the elevation of art to the sacrosanct and renders its catastrophically uninspired architecture vulnerable to the wind of ridicule. The Harvard University Museums recently drew a strong parallel between Ruscha and a well-known student of the Bechers in an exhibition entitled *Landmark Pictures: Ed Ruscha and Andreas Gursky*. Like the American painter, Gursky (see pages 90–91) has shown a talent for carefully selecting banal commercial or architectural environments and photographing them in such a way as to give them a grandeur that is tempered with the artist's irony. With the influence he exerted on figures as diverse as Venturi or Gursky, Ruscha proves to be a significant link between the realms of architecture and art in the past forty years. The French architect Dominique Perrault feels that art is often twenty years ahead of architecture when it comes to new ideas. Although in this instance Ruscha's head start on architecture's own interest in its heritage in the domain of banal structures was not quite so long, there is surely an exchange of ideas evidenced and admitted by the participants.

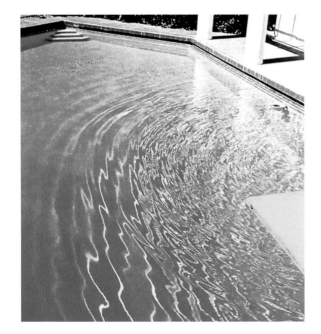

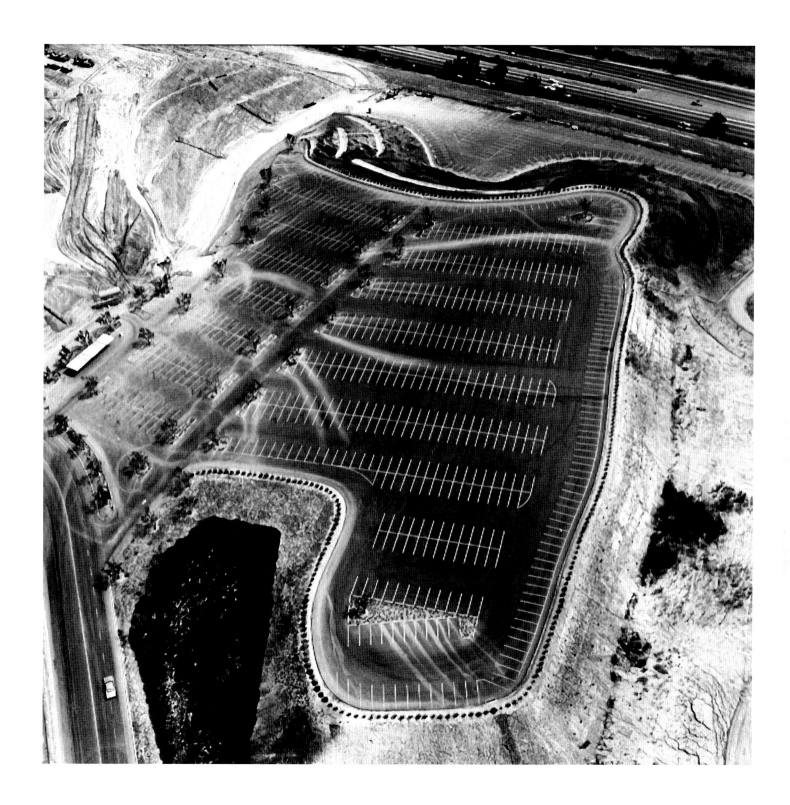

Ed Ruscha, *The Los Angeles County Museum on Fire*, 1965–68.
Oil on canvas, 135.9 x 339.1 cm. Hirshhorn Museum and Sculpture Garden, Smithsonian Institution,
Washington D.C. Gift of Joseph H. Hirshhorn, 1972

Ed Ruscha, *Pools (9)*, 1968–97.
Detail, one of nine Ektacolor photographs, edition of thirty, 40.6 x 40.6 cm (image), 61 x 61 cm (matted)

Ed Ruscha, *Parking Lots (Universal Studios, Universal City) #18,* 1967–99.
Detail, one of thirty silver gelatin photographs, edition of three, 38 x 38 cm each (image), 54 x 54 cm (matted)

The city of Kanazawa, near the Sea of Japan, is known more for its traditional temples and gardens than it is for contemporary art. It is all the more surprising that Kazuyo Sejima and Ryue Nishizawa (SANAA), known for their cutting-edge architecture, should have erected the **21st Century Museum of Contemporary Art** here, just across the street from Kenroku Garden. Opened on October 9, 2004, the Museum is essentially a circle 112.5 meters in diameter, with a broad band of glass allowing passersby to see into some of the display spaces. One of the principles of the structure is to be open and friendly to the city's residents. In fact, it is possible to enter the Museum and walk around its inner periphery without paying anything. The main exhibition areas, with ceiling heights varying between four and 12 meters, are orchestrated within the circular plan according to a pattern devised by the architects, and allow for the space requirements set out by the Museum's curators in the course of a four-year collaboration.

SANAA has worked on numerous cultural projects, including the O-Museum in Nagano (1999), and the N-Museum in Wakayama (1997). Current work includes the Glass Pavilion of the Toledo Museum of Art, a theater and cultural center in Almere, an extension of the Instituto Valenciano de Arte Moderno (IVAM), and a building for the New Museum of Contemporary Art in New York. Kazuyo Sejima was born in Ibaraki Prefecture in 1956 and worked in the office of Toyo Ito from 1981 to 1987. She established Kazuyo Sejima and Associates in Tokyo in 1987. Her Saishunkan Seiyaku Women's Dormitory in Kumamoto (1990–91) was on the cover of the catalogue of the 1995 *Light Architecture* exhibition, organized by Terence Riley at the Museum of Modern Art in New York. 1995 was also the year of the creation of SANAA.

Sejima's work and that of SANAA has always carried with it a sense of lightness that is omnipresent in the white volumes of the 21st Century Museum of Contemporary Art. Despite its geometric forms, there is an ambiguity in the space of the structure, where interior and exterior are intentionally rendered somewhat indistinct. A sophisticated play on transparency and opacity are also part of the architectural *parti*. Though these devices are frequently used in Japanese architecture, Sejima rejects the suggestion that she is inspired by traditional forms. "I do not specifically look at traditional architecture," she says. "It is probably in my blood somewhere, but I believe that it is Westerners who analyze Japanese architecture in these terms more than we do."

A space intended for the display of contemporary art, the Kanazawa Museum brings to mind certain works of American artist Dan Graham, albeit on a much larger scale. The full-height curving glass wall of the structure reflects and diffracts light in much the same way as Graham's pieces do, and the works within or the garden outside are always visible in a slightly altered layering that gives the building an extraordinary visual vibrancy despite its apparent simplicity. However, Ryue Nishizawa rejects the suggestion that Graham had any influence on the design, pointing out that the American's environments have heavy steel frames, while in Kanazawa the windows have almost no visible support. Significantly, the Museum itself appears anxious to offer images of the building before it contained works of art, as though the structure itself were part of the collection. A subtle study of space and light, the 21st Century Museum functions quite well, but does its shimmering ambiguity serve a purpose other than an esthetic one? If it is beautiful, is it art?

With its perfectly circular plan, the Kanazawa Museum houses a collection of geometrically defined volumes, redefining the ideas of facade and form, or front and back, that have long dominated architecture.

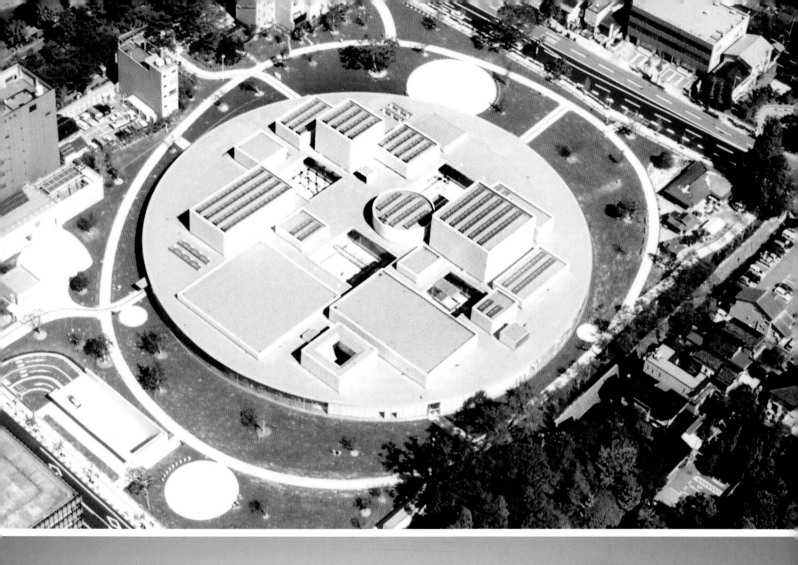
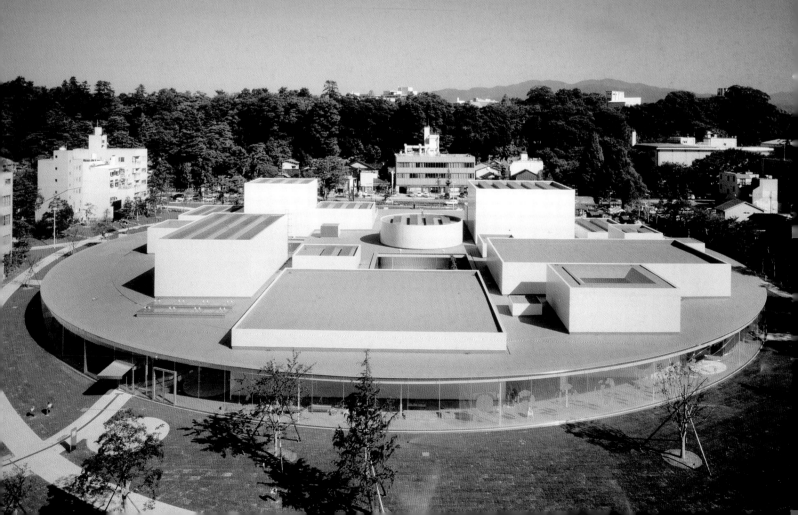

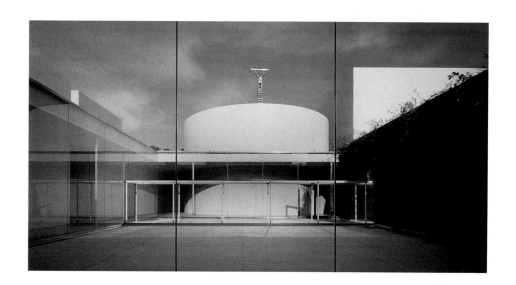

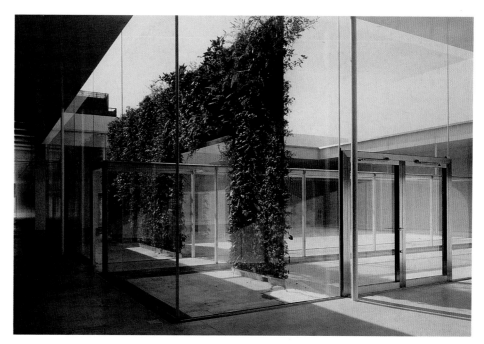

Patrick Blanc's "Vegetal Wall", visible above,
contributes to the unexpected combination of art,
architecture and nature in this museum.

Richard Serra is a tough guy. He deals with enormously heavy sheets of steel — the kind used for shipbuilding. His work has often carried an element of threatened collapse that makes it seem dangerous, even if it usually is not. A recent series of sculptures he calls *Torqued Ellipses* deals with the issue of space in a way that surely approaches architectural volume. He says clearly that his immediate source of inspiration was, in fact, a church. "I went to Rome and saw Borromini's San Carlo alle Quattro Fontane," said Serra in a 1999 interview. "I came along the side aisle and looked up. It's an elliptical space that just rises vertically. Basically, the spaces I had been making between two conical sections were elliptical — a long axis and a short axis. I thought, what if I could turn this space on itself, turn it on a right angle to itself. I never thought about using architecture as a guidepost like that before, but it intersected with something I was doing anyway and I thought that that might be feasible."

Weighing something in the range of 35,000 kilos, Richard Serra's *Torqued Ellipses* are big enough for visitors to walk inside their volumes. Their five-centimeter-thick Cor-Ten steel walls curve and bend in a way that makes the viewer have some doubts about verticality, even if they are placed on solid, flat concrete floors. This, it seems, is more a feeling that might be given by architectural space than art, and yet Serra sees a difference. "Basically, the program of architecture probably prevents it from becoming art because it is usually applied to utility," he says. "The interesting thing about art is that it is purposelessly useless. That doesn't mean that it isn't a catalyst for thought and that it doesn't fulfill other things that we lack and need, but I don't think that it is useful in the way that architecture is useful. I think that once sculpture got off the pedestal and you had to walk around and into it, that is what it had to compare itself to — architecture was the other thing that had a likeness to it."

Speaking in the late 1990s at the time of the creation of the *Torqued Ellipses*, Richard Serra said he imagined that architects might inspire themselves from his forms. It might be noted in passing that Tadao Ando's Chichu Art Museum on the island of Naoshima (see pages 40–43) has a number of walls that are tilted at a 6° angle. Serra and Ando have come into frequent contact, for example, at the Pulitzer Foundation in Saint-Louis or the Fort Worth Museum of Modern Art. The architect's chief assistant says he believes that the angled walls in Naoshima are due to the influence of Serra's sculptures.

There is no need to go further than Richard Serra's own words in showing the intimate relationship that exists between contemporary sculpture and architecture. He says that the *Torqued Ellipses* were inspired by a Baroque church, but makes it clear that he was in no way trying to create an architectural environment himself. He

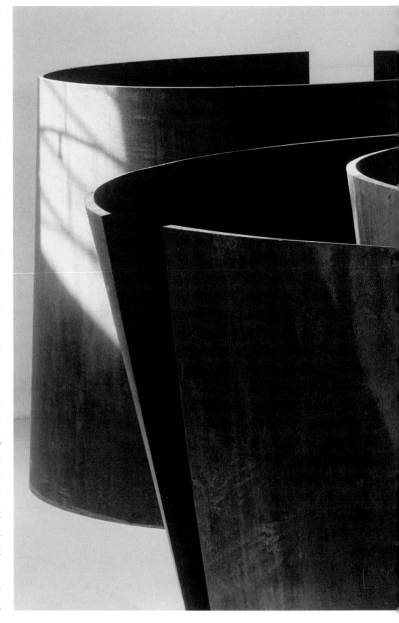

works at an almost architectural scale and comparisons and influences are therefore inevitable. Like many architects, Serra invokes physical responses to his art, a vertigo that some critics have related to the thought of Merleau-Ponty. Mark Taylor, in attempting to explain the powerful presence of Serra's *Torqued Ellipses*, cites Martin Heidegger's belief that the association between the body and the work of art is at the origin of art. Architecture, too, must relate itself intimately to the body, to human proportions, and to such primal responses as vertigo.

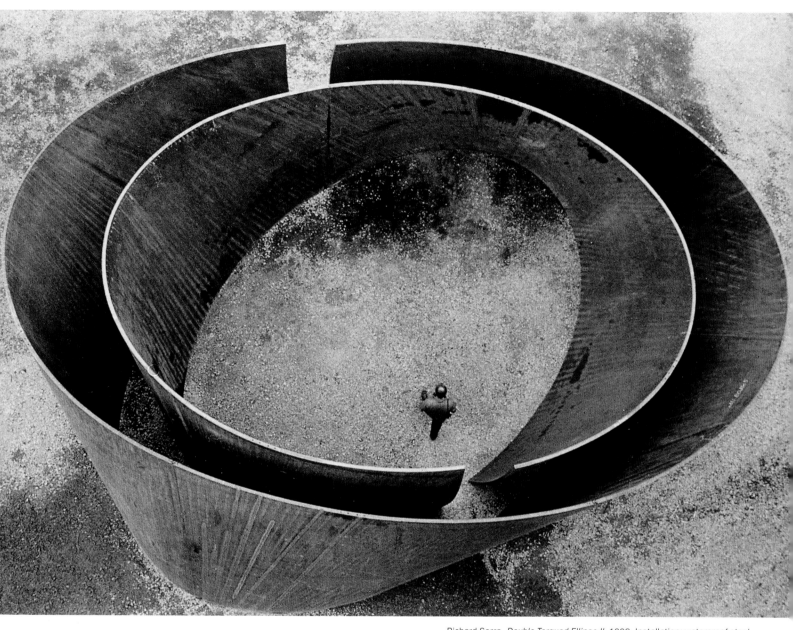

Richard Serra, *Double Torqued Ellipse II,* 1998. Installation: waterproof steel, outer ellipse 3.58 x 8.38 x 10.9 m, inner ellipse 3.58 x 8.69 x 5.99 m, plate thickness 51 mm. Photographed at Pickhan Umformtechnik, Siegen, Germany

Richard Serra, *Double Torqued Ellipse,* 1997. *Torqued Ellipse,* 1996. Installation view. Geffen Contemporary, Los Angeles

Kunsthaus Bregenz, designed by Peter Zumthor

"292 tons of cinder blocks were carried to the top floor of the Kunsthaus Bregenz and their weight distributed on temporary supports throughout the building. That will almost result, though with sufficient leeway, in the entire building collapsing as a result of the overload. For this reason, the number of visitors present at any time may never be more than 100, which represents an additional eight tons." Santiago Sierra's written concept for his project *300 Tons*, shown in Bregenz in April and May 2004, gives a measure of his ambitions and intentions.

Designed by the Swiss architect Peter Zumthor, the Kunsthaus Bregenz (1990–97) is a masterpiece of sensual minimalism, a concrete tower surrounded by a free-standing glass skin, standing on the shore of Lake Constance. Extremely simple within, the concrete floor slabs are supported by three interior load-bearing walls located at the perimeters of the galleries. Santiago Sierra, who was born in Madrid in 1966, but has lived in Mexico City since 1995, has consistently created unusual works that involve an implicit criticism of the market economy. For one video, he paid an Irish street vagrant from Birmingham's New Street to say over and over again: "My partici-pation in this piece could generate a profit of 72,000 dollars. I am being paid five pounds." Criticized for the apparent exploitation of those involved in his work, he replies: "These are the conditions of your life that you don't want to see." More pointedly still, he de-clares: "Persons are objects of the State and of Capital and are employed as such. This is precisely what I try to show." Basing his design for Bregenz on the calculations of the engineer who worked with Zumthor on the Kunsthaus, Sierra had workers from two local building companies who had erected the structure bring cinder blocks to the top floor and place them in fourteen identical cubic piles. The other floors of the building were left completely empty except for the additional temporary supports added to stabilize the building. A counter at the door allowed visitors to see how many people were actually in the exhibit, and consequently how close the building was to its theoretical point of collapse.

Despite occasional questions about the stability of contemporary architecture, the essential fact of any building is its solidity. Dedicated to art, the Kunsthaus in Bregenz, despite its glass skin, gives an impression of strength through concrete floors and walls. *300 Tons*, whose form might be compared to that of Minimalist sculptures by Donald Judd or Carl Andre, adds an indisputable element of risk with the danger of the structure crashing down. This piece involves a reflection on the fundamental instability of art, architecture and the very systems that hold them up. Richard Serra has experimented with extremely heavy Cor-Ten steel sculptures that appear to threaten the viewer for many years, but Santiago Sierra has in a sense gone further, with his rough and dirty cinderblock installation poised at the limits of catastrophe. In his installation at the Fondation Cartier, *The Fall* (see pages 212–17), Lebbeus Woods intellectually extrapolates the consequences of the imagined collapse of the building. Sierra makes visitors feel as though they are the willing participants in a potential calamity, and questions the very foundations of modern society in the process.

Santiago Sierra, *300 Tons*, April 2004.
Exhibition view, Kunsthaus Bregenz

There is an old-world richness in the personality of Álvaro Siza, an absence of the media-driven frenzy that seems to have overtaken so many of his colleagues. And yet Siza is one of the great figures of contemporary architecture, blending the culture of Portugal with an undeniable modernity. One of his most stunning buildings was the **Portuguese Pavilion** for *Expo '98* (Lisbon, 1996–98). Although it was built not far from the shores of the Tagus, close to the main entrance to *Expo '98*, his relatively low building remains discreet, despite an enormous concrete "veil" suspended from steel cables between two main buildings.

Converted for use by the Portuguese Council of Ministers, the building included a number of Siza's own drawings, reproduced on the walls of the dining room, for example. On the upper level, around a central courtyard, the "VIP" rooms were designed and decorated entirely by Siza. "Since I was a boy," says Siza, "I have made drawings. I wanted to be a sculptor, but for my family that was not realistic. I decided to enter art school where there were three courses — painting, sculpture and architecture taught simultaneously in the first two years. My intention was to switch without discussing the matter with my family, but then I became deeply interested in architecture. Drawings — landscapes, portraits and trip sketches — have always kept me busy. I don't think that it has a direct relation with architecture but it is a good way to develop the acuity of vision. There are two different words in Portuguese that mean 'to look' and 'to see and understand.' The tool of the architect is to be able to see. I remember reading a text by Alvar Aalto in which he wrote that when a project was halted he would stop and just make drawings without any specific intention. Sometimes from this exercise, ideas would come to help move the project forward. There is a relation which is not direct."

Part of Siza's continued interest in drawing is related to his frustration with the methods of contemporary architecture. "There used to be an understanding, though, that business needs quality. That is no longer the case. What is interesting is to be quick. It is normal in some European countries for the architect to make a design, and after that it goes to a promoter and a builder and they change whatever they want. It is felt that the architect is not necessary, and is not even allowed to go to the construction site. The relationship between designing and building, which is for me the same thing, is no longer maintained. To make a building it is necessary to have a complete team, acting like a single person, but today, all of the responsibility is broken up. This is what gives me the need to draw or to sculpt. In the end it is the same family of activities...."

Although he publishes his drawings freely and occasionally uses them in his architecture — like one of his mentors, Oscar Niemeyer — Álvaro Siza is careful to make the distinction between considering himself an artist and describing the act of designing. One naturally engenders the other in his mind. Indeed, this type of symbiosis is a key to understanding the real relationships that often exist between art and architecture at the highest level. His is surely not the case of an architect trying to be an artist, despite his early and continual interest in drawing. Rather, it is a matter of a natural community of spirit and forms of expression.

Working with his colleague Eduardo Souto de Moura, Siza defined space and form in his Portuguese Pavilion around the lines of his own sketches, reproduced on walls in the dining room (above right).

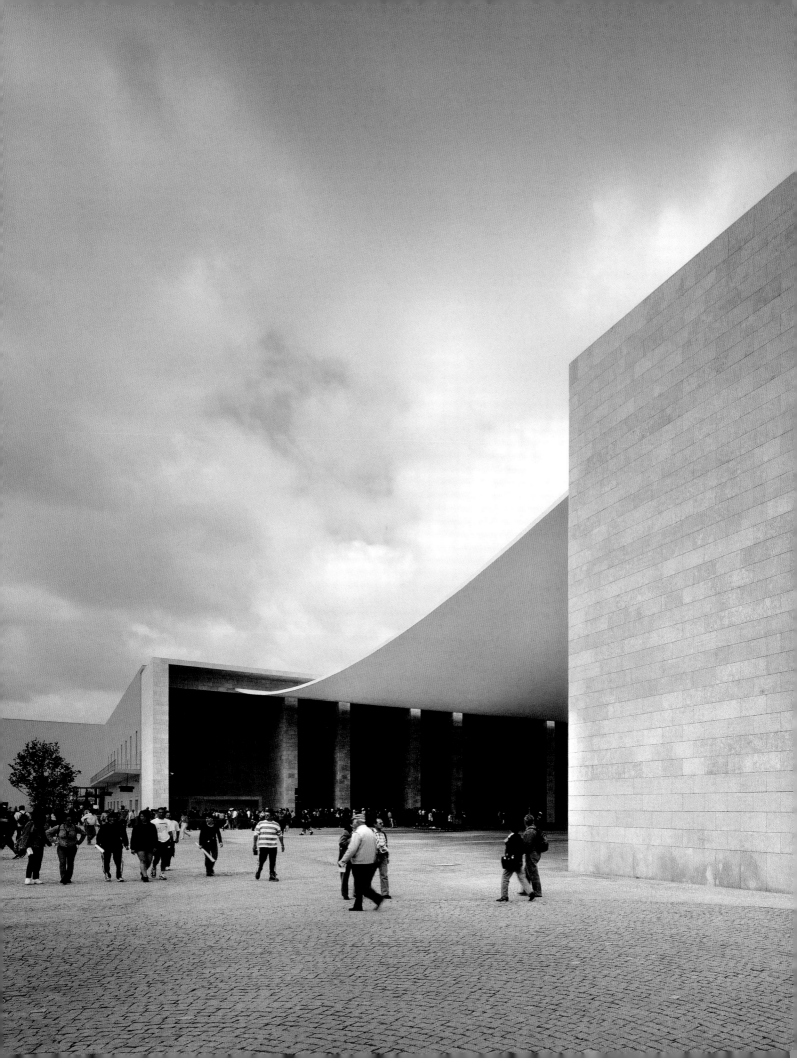

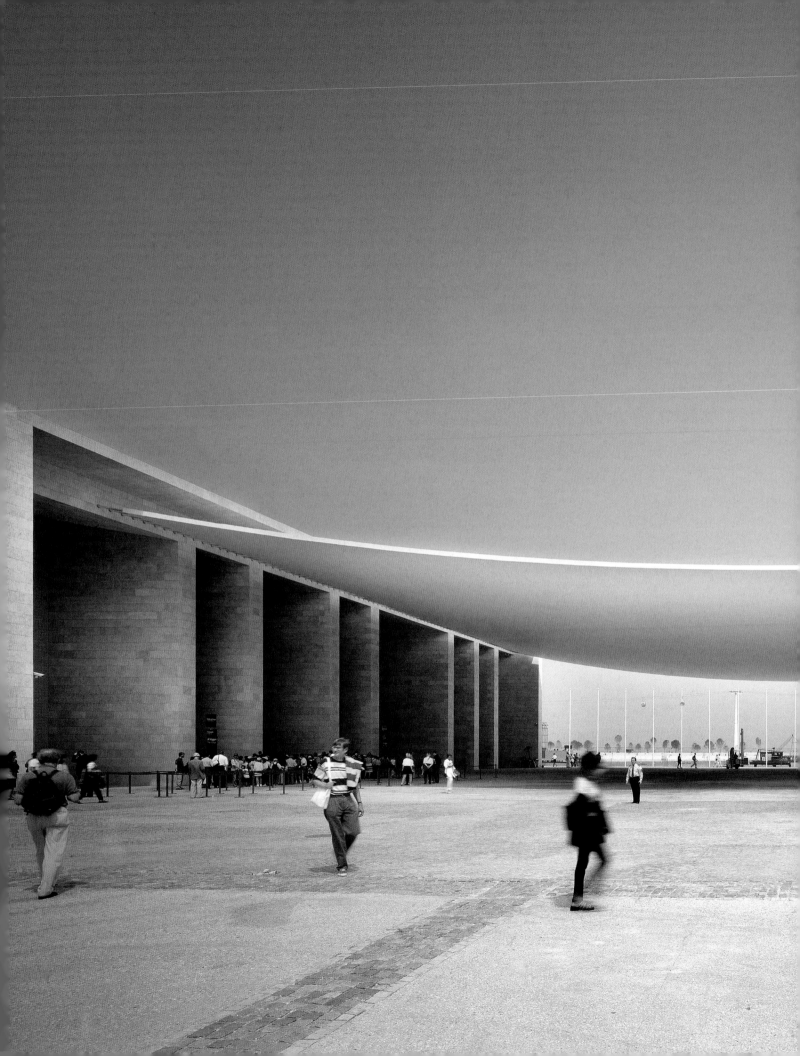

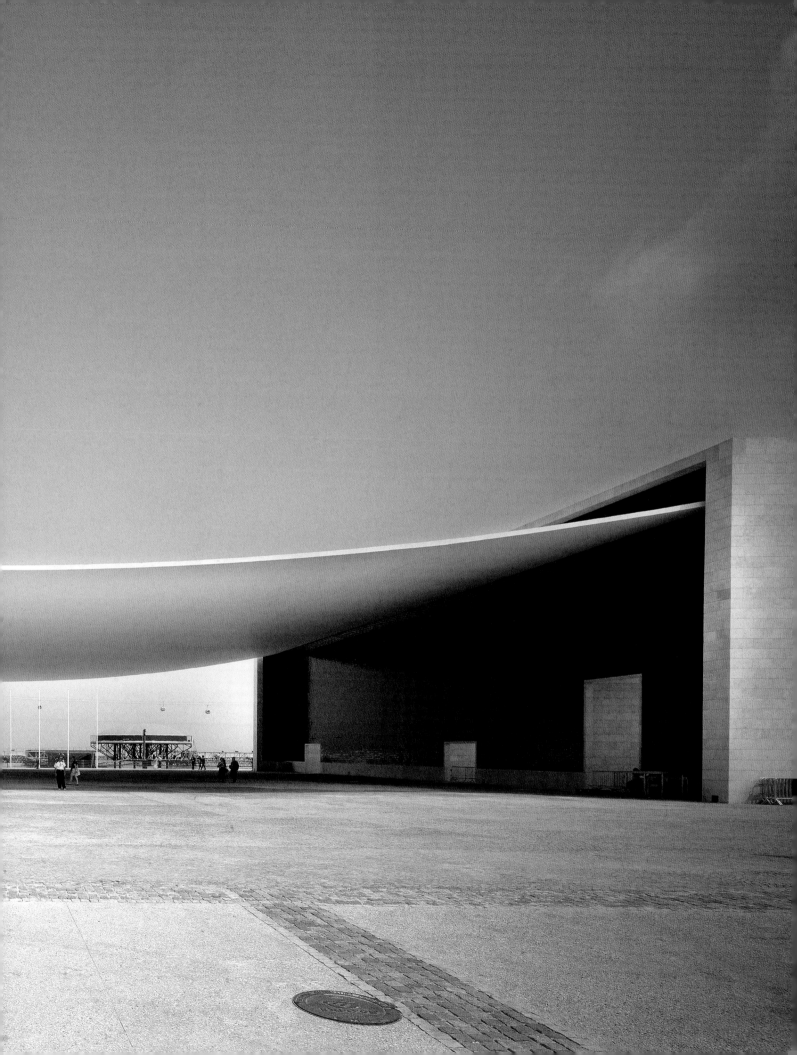

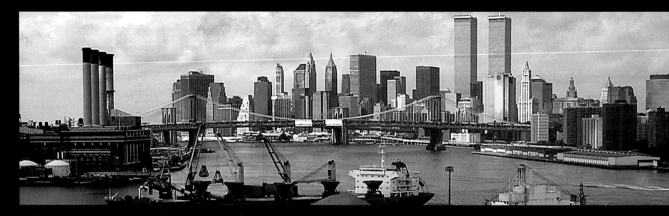

Wolfgang Staehle, *Untitled*, 2001. Video. Postmasters Gallery, New York

It is hardly surprising that architecture continues to play a role in the newest forms of artistic expression, but more and more, this presence is a layered one, emerging in unexpected ways and combined with other influences and art forms. Wolfgang Staehle, born in Stuttgart in 1950, is an important figure in the acceptance of Internet as a vehicle for artistic expression. He attended the Freie Kunstschule there for two years, and has lived in New York since 1976. In 1991, he founded *The Thing* (http://bbs.thing.net), an independent media project which became one of the most important online (after 1995) and offline forums for new media art and theory. His work *Empire 24/7*, a live image of the Empire State Building in New York, was included in the *net_condition* show at the ZKM Center in Karlsruhe (1999) and in *Loans from the Invisible Museum* at Yerba Buena Arts Center in San Francisco (2000). A more recent piece, **Untitled** (2001), involved three live Internet video feeds, including a view of the World Trade Center. The other two feeds showed the television tower in Berlin, and the Comburg monastery, "offering an instantaneous compression of time and space." Projected onto the walls of the Postmasters Gallery in New York, from September 6 to October 6, 2001, this work unintentionally recorded the events of the morning of September 11. Paul Virilio included it in his exhibition *Ce qui arrive* (Fondation Cartier, Paris, November 29, 2002–March 30, 2003). Virilio is, of course, interested in accidents and their inevitability, but it is clear that the force of the unexpected animates *Untitled* to a degree that Wolfgang Staehle could never have guessed beforehand. One might expect that filming any building or urban landscape for a month would give very few signs of fundamental change, and yet here, one of the significant events of recent his-

tory suddenly erupts on the screen. Virilio's theories that modern society is becoming more and more likely to generate catastrophic incidents are thus confirmed, and architecture, intended as a symbol of modernity and solidity, is explosively vaporized. The fact that Staehle made this work without any idea what would happen makes its acceptance as a work of art easier, though it raises troubling questions about the limits between "news" and "art." Andy Warhol famously photographed and repainted images of catastrophe headlines from the tabloid press. Staehle's process is somewhat different, but his source of inspiration also appears to be the media. "It's just that the media, like television, are so pervasive in our culture," says Staehle. "A lot of people watch it all the time, and then you have the snobs who say 'I don't watch television.' I think, either way you're deprived culturally, whether you watch it or not, because it informs all the people around you. To understand how they think and what's going on, you should go to the source and try to analyze it. I ran into an interesting quote recently by Duhamel, who said in the 1930s: 'I can no longer think what I like. Moving images substitute themselves for my own thoughts.'" Staehle deals in his work with the boundaries between "real" space and new media. As he puts it, "When you go out to have dinner and charge it to your credit card you are in information space. Distinctions like natural and constructed space — they don't make a whole lot of sense anymore…. Whatever happens in-between, there are still real bodies sitting at the terminals." The layering of images and different realities in *Untitled* makes it a very contemporary work of art indeed. Architecture becomes the unwitting "star" of art, but as Staehle might put it, there were still real bodies in those buildings.

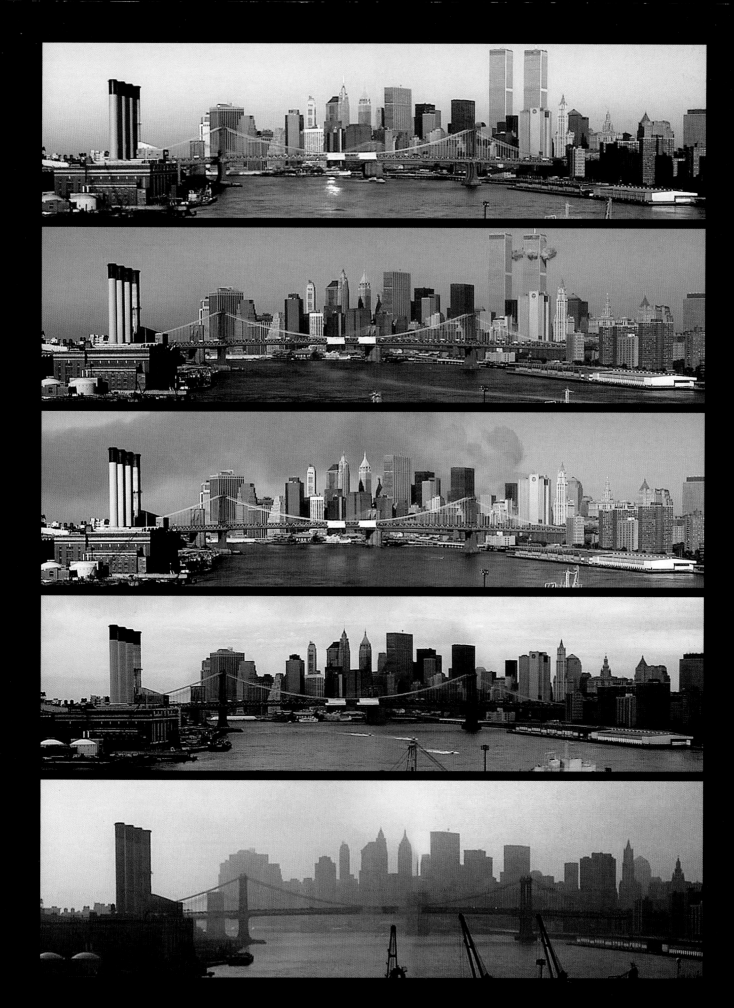

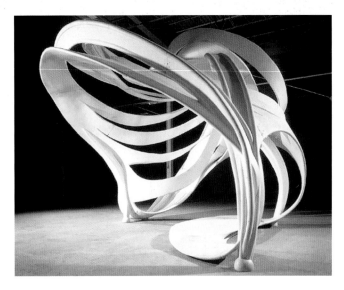

Frank Stella, *The Broken Jug*, 1st Version 1999.
Painted fiberglass and wood, 3.66 x 4.45 x 4.57 m

Frank Stella is known mainly as a painter, but his work progressively took on a more and more sculptural presence, A recent work of his, given to the National Gallery in Washington, is almost as large as a building (*Prinz Friedrich von Homburg, Ein Schauspiel, 3X, 2001*). In fact, Stella has long been fascinated with the idea of crossing the boundary into architecture. In 1986, he created a 10.6-meter-high *Cone and Pillar* relief for an office building located at 599 Lexington Avenue in New York, and, he declared, "It sparked something in me. I started becoming a public artist instead of a gallery artist." In 1992, Stella wrote an article entitled "Critique of Architecture," in which he stated, "I believe artists can now, as they have in the past, make a helpful contribution to the invention of some necessary new or, at least slightly more thoughtful, building processes. I believe that the ability of artists to extend a meaningful note of the pictorial into the domain of sculpture and architecture will help enrich our habitable landscape." Frank Stella's first attempt at building design occurred at the request of Alessandro Mendini, who wanted the artist to create a pavilion for older art forms in the Groninger Museum (Groningen, 1990–94). "Since the program called for a sympathetic home for the art of the past, it seemed appropriate to take a pictorial approach to architectural design," said Stella. "In those paintings, simple geometric shapes interacted with each other so that they occupied the same plane rather than overlapping. It made an effective two-dimensional image, especially when the background support plane was cut away, leaving a shaped canvas with an irregular perimeter. It seemed natural to seek the same effect in three dimensions. A pyramid pushed into a cube must work as well as a triangle stuck into a square." A second unbuilt project was an Orangerie designed by Stella for the Herzogin Garden in Dresden at the request of real-estate developers and contemporary art collectors Rolf and Erika Hoffmann.

Frank Stella finally realized his first work of architecture in 2000, a 10.4-meter-high, 15-meter-long bandshell called ***The Broken Jug***, which was to be placed in front of Arquitectonica's American Airlines Arena (Miami, Florida). Made of aluminum in the CMN shipyard (Cherbourg) with the assistance of the engineers RFR, *The Broken Jug* was finally never placed in Miami, and remains in Cherbourg. When asked if this work was not really a form of sculpture, he answered, "Architecture is really about the physicality of the forms, making things that seemed three dimensional — at a certain point, you make something big enough, it's potentially habitable. If it's a habitable sculpture, why isn't it architecture? Because it doesn't have a toilet in it?" In some ways, the building projects of Frank Stella seem to have more to do with German expressionist architecture than they do with painting. As he says, "Hermann Finsterlin designed a lot of things that were never built. The Bauhaus might have turned out to be more like that because they were oriented toward the possibility of marrying art and architecture, but art and technology put an end to that affair.... The glass and steel wall ... that was the end. Art and architecture never came together again." (http://www.bombsite.com/stella/stella 12.html) His *Broken Jug* makes references to a number of ideas that Stella has employed in his paintings and sculpture, and thus his terms might be the most accurate explanation of his own ambition — to "marry art and architecture."

Frank Stella, *Prinz Friedrich von Homburg, Ein Schauspiel, 3X*, 2001. Sculpture, stainless steel, aluminum, paint on fiberglass and carbon fiber, 9.4 x 11.9 x 10.4 m approx., view 3/5. The Archive of Frank Stella, New York

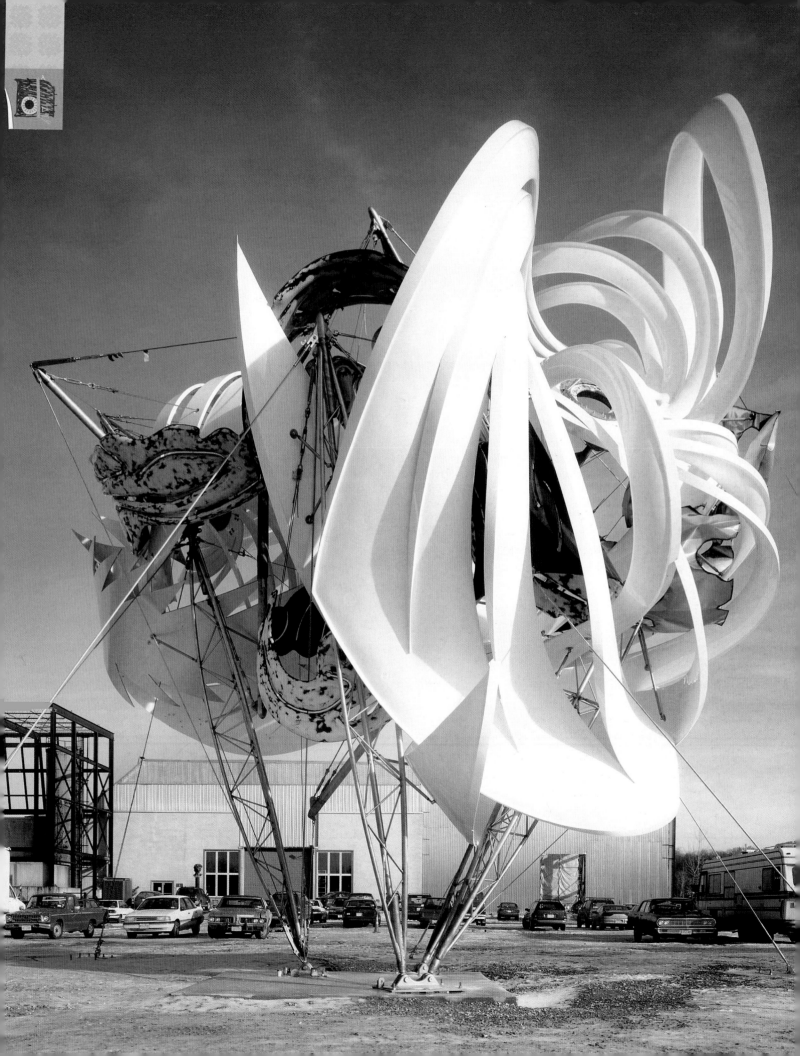

Thomas Struth is, together with Andreas Gursky, the most fa-
mous of the graduates of the Düsseldorf Kunstakademie. He, of
course, came under the influence there (1973–80) of Bernd and
Hilla Becher, but also of Gerhard Richter. His early works were re-
lated directly to architecture and urban environments — street
views in black-and-white taken in Japan, Europe and the United
States with a precision and detachment that led critics to com-
pare him with the French photographer Eugène Atget. He also
produced a series of laconic family portraits after working with
the psychoanalyst Ingo Hartmann. Struth's reputation was great-
ly enhanced by his *Museum Photographs*, a series of pictures
taken in great museums, usually with very well-known works of
art visible, as well as the architectural context of the hangings.
Again, there is a kind of bemused detachment as the often very
animated paintings are contrasted with the poses and movement
of visitors. His 1990 picture of the **Pantheon** in Rome makes the
great monument's architecture participate in a commentary on a
group of tourists, rendered miniscule by the scale of the building
and the wide angle of the image. The orderly forms of the
Pantheon seem to stand as silent criticism of the smallness of
contemporary visitors. In works such as his *Art Institute of
Chicago I* (1991) he photographs a painting by Caillebotte in such
a way as to suggest that the space of the canvas is extended into
the gallery in which it is being viewed. The very large dimensions
of the photograph heighten this impression. An interesting as-
pect of this and other photographs by Struth is that they are ac-
cepted in the world of art, being exhibited in such prestigious
locations as New York's Metropolitan Museum of Art (February 4,
2003–May 18, 2003), and yet they are accessible even to those
who have little or no education in the history of art. This does not
mean that their complexity is readily apparent to the uninformed
viewer; indeed, they tend to make many viewers uneasy, in all
of their large-scale "objectivity." In a way, Struth's images are
as cold and calculated as those of Andreas Gursky, even if the
subject matter is different.

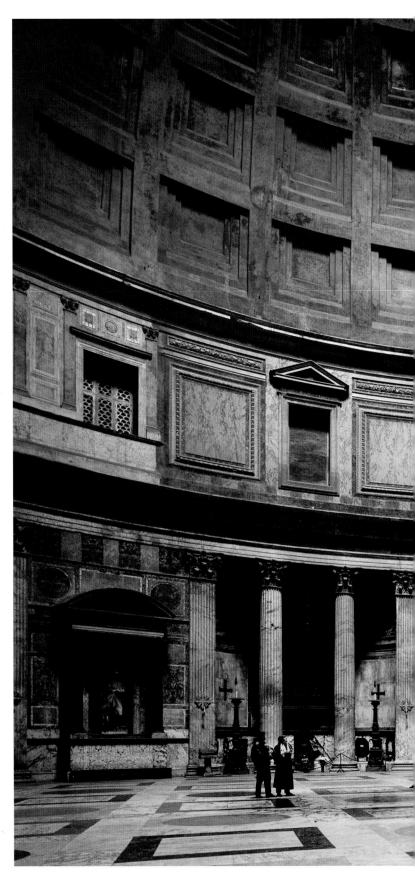

Thomas Struth, *Pantheon, Rome,* 1990.
C-Print, 137.5 x 194 cm (image), 183.5 x 238 cm (frame)

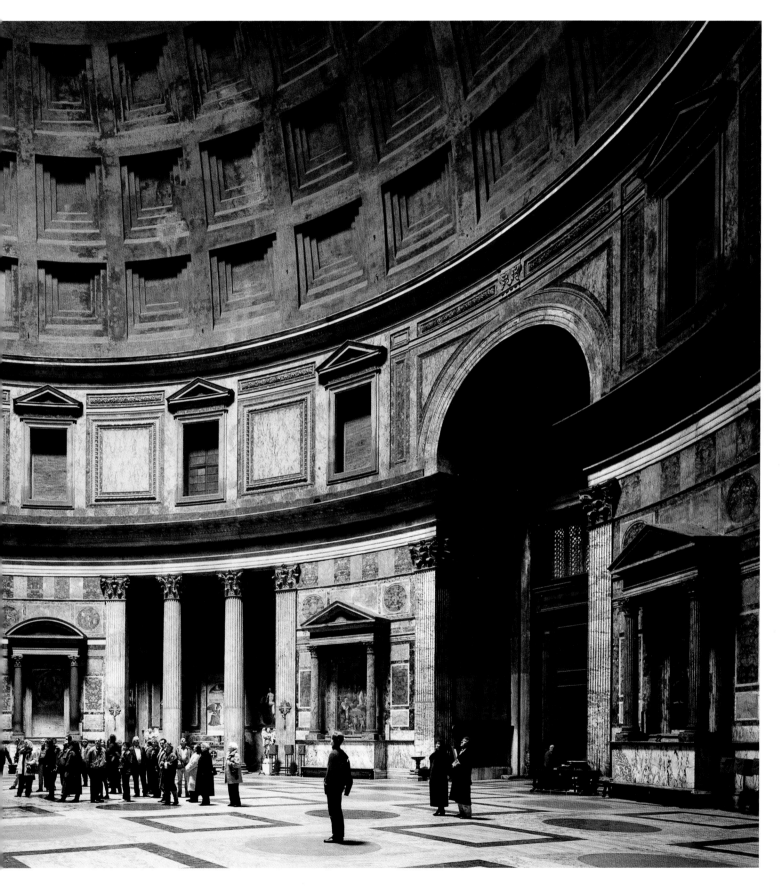

Thomas Struth has more recently taken numerous pictures of modern cityscapes, such as his **Shanghai Panorama** (2002). Here the detachment remains and the remarkable shapes of the architecture of contemporary Shanghai seem to be little more than a movie décor — an opera set with as little substance as a cardboard imitation of "real" architecture. Although Struth did not, like his mentors, the Bechers, set out on a typological quest, he does retain from them a frontality and a dryness that colors his work even more than the tones of a C-Print. Whereas there seems to be an anthropomorphic vivacity in many of the Bechers' industrial buildings, Thomas Struth finds more life in old paintings and buildings than he does in the architectural and artistic production of modernity. Where his pictures first elicit a feeling of warm familiarity, the attentive viewer is quickly surprised to find that he, too, looking at this image in a gallery or museum, has been given a small role in Struth's morality play. His detachment and irony make him a formidable critic of contemporary architecture and urbanism, yet architecture permeates his art.

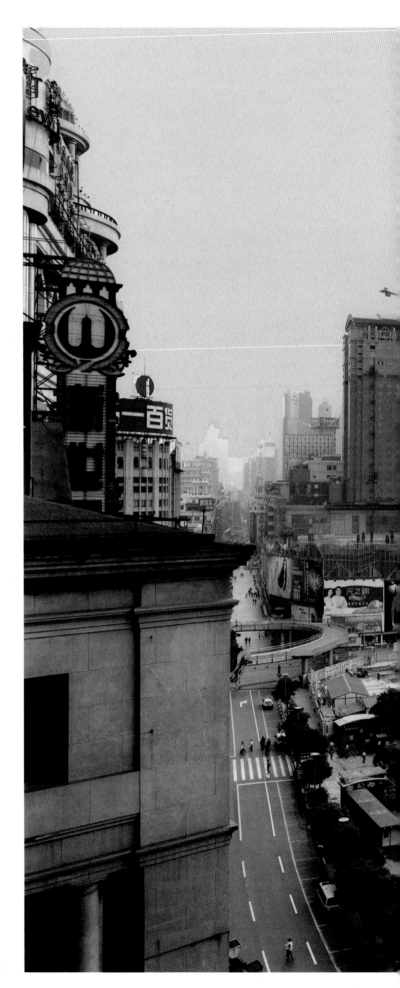

Thomas Struth, *Shanghai Panorama, Shanghai,* 2002.
C-Print, 138 x 173.1 cm (image), 176 x 209.1 cm (frame)

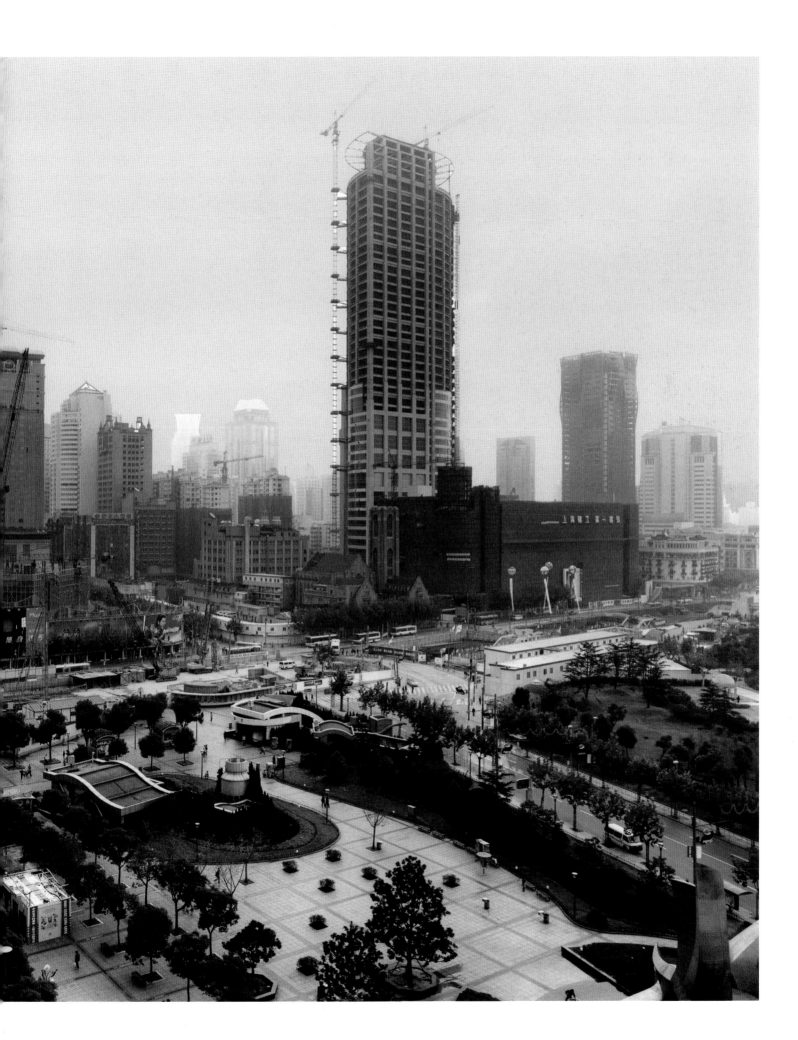

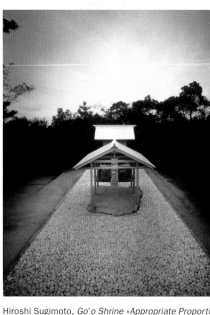

Hiroshi Sugimoto, *Go'o Shrine »Appropriate Proportion«*, 2002. Sculpture. Naoshima

Hiroshi Sugimoto is an artist who has shaped his own form of expression. Born in 1948 in Tokyo, he went to the Art Center College of Design in Los Angeles to study photography in 1970. He has lived in New York since 1974, but still maintains close ties to Japan. As a photographer, Sugimoto has long been accepted in the company of the most prestigious contemporary artists, exhibiting at White Cube in London or at Sonnabend in New York. Very often, his photographs reveal a connection to architecture, either in their form or in their inspiration. Five main series have characterized his work to date: *Dioramas and Wax Museums* (both since 1976), *Theaters* (since 1978), *Seascapes* (since 1980), *Sanjusangendo, Hall of Thirty-Three Bays* (sculptures of the Buddhist temple Sanjusangendo, 1995), and *Architecture* (since 1997). For movie theater pictures, Sugimoto used time-lapse photography, while an entire film was projected on the screen — leaving only a white imprint on the film that nonetheless signifies a passage of time. His views of famous works of modern architecture are intentionally out of focus, and are taken from unusual angles. In both instances, the photographer has reinterpreted architectural settings in a personal manner, revealing function and form in ways that they are not generally seen.

His most recent series, called *Conceptual Forms*, consists of pictures of machines and stereometric plaster models that were made in Germany in the late 19th and early 20th centuries to "provide a visual understanding of complex trigonometric functions." Photographed in the museum of the University of Tokyo, "these machines and models were created without any artistic intention," says Sugimoto. "This is what motivated me to produce this series of photographs and title them *Conceptual Forms*. Art is possible without artistic intention and can be better without it," he concludes. The image reproduced here, **Surfaces 0012, Clebsch diagonal surface, cubic with 27 lines** (2004), shows a surprising architectural presence, indeed a monumentality accentuated by the high quality and large dimensions of the photograph. Bringing to mind some of the more extravagant forms seen in the paintings of Salvador Dalí, in the sculptures of Henry Moore or in the architecture of Oscar Niemeyer, the *Clebsch diagonal surface* is not an artistic creation in itself, but a mathematical construct. It is the eye of Hiroshi Sugimoto that elevates this object into a work of art "without artistic intention." Niemeyer's architecture is often related to a rigorous analysis of engineering, but it is by no means a pure product of a mathematical calculation. There is an inevitability or a truth in the *Clebsch diagonal surface* that the photograph renders monumental. It is said that the difference between art and architecture is that art serves no purpose, but in this instance, the plaster model does have a pedagogical usefulness, not as a building, of course, but as something other than an esthetic product of the imagination. Sugimoto relishes in the creation of this kind of multilevel content in his work.

He proved his consistent interest in architecture recently by designing a shrine on the island of Naoshima in the Inland Sea of Japan. His **Go'o Shrine** makes use of the precepts of Japanese temple construction but features a series of thick, rough glass steps that rise up from a granite crypt. His fascination with light and with the passage of time is here just as evident as it is in his photography. In his photography Sugimoto also plays on the third-dimension, that of architectural space only perceived but never expressed in a mere image. By actually building a shrine, he breaks through the invisible barrier that separates his photography from the "real" work, and shows how deeply tempted he is to step through the looking glass of his own invention.

Hiroshi Sugimoto, *Conceptual Forms. Mathematical Forms: Surfaces 0012, Clebsch diagonal surface, cubic with 27 lines*, 2004. Gelatin silver print, 148.2 x 119.4 cm (image), 182.2 x 152.4 cm (framed)

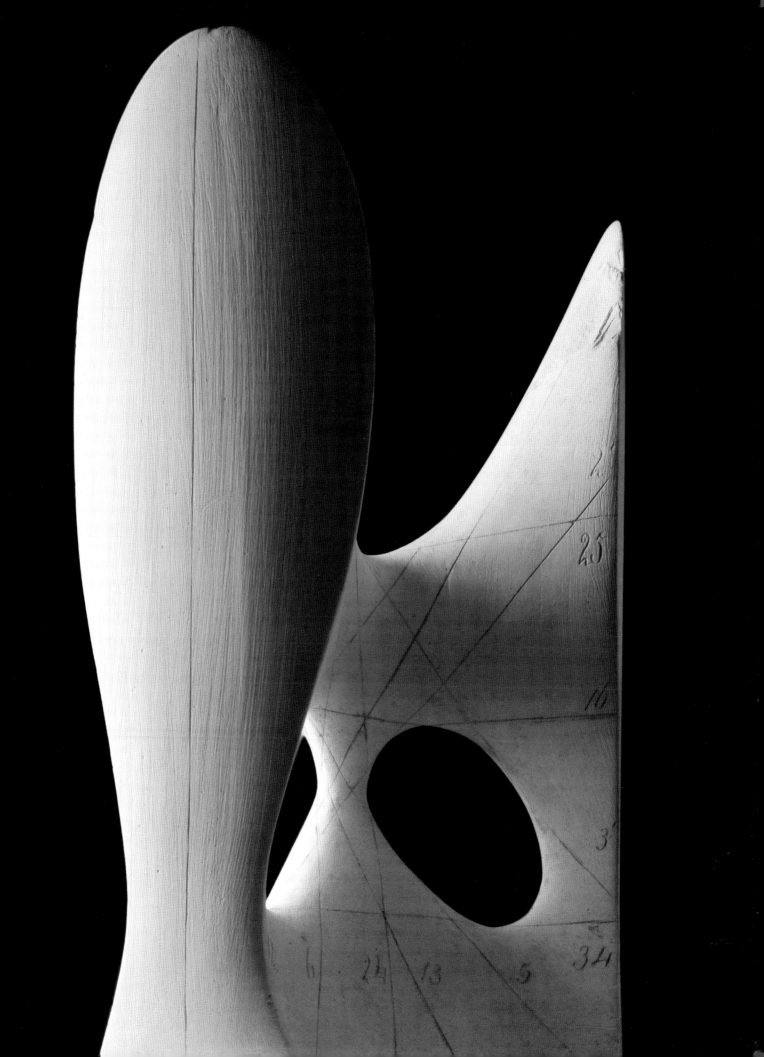

Born in 1972, David Thorpe has shown an unusual interest in architecture since he came to public attention in the *Die Young Stay Pretty* show at London's ICA in 1998, the year he graduated from Goldsmiths. Working first with paper collage and sharply figurative representations of modern buildings, he has evolved more recently toward depictions of structures that might have been built by an imaginary wilderness community. His collage work has changed as well, including such unexpected materials as copper, bark and pebbles as well as paper. Though the buildings he represents in paintings such as **Good People** are not real in any sense, they do recall the kind of mystical or magical atmosphere of movies like *The Lord of the Rings*, or perhaps the work of some American "organic" architects. He says: "I've recently become interested in fringe architects like Bruce Goff. And I've been getting into the lifestyles and communities that these buildings seem to be made for. I'm playing with certain associations, slightly New Age, slightly Space Age, slightly threatening. I find most fundamentalist communities extremely worrying but I'm absolutely in love with people who build up their own systems of belief." David Thorpe's comments about the materials and techniques he uses may be more revealing than his affection for the work of Bruce Goff. As he says: "I've always been interested in creating my own world and it seems like common sense that if I'm constructing a tree I should do it in bark.... The technique also seems appropriate to the subject matter — these obsessive, hick communities. These pictures are images of things, but they could also potentially be manufactured within these worlds. They could be the types of images that would be seen inside these buildings. I'm always trying to find equivalences between the subject matter and the materials, and as in the last few years the subject matter has become more esoteric, so the materials have become odder."

The naturalistic or representative style of David Thorpe might also be from another time — there are few indications that it is really contemporary. Indeed, the kind of community that he imagines has intentionally cut off from modern society, just as he does in a way, creating his "own world." Though many artists or architects have chosen more sociable forms of expression, creating one's own world has always been a powerful motivation in both areas. An artist or an architect is meant to have a "vision," a way of seeing things as they are or as they might be. Imaginary views of cities or buildings have been legion in art since the earliest times of pictorial representation. So, too, architects have longed for the "ideal city" or, more modestly, a building that is a world unto itself. These are the utopian longings that run through almost every society and that are at the origin of much artistic expression.

Thorpe introduces a modern aspect to his work when he talks about "obsessive hick communities" or "extremely worrying" people. He is not, on the face of it, a New Age priest, but there is a

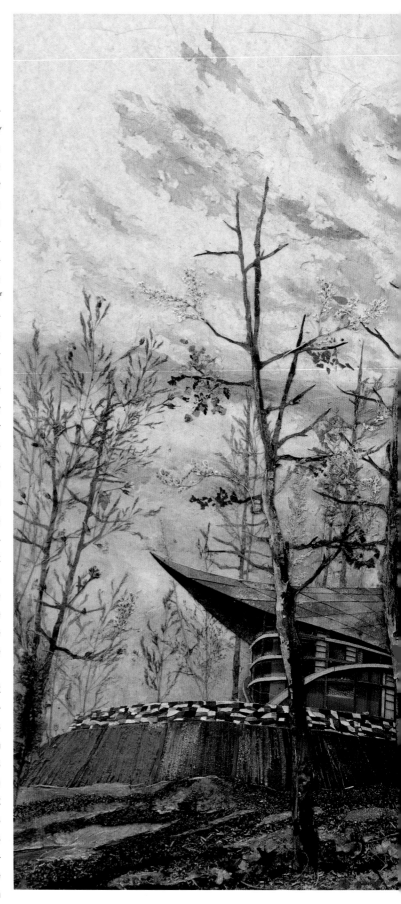

romantic nostalgia in his images that might give pause for thought. There is no overt criticism of separatist millenarian communities in these images, rather a kind of fascination with their perceived inventiveness and "purity." Thorpe admits to identifying with the

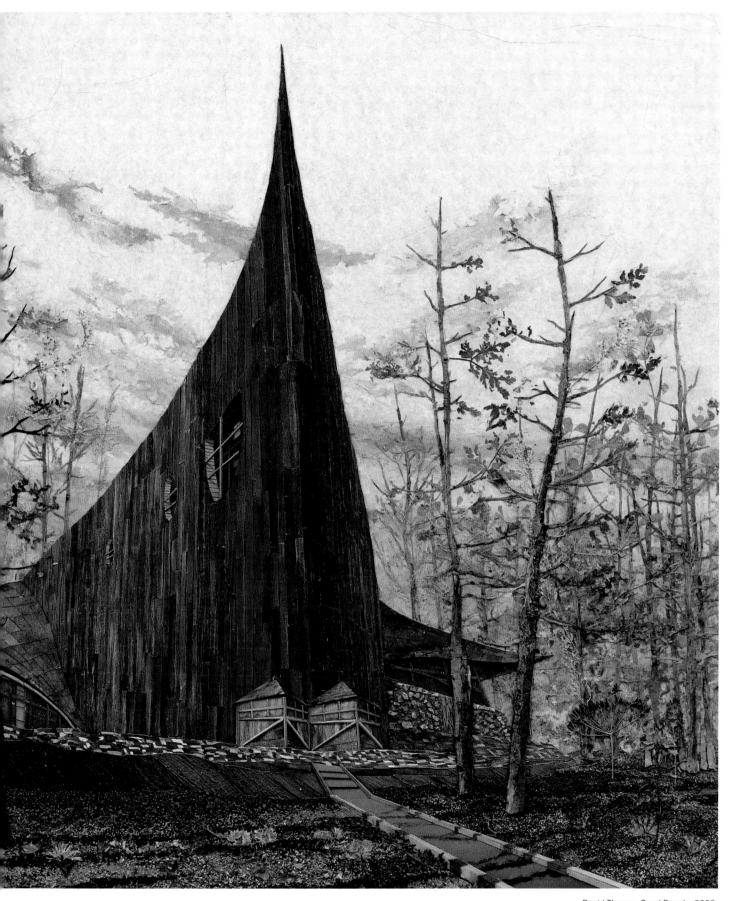

David Thorpe, *Good People,* 2002.
Mixed media collage, 75 x 99 cm

esoteric, if imaginary, creators of the architecture he represents.
He is careful not to step over the line into the kind of architectural
fantasies that animated other, more authentically dangerous keep-
ers of a flame.

La Defense is a rather large office building designed by UN Studio (Almere, 1999–2004, 23,000 square meters). The complex is, for the most part, closed but it opens at two points, allowing access to a park at the rear. Varying heights and numerous entrances allow for La Defense to be used by several companies simultaneously. Its exterior facade is metallic silver in color, blending as unobtrusively as possible with the neighboring gray brick buildings and homes. The layout of the building follows the complicated outline of the 8,833-square-meter site, and as the architect Ben van Berkel says: "We animate the geometry of our buildings through parametric modeling. We still do sketching and modeling but the computer plays an extremely important role." Where La Defense differs even more considerably from what might be expected in a small business center located in a medium-sized town is in its interior surfaces. "When you enter the inner courtyard the building reveals its genuine characteristics," says van Berkel. "The facade adjacent to the courtyard is built up out of glass panels in which a multicolored *dichroide* foil (also called Radiant Color Film) is integrated. Depending on the time of the day and the angle of incidence of light, the facade changes from yellow to blue to red or from purple to green and back again." Usually used for perfume bottles, the foil, manufactured by 3M, had to be specially produced for such large surfaces.

Born in Utrecht in 1957, Ben van Berkel studied at the Rietveld Academie in Amsterdam and at the Architectural Association (AA) in London. After working briefly in the office of Santiago Calatrava (1988) he set up his practice in Amsterdam with Caroline Bos. In addition to the Erasmus Bridge in Rotterdam (1996), they have worked on the Möbius House (Naarden, 1993–98), Het Valkhof Museum (Nijmegen) and an extension for the Rijksmuseum Twente (Enschede, 1992–96). They are currently working on the new Mercedes Benz Museum in Stuttgart. UN Studio was also a participant in the recent competition for the World Trade Center in New York (in collaboration with Foreign Office Architects, Greg Lynn FORM, Imaginary Forces, Kevin Kennon and Reiser + Umemoto, RUR Architecture P.C. under the name of United Architects). Van Berkel has long been attentive to developments in contemporary art. As he says: "I find digital photography particularly interesting. In a sense it is like painting with information. There is a relationship to time and color that we tried to obtain in La Defense, as though a visitor might be walking in a moving painting. Images from the sky are, in a sense, projected onto the facade. Because of its variable reflectivity, weather participates in creating a new facade continually as the day advances. At night, another effect is generated by light behind the glass."

As Ben van Berkel makes clear, the work of UN Studio, one of the most important architectural firms working in The Netherlands, is informed and influenced by his own sense of the developments of contemporary art. Interested in science and technology, van Berkel sought ways to create a facade that would change with available light, giving visitors the impression that they are in a "moving painting." The architect might not claim to have created a work of art in his own right in this instance, but he has enriched his work through an awareness of contemporary art.

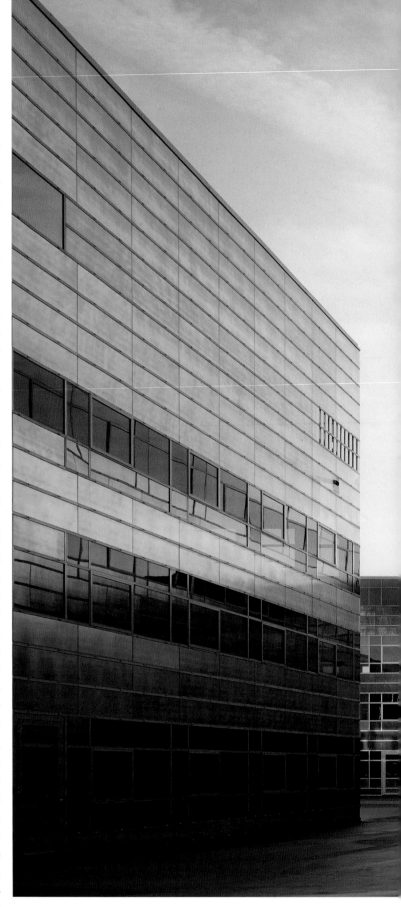

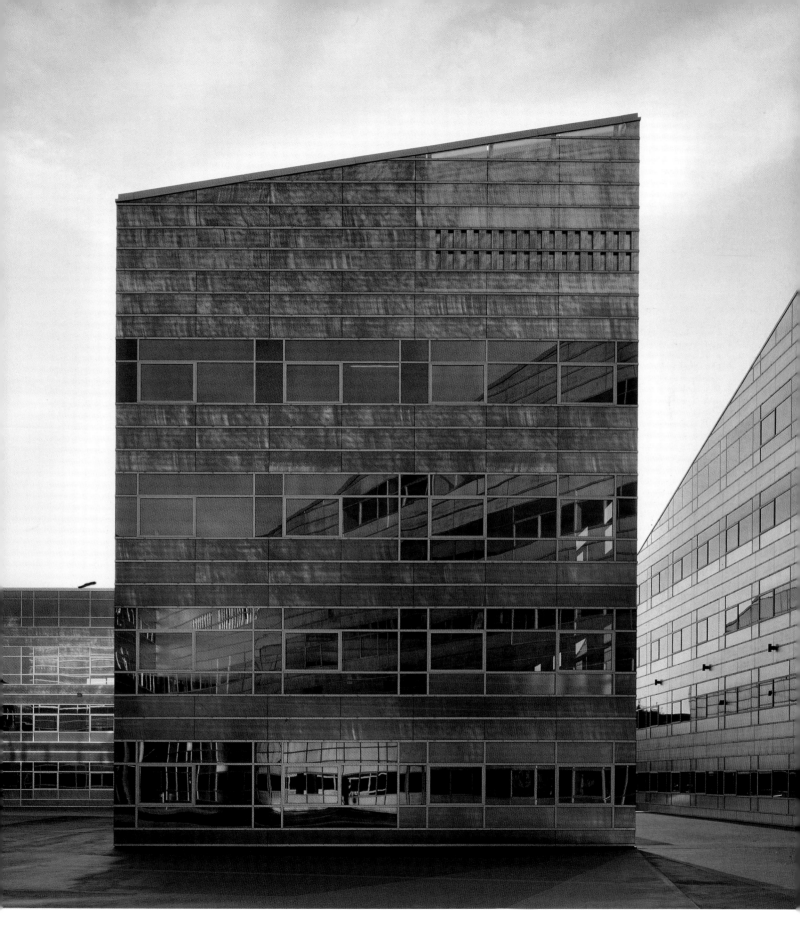

Ben van Berkel, *A Life in the Day*, 2004. Photographic print on polyester,
184 x 197 cm

Fascinated by contemporary photography, Ben van Berkel sought to give
a cinematographic sense of movement and color to La Defense.
One of the architect's own pictures of his building appears on the next
double page.

199

Felice Varini, *Octogone au carré,* 2003. Installation view,
Photo jet painting. Château des Adhémar, Montélimar

What happens when a work of art exists only because of its location,
if it cannot be extracted from that location without losing its very
raison d'être? Architecture then becomes the necessary back-
ground for art. In 1969, the French artist Daniel Buren wrote about
the fundamental importance of location for many works of art. Cer-
tain pieces, he argued, like Duchamp's *Readymades,* existed only
because of their placement. A museum would thus serve as a kind
of "frame" in this context.

The work of Felice Varini is undoubtedly related to the much
more ancient art of anamorphosis. A dictionary defines anamorpho-
sis as: "A distorted or monstrous projection or representation of an
image on a plane or curved surface, which, when viewed from a cer-
tain point, or as reflected from a curved mirror or through a polyhe-
dron, appears regular and in proportion; a deformation of an im-
age." Varini himself, born in 1952 in Locarno, describes his work as
follows: "My field of action is architectural space and everything that
constitutes such space. These spaces are and remain the original
media for my painting. I work "on site" each time in a different space

and my work develops itself in relation to the spaces I encounter. I
generally roam through the space, noting its architecture, materials,
history and function. From these spatial data and in reference to the
last piece I produced, I designate a specific vantage point for view-
ing, from which my intervention takes shape. The painted form
achieves its coherence when the viewer stands at the vantage point.
When he moves out of it, the work meets with space, generating
infinite vantage points on the form. It is not, therefore, through this
original vantage point that I see the work achieved; it takes place in
the set of vantage points the viewer can have on it."

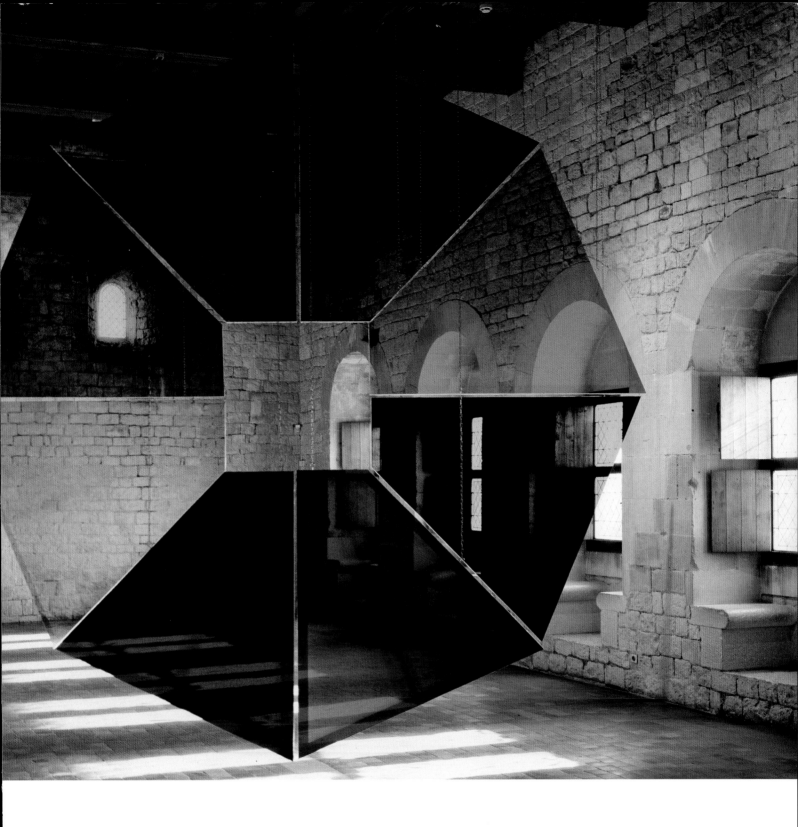

Selecting the octagonal form of the photographic diaphragm, Varini created his work *Octogone au carré* in 2003 in one of the austere spaces of the Château des Adhémar in Montélimar. Like most of his works, this one becomes a disjointed series of apparently unrelated forms when the viewer is not standing at the correct vantage point. The work resolves itself into the intended octagon only when that point is reached. This is a commentary on vision and the exactitude of the perceived image which also influences the viewer's impression of the space he is in. The artist directs the viewer toward the vantage point, and surely initiates a reflection on the relativity of apparently well-defined architecture. Varini paints lines or flat, geometric forms on walls, floors, ceilings or facades to obtain the desired effects, often creating a destabilizing effect, a kind of vortex into which viewers are inevitably drawn. This is not so much an act of collaboration between artist and architect as an artistic commentary on space, a modulation of perception that tends to make accepted facts about architecture dissolve. This art cannot exist without its architectural décor, but the relationship Varini establishes is symbiotic: his painted surfaces live only because of the place he chooses for them.

When he was commissioned to build the German pavilion for the International Exhibition of Barcelona in 1929, Ludwig Mies van der Rohe asked the Ministry of Foreign Affairs what was to be exhibited. "Nothing will be exhibited," he was told, "the pavilion itself will be the exhibit." Together with works like Frank Lloyd Wright's Falling Water, or Le Corbusier's Ronchamp and Villa Savoye, it is considered one of the most significant works of 20th-century architecture. As the ministry reaction implies, the building had no specific program, except to accommodate a reception for the King and Queen of Spain as they signed the "Golden Book" officially opening the exhibition. According to the architect, the furniture he designed specifically for the pavilion, the famous Barcelona chairs and stools, were not used during the opening ceremony. "To tell the truth," he said, "nobody ever used them." Dismantled in 1930, the Barcelona Pavilion was rebuilt in 1986.

Jeff Wall was born in Canada in 1946. He lives and works in Vancouver. In 1977, he began making carefully composed, backlit Cibachrome photographs. Since 1991, he has used digital technology to produce panoramic photographs, often making reference to well-known works of art. His photographs can often be described as laconic or emotionless, but the historic references he dissimulates in these large, sharp images give them a resonance that goes beyond the immediate impression they make. They are intended, as he explains, to depict modern life. "The idea of the 'painting of modern life,' which I've liked very much for many years," he says, "seemed to me just the most open, flexible and rich notion of what artistic aims might be like, meaning that Baudelaire was asking or calling for artists to pay close attention to the everyday and the now." Although he was trained as a painter, Wall intentionally uses the word "painting" when referring to his photography. "The painting of modern life would be experimental," he says, "a clash between the very ancient standards of art and the immediate experiences that people were having in the modern world. I feel that that was the most durable, rich orientation, but the great thing about it is that it doesn't exclude any other view. It doesn't stand in contradiction to abstraction or any other experimental forms. It is part of them, and is always in some kind of dialogue with them, and also with other things that are happening, inside and outside of art."

In choosing the silent perfection of the Barcelona Pavilion as the theater for his work **Morning Cleaning** (1999) Wall introduces one discordant element — a sign of life. The representation of architecture, as François Roche points out, is usually devoid of narrative, but in this instance, real, practical life intervenes not only in the geometry and light of Mies, but also in the carefully crafted composition of the photographer. Narrative is added to the image, but in a laconic

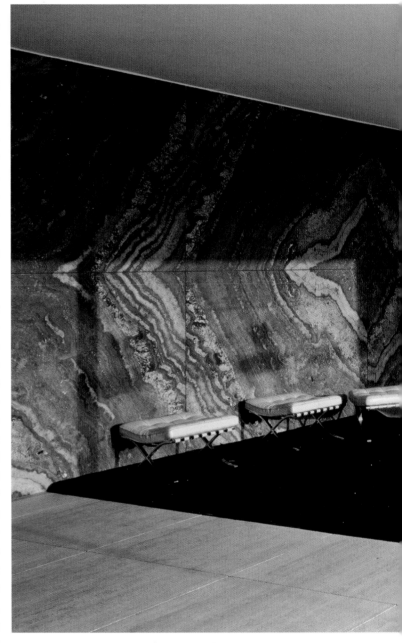

Jeff Wall, *Morning Cleaning,* 1999. Cibachrome in light boxes, 204 x 365 cm. Kunstsammlung Nordrhein-Westfalen, Düsseldorf

way, without specific commentary. The viewer is so used to seeing the Barcelona Pavilion as an icon of modern perfection that the cleaner's presence suddenly throws the entire design into doubt. Architecture meets life through the lens of art.

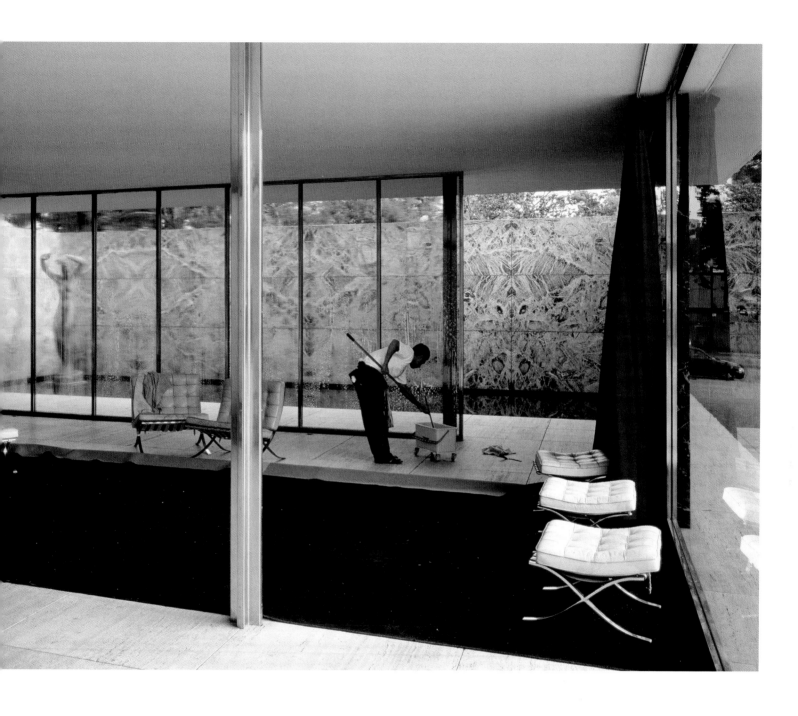

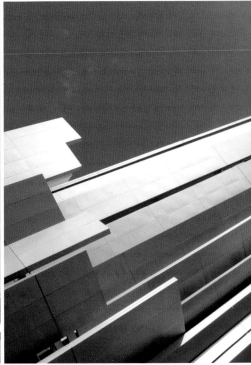

Minamata is in Kumamoto Prefecture, in the south of Japan. It became famous worldwide after the photographer W. Eugene Smith (1918–78) began documenting the consequences of methyl mercury poisoning among residents in 1971. Kumamoto has developed greatly since then, and on March 13, 2004 a new, 257-kilometer-long section of the Shinkansen "Bullet Train" lines was opened in the prefecture. One of the four new stations on the line, **Shin Minamata Station**, was designed by architect Makoto Sei Watanabe. Born in 1952 in Yokohama, the architect worked from 1979 to 1984 in the office of Arata Isozaki before creating his own firm. His first work, the Aoyama Technical College, built in the Shibuya area of Tokyo in 1989, brought him international acclaim thanks to its spectacular forms influenced by cartoon graphics. Watanabe has since become increasingly interested in computer-generated designs. For the Shin Minamata Station, he imagined that "the roof and walls of the station consist of a collection of rectangular unit pieces which continue into each other without distinction. The design process began by imagining that a number of the unit pieces were gliding past and then frozen at a particular moment," liked a blurred train coming to a halt.

But from the first, Watanabe went beyond the unusual design of just the station to take into account the town itself. As he points out, in Japan, railway stations usually appear to be distinct from the cities in which they are located because different authorities are responsible for the stations and their immediate environment. Watanabe explains that "In response to this situation, as the architect of the new station, I took it upon myself to meet with the various organizations involved and urge them to think about coordination. I explained the importance of integrating the various designs and

suggested some methods for doing so. As a result, the development was headed in the direction of overall coordination. It is not enough yet, but one step toward achieving a better city and environment."One concrete result of this intervention was that the city of Minamata asked the architect to design a monument for the station plaza. Called **Shin Minamata Mon** ("mon" means "gate" in Japanese), the work was meant to symbolize the understandable ecological orientation of the municipality today. "I developed a new computer program to generate forms that are related to natural growth, such as that encountered in plants or bones. *Shin Minamata Mon* may look like a tree, but its shape is derived from rules similar to those that govern any naturally growing form, says Watanabe. The form-generation aspect of Watanabe's program is completed by a structural optimization that governs the thickness and disposition of the elements. He insists that although the sculpture is entirely computer-generated, its starting point, based on the rules of growth in nature, is his interpretation. This work of art is, therefore, the combined result of his thought and automatic calculations. The final project, accepted by the municipality and inaugurated in March 2005, is made of galvanized steel varying in thickness from 32 to 38 mm. Seven meters high, it covers an area four by four meters in size.

Sensitive to issues of motion and light, the Shin Minamata Station is thus crowned by a work of art conceived by the architect in harmony with the building. Watanabe's forms are often at the limit between what might be considered an artistic design and a computer-generated web, as is the case in his surprising Iidabashi subway station in Tokyo. Serving no other purpose than a symbolic one, *Shin Minamata Mon* cannot be considered as anything but art — the art of an architect.

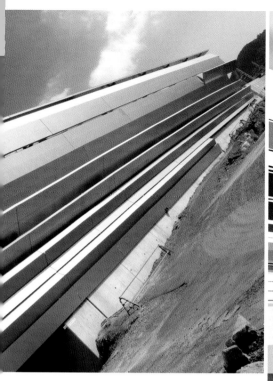

Makoto Sei Watanabe has sought to embody the movement of the Shinkansen "Bullet Trains" in this station, as well as to create a sculpture related to the architecture (right).

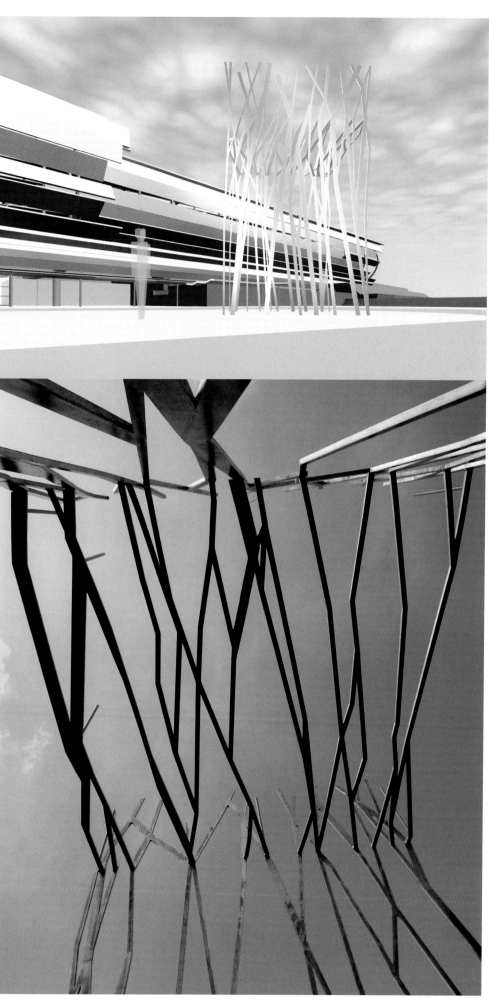

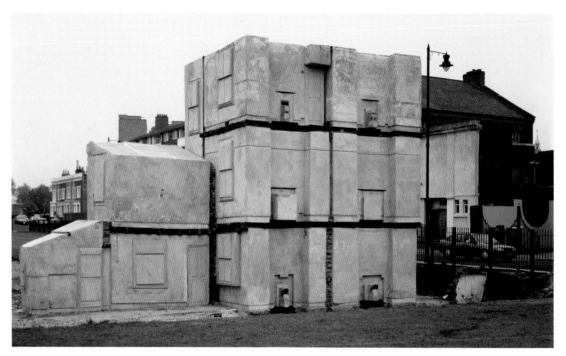

Rachel Whiteread, *(Untitled) House,* 1993. Mixed media, Dimensions variable. London

Rachel Whiteread was born in London in 1963. She had her first solo exhibition at the Carlisle Gallery in London in 1988, but she really came to the attention of the public when she won the Turner Prize in 1993. Her ongoing interest in architecture has been undeniable. Perhaps her most famous work, **Untitled (House)**, 1993, was nothing more than a concrete cast of the interior of a demolished house located on Grove Road. Rather than being a reproduction of a house, like Michael Landy's *Semi-Detached* (see pages 132–33), albeit stripped of its original materials, *House* was a "negative" of its model, representing what had been empty space with concrete, and doing away with the form of the attic. Intended, to be ephemeral despite its weighty solidity, *House* was demolished on January 11, 1994, having caused a considerable uproar in the English press. A local paper, the *East End Advertiser,* carried a photo of the work with a banner headline that read, "If this is art then I'm Leonardo da Vinci." When she won the Turner Prize, on November 23, 1993, Whiteread was also given a £40,000 prize as the "worst artist of the year" by a group calling itself the K Foundation. Despite the typical anti-intellectual strain of the English tabloid press, Whiteread's works, including numerous other pieces she has done that concern architectural forms, are closely related to trends in modern art. As Charlotte Mullins of the Tate Gallery has pointed out, the American artist Gordon Matta-Clark used fragments of real buildings and interventions on architecture that created precisely the kinds of "negative" spaces or voids that are at the heart of Whiteread's process.

Certain of her other works have also attracted considerable attention, including a resin cast of the interior of a wooden water tank, mounted on a roof at the corner of West Broadway and Grand Street in Manhattan (1998), or her *Judenplatz Holocaust Memorial for Vienna* (1995–2000). Through a transposition of materials, using plaster, concrete or resin to take the place of architectural spaces (empty or full), there is no doubt that Rachel Whiteread creates a significant form of art, the opinion of the English street notwithstanding. Hers is an art of metamorphosis and contemplation, not unrelated to the thoughts expressed by François Roche (see page 158), who speaks of the deadness of the representation of architecture, and the need to create a fictional "life" for buildings. For Roche, buildings live only when they have a story associated with them, while Whiteread may go a step further in exposing the solid concrete interior of her *House*, as though any life that may have gone on there were to be just as dead and absent as the demolished original structure. Speaking of the *Judenplatz Memorial*, Rachel Whiteread says that her work has much "in common with Maya Lin's *Vietnam Memorial* in Washington, D.C." (see pages 134–35). "When I was thinking about making the *Holocaust Memorial*," she says, "I spent a week in Washington and visited Lin's memorial twice. I wasn't interested in the politics related to the monument but the way people who are alive today respond to it, reacting to something that may be within their history or within their own family's history."

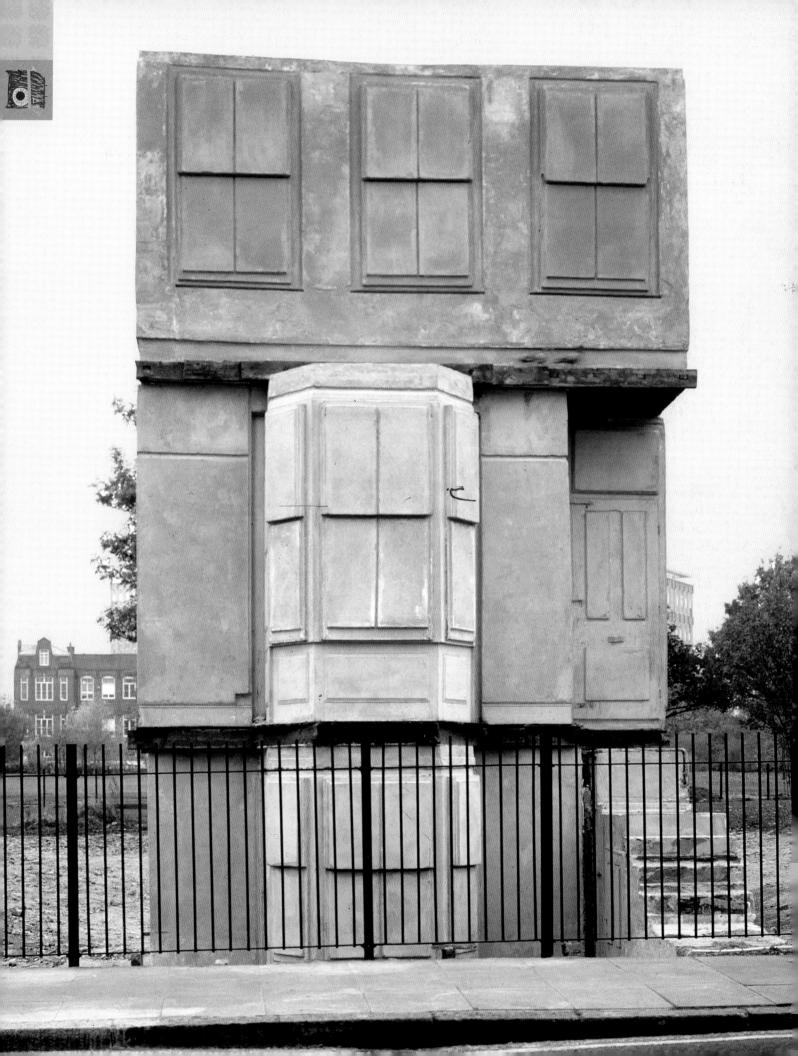

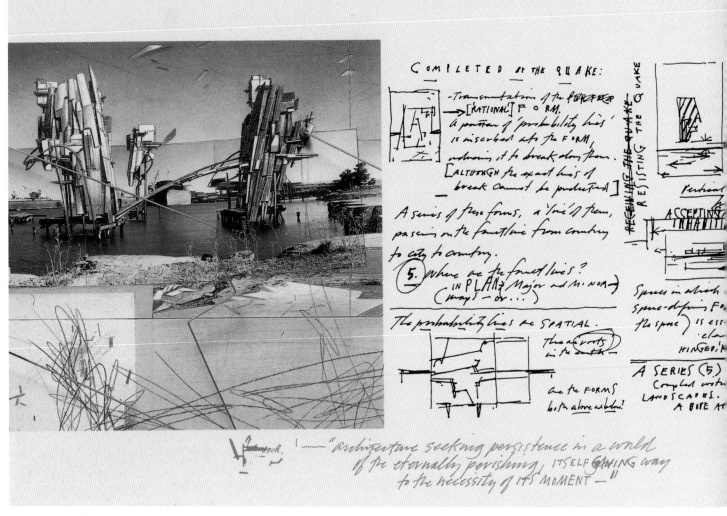

Lebbeus Woods, *Shard Houses*, 1997. Mixed media

Many artists imagine architectural environments for their work. Some architects draw to express what they would like to build. However, very few persons with real architectural training have devoted themselves entirely to drawing. Lebbeus Woods was born in 1940 in Lansing, Michigan, and attended the Purdue University School of Engineering, and the University of Illinois School of Architecture. He worked for the firm of Eero Saarinen and Associates (later Roche Dinkeloo) on the John Deere and Ford Foundation Headquarters building projects. He decided to abandon building in favor of theory in 1976. Given his level of professional expertise, Woods creates imaginary environments which could, according to him, actually be built. He has done this in such projects as his *Underground Berlin* (1988), *Zagreb Freespace Structure* (1991), and the *Apartment Blocks* (1994), conceived for the reconstruction of war-damaged modernist apartment complexes in Sarajevo. His **Shard Houses** (1997) imagined residences built from the "scavenged shards of the industrial wasteland" in San Francisco. Catastrophes clearly interest him and he has often focused on destruction as a basis for rebuilding, using complex aggressive organic forms to heal the wounds of war or economic disaster. Typically, he proposed an enormous vertical memorial park called the *Ascent* for the site of the former World Trade Center.

His installation **La Chute (The Fall)** was featured in the exhibition curated by Paul Virilio entitled *Ce qui arrive* at the Fondation Cartier (Paris, 2002–03). Inspired in part by the destruction of the Twin Towers, his work consisted of an attempt to conceptualize the collapse of the very exhibition gallery in which it was located. "Let us say, for the purposes of understanding the hypothesis," writes Woods, "that the exhibition space suddenly collapses, as the ceiling falls down toward the floor. This fall may be the product of any number of different causes — structural defects in construction or design, a terrorist's bomb exploding, or something else entirely un-

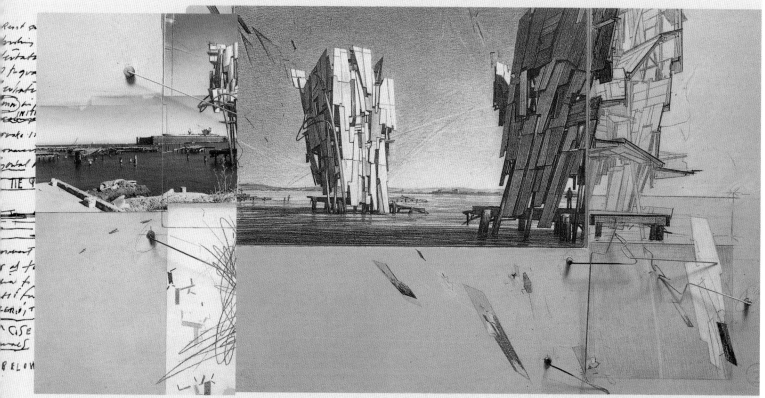

expected. The structural system, the materials that support the building, resisting the imperative to fall, suddenly succumb to the attraction of gravity and give way, precipitating a fall toward the planet's center of mass. Gravity is nothing more or less than acceleration, induced by the attraction of masses ... the collapse of the exhibition space takes less than two seconds. Too fast to see, no doubt, but not at all too fast to conceptualize. This is the time-space of the fall — too brief to inhabit, except in imagination."

Looking back on September 11, 2001, Lebbeus Woods reminds viewers that catastrophic collapse is inevitably a part of architecture, if only because buildings are designed to avoid such events. The architect and philosopher Paul Virilio goes one step further and says that the creation of any working system insures the probability, thus the inevitability, of accidents. Collapse, whether architectural or artistic, is projected in the installation of Lebbeus Woods and poses the question of what new natural order arises from what we

have tended to see only as destruction. For Woods, *The Fall* "may be a glimpse into what architecture might become if it invests its creative capital less in the struggle against gravity and more in seeing what might happen when we let go." Though it can be perceived as a sculptural work of art, *The Fall* is the result of a radical thought about the inherent instability and unreliability of architecture. Art and architecture are thus combined to think the unthinkable, to make art out of catastrophe. Whereas the fall of Icarus and the collapse of the Tower of Babel are the stuff of ancient legends and warnings, this is a modern call to look at the lessons of disaster.

Following pages:
Lebbeus Woods, *The Fall*, 2002–03. Installation.
Fondation Cartier pour l'art contemporain, Paris.
Construction and design: Alexis Rochas

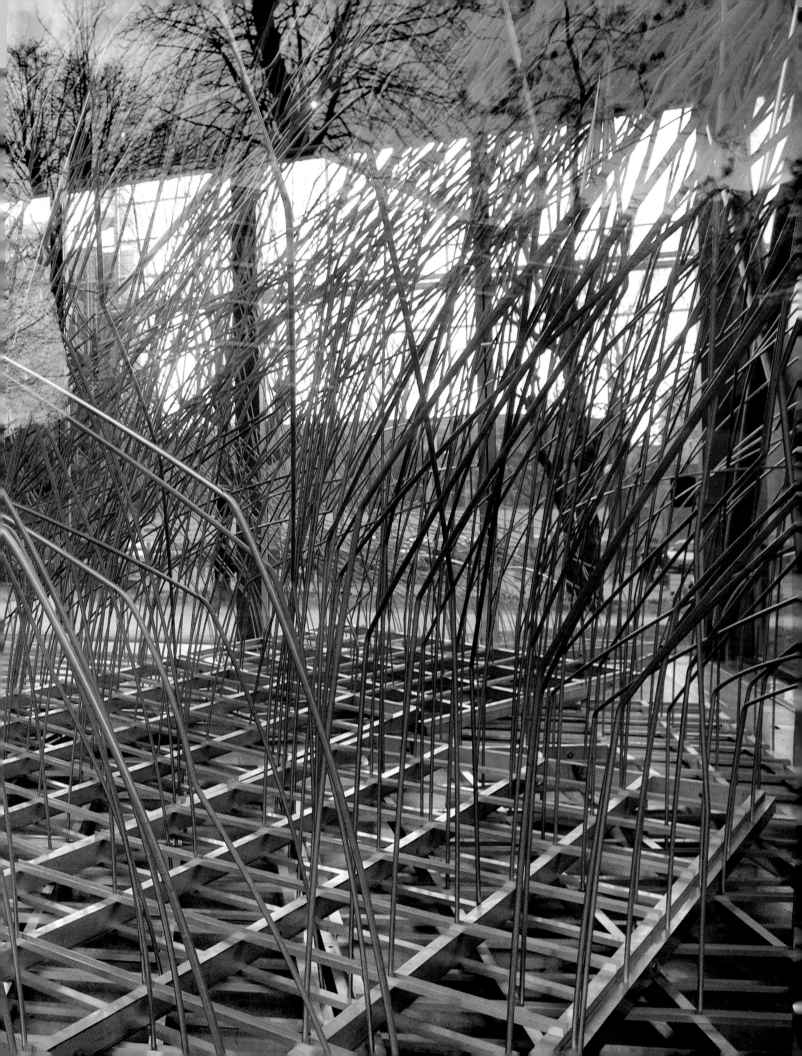

Suggested Reading

General

Arnheim, Rudolf, *Art and Visual Perception, A Psychology of the Creative Eye*, University of California Press, Berkeley, 1974

Bingham, Neil, *Fantasy Architecture, 1500–2036,* Hayward Gallery Publishing, London, 2004

Brüderlin, Markus (ed.), *ArchiSculpture*, Fondation Beyeler, Hatje Cantz, Ostfildern-Ruit, 2004

Celant, Germano (ed.), *Architecture & Arts, 1900–2004*, Genova Palazzo Ducale, Skira Editore, Milan, 2004

Ghyka, Matila C., *Le nombre d'or*, Gallimard, Paris, 1982

Gombrich, E.H., *Art and Illusion*, Phaidon Press, London, 1959

Haskell, Francis, and Penny, Nicholas, *Taste and the Antique*, Yale University Press, New Haven, 1993

Johnson, Philip, and Mark Wigley, *Deconstructivist Architecture,* The Museum of Modern Art, Little Brown and Company, Boston, 1988

Kruft, Hanno-Walter, *A History of Architectural Theory*, Zwemmer, Princeton Architectural Press, New York, 1994

Makarius, Michel, *Ruines*, Flammarion, Paris, 2004

Neumann Dietrich (ed.), *Film Architecture, From Metropolis to Blade Runner,* Prestel, Munich, 1996

Provoyeur, Pierre, *Le Temple*, Editions de la Réunion des Musées Nationaux, Paris, 1982

Rykwert, Joseph, *The Dancing Column, On Order in Architecture,* MIT Press, Cambridge, 1996

Virilio, Paul, *Unknown Quantity,* Fondation Cartier, Thames & Hudson, London, 2002

Wood, Paul, et al., *The Great Utopia, The Russian and Soviet Avant-Garde, 1915–1932*, Guggenheim Museum, New York, 1992

Bernd and Hilla Becher

Basic Forms of Industrial Buildings, Bernd & Hilla Becher, Hasselblad Center, Schirmer/Mosel, Munich, 2004

Santiago Calatrava

Zardini, Mirko (ed.), *Santiago Calatrava, Secret Sketchbook,* The Monacelli Press, New York, 1996

Giorgio de Chirico

Rubin, William, et al., *De Chirico,* The Museum of Modern Art, New York, 1982

Olafur Eliasson

May, Susan (ed.), *Olafur Eliasson, The Weather Project,* Tate Publishing, London, 2003

Frank O. Gehry

Ragheb, J. Fiona (ed.), *Frank Gehry, Architect,* Guggenheim Museum, New York, 2001

Andy Goldsworthy

Strauss, Anne L., *Passage, Andy Goldsworthy,* Thames & Hudson, London, 2004

Dan Graham

Mizunuma, Hirokazu (ed.), *Dan Graham by Dan Graham,* Chiba City Museum of Art, Chiba, 2003

Cai Guo-Qiang

Friis-Hansen, Dana, *Cai Guo-Qiang,* Phaidon, London, 2002

Andreas Gursky

Galassi, Peter, *Andreas Gursky,* The Museum of Modern Art, New York, 2001

Zaha Hadid

Fontana-Giusti, Gordana, and Patrik Schumacher (eds.), *Zaha Hadid, Complete Works,* Thames & Hudson, London, 2004

David Hockney

Stangos, Nikos (ed.), *The Way I see it, David Hockney,* Thames & Hudson, London, 1993

Weschler, Lawrence, *David Hockney Cameraworks,* Thames & Hudson, London, 1984

Candida Höfer / Rem Koolhaas

Chaslin, François, *The Dutch Embassy in Berlin by OMA / Rem Koolhaas,* Candida Höfer, NAI Publishers, Rotterdam, 2004

Edward Hopper

Levin, Gail, *Edward Hopper, the Art and the Artist,* Whitney Museum of American Art, W.W. Norton & Company, New York, 1980

Donald Judd

Serota, Nicholas (ed.), *Donald Judd,* Tate Publishing, London, 2004

Tadashi Kawamata

Brayer, Marie-Ange, *Kawamata,* Calder Atelier, CCC, Tours, 1994

Yann Kersalé

Curnier, Jean-Paul, *Yann Kersalé,* Norma Editions, Paris, 2003

Anselm Kiefer

Arasse, Daniel, *Anselm Kiefer,* Editions du Regard, Paris, 2001

Yves Klein

Noever, Peter (ed.), *Air Architecture Yves Klein,* Hatje Cantz, Ostfildern-Ruit, 2004

Maya Lin

Lin, Maya, *Maya Lin Boundaries,* Simon & Schuster, New York, 2000

Gordon Matta-Clark

Diserens, Corinne (ed.), *Gordon Matta-Clark,* Phaidon, New York, 2003

Ludwig Mies van der Rohe

Spaeth, David, *Mies van der Rohe,* The Architectural Press, London, 1985

Piet Mondrian

Bois, Yves-Alain, et al., *Piet Mondrian,* Haags Gemeentemuseum, Leonardo Arte, Milan, 1994

François Roche

Ruby, Andreas (ed.), *Spoiled Climate, R&Sie...architectes,* Ante Prima, Paris, Birkhäuser, Basel, Boston, Berlin, 2004

Ed Ruscha

Wolf, Sylvia, *Ed Ruscha and Photography,* Whitney Museum of American Art, Steidl, Göttingen, 2004

Rudolf Schindler

Noever, Peter (ed.), *MAK Center for Art and Architecture,* Prestel, Munich, 1995

Richard Serra

Cook, Lynne, et al., *Richard Serra, Torqued Ellipses,* Dia Center for the Arts, New York, 1997

Ferguson, Russel (ed.), *Richard Serra Sculpture, 1985–1998,* Museum of Contemporary Art, Los Angeles, Steidl Verlag, Göttingen, 1998

Santiago Sierra

Schneider, Eckhard, *Santiago Sierra, 300 Tons and Previous Works,* Kunsthaus Bregenz, Verlag der Buchhandlung Walther König, Cologne, 2004

Hiroshi Sugimoto

Sugimoto, Conceptual Forms, Fondation Cartier, Actes Sud, Arles, 2004

Hiroshi Sugimoto, L'histoire de l'histoire, Rikuyosha, Tokyo, 2004

Vladimir Tatlin

Zhadova, Larissa Alekseevna (ed.), *Tatlin,* Rizzoli, New York, 1984

Felice Varini

López-Durán, *Fabiola, Felice Varini, Points de Vue,* Lars Müller Publishers, Baden, 2004

Jeff Wall

de Duve, Thierry, et al., *Jeff Wall,* Phaidon, London, 1996

Rachel Whiteread

Mullins, Charlotte, *Rachel Whiteread,* Tate Publishing, London, 2004

Lebbeus Woods

Wagner, Aleksandra, *Radical Reconstruction, Lebbeus Woods,* Princeton Architectural Press, New York, 1997

Philip Jodidio studied economics and art history at Harvard University. From 1979 to 2002, he was editor-in-chief of *Connaissance des Arts*, France's leading art magazine. He has written widely in magazines, and is the author of more than thirty books on contemporary architecture, including the *Architecture Now* series. Jodidio's most recent publications are comprehensive monographs devoted to the Japanese architect Tadao Ando and the Italian architect Renzo Piano. He is also the editor of *Cairo, Revitalising a Historic Metropolis* (Aga Khan Trust for Culture).

Index

Names and Works

Aalto, Alvar 140, 146, 182
Acconci Studio 38
 Mur Island, Graz 38–39
Acconci, Vito 32, 38, 39, 102
 Storefront for Art and Architecture 32, 33,
 39, 102, 126
Akimoto, Yuji 40
Al-Ahmar, Muhammad ibn 10
 Alhambra, Granada 9, 10, 12
Albers, Joseph 107
Alberti, Leon Battista 9
Alfonso XIII, King of Spain 26
Anderson, Laurie 29
Ando, Tadao 17, 34, 40–43, 140, 146, 178
 Chichu Art Museum, Naoshima 40–43, 178
 Ryotaro Shiba Memorial Hall, Higashiosaka,
 Osaka 17
Andre, Carl 44, 180
Annenkov, Iuri 23
Apollinaire, Guillaume 25
Arakawa, Shusaku 108
Arasse, Daniel 130
Arendt, Hannah 156
Arnheim, Rudolf 8
Arp, Hans 25, 26
Arquitectonica 188
 American Airlines Arena, Miami 188
Atget, Eugène 190
Auden, W. H. 96
Banu, Arjmand 10
Barocci, Federico 13
Barra, Didier 16
Baudelaire, Charles 204
Baudin, Jean-François 114
Baudrillard, Jean 143
Becher, Bernd and Hilla 44–45, 90, 98,
 172, 190, 192
 Blast Furnaces, Aliquippa, Pennsylvania 44–45
 Blast Furnaces, Duisburg-Bruckhausen 44–45
 Blast Furnaces, Hainer Hütte, Siegen 44–45
 Blast Furnaces, Terre Rouge, Esch-Alzette
 44–45
Becher, Max 170–171
 Where do you think you are? 170–171
Behnisch, Günter 140
Behrens, Peter 130
Benjamin, Walter 158
Berkel, Ben van 198
Berry, Duke of Burgundy 12
Beuys, Joseph 88, 90
Bibliotheca Angelica, Rome 98
Blanc, Patrick 129
Bohigas, Oriol 26
Bois, Yves-Alain 29
Borromini, Francesco 178
 San Carlo alle Quattro Fontane, Rome 178
Bos, Caroline 198
Bosch, Hieronymus 17
Botta, Mario 46–49
 Chapel of Santa Maria degli Angeli,
 Monte Tamaro 46–49
 Church of Saint John the Baptist, Mogno 49
Bourgeois, Louise 74, 120
Bramante, Donato 8, 13
 Tempietto of San Pietro in Montorio, Rome 8,
 13
Brandenburg Gate, Berlin 72, 82
Brett, Lionel 20
Breughel, Pieter the Elder 14, 15, 16
 Tower of Babel 15, 16, 18, 213
Breuer, Marcel 170
Broederlam, Melchior 12
Brown House, Munich 130
Brunelleschi, Filippo 13, 96
Burden, Chris 50–51
 Tyne Bridge, Gateshead 50–51
Buren, Daniel 202

Cage, John 152
Cai Guo-Qiang 88–89, 146, 156
 Tonight So Lovely, Shanghai 88–89, 156
Calatrava, Santiago 52–53, 140, 198
 Planetarium, City of Arts and Sciences,
 Valencia 52–55
Cambrai, Robert de 12
Campen, Jacob van 14
Campin, Robert 12
Caro, Anthony 132
Carrà, Carlo 22
Caruso/St John 62
Cattaneo, Egidio 48–49
Cézanne, Paul 53
Charles V 12
Chernikhov, Yakov 68
Chia, Sandro 48
Chirico, Giorgio de 18
Christo and Jeanne Claude 31, 56–59, 126
 The Gates, Project for Central Park 56–59
Cirici, Cristian 26
Clemente, Francesco 48
Cocteau, Jean 96
Colomina, Beatriz 87
Cook, Peter 92
Coop Himmelb(l)au 92
Costa, Lucio 144
Crown, Steven 162
Cucchi, Enzo 46–49
 Chapel of Santa Maria degli Angeli,
 Monte Tamaro 46–49
Dalí, Salvador 150, 194
Dammartin, Drouet de 12
Dammartin, Guy de 12
Dante Alighieri 15
De Maria, Walter 40, 102
dECOi 60–61
Dedieu, Jean 166
Desiderio, Monsù – Nomé, François de
Delaunay, Robert 18, 25
Demand, Thomas 62–63
 Public Housing 62–63
Derrida, Jacques 143
Deupree, Taylor 112
Diller, Elizabeth 64
Diller + Scofidio 64–65, 119, 122, 132, 148
 Blur Building, Yverdon-les-Bains 64–65,
 119, 122, 132
Doesburg, Theo van 20, 25, 26, 158
 Café l'Aubette, Strasbourg 25, 26
Donatello 13
Duchamp, Marcel 29, 132, 202
Eco, Umberto 170
Egeraat Erick van 68–69, 82
Eiffel Tower, Paris 20
Einstein, Albert 144
Eisenman, Peter 72–73, 78, 92, 140, 146
 Memorial to the Murdered Jews of Europe,
 Berlin 72–73, 146
Ekster, Aleksandra 23, 68
Eliasson, Olafur 74–75
 Weather Project, London 74–75
Empire State Building, New York 186
Enshu, Kobori 11
Erick van Egeraat associated architects 66–69
 Yakimanka Residential Complex;
 Moscow 66–69
Eyck, Jan van 12, 13, 24, 96
Feininger, Lyonel 18
Fellini, Federico 52
Fen, Weng 76–77
Ferdinand, King of Aragon 10
Finsterlin, Hermann 23, 24, 34, 188
FOA – Foreign Office Architects 78–81, 198
 Yokohama International Airport, Yokohama
 78–81
Foster, Norman 20, 31
 Swiss Re Tower, London 20

Francesca, Piero della 12, 13
Friedrich, Caspar David 17
Fukutake, Soichiro 40
Funi 22
Future System 146
Gabo, Naum 23
Galli Bibiena, Antonio 16
Galli Bibiena, Fernandino 16
 Teatro Communale, Bologna 16
Gaudí, Antoni 20, 52–53, 150
 American Hotel, New York 20
Gaulle, Charles de 126
Gehry, Frank O. 23, 33, 34, 82–83, 92–95,
 134, 140, 158
 Chiat/Day building, Venice 158
 DG Bank, Berlin 82–83
 Disney Concert Hall, Los Angeles 33
 Guggenheim Museum Bilbao, Bilbao 33, 34, 82
Ghyka, Matila 8
Girouard, Tina 29
Goebbels, Joseph 130
Goethe, Johann Wolfgang von 18
Goff, Bruce 196
Goldsworthy, Andy 84–85, 107, 150
 Stone House, New York 84–85
Gomino-o, Emperor 11
Gonzalez, Julio 52
Goulthorpe, Mark 60–61
 Aegis Hyposurface, London 60–61
 Bankside Paramorph, London 60–61
Goyozei, Emperor 10
Graham, Dan 86–87, 174
 Café Bravo, Berlin 86–87
Gropius, Walter 11, 23, 24, 130
Guggenheim, Solomon R. 27
Gursky, Andreas 90, 172, 190
Hadid, Zaha 92–93, 136, 146
 Contemporary Arts Center, Cincinnati 136
 Guggenheim Museum Taichung, Taichung
 92–95
 Vitra Fire Station, Weil am Rhein 93
Hartmann, Ingo 190
Hasegawa, Itsuko 78, 112
 Museum of Fruit 112
 Shonandai Cultural Center, Fujisawa 78
Haskell, Francis 17
Haus der Deutschen Kunst, Munich 130
Hausmann, Raoul 26
Heide, Edwin van der 152
Heidegger, Martin 178
Herzog & de Meuron 74–75
 Tate Modern, London 60, 74–75, 120
Herzog, Jacques 74
Hitler, Adolf 19, 72, 130
Höch, Hannah 25
Hockney, David 96–97
 A Bigger Splash 96–97
 Pearblossom Highway 96–97
Höfer, Candida 44, 98–101
 Netherlands Embassy, Berlin 98–101
Hoffmann, Rolf and Erika 98
Holl, Steven 32, 38, 102–105
 Kiasma Museum of Contemporary Art,
 Helsinki 102
 Loisium Visitors' Center, Langenlois 102–105
 Storefront for Art and Architecture 32, 33,
 39, 102
Hopper, Edward 18, 19
Hunte, Otto 18
Huszár, Vilmos 26
Huxtable, Ada Louise 170
Imaginary Forces 198
Imperial Villa of Katsura, Katsura 11
Irwin, Robert 106–107
 Prologue: x183 106–107
Isozaki, Arata 12, 27, 98, 108–111, 126,
 146, 206
 Los Angeles Museum of Contemporary Art,
 Los Angeles 98

Nagi MoCA 108–111
Ito, Toyo 78, 112–113, 144, 174
 Saishunkan Seiyaku Women's Dormitory,
 Kumamoto 174
 Tower of the Winds, Yokohama 112–113
Jahn, Helmut 128
 Deutsche Post Tower, Bonn 128
 Sony Center, Berlin 128
Jakob, Dominique 114–117
Jakob + MacFarlane 114–117
 Georges Restaurant, Centre Georges
 Pompidou, Paris 114–117
Jantzen, Michael 118–119
 Virtual Reality Interface VRI
 118–119
Jean le Bon, King of France 12
Jehan, Shah 10
John Paul II, Pope 140
Johns, Jasper 33, 82
Johnson, Philip 142
Jones, Wes 45
Judd, Donald 29, 30, 44, 180
 Chinati Foundation, Marfa 30
Kahn, Louis I. 28, 29, 32
 Kimbell Art Museum, Fort Worth 29
Kandinsky, Wassily 25, 68
Kapoor, Anish 74, 120–125, 146
 Cloud Gate, Chicago 120–125
 Marsyas, London 120–123
Katsura Palace, Katsura 12
Kawamata, Tadashi 126–127
 Sur la voie, Évreux 126–127
Kennon, Kevin and Reiser + Umemoto 198
Kersalé, Yann 128–129
 LED System for Agbar Tower 128–129
Kettelhut, Erich 18
Kiefer, Anselm 19, 20, 33, 130–131
 The Unknown Painter 130–131
Kienholz, Ed 33, 82
Klein, Yves 27, 28, 29, 34
Kliun, Ivan 23
Kolbe, Georg 26
Koolhaas, Rem 45, 68, 92, 98
Krens, Thomas 33, 170
Krinskii, Vladimir 23, 24
Kruchenykh, Alexei 24
Krueck & Sexton 162
Kruft, Hanno-Walter 22, 24
Kurosawa 52–53
Labrouste, Henri 98
 Bibliothèque Nationale, Paris 98
Landry, Richard 29
Landy, Michael 132–133, 210
 Semi-Detached, London 132–133, 210
Lang, Fritz 18, 19
Lao Tse 88
Laurana, Luciano 12
Le Corbusier 11, 26, 140, 144, 204
 La Tourette, Eveux 140
 Ronchamp, France 49, 140, 204
 Villa Savoye 204
Leck, Bart van der 26
Lentulov, Aristarkh 23
Levin, Gail 18
LeWitt, Sol 44
Libeskind, Daniel 72, 92
Liege, Jean de 12
Limbourg, Jean and Paul (Limbourg brothers) 12
Lin, Maya 72, 134–135, 162, 210
 Vietnam Memorial, Washington D.C. 72,
 134–135, 162, 210
Lindsay, John 29
Lissitzky, El 24
London Bridge, London 170
Long, Richard 78
Loos, Adolf 22
Louis de Male, Count of Flanders 12
Louvre, Paris 12, 17
Lynn, Greg 93, 198

MacFarlane, Brendan 114–117
Manglano-Ovalle, Iñigo 136–137
 Cloud Prototype No. 1 136–137
Mapplethorpe, Robert 136
Marguerite, Duchesse of Burgundy 12
Marville, Jean de 12
Masaccio 13
Matamala, Juan 20
Matta, Roberto 29
Matta-Clark, Gordon 28, 29, 34, 210
Mayakovsky, Vladimir 23
McLuhan, Marshall 14
Meier, Richard 60, 138–141
 Jubilee Church, Rome 138–141
Melnikov, Konstantin 23
Mendini, Alessandro 188
Merz, Mario 84
Michelangelo Buonarroti 82
 Laurentian Liberary, Florence 82
Mies van der Rohe, Ludwig 25, 26, 27, 87,
 136, 204–205
 Farnsworth House, Illinois 136
 German Pavilion, Barcelona 26, 27, 87,
 136, 204–205
Migayrou, Fréderic 61
Millennium Park, Chicago 120
Miyajima, Tatsuo 146
Miyawaki, Aiko 108
Modigliani, Amedeo 25
Monville, François Racine de 18
Moore, Henry 194
Moss, Eric Owen 142–143
 The Umbrella, Culver City 142–143
Moussavi, Farshid 78
Mullins, Charlotte 210
Muñoz, Juan 74, 120
MVRDV 144
Nagakura, Takehiko 22
Nakaya, Fujiko 64
Merleau-Ponty, Maurice 8, 15, 107, 178
Monet, Claude 14, 15, 40
Mondrian, Piet 20, 21, 22, 24, 25, 158
Malevich, Kasimir 23, 24, 68, 92
Nalbach, Johanne 86–87
 Café Bravo, Berlin 86–87
Nauman, Bruce 88
Neumann, Dieter 18
Newton, Isaac 143
Niemeyer, Oscar 86, 144–145, 182, 194
 Serpentine Gallery Pavilion, London 144–145
Nieuwenhuys, Constant 19
Nishizawa, Ryue 174
Noever, Peter 24, 25
Noguchi, Isamu 28, 29, 32
Nomé, François de 16, 34, 156
Norten, Enrique 146–147
 The Snow Show, Kemi 146–147
Nouvel, Jean 20, 62, 128–129, 148–149, 158
 Agbar Tower, Barcelona 20, 128–129
 Fondation Cartier, Paris 62, 129, 148,
 156, 180
 Museum of Arts and Civilizations, Paris 128
 The Monolith, Murten 148–149
 Opera, Lyon 128
 Tour sans Fin 129
Novak, Marcos 150–151
 Allobio, Architectural Biennale, Venice
 150–151
NOX Lars Spuybroek 152–153
 Son-O-House, Son en Breugel 152–153,
Office of Metropolitan Architecture 98–101
 Netherlands Embassy, Berlin 98–101
Okazaki, Kazuro 108
Oldenburg, Claes 33, 82, 158
OMA – Office of Metropolitan Architecture
Ono, Yoko 146
Oud, Jacobus Johannes Pieter 25
Oursler, Tony 156–157
 9/11 156–157

Paladino, Mimmo 48
Palazzo Ducale, Urbino 12
Palazzo Pitti, Florence 62
Pantheon, Rome 8, 130, 190–192
Parreno, Philippe 158–161
 Hybrid Muscle, Chiang Mai 158–161
 The Boys from Mars, Chiang Mai 158–161
Parque Guell, Barcelona 20
Parthenon, Athens 9
Pei, Ieoh Ming 17
 East Building of the National Gallery of Art,
 Washington D.C. 17
Penny, Nicholas 17
Pergamon Museum, Berlin 40
Perrault, Dominique 172
Pevsner, Antoine 23
Peyton-Jones, Julia 144
Philippe le Bon, Duke 12
Philippe le Hardi, Duke of Burgundy 12
Piano, Renzo 114
Centre Pompidou, Paris 29, 60–61, 114–117
Picasso, Pablo 25
Piranesi, Giambattista 16, 17, 34
Plensa, Jaume 162–165
 Crown Fountain, Chicago 162–165
Po Chu-I 11
Polke, Sigmar 90
Pollock, Jackson 98, 143
Polo, Alejandro Zaera 78
Pont Neuf, Paris 56
Popova, Ljubov 23, 68
Post, Pieter 14
Prattz, Gustav 27
Public Library, New York 170
Puni, Ivan 23
Punkenhofer, Robert 38
Ramos, Fernando 26
Rauschenberg, Bob 33, 82
Raymond du Temple 12
Raynaud, Jean-Pierre 30, 31, 166–169
 La Mastaba, La-Garenne-Colombes 166–169
Rebay, Hilla 27
Reichstag, Berlin 31, 32
Richter, Gerhard 90, 190
Richter, Hans 26
Rietveld, Gerrit 158
Riley, Terence 174
Robbins, Andrea 170–171
 Where do you think you are? 170–171
Robert, Hubert 17, 156
Roche, François 158–161, 204, 210
 Hybrid Muscle, Chiang Mai 158–161
 The Boys from Mars, Chiang Mai 158–161
Roche Dinkeloo 212
Rodchenko, Alexander 24, 68
Romano, Giulio 15, 16
 Palazzo del Tè, Mantua 15
Rothko, Mark 35
Rouen Cathedral, Rouen 14, 15, 34
Rubin, William 13, 18
Ruff, Thomas 44
Ruisdael, Jacob van 14
RUR Architecture P.C. 198
Ruscha, Ed 44, 90, 156, 172–173
 The Los Angeles County Museum on Fire
 172–173
 Parking Lots #18 172–173
 Pools (9) 172–173
Ruskin, John 140
Russolo, Luigi 152
Rykwert, Joseph 8
Saarinen, Eero 212
Saenredam, Pieter Janszoon 14, 15, 18
 St. Bavo Church, Haarlem 14
SANAA – Sejima, Kazuyo and Nishizawa, Ryue
 174
Sant'Elia, Antonio 21, 22
Satie, Erik 96
Schapiro, Meyer 21

221

Schindler, Rudolf 24, 25
 Schindler House, Los Angeles 24, 25
Schwitters, Kurt 25, 26
 Merzbau 25
Scofidio, Ricardo 64
Scott, Giles Gilbert 74–75
Sejima, Kazuyo and Nishizawa, Ryue 174–177
 21st Century Museum of Contemporary Art,
 Kanazawa 174–177
 Glass Pavilion, Museum of Art, Toledo 174
 Instituto Valenciano, Valencia 174
 N-Museum, Wakayama 174
 O-Museum, Nagano 174
Serota, Nicholas 30
Serra, Richard 33, 72, 148, 178–179
 Torqued Ellipses 178–179
Shikibu, Murasaki 10
Shokoku-ji Temple 11
Sierra, Santiago 180–181
 300 Tons, Kunsthaus Bregenz 180–181
Siza, Álvaro 182–185
 Portuguese Pavilion, Lisbon 182–185
Sluter, Claus 12
S. Maria del Priorato, Rome 17
Smith, Frederick 142
Smith, Kiki 146
Smith, Mike 132
Smith, W. Eugene 206
Smithson, Robert 78
Solà-Morales, Ignasi 26
Souto de Moura, Eduardo 182
Speer, Albert 19, 20
 Reichskanzlei, Berlin 19, 20, 56, 72
Spuybroek, Lars 112, 152–153
 Son-O-House, Son en Breugel 152–153,
Staehle, Wolfgang 186–187
 Untitled 186–187
Stella, Frank 138, 140, 188–189
 The Broken Jug 188–189
 Prinz Friedrich von Homburg,
 Ein Schauspiel, 3X 188–189
St. Taurin Church, Évreux 126
Stockhausen, Karl-Heinz 89
Stonehenge, UK 84
Strauss, Anne 84
Stravinsky, Igor 96
Strigalev, Anatolii 23
Struth, Thomas 44, 190–194
 Pantheon, Rome 190–192
 Shanghai Panorama 190–193
Sugimoto, Hiroshi 170, 194–195
 Go'o Shrine "Appropriate Proportion" 194–195
Suh, Do-Ho 146
 Surface 0012 194–195
Sydney Harbor Bridge, Sydney 50
Taeuber-Arp, Sophie 25, 26
Taj Mahal, India 10, 12
Tange, Kenzo 11
Tatlin, Vladimir 22, 23, 24
 Monument to the Third International 22, 23, 34
Taut, Bruno 11, 23, 24, 27
Taylor, Mark 178
TEN Arquitectos 146
Teshigahara, Hiroshi 78
Thorpe, David 196–197
 Good People 196–197
Tiravanija, Rirkrit 158
Toop, David 112, 152
Toshihito, Prince 10, 11
Toshitada, Prince 11
 New Shoin, Katsura 11
Troost, Paul Ludwig 130
 Honor Temple, Munich 130
Tschumi, Bernard 92
Turrell, James 8, 28, 30, 34, 35, 40, 78,
 128–129, 140
 Roden Crater 78
Tzara, Tristan 25, 26
UN Studio 198–201

Erasmus Bridge, Rotterdam 198
Het Valkhof Museum, Nijmegen 198
La Defense, Almere 198–201
Mercedes Benz Museum, Stuttgart 198
Möbius House, Naarden 198
Vantongerloo, Georges 26
Varini, Felice 202–203
 Octogone au Carré, Montélimar 202–203
Venturi, Robert 162, 172
Venturi Scott Brown 172
da Vinci, Leonardo 8, 10, 13, 210
Virilio, Paul 156, 186, 212–213
Vitruvius, Pollio 8
Vollbrecht, Karl 18
Wagner, Otto 22, 24
Wall, Jeff 204–205
 Morning Cleaning 204–205
Warhol, Andy 156, 186
Watanabe, Makoto Sei 206–209
 Shin Minamata Station and Shin Minamata
 Mon, Minamata 206–209
Weiner, Lawrence 146–147
 The Snow Show, Kemi 146–147
Whiteread, Rachel 132, 210–211
 Judenplatz Holocaust Memorial, Vienna 210
 Untitled (House) London 210–211
Whyte, Boyd 20
Wigley, Mark 19, 27, 92
Wils, Jan 25
Wilson, Rob 16
Woods, Lebbeus 146, 180, 212–215
 Shard Houses, 212–215
 The Fall, Paris 212–215
World Trade Center, New York 50, 156, 186, 212
Wright, Frank Lloyd 24, 26, 27, 45, 140, 170
 Falling Water, Bear Run 204
 Solomon R. Guggenheim Museum, New York
 27, 170–171
 Wayfarer Chapel, USA 140
Ysatis, Savvas 112
Zumthor, Peter 74, 98, 180
 Kunsthaus Bregenz, Bregenz 98, 180

Places

Almere, Netherlands 198–201
Amsterdam, Netherlands 62, 68, 198
Athens, Greece 52
Baghdad, Iraq 92
Barcelona, Spain 20, 26, 128–129, 162,
 204–205
Bellinzona, Switzerland 48
Berlin, Germany 26, 31, 32, 40, 56, 72–73,
 82–83, 128
Beverly Hills, USA 82
Bologna, Italy 16
Bonn, Germany 128
Boston, USA 50
Bregenz, Austria 74, 98, 180
Bremerton, USA 102
Caracas, Venezuela 150
Casablanca, Morocco 56
Celle Saint-Cloud, Paris 30, 31, 166
Central Park, New York, USA 56–59
Chartreuse de Champmol, Dijon 12
Chiang Mai, Thailand 158, 161
Cincinnati, USA 93, 136
Copenhagen, Danmark 74
Culver City, USA 142–143
Delhi, India 10
Dijon, France 12
Domburg, Netherlands 21, 22
Duisburg-Bruckhausen, Germany 44
Düsseldorf, Germany 44, 62, 90, 98
Eberswalde, Germany 93
Esch-Alzette, Luxembourg 44
Évreux, France 126–127
Florence, Italy 13, 62

Fujisawa, Japan 78
Gabrovo, Bulgaria 56
Gateshead, UK 50–51
Gelmeroda, Germany 18
Granada, Spain 10
Graz, Austria 38, 39
Grenoble, France 126
Guangzhou, China 76
Haarlem, Netherlands 14
Haikou, China 76
Hainan Islands, China 76
Hanover, Germany 25
Harvard, USA 33, 50, 114
Honmura, Japan 34
Katsura, Japan 11, 12, 27, 34
Kemi, Finland 146–147
Kyoto, Japan 10, 11
La Garenne-Colombes, France 166–169
La Rochelle, France 14
Langenlois, Austria 102–105
Las Vegas, USA 170
Leipzig, Germany 90
Lisbon, Portugal 182–185
Liverpool, UK 60
London, UK 20, 50, 60–61, 78, 92, 102, 132,
 144–145, 198, 210–211
Los Angeles, USA 33, 98, 114, 142, 172, 194
Lugano, Switzerland 48
Lyon, France 128
Malibu, USA 97
Mantua, Italy 15, 16
Marfa, USA 29
Metz, France 16
Mexico City, Mexico 147
Minamata, Japan 206–209
Mogno, Switzerland 49
Monte Tamaro, Switzerland 46–49
Montélimar, France 202–203
Moscow, Russia 66–69
Munich, Germany 25, 62–63, 130
Münster, Germany 29
Murten, Switzerland 148–149
Nagi-cho, Japan 108–111
Naoshima, Japan 34, 40, 194
Neuchâtel, Switzerland 148
New York, USA 18, 20–21, 27–29, 32, 38–39,
 50, 62, 64, 84, 88, 90, 96, 102, 170,
 186–187, 188, 194
Orlando, USA 170
Osaka, Japan 40
Pamulha, Brasilia 144
Paris, France 21, 25, 28, 29, 30, 116,
 126, 128, 144, 156, 212–215
Petrograd, Russia 23
Princeton, USA 78
Quanzhou, China 88
Quimper, France 128
Rio de Janeiro, Brazil 144
Rome, Italy 8, 13, 16, 20, 138–141, 178
Rotterdam, Netherlands 68
Rovaniemi, Finland 146
San Francisco, USA 212
Santa Ana, USA 50
Shanghai, China 88–91, 190–194
Singapore, Singapore 62
Sydney, Australia 50
Taichung, Taiwan 92–93
Tokyo, Japan 88, 126, 194, 206
Toronto, Canada 33
Valencia, Spain 52–55
Venice, Italy 44
Versailles, France 18
Vienna, Austria 210
Washington D.C., USA 134–135
Weil am Rhein, Germany 93
Weimar, Germany 18, 26
Yokohama, Japan 78, 112–113, 126
Yverdon-les-Bains, Switzerland 64–65, 122, 148
Zurich, Switzerland 25, 52

222

Illustration Credits

Our special thanks to the architects and artists who made illustrative material available for this publication.

The illustrations in this publication have been kindly provided by the architects, artists, museums, galleries, institutions and archives mentioned in the captions, or taken from the publisher's archive, with the exception of the following:

Numbers refer to pages (t = top, b = bottom, l = left, r = right, c = center)

Courtesy 21st Century Museum of Contemporary Art, Kanazawa: 175–77
Acconci Studio, Mur Island, Graz, Austria 2003: 38 b, 39 b l, b r
Courtesy Vito Acconci: 32
allOver, Kleve: Werner Scholz: 10
© Tadao Ando, Osaka: 40
Artothek, Weilheim: 12, © Alinari 2005 15 r; Photo: Peter Willi 14 r, 17
artur, Cologne: Archiv Archipress Le Georges, Centre Pompidou, Paris, Restaurant 114 b, 116 r, 117; Klaus Frahm 138–41; Dennis Gilbert/VIEW 74, 75, 120, 121; Roland Halbe 52/53 t, 54/55, 144, 145; Jochen Helle 33; Monika Nikolic 38 t, 219; Paul Raftery/VIEW 65, 148/149; Nathan Willcock/VIEW 6/7, 27, 122–25
Bernd and Hilla Becher. From: *Grundformen industrieller Bauten*, Munich 2004: 44, 45
Ben van Berkel. Photographic print assistant: Khoi Tran and Jorgen Grahl-Madsen: 200
Tom Bonner, Santa Monica, CA: 142 r, 143
Nicola Borel: 115
Photos: Chris Burden, Topango, CA: 51
Santiago Calatrava, Zurich: 52 b
Enrico Cano, Como: 46–49
Photo: DDR/Archives Denyse Durand-Ruel, Ruel-Malmaison: 30 b
dECOi: 42, 43
Diller + Scofidio, New York: 64
© EEA, Rotterdam: 66–70, 71 t l, t r, b r
Courtesy Electronic Arts Intermix (EAI), New York: 157
Hans Engels, Munich: 26
Esto, Mamaroneck, NY: Jeff Goldberg 134, 135
Courtesy of Weng Fen and CourtYard Gallery, Beijing: 76, 77
Photo courtesy of Fireworks by Grucci Inc.: 88
Courtesy Fondation Custodia, Collection Frits Lugt, Paris: 14 l
FRPP: 158–61
Katsuaki Furudate: 108, 108/109, 110/111 t, 224
Courtesy Gagosian Gallery: 82 b
Frank O. Gehry, Los Angeles: 82 t
© Andy Goldsworthy. Courtesy Galery Lelong, New York. Courtesy Metropolitan Museum of Art, New York: 84, 85
Photo: Andreas Greber: 214–17
Photo: Cai Guo-Qiang, New York: 89
Zaha Hadid, London: 92–95
© David Hockney: 96, 97
Steven Holl, New York: 102, 103 b, 104 l
Edward Hueber, New York. Courtesy Kunsthaus Bregenz: 180
Timothy Hursley, Little Rock, AR: 34
Arata Isozaki, Tokyo: 110 b
Jakob + MacFarlane, Paris: 114 t, 116 l

Michael Jantzen, Valencia, CA: 118, 119
Photo: Thibault Jeanson. Courtesy Dia Center for the Arts, New York: 106/107
Yann Kersalé, Vincennes: 128, 129
Elvira Klamminger: 39 t
© Leo van der Kleij, Den Haag: 126, 127
laif, Cologne: Langrock/Zenit 72 b, 73; Anna Neumann 9; Plambeck: 72 t; Wolfgang Volz 31, 56, 58/59; Wolfgang Volz/Christo 2004 57
© Michael Landy. Photograph: Tate, London 2005: 133
Iñigo Manglano-Ovalle. Photo: Paul Warchol Photography, New York: 137
Time/Timeless/No Time (2004): © Walter de Maria. Photo: © Mitsuo Matsuoka: 42/43
© Massachusetts Institute of Technology, 1999. Computer simulation from Prof. Takehiko Nagakura's synthetic film project, Tatlin's Tower. Computer graphic by Takehiko Nagakura, Andrzej Zarzycki, Dan Brick and Mark Sich: 22
© Mitsuo Matsuoka: 41
Satoru Mishima: 79–81
Ruis Morais de Sousa, Carnaxide: 182 r
Photo: André Morin: 202, 203
Eric Owen Moss, Culver City, CA: 142 t l, m l, b l
Stefan Müller, Berlin: 86, 87
Marcos Novak: 150, 151
Tomio Ohashi: 113
Hartmut Pohling/JAPAN-PHOTO-ARCHIV, Obersulm: 11
Christian Richters, Münster: 36/37, 83, 182 l, 183–85, 198/199, 201
© Ed Ruscha. Photo: Lee Stalsworth 172 t. Courtesy Patrick Painter Editions, Los Angeles 172 b, 173
© Photo: SCALA, Florence: Art Resource 188, 189; Gabinetto dei Disegni e delle Stampe degli Uffizi. Courtesy of the Ministero per i Beni e le Attività Culturali, 1991 13
Ernst Schwitters: 25
© David B. Seide www.definedspace.com: back and front cover
Harry Shunk/Kender: 28 l
© Santiago Sierra. Courtesy Galerie Peter Kilchmann, Zurich: 181
Courtesy the Snow Show. Photo: Camille Mousette 146, 147 t; Photo: Jeffrey Debany *Frontispiece*, 147 b
Courtesy Sonnabend Gallery, New York: 170, 171
Margherita Spiluttini, Vienna: 103 t, 104/105
Courtesy Monika Sprüth/Philomene Magers: 63, 91
© by Lars Spuybroek/NOX, Rotterdam: 152–55
© Thomas Struth, 2005: 190–93
© Hiroshi Sugimoto: Courtesy Koyanagi Gallery, Tokyo 195; courtesy Benesse Corporation, Kagawa 194 l, r; Philip Jodidio 194 c
Kenneth Tanaka, Chicago, IL, 2004: 162–65
© David Thorpe courtesy Maureen Paley, London: 196/197
Philip Ursprung, Zurich: 30 t
VISUM, Hamburg/Dirk Reinartz: 178, 179
Courtesy Makato Sei Watanabe, Tokyo: 206–09
Courtesy of Rachel Whiteread and Gagosian Gallery. Photographs by Sue Omerod: 210, 211
© Photo: Bram Wisman/Maria Austria Institut, Amsterdam: 19
Photographs by Gerald Zugman. Courtesy of the MAK Center, LA: 24
Courtesy David Zwirner, New York: 28 r

© Prestel Verlag, Munich · Berlin · London · New York 2005
© of works by the artists and by architects, their heirs or assigns, with
the exception of works by: Giorgio de Chirico, Thomas Demand,
Hermann Finsterlin, Candida Höfer, Robert Irwin, Yves Klein, Gordon
Matta-Clark, Ludwig Mies van der Rohe, Constant Anton Nieuwenhuys,
Jean Nouvel, Jaume Plensa, Jean-Pierre Raynaud, Kurt Schwitters,
Richard Serra, Frank Stella, Vladimir Evgrafovich Tatlin, UN Studio /
Ben van Berkel, Felice Varini, Lawrence Weiner, Frank Lloyd Wright by
VG Bild-Kunst, Bonn 2005; Andreas Gursky by VG Bild-Kunst, Bonn
2005, courtesy: Monika Sprüth Galerie, Cologne; Donald Judd by Art Judd
Foundation, licensed by VAGA, NY / VG Bild-Kunst, Bonn 2005.

Front and back cover: Crown Fountain, Millennium Park, Chicago,
Illionois, USA
Photograph by David B. Seide, www.definedspace.com, see pp. 162–65
Frontispiece: Enrique Norten, Lawrence Weiner, The Snow Show,
Kemi, Finland. Photograph by Jeffrey Debany. Courtesy the Snow Show,
see pp. 146–47
Pages 6/7: Frank O. Gehry, Guggenheim Museum, Bilbao, Spain
Photograph by artur/Richard Hell
Pages 36/37: UN Studio, La Defense, Almere, The Netherlands,
see pp. 198–201. Photograph by Christian Richters, Münster
Page 224: Arata Isozaki, Nagi MoCA, Nagi-cho, Japan. Photograph by
Katsuaki Furudate, see pp. 108–11
Page 219: Acconci Studio, Mur Island Project, Graz, Austria 2003.
Photograph by artur/Monika Nikolic, see pp. 38–39

Prestel Verlag
Königinstraße 9
80539 Munich
Tel. +49 (89) 38 17 09-0
Fax +49 (89) 38 17 09-35
www.prestel.de

Prestel Publishing Ltd.
4, Bloomsbury Place
London WC1A 2QA
Tel. +44 (20) 73 23-5004
Fax +44 (20) 76 36-8004

Prestel Publishing
900 Broadway, Suite 603
New York, NY 10003
Tel. +1 (2 12) 9 95-27 20
Fax +1 (2 12) 9 95-27 33
www.prestel.com

Library of Congress Control Number: 2005905468

The Deutsche Bibliothek holds a record of this publication
in the Deutsche Nationalbibliografie; detailed bibliographical
data can be found under http://dnb.ddb.de

Prestel books are available worldwide. Please contact your
nearest bookseller or one of the above addresses for information
concerning your local distributor.

Editorial direction by Angeli Sachs
Copyedited by Danko Szabó, Munich
Picture research by Sabine Schmid, Munich
Design and layout by Cilly Klotz
Origination by Repro Ludwig, Zell am See
Printing by Aumüller, Regensburg
Binding by Conzella, Pfarrkirchen

Printed in Germany on acid-free paper

ISBN 3-7913-3279-1